FORM AND MEANING

FORM
AND
MEANING

Essays on the Renaissance and Modern Art

By ROBERT KLEIN

Translated by Madeline Jay and Leon Wieseltier

Foreword by Henri Zerner

Princeton University Press
Princeton, New Jersey

La forme et l'intelligible
© Editions Gallimard, 1970
English-language and Foreword
Copyright © Viking Penguin Inc. 1979
First published in 1979 by The Viking Press
Published by Princeton University Press,
Princeton, New Jersey

LIBRARY OF CONGRESS CATALOGING IN PUBLICATION DATA

Klein, Robert, 1918-1967.
Form and meaning.

Translation of La Forme et l'intelligible.
"Bibliography of Robert Klein's writings"
Bibliography
1. Art, Renaissance—Addresses, essays, lectures.
2. Aesthetics, Modern—Addresses, essays, lectures.
3. Ethics, Modern—Addresses, essays, lectures.
I. Title.
BH151.K5513 701 80-8772
ISBN 0-691-00328-9 pbk.

Printed in the United States of America
Set in V.I.P. Caledonia

Reprinted by arrangement with The Viking Press

First PRINCETON PAPERBACK printing, 1981

CONTENTS

FOREWORD, *by Henri Zerner* vii

PART I **Thought and Symbolism In the Renaissance**

1 The Theory of Figurative Expression in Italian Treatises on the *Impresa* 3

2 Burckhardt's *Civilization of the Renaissance* Today 25

3 Form and Meaning 43

4 Spirito Peregrino 62

PART II **Perspective and Scientific Speculations in the Renaissance**

5 Utopian Urban Planning 89

6 Pomponius Gauricus on Perspective 102

7 Studies on Perspective in the Renaissance 129

PART III **Aesthetic and Method**

8 Thoughts on Iconography 143

9 Judgment and Taste in Cinquecento Art Theory 161

10 Notes on the End of the Image 170

11 The Eclipse of the Work of Art 176

12 Modern Painting and Phenomenology 184

13 Thought, Confession, Fiction: On *A Season in Hell* 200

NOTES 209

Bibliography of Robert Klein's Writings 258

FOREWORD

I was born on September 9, 1918, in Timisoara. Rumania.

I studied medicine, 1936–37 in Cluj (Rumania); philosophy, 1937–38 at the German University in Prague; science, 1938–39 in Bucharest.

Between 1939 and 1945, first I did regular military service, then compulsory labor for Jews, and finally, after the liberation of Rumania, I engaged as a volunteer in the war in Hungary and Czechoslovakia.

In 1947, I got a degree (licence) in philosophy at the University of Bucharest, and then I won a French Government Scholarship to study in Paris. I declared myself a refugee in the spring of 1948, whereupon my scholarship was withdrawn on request of the Rumanian government. I have remained without nationality until the present day.

From 1948 to 1962, I made a living by giving private lessons and by taking on various odd jobs while earning a diplôme d'études supérieures in aesthetics (1953), with a thesis on Technè and ars in the tradition from Plato to Giordano Bruno, and in 1959, a diplôme de l'Ecole pratique des hautes études, IVe section, with a critical edition of Lomazzo's Idea (unpublished), prepared for Professor André Chastel. From 1954 to 1958, I worked as secretary for the historian Augustin Renaudet, Professor Emeritus at the Collège de France, and from 1958 to 1962 as technical assistant to the Hispanist Marcel Bataillon, Administrator of the Collège de France.

Since 1962 I have been attached to the Centre national de la recherche scientifique, and have worked on an index of Leonardo's manuscripts and a critical edition of Gauricus's De Sculptura (1504), with a research group at the Ecole pratique des hautes études, IVe section.

I have been invited to be Professor of the History of Art at the University of Montreal for the academic year 1965–66.

This brief biography was written by Robert Klein in 1965 when he applied for a Canadian visa. He did, indeed, spend that year in Mon-

treal, with some brief visits to the United States. He returned to Europe in the summer of 1966, and went to Florence in 1966–67 as a fellow of Harvard's Berenson Foundation at the Villa I Tatti. He died there on Saturday, April 22, 1967, leaving much of his scholarly work unfinished.

All the essays translated in this volume were written in the last ten years of Klein's life. The war had taken six years of Klein's youth, and his early years in Paris were mostly devoted to survival—washing dishes for a living does not leave much time for scholarship. With an increasing if very modest prosperity (which seemed quite splendid to him), he gained intellectual assurance, and it brought his extraordinary gifts into full play.

Nearly fifty at the time of his death, he was enormously fertile, full of plans and projects, ready to venture into new domains. Shortly before the end, he told me he had been deeply moved by seventeenth-century Dutch landscapes, Ruysdael's in particular, and planned some work in this field.

It is tempting in the case of Klein, as in that of Aby Warburg (the founder of modern iconographical studies, with whom Klein had so much in common intellectually), to consider the published work as a mere fragment of what the man amounted to. But while the great Hamburg patrician kept every scrap of paper, the wandering Rumanian expatriate left almost nothing behind. The task of construing a general "project," of drawing the "quintessence" of Klein's thought, has been attempted once in André Chastel's substantial introduction to the original French edition of La forme et l'intelligible. I shall restrict myself here to a few brief remarks about Klein and his essays.

Klein's papers were collected after his death in a large volume published by Gallimard in 1969. The title, La forme et l'intelligible, is that of one of the essays and does, indeed, describe the major concern of the author. Except for what Klein published in book form, like the volume on Savonarola's trial, there is nothing crucial missing from the French collection; although many of Klein's pieces that were left out of it are still worth reading, one can still form a full idea of his cast of mind from that volume.

For this selection—the first of Klein's to be published in the English language—we have tried to think of what would be most useful for the reader and student. We have eliminated some strictly ethical writings like "Appropriation et aliénation" (1961). They were very im-

portant to Klein—who always talked, only half in jest, about devoting himself entirely to the writing of a grand treatise on ethics; but for this smaller volume, the subject matter should not be too disparate. Other essays that are left out, especially those on the Renaissance, might perhaps have been as helpful as those included. "Le thème du fou et l'ironie humaniste" (1963) is an important piece on humanism, and it also reveals a scholar in whom irony and self-irony were pushed to an extreme point, as André Chastel remarked; it has been omitted here, albeit regretfully, because it seemed a bit tortuous. On the other hand, it seemed important to make Klein's essays on modern art available in English. They remain readable, fresh, and incisive, and they remind us that Klein's pursuits, even when they appear recondite, were always an attempt to make sense of his immediate experience. *Form and Meaning* therefore will give some idea of Klein's remarkable erudition, his wide curiosity about the culture and art of different times and people, and his originality in attacking problems the interest and relevance of which have only become more evident today.

Klein's main training was in philosophy, and he was most at ease in philosophical discourse, so that a few of the essays may be arduous for a reader with no philosophical background. He was capable, however, of lucid exposition aimed at a general public—as, for instance, in his essay on Burckhardt, which is a model of clarity and of generous criticism. Klein also made himself into an art historian with a total command of the professional literature, and he taught art history. The "physiology" of the connoisseur and collector fascinated him. He talked about connoisseurs with a sort of skeptical admiration, with the mixture of wonder and incredulity one might have before a duck-billed platypus. Among art historians he admired Erwin Panofsky most of all, especially the earlier Panofsky, the friend of Ernst Cassirer, the collaborator of Saxl, and the brightest star of the Warburg Institute in Hamburg. It is in this light that one must read Klein's "Thoughts on the Foundation of Iconology," which is the best critique I know of Panofsky.

Klein loved art, literature, all aspects of human culture—only music left him unmoved, or at least he claimed it did. For sheer enjoyment, I think what he loved best was the abstract beauty of pure argument, which he experienced as a kind of emotion recollected in tranquillity. But his real province as a scholar was that area where art,

literature, and scientific or parascientific discourse meet with philosophy. He, if anyone, was a historian of ideas.

The thought *behind* things is what preoccupied him, whether it was the most recent art or the most obscure treatises of the past. This was not only because of his delight in thought as such but also because he was trying to uncover the most profound existential preoccupations of the past and present. Even when this is least apparent, as in some of the strictly scholarly essays on humanism or art theory, his thinking is always informed by phenomenology or, to be more exact, by his own meditation on Husserl.

Where Klein was superlative was in the way he could take a specific problem or subject and, at the end of a careful technical examination, make it yield larger and unexpected consequences. This is striking in his famous and influential essay on perspective, where he starts from an obscure and uninspired text and ends up with a reassessment of Renaissance attitudes to space, clarifying a number of precise technical points along the way.

His great success in Renaissance studies is due to his understanding of the relation between the theory of art, which he often wrote about and knew intimately and thoroughly, and art itself. He did not see theory and art as independent, nor one as simply dependent on the other; he knew that theory was neither the reflection nor the informing principle of art. What he wrote on theory never remained purely theoretical; his erudition did not turn into pedantry. For him, both theory and art were means to express underlying mental attitudes and sensibilities that could not, at least at the time, be articulated explicitly.

The essay on *imprese* is a typical example. These personal emblems made of a little picture and a motto had been enormously popular during the Renaissance. Klein's keen examination discovers that this purely social and to our eyes minor kind of art had come to be understood as the very model of artistic expression. Study of the many treatises that discuss the theory of these *imprese* enabled him to make a striking contribution to our understanding of sixteenth-century ideas on expression, and brilliantly to disentangle the fundamental Aristotelian ideas from the Neoplatonic vernacular—while still accounting for a minor but real Neoplatonic contribution. Klein is dealing here with the period that saw the end of the Renaissance and the emergence of a new art in the seventeenth century; he brings out the

parallel between the transformation of the theory and the change in style without making one account for the other; it is the indirect interconnection that is significant. We might say that the *impresa* itself is a metaphor of Klein's understanding of cultural phenomena. The motto does not explain the image, nor the image illustrate the words, but their juxtaposition both reveals and hides the underlying impulse; similarly, the juxtaposition of theory and art reveals the dynamic significance of the culture that produced them, and also expresses the inaccessibility of its prearticulated state, before it has been comprehended and made explicit by the observer, who must be both critic and historian of ideas.

Henri Zerner
Cambridge, Mass.
Paris
1979

PART I | THOUGHT AND SYMBOLISM IN THE RENAISSANCE

The Theory of Figurative Expression in Italian Treatises on the *Impresa*

There is no real equivalent today for the term *impresa*, a symbol principally composed of an image and a motto, serving to express a rule of life or the personal aspirations of its bearer. The French in the sixteenth century called it *devise*, in the ancient sense of project, design, "device," which agreed well with the sense of *impresa* as "enterprise." The invention was indeed French, or passed for such; the first collection was in French,[1] * and in a famous passage of his *Dialogo dell'imprese militari e amorose* (1550), Giovio wrote that the fashion had been introduced in Italy by Charles VIII s captains, and was imitated by Italian warriors who drew *imprese* on their weapons and gave them to their men to distinguish them in the fray and to stimulate their courage. Franco-Italian society in Lyons was one of the first, in the sixteenth century, to adopt the custom of the *impresa* and make it literary, in line with the contemporary vogue for emblems in the same circles.[2]

Giovio's account was accepted and repeated by all his contemporaries. A French origin was almost self-evident for a custom held generally to be chivalric. In 1562 Scipione Ammirato called it "a philosophy of the knight." The first collections of *imprese* contained only "amorous and military" or simply "heroic" devices; the fashion then reached the salons, where the *impresa* swiftly became popular because of its socially useful ambiguity and capacity for guarded revelations. It became the basis of many society games, in which one characterized others or oneself in improvisations of this kind. The Academy of the Intronati in Siena around 1570–80 was the center that set the tone: Scipione Bargagli described the local youths as "en-

thusiasts not only of poetry, painting, and architecture but also of this genre of beautiful and clever works; considering above all that so many *beaux esprits* (*belli ingegni*) practice it these days, in conversation and in writing";[3] and the *Dialogo de' giuochi* by the Sienese Girolamo Bargagli codified entertainments derived from the *impresa* that were adopted even in the Rambouillet salon. But although the Intronati enjoyed this social amusement (two other collections, one anonymous, the *Rolo degli uomini d'arme sanesi*, the other by Ascanio Piccolomini, friend of Galileo, hail from that circle), they did not overlook a more learned symbolism: we know that Cesare Ripa, author of the famous *Iconologia*, was one of them. This is not a coincidence, and it would be surprising if the interest in symbolism and pictography, so widespread in cultivated Italian circles after the mid-sixteenth century, had nothing to do with the vogue for these symbolic images.

Giovio was nearly seventy when he wrote his *Dialogo*, and more than fifty years had elapsed since Charles VIII's campaign. Hence his version of the origin of this fashion in Italy somewhat simplified matters. The fact is that even before 1498 nonmilitary *imprese* were well known in Italy and, significantly, were commissioned from poets. Politian and Sannazaro complained of troublesome clients importuning them with demands for *imprese*.[4] Of course, we cannot state with certainty that *impresa* meant in the fifteenth century what it did in the pedantic treatises of the sixteenth; it might have been simply a motto, a "device," in the literal sense, or an image of the sort of a personal emblem, like the firestone of Charles the Bold. But in any case evolution of the Italian *impresa* from a starting point in the expressive images of the Quattrocento, the hieroglyphs and the allegories, is far more plausible than any military origin.[5] Writers who repeated after Giovio the origin of the *impresa* always cited as innovators, after the warriors (among other things they referred to a passage from Aeschylus's *Seven against Thebes*), all the traditions of the mysterious wisdom of the ancients, the Egyptian designers of hieroglyphs, the cabalists, and often Noah, Adam, or even God the Father. This twofold mythical origin reflects the real twofold origin of the fashion: the knightly affectation of men of arms and the philosophical affectation of literary circles. This inevitably became pedantry in the academies, as early as 1570–80: each academy chose its *impresa*, compelled its members to adopt it, published collections and trea-

tises. Instead of the exploits of love and war, these mottoes spoke of moral virtues. Andrea Chiocco's definition (in *Discorso delle imprese*, Verona, 1601) is typical of the period: the *impresa* is "an instrument of our intellect, composed of figures and words which represent metaphorically the inner concept of the academician." "Instrument of our intellect," "composed," "inner concept," "academician"—Giovio would never have recognized in that description the *impresa* he had brought into fashion in the book whose writing he claimed had "rejuvenated" him. There is no mention anymore of the essential part of the knight's *impresa*: personal aspiration, confession colored by a hint of defiance, as the public avowal of feelings always was in the Middle Ages. (Ruscelli, in 1556, was still careful to stress that the *impresa* should never be too daring or presumptuous.) For Chiocco it simply expressed an "inner concept" of whatever kind.

In 1612, *Della Realtà*, a large volume by Ercole Tasso that was a complete summary and detailed study of all the writings on the subject since Giovio, marked the end of a period; just before, Simone Biralli had assembled in two volumes (1600 and 1610) the most complete, and in large part recapitulatory, collection. The *impresa* now reached a new stage in its development: it became a work whose chief merit consisted in the wealth of meaning and allusions that could be hidden or discovered within its complex structure. The "explication" of a verse or prose *impresa* had become a literary genre on its own— primarily an opportunity to flatter the bearer, but also a typical exercise of *concetti*. After the Mannerist *impresa* of the salons and academies, the period of concetti-like *imprese* was beginning.

The transformation that took place during the Mannerist period was particularly felt in a change of technical requirements. The first "rules" were, in fact, only conventional precepts. Giovio had formulated five, which remained famous: there must be a just proportion between the "soul" and the "body" (the motto and the figure); the *impresa* must be neither too obscure nor too obvious; it must be pleasing to look at; it must not include the human body; the motto, preferably in a foreign language, must not include more than three or four words, unless it is in verse or is a quotation from a known author.[6] Very early, in 1556, Ruscelli added a first structural rule: the figures and the motto only have meaning through their mutual connection.[7] Palazzi, reducing Giovio's five rules to three, retained that clause.[8] Emperor Titus's famous *impresa*, consisting of a dolphin

around an anchor with the motto *Festina lente*, came under criticism because its picture and its motto had the same meaning. Ammirato, more critical still, excluded even mottoes that only explain the picture, such as the *cominus et eminus* under Louis XII's porcupine: "neither must the soul be the interpreter of the body nor the body of the soul."[9] Rebus *imprese* were universally scorned;[10] Charles V's columns of Hercules with the sentence *Plus oultre* was also criticized because the *impresa* was not based on a comparison but simply stated a purpose. The yew with the inscription *Itala sum, quiesce* (the reader was supposed to know that the shade of the Spanish yew was lethal while the Italian variety was harmless) was faulted for another reason: the motto is pronounced by the figure represented in the design. Apothegms, proverbs, precepts, enigmas, and questions were not acceptable, since they already contain a general meaning within themselves. Such purely aesthetic conditions did not exclude requirements of decency or rank—on the contrary, the Counter-Reformation spirit tended to multiply them—but around 1600 the ideal *impresa* was obviously self-contained and technically coherent, consisting of elements that were all necessary and sufficient to express a unique *concetto*, a single act of thought; external limitations and personal considerations were, for *imprese*, thus conceived only as supplementary conventions.

Mario Praz's *Studies in Seventeenth-Century Imagery*—the fundamental book on the subject—has shown the affinity that existed from the beginning between *impresa* and *concetto*, and has enabled us to understand its development.[11] As one would expect, his analysis adopts the point of view of the history of taste, of styles, of artistic conceptions. Praz did not ponder the philosophical foundation, implicit or acknowledged, of this new symbolic language.[12] This question, which concerns us here, was posed not by *imprese* themselves, but by the theoretical introductions to the collections, and by the discourses and dialogues on the subject—a body of stereotyped discussions on the origins of the *impresa*, on distinguishing *imprese* from shields, ciphers, coin reverses, "hieroglyphs," emblems, etc., on the rules of that art, on the respective roles of the motto and the figure. The central part of such works was usually a long-winded definition defended at length against differing opinions. Those discourses, which may seem frivolous, dealt in fact with a crucial aspect of the philosophical anthropology of Mannerism—that is, the problem of

expression. Toward it converged, in those logic-chopping years, theories of art, poetry, rhetoric, and, in a sense, psychology; by means of it, too, was elaborated the precise meaning of *concetto* as the beginning of a new aesthetic: the *impresa*, both picture and idea, "a knot of words and images," to quote Ammirato, was, in the eyes of many, the *concetto* in purest form.

Authors of treatises on *impresa* generally possessed a fairly thin philosophical culture; the Neoplatonism of Alessandro Farra and Luca Contile, both members of the Academy of the Affidati in Pavia, was so outmoded that, eighty years after Pico della Mirandola, both planned to write discourses on the dignity of man. Torquato Tasso had a good knowledge of philosophy—and his dialogue on *imprese* is one of the least pretentious. Father Horatio Montalto, a Jesuit, was a reader in Aristotelian rhetoric in Milan; those authors who were close to Jesuit circles (Scipione Bargagli had been one of the first pupils at their Sienese college) were solidly in possession of their Aristotle. But the greatest authors of collections or treatises during the years of the "knightly" *impresa* were historians or *beaux esprits*: Giovio and his direct followers, Domenichi and Ruscelli, had written biographies and histories, and were interested in problems of epigraphy, language, and literary criticism. The same applies to Simeoni and many of the treatise-writers of the following generation. Scipione Ammirato, like Giovio a bishop and a historian, was also a genealogist, like Claude Paradin before him. Professional writers, hoping to make their dedications rewarding, were the most numerous: we find mostly more or less itinerant courtier-secretaries such as, after Simeoni and Ruscelli, Contile and Capaccio. (Ruscelli and Capaccio, accomplished literary *tantecose*, even left models for "the perfect secretary.") In the academies, where wit was not a professional matter, we find among amateurs of *imprese* a retired soldier like Farra, a jurist and criminologist like Taegio; but among the complete works of the treatise-writers, we find mainly *Rime* (Caburacci, Ercole Tasso) or literary controversies, praises of Ariosto. Later, during the epoch of *concetti*, the intellectual orientation of the authors and the philosophical background of treatises completely changed. The theory of the *impresa* was annexed by the Jesuits, notably the French, and revived as a kind of baroque metaphysics.

We cannot, therefore, expect the sixteenth century to be fully aware of the philosophical problems posed by such writings. But the

structure of the *impresa* was such that the commonplaces that converged to form its theory can be naturally separated along lines that reveal the underlying philosophy in a strikingly precise manner.

Figurative Expression

All the authors agree in classifying the *impresa* among means of expression—"un modo di esprimere qualche nostro concetto," as Palazzi put it.[13] Scipione Bargagli stressed that he defined the *impresa* as "the expression of a *concetto*," not as "an expressed *concetto*": it is not a concept, but a way of representing one.[14] In the Materiale Intronato it was stated inadvertently that the *impresa* was a "mute comparison"; Ercole Tasso replied in three long pages, citing seventeen definitions by different writers, that *imprese* are not "mute," but rather represent, signify, and express—in other words, that they are always, more or less explicitly, addressed to somebody. Like the symbolic images that preserve the mythical wisdom of the ancients, they may even have some didactic value.

To those who believed, like Ruscelli or Domenichi, that an *impresa* could do without words, Ercole Tasso replied that if that were so then any object, any gesture, any drawing would be an *impresa*.[15] But this objection only expressed the hidden thought of his adversaries: in their eyes, the *impresa* was indeed figurative expression *par excellence*; any image with a meaning, or even any object considered as an image or a symbol, was in some sense an *impresa*. It all depended on the context; Ercole Tasso himself had shown that a lion could be in turn an animal hieroglyph, a heraldic sign, a house of the Zodiac, a street sign, the symbol of an Evangelist, an *impresa*.[16] Distinguishing between symbolic genres according to their subjects and their techniques was a fairly common game: for instance, it was stated that colors were used exclusively to represent "certain incorporeal things"— emotions, feelings;[17] as many as thirty-two kinds of "natural and artificial signs" were distinguished;[18] and most of all, a hierarchy of means of expression was described—gestures for the dumb, words for the vulgar, writing for the "erudite or fairly erudite," and *imprese*, synthesis of all the means of expression, for refined minds.[19] Scipione Bargagli's hierarchy was composed of gestures, cries, articulated sounds, words, alphabetical writing; writing by ciphers and figures appeared as a sort of intellectual luxury; and the rarest and most singular invention of the mind was the *impresa*, for the interdependence

of words and figures made it the best structured and most complex instrument.[20] Ruscelli justified the same view differently: the *impresa*, he said, crowned the language of imitation (innate or "naturally acted out") with articulated language (learned or "potentially natural"). The very evolution of symbolic forms of expression (i.e., of *imprese* in the widest sense) revealed a similar striving toward perfection, according to Taegio: first came symbolic words, or the cabala; then symbolic figures, or hieroglyphs; then a combination of both, either inept or "superfluous" (tautological); finally, the actual *impresa*, which was perfect.[21]

Thus the top of the scale is occupied not by the most convenient, the simplest, or the most adaptable means of expression, but by the most complex and richly organized. This is a remarkable valorization of indirectness, of the veil that at once reveals and conceals. We find it again, in more deeply studied form, in Francesco Caburacci; he distinguished three expressive acts: to signify by conventional means; to represent, or imitate, by creating a duplicate object; and to show— which belongs to discursive or figurative expression, where a concept is expressed indirectly through another concept. Like Vico later, Caburacci assimilated speech to figurative expression, and stressed that poetry did not "imitate" but "showed": like the *impresa* that must not be confused with the mimetic representation of an object, it was essentially a figure.[22]

Taegio went in the same direction when he viewed the *impresa* as "the image of a concept expressed, with suitable brevity, through words or figures or both together."[23] This definition applies to *imprese* in the larger sense, of course, that is, to any symbolic expression; its subject is not the concept, but the "image of a concept"—an image that the context show us is prior and alien to the difference between verbal and plastic expression. However, it is not identical with the initial thought that has to be translated, which the treatise-writers usually referred to as *intentione dell'autore*, and which Taegio called "concept." The "image of the concept" could only be an initial putting into form, as yet unexpressed; thought's clothing of thought, indirect meaning as Caburacci called it, the expression of one concept by means of another, in short, a metaphor. The "figure" of style is in effect a thought-image replacing a concept; Praz showed how the figure, in the *impresa*, usually reduced to the illustration of a metaphor. The metaphor taken literally and developed in detail has the favorite

literary means of the ingenious Seicento; at the same time it was the apparent mechanism of most hyperboles, as in the banal variations on "rivers of tears" and the "wind of sighs." In other words, the passage from the "figure" of style to quasi-visual representation, and the exploitation of the "image" thus obtained by speech, was among the essential techniques of *concetti* writing. *Concetti* were possible, and closely linked with the *impresa*, because the metaphor was originally a clothing of thought prior to expression, an image at once discursive and capable of visual representation—or, rather, existing prior to the distinction between these two means of expression.

The Intelligible Image

Caburacci and Taegio showed that the philosophical interest of the *impresa* as a form of expression lay in the relationship it presupposed between the idea and the image. Can an image be universal? Is the idea an image, or can it be?

These questions were very real in the sixteenth century. The first postulate of the theory of art was the universality of the *disegno*, and the possibility of making the Idea visible. The logicians' study of Topics, a dominant discipline, developed the spatial implications of the *artes inveniendi* transformed into "theaters" of symbolic figures (Camillo, Bruno), and of the progress of mnemotechnics. And, finally, in the theory of the soul, a leading role was assigned by Bruno to imagination, the central faculty which for twelve centuries had held the secret of how images received by the senses were transformed into notions wielded by the intellect.

In the effort to conceive the union of the visible with the intelligible—which the *impresa* was supposed to achieve—thirteenth- and fourteenth-century philosophers had if not the solution, at least a framework: the *species intelligibilis* that they interposed between the mental image and the universal in the genesis of the abstract idea. But they only displaced the difficulty: they faithfully reproduced the familiar discussions and arguments exchanged between nominalists, empiricists (Roger Bacon), conceptualists (Thomas Aquinas), and "Platonists" (Mayron).

In the case of the *impresa*, there was an additional difficulty because the "concept" to be expressed was not a notion, but a judgment: a metaphor, an analogy, or a comparison. Only one Scholastic logician, Pierre d'Ailly, had asserted (as a few neo-Kantians would

later) that judgment as an intellectual operation, *propositio mentalis*, was a simple act and not composed of terms; this distinction helped him to explain those difficult sophisms known as *insolubilia* which have now been rediscovered as "Russell's paradoxes." Without citing Pierre d'Ailly, and probably without knowing him, the theoreticians of the *impresa* tried to blur the allegedly composite character of mental judgment.

In fact, an explanation of ideas as images could not be found in logic or the theory of knowledge, but evidently must be sought in a theory of symbols. The crucial idea was as outlined by Caburacci: no universal meaning can be expressed otherwise than through a "figure," which hides and reveals it at the same time. This notion was not alien to the Middle Ages but, as is often the case in philosophical anthropology, what had to be discovered in man was found first in animist projections. Roger Bacon indicated that any "natural" action, that is, any act of God, is a manifestation, a creation, of images: "Transumitur hoc nomen [species] ad designandum primum effectum cuiuslibet agentis naturaliter." It is the same omnipresent force whose products are always forms, reflections, figures, speaking "shadows": "Virtus habet multa nomina, vocatur enim similitudo agentis et imago et species et idolum [=image within the soul] et simulacrum et phantasma et forma et intentio [=logical determination] et passio et umbra philosophorum [=notion, mental image].²⁴ This is almost exactly what Giordano Bruno said later: "Idea, adsimulatio, configuratio, designatio, notatio est universum Dei, naturae et rationis opus, et penes istorum analogiam est ut divinam actionem admirabiliter natura referat, naturae subinde operationem (quasi et altiora praetentans) aemuletur ingenium."²⁵ These texts are only the—admittedly magnificent—metaphysical amplification, and application to "God's language," of what Caburacci, Taegio, and in a way Vico claimed about human expression, and about "the figure" as a common source for speech and image.

To represent an idea by a figure that "partakes" of the universal and ideal character of its object is, as we know, the particular function of the symbol as it was conceived by Renaissance Neoplatonists: a magical or expressive sign, an evocative charm, an incarnation or reflection of the archetype, the attenuated presence of the intelligible "shadow" or preparation of mystic intuition. To the richness of Platonism, and of the currents to which it fell heir, it is said that Aris-

totelianism could only oppose the conventional sign or the allegory as a mere label and "illustrated definition." But in fact Aristotle, through his conception of the relation between thought and expression, between the idea and its realization in the work, offered a new way of deepening the meaning of the images of ideas. We can envisage them from two points of view that complement each other in a characteristically Peripatetic way: in one, expression imitates the articulations of the thought, which are those of the object, and thus authorizes the logic of *imprese*; in the other, invention and representation re-create the concept within sensible matter, and this process founds not an aesthetic, but a *techne*; a science of the art of the *impresa*. I propose to show how the Aristotelian tradition was applied to those two tasks, and provided at the same time impressive proof of its own vitality.

Impresa and Thought

The logicians of the *impresa* were above all interested in the possibility of considering the initial *concetto* as an abstract notion. Such an identification is not self-evident, because the explicit *concetto* is more a judgment than a concept. But the logicians wanted to bring the two closer; so they first had to distinguish between the idea of the *impresa* and the "interior"—and alogical—"concept" of other artists. That was, at least, the opinion of Luca Contile: for him, the *impresa* was an "invention" rather than an art,[26] for invention was the outcome of thought, while imitation (in its wider sense: the "imitation" of objects or of other people) was the instrument of invention, and art, in the end, was the act of execution. It is clear that conceived in this way, imitation was the expression of thought and art its lasting realization. Contile added that the three terms formed a chain, each one the instrument or auxiliary of that which preceded it. But if one thus carries the *concetto* of the *impresa* toward thought, one seems to be drawing it away from art: it is enough to endow expression with the attributes of artifice to restore the equilibrium—and that is precisely what Contile himself (among others) did.

This "thought" was, as much as possible, reduced to the unity of a single act of intelligence to make it resemble the concept more closely. This is only a verbal trick: the "definite purpose" to be expressed was labeled *concetto* or *pensiero*; the drawing was the expression of this "*concetto*," and the comparison or analogy became a relationship between the two terms. This process can be attacked

logically: the same relationship cannot be called expression at one
time and comparison at another. But by such a move—and this is the
important thing—a simple initial *concetto* is obtained. The *impresa*,
Girolamo Bargagli said, was "una mutola comparatione della stato, e
del pensiero di colui che la porlta, con la cosa della impresa con-
tenuta."[27] Ercole Tasso forbade the use of the allegory in the design
of the *impresa*, under the pretext that it would introduce secondary
significations into a work which is "tutta per stessa figura." Without
denying that the *impresa* was a judgment, it was thus returned to the
unique image of a thought; Capaccio further defined it as "un ritratto
del concetto che col penello dell'imaginativa ha lineato in quell'es-
pressione, e parturendo una cosa simile a se, la manda fuori in quella
demonstratione, non matematica, ma ombreggiata di spirito del suo
pensiero."[28] Thus thought itself was an image which copied the
image of the *impresa*; for Capaccio, the motto was not even essen-
tial—it might serve to narrow down, particularize, or stress this or
that aspect; it was the "color" added to the design.[29]

With Scipione Bargagli, we find the ambiguity between expression
and comparison at its worst: "L'impresa e espression di singolar con-
cetto per via di similitudine con figura d'alcuna cosa naturale (fuor
della spezia dell'huomo) ovvero artifiziale, da brevi e acute parole
necessariamente accompagnata." The exclusion of the human figure
from a picture was meant to avoid pleonasm: man was already impli-
cated in the initial *concetto* of what is called his *impresa*—his "en-
terprise." For the same reason the motto must not contain the name
of an object represented in the drawing. It should also avoid if possi-
ble the use of a first-person verb: it must be more or less substan-
tivized, so as to be the term of a comparison and not the autonomous
expression of an idea. As we see, any relationship of analogy is rel-
egated to the instrumental order and subordinated to a *concetto* that
is not necessarily a simple notion, but whose eventual composite
character does not play a positive part.

Under the name Cesare Cotta, Father Horatio Montalto published a
treatise that seems to be an attack on Ercole Tasso's, and which must
have been a perfect, although pedantic, example of applied Aris-
totelianism.[30] He began by arguing that the "facultas, quae tradit ra-
tionem condendi Impresiam" belonged to no other art, but rather
employed painting, poetry (metrics), history, rhetoric: it was there-
fore an autonomous art, belonging, together with the art of emblems

and some others, to the group of "facultates, quae leges tradunt constituendi peculiaria Symbola." The elements of the *impresa* were: *figura extranea* (design), *consilium mentis* (*concetto*) and as a link between the two, *similitudo*. The *concetto* was the idea to be expressed; the external figure, second term of the comparison, was the "matter" "informed" by the *concetto*. This combination constituted the *impresa* "quatenus [habet] vim aptam ad exprimendum quidquid materia potest esse Impresiae"—a matter which was, naturally, the "firm purpose" or state of mind of the bearer. The motto was optional. This scheme is on the whole the same as that of Scipione Bargagli, and although Montalto insisted on introducing Aristotelian metaphysics, he did so only to define the necessary resemblance between the *concetto* and its representation as a "link between matter and form." Once more, the metaphor or comparison was left outside the concept; it was neither within it nor in the picture, but between the two: the *consilium mentis* appeared theoretically as a simple element, close to the universal image.

With all these writers, we thus hark back, strangely, to Pierre d'Ailly's *propositio mentalis*, a simple act of the intellect. Whether we like it or not, the thing to be expressed, the subject, remained a thought, a judgment, and often a self-judgment. To articulate it, the *impresa* used certain properties of things: "[le imprese] furono ritrovate per un certo occulte discoprimento nella similitudine c'hanno le cose con i pensieri e con i disegni honorati dell'huomo," Contile wrote.[31] It was, according to Chiocco, "un instrumento dell'intelletto, composto di Figure e di Parole, rappresentanti metaforicamente l'interno concetto dell'accademico."[32] It was, therefore, as the "instrument" of an expression of the thought—admittedly an indirect and metaphorical expression—that it must be considered. Despite its concrete form, it belonged to the order of logic.

This explains the nature of critical judgments on *imprese*: the question of the quality or aptness of the expression was never raised, but conformity to rules was required. It was enough for the *impresa*, like the syllogism, to fit its definition exactly, and to respect all its material and, above all, formal requirements. A true syllogism is truly a syllogism; a true *impresa* is truly "perfect."

The assimilation to logic or, rather, to Analytics was taken very far with Farra: "l'impresa è operatione dell'intelletto, o seconda [judgment] o ultima [reasoning], dimostrata con parole brevi, e con figure

sole, o necessarie."[33] The representation of a yoke with the motto *soave* is an *impresa*-judgment; an empty escutcheon with the motto *non est mortale quod opto* is an enthymeme. Caburacci, more systematically, extended the analogy to almost the entire Organon. In syllogistic *imprese*, the major premise was almost always a commonplace: therefore Topics must intervene. Other *imprese*, used as *exempla*, naturally depended on Rhetoric. As for the third type of *imprese*—those which were only images—they were better treated as judgments, with the attribute expressed by the motto.[34]

From its beginnings, humanist logic favored Topics over Analytics—or logic as an art over logic as a science.[35] Many treatises tend toward Topics: Torquato Tasso's and Capaccio's were mainly inventories of the Creation, with a list of *imprese* which could be obtained from each class of objects; Ammirato, more faithful to the spirit of Aristotle—and, it must be said, to the spirit of the *impresa*—proceeded according to categories of similarity, of the more or the less, of opposites. Caburacci, whose text is incomplete on this point (the 1580 edition is posthumous), at least defended at length the possibility and necessity of a Topics of *imprese* against those who gave rules without first teaching "invention" (the supporters, so to speak, of Analytics), and also against those who believed that invention did not allow for rules, being *ventura di capriccioso cervello*, or, finally, against those who claimed that the classical topics of orators and dialecticians were all-sufficient.[36]

Rhetoric, an appendix to the Organon, was also taken to be a model for the art of *imprese*; that art, it was said, aimed to "persuade," to fire hearts with enthusiasm for noble enterprises. Such ideas, pushed to improbable lengths, were found more and more frequently with the approach of the seventeenth century; after Torquato Tasso, who, like many others, thought only of the "dignity" or nobility of the feelings expressed, Chiocco launched into pedagogical and moral fantasies. But the only one to draw precise consequences for the theory of *imprese* from this was Caburacci.[37]

The *Impresa* as a Work of Art

The initial *concetto*, considered negatively as different from the design or words that express it, seems to allow a logic of the *impresa*. But sixteenth-century theoreticians also liked to see it under its positive aspect, as speech and design at the same time. This was not star-

tling in an epoch when *ut pictura poesis* gave rise to many surprising developments:[38] literature was not "similar to painting" but, according to Lodovico Dolce or Michelangelo Biondo, a particular kind of painting; inversely, a whole aesthetic theory of the plastic arts was based on the idea that painting was discourse, expressing "inventions" and "concepts." Treatises of painting, citing the *impresa* along with hieroglyphs to prove that painting was poetry, consciously annexed the realm of the universal; Federico Zuccaro, with his theory of *disegno interno*, spoke of thought when he believed he was speaking of art.[39]

Everything changed, however, when one turned to the "pleasure" given by the work of art: then interest shifted to the quality of mind expressed in the work. Thus Cesare Ripa, establishing that the poet started from an "intelligible accident" to suggest the sensible, while the painter on the contrary started from the sensible to arrive at meanings grasped by the mind, concluded: "The pleasure which we receive from each of those professions is nothing other than the fact that by the power of art and by, so to speak, deceiving nature, the one makes us understand with our senses and the other makes us feel with our intellect."[40] If, after the end of the fifteenth century, the *impresa* was by far the most important and widespread exercise of the "symbolic faculty," this was because it was by definition a manifestation of the mind rather than a symbol to be deciphered. The beauty of the work is the beauty of the *ingegno*—"ingenuity"; the very word *concetto*, used at first to describe the initial idea, came to signify a cunning form of expression. The characteristic taste for writing as an art—the taste for programs, hieroglyphs, and festivals, which was common to humanists, philosophers, "antiquarians," theologians, and many amateurs—displayed a tendency to go beyond art, and sometimes beside art, to a creative *ingegno*. And mind talked to mind: the secrets of alchemy, Michael Majerus said, were the highest and rarest, "ideoque intellectu comprehendenda prius, quam sensu."[41] Therefore he communicated them to all senses at once, expressing each secret in verse, in prose, through images and music—thus could the soul rise above all these means of expression to attain the pure concept. But *imprese* and emblems that were illustrated metaphors, and Petrarchist metaphors that were emblems,[42] both logically possible because thought is also an image, were artistically valid for the public only because expression played with both resources at once;

this play was an express invitation to recover, beyond the work, the ambiguous *concetto* that created it.

Therefore to speak of the *impresa* as art—*quasi poesia*, as Scipione Bargagli put it[43]—meant first of all to consider it a product of ingenuity, a work of the mind. It was not properly speaking an "imitation": Bargagli was emphatic on that point, and so was Contile, as we have seen. The Aristotelian work enlisted for the interpretation of the *impresa* as art was not the Poetics, but the Nicomachean Ethics, and passages from Physics and Metaphysics describing the structure of artifice, *techne*: the realization, according to definite laws, of an idea conceived in advance. This idea to be "realized" or expressed could be found in "resemblance," according to Bargagli: "E ingegnosa cosa veramente la similitudine e degna di lode in chi trovar la sà; da intelletto ella nascendo [!], che, o per sua acutezza e bontà, o per certa scienza e longa sperienza che tenga delle cose, riconosce in quelle, per natura fra loro diverse, le simiglianze e conformità loro."[44] This resemblance had already been acknowledged, in Bargagli's time, for what it was: the source of the *meraviglia*, or the *concetto*'s point. It was defined in Naples, naturally: "Deve l'impresa eccitare la meraviglia nelle persone dotte; la quale non nasce da l'oscurità delle parole, nè dalla recondita natura delle cose, ma dall'accoppiamento, e misto dell'una, e l'altra, per cagione di che vien poscia constituito un terzo, di natur da lor diverso, producente essa meraviglia."[45] The recommendation to write the motto in a foreign language, "perchè difficilmente si cava stupore dalle cose communi," was almost superfluous here to make one recognize the *agudezza*, the wit of the *concetto*. If one simply replaces Aristotle's theory of poetry by his general theory of art, we pass at once from Trissino to Giambattista Marini.

In practice, the "artistic" conception of the *impresa* was recognized by the role assigned to expression for its own sake. For a pure "logician," such as Torquato Tasso, the figure and the motto expressed equally well the initial *concetto* and duplicated each other, as parallel signs of the same idea. For an "artist," like Ercole Tasso, the meaning of the *impresa* must derive from the mutual connection between figure and motto. Scipione Ammirato and Montalto conceived this connection as "resemblance"; according to Capaccio, the motto must determine, highlight, particularize, "color" the aspect of the figure relating to the *impresa*; Farra and Caburacci discovered between figure and motto the relation of subject to object, or of major to minor

premise in a syllogism; for Ercole Tasso they were simply comple-
mentary.

The essential point was the autonomy of the *impresa*-expression
from any relation to the initial *concetto*. This autonomy was slowly
acquired. As its "art" became more complex, the *impresa* required an
increasing number of technical qualities; instead of revealing the
bearer and his temperament, it came to reveal the author and his
ingegno. It was defined as "una mistura mistica di pitture e parole,[46]
un nodo di parole e di cose,[47] un componimento di figure e di
motto"[48]—all the while understanding, of course, that this "composi-
tion" both hid and revealed an intention of the mind. A typical defini-
tion in that category was Ercole Tasso": "Impresa è Simbolo constante
necessariamente di Figura naturale (toltane l'humana semplicemente
considerata) overo artificiale, naturalmente prese, e di Parole proprie,
o semplicemente translate: dalle quali Figura e Parole tra se
disgiunte, nulla inferiscasi, ma insieme combinate, esprimasi non pro-
prietà alcuna d'essa figura, ma bene alcun nostro instante affetto, o at-
tione, o proponimento."[49] It is significant that Tasso should have
loaded his definition with various distinctions that constitute so many
rules (the only human figures allowed in the picture must be histori-
cal or mythical heroes, gods, etc.; the other objects represented must
be considered in their proper, not metaphorical, meaning; the words
of the motto can only be understood figuratively if they belong to ev-
eryday metaphors, etc.); as for works of art, the rules constitute the
essence.

The depersonalization of the *impresa* did not do away with the
obligation to attach it to a particular person. Ercole Tasso insisted
several times on this point, stressing that an *impresa* was all the bet-
ter for suiting the character and particular circumstances of the
bearer, and he was not the only one to think so.[50] But really this is a
direct consequence of "artistic" and ingenious resolve: for the art, by
definition, concerns the particular, conformity to which is an obliga-
tory extra "technical" difficulty which makes the performance all the
more brilliant.

Speculations about the soul and body of the *impresa* accorded
nicely with this new emphasis. "The straightforward identification by
Giovio of these two elements of the device with the figure and the
motto was rarely maintained; we still find it with Ammirato or Pa-

lazzi. But already Ruscelli disagreed: one might as well call soul, he said, the words of a song or the subject of a painting—*sottilezze da riso*, worthy of a *filosofo bestiale*.[51] This ridiculous subtlety was, indeed, quite current: Ficino introduced it in relation to music,[52] and there were numerous examples in treatises on painting.[53] Ruscelli, however, suggested sensibly that if an *anima* absolutely must be found, it must be in the intention of the bearer rather than in the motto accompanying the figure.

This new idea, followed among others by the Materiale Intronato,[54] opened the way to strange distinctions. If the author's intention is the soul, and the figure is the body, then the *impresa*'s motto—whose function is precisely to bind the figure to the intention, to create a link between them (as, for instance, in the case of the moth flying to a flame accompanied by the words *sò bene*)—will be the physicians' "animal spirits," the *spiritus*. This was Capaccio's opinion[55] and the beginning of another complication for Ercole Tasso. The latter distinguished between the *concetto* (the "comparison," or initial symbol) and the intention (the "feeling" of the bearer), and established a chain: intention-*concetto*-motto-figure. The Organon-like analogy, he argued, was valid for the three last terms: the *concetto* quickened the motto-figure combination, the motto being the intermediary *spiritus*, the "form" of the design;[56] the intention seemed to be sometimes the primary form, sometimes the matter of the whole.

Almost every author added his own particular touch. Contile saw the motto as the "particular" soul of the picture; the motto was not "entirely in each point" of the object represented, but underlined only one aspect of it.[57] Chiocco identified the words with the sensitive soul because they gave the *impresa* substantial being, individuality, and the possibility of "operating"; this sensitive soul, however, became rational if one removed the body: the motto, considered by itself, contained a general meaning.[58] Farra, finally, carefully developed the whole system of analogies: to the intellect (*mens*) corresponded the original intention of the author, to the rational soul the motto, to the vital spirits the relationship between motto and picture, to the quality ("temperament") of the body the immediate meaning of the figure, and to the material body the material design. Farra even deduced from this double hierarchy some of the known rules of the *impresa*.[59]

A General Theory of Expression

For the authors of treatises on *imprese*, there was in the end no essential difference between art and the expression of an idea; it was in both cases a matter of the incarnation of a concept. The difference was a matter more of emphasis than of spirit: whether the concept was a pure abstraction or a thought-image it was always the object of a logic, and to turn that logic into art it was enough to stress the structured aspect, the "architecture" of the means of expression, and the ingenuity of the process. The period was favorable, on one hand, to systems in which logic appeared as an art, and especially to the *artes inveniendi*, to pictorial topics and, on the other, to theories of painting which assimilated art to the direct expression of thought or of knowledge. True, we can roughly separate the "logicians," who insisted on the analogy with the Organon and stressed the resemblances between the *concetto* and the simple apprehending of a universal truth, and the "artists," who elaborated rules, established interacting relationships between motto and figure, spelled out the correspondences of the *impresa* with human features. We can even trace a chronological evolution from the logical to the artistic attitude; nonetheless those two points of view are not incompatible. That is because, basically, any mental activity, logical or artistic, is first and foremost an expression, a metaphor—a thought-image, or, in the double sense of the word, a *concetto*. And since art consists, as we have seen, in going beyond the proposed object to the art of *ingegno* that created it, all art, as indeed all thought, is reduced in the end to metaphor. The frequent assertion that "whoever is fully master of one art is master of all" means in the end that, essentially, there is only this one activity of the mind.

Intellectual Intuition

This philosophical background seems far removed from the Aristotelian principles that were supposed to explain the theory of the *impresa*: the mind as a creator of symbolic images is, in my view, primarily an idea of Renaissance Neoplatonism. E. H. Gombrich takes Neoplatonism as his point of departure for the study of the structure of allegorical *concetti*, with the example of a discourse by Giarda (1626).[60] But the value of the allegory, according to Giarda, resided in the real participation of the image in the Idea; it implied

the common Neoplatonist conception of the world as ciphered writing, a collection of magic or sympathetic signs, a language of God; and the force of the image required the beatifying force of contemplation. In fact such views corresponded less to a philosophical theory than to an archaic and mystic cast of mind, and one of Gombrich's merits is to insist upon this point. The background of the *impresa*, on the other hand, was linked with a particular Aristotelian doctrine which concerned solely the functions of the mind; it had no metaphysical pretensions and assumed no "real" efficacy of symbols.

The theorists of the *impresa* might well be, individually, Neoplatonists; they might use the language of that school, introduce into their discourses their beloved myths, accord with all the idiosyncrasies of the Neoplatonist spirit: but it is easy to show that taken together their views were, perhaps despite themselves, or unwittingly, mere applications of Aristotle. Farra, for instance, expressed himself in a style clearly reminiscent of Ficino: "*essendo* [le imprese] le Imagini de' nostri concetti più nobili, hanno necessariamente un'altissimo principio, perciochè nella formatione loro gli Animi humani vengono a farsi seguaci e imitatori dell'Anima Regia o gran Natura, della Mente prima, e finalmente d'Iddio sommo opefice, nella creatione del Mondo ideale, del ragionevole, e del sensibile."[61] Which meant, more clearly, that the creation of the *impresa* was like the work of the artisan who first conceives an idea, then realizes it in sensible matter, according to the well-known Aristotelian scheme. The analogy of the *impresa* with man, which as we have seen is perfectly consonant with the Aristotelian system, was exploited under all its aspects to give the thesis a Neoplatonic flavor: the "Orphic" myth of Dionysos torn to pieces by the Titans was given a cosmological interpretation leading to an explanation of man's structure, then a parallel psychological interpretation that accounted for the structure of the *impresa*. For this reason the *impresa* was "an image of man";[62] further, the *impresa* "può dirse huomo ideale"[63] (a phrase that reawakens for us the speculations about Adam Cadmon and other gnostic–cabalistic traditions); but Farra continues—and he underlines the words—"l'impresa può dirse] *vera, e propria operatione e impresa* [enterprise] dell'intelletto humano." None of the theoreticians has ever summed up so aptly, in one sentence, what seems to me precisely the main point of the Aristotelian, *concetto*-ist interpretation: each act and each thought of the mind is essentially an *impresa*.

The same can be demonstrated about Torquato Tasso. Despite his mention of Adam's language, of God's imprinting the first signs of writing on the souls of men—in spite of an allusion to Pseudo-Denys included in the very definition of the *impresa*[64]—his description accords entirely with the ideas we are already familiar with: the *impresa* is a *sign*, that is, expression in the wider sense of the word (according to him, the word applies indifferently to the motto, the figure, or the whole); as comparison or metaphor it is painting, by its motto it is poetry; the comparison is the vital soul of the *impresa*, the motto its rational soul.[65] It is remarkable that the *impresa* should be assimilated to painting not because of the actual design that constitutes its body, but because of the "comparison" or metaphor that constitutes its soul; the *concetto* as a "figure" of style is thus considered as a figure *tout court*. This text is one of the clearest proofs that the identity of figure and thought in the *concetto* was commonplace.

On only one point Neoplatonism was not a superfluous ornament in the theory of *imprese*: it contributed the idea of intellectual intuition, of which the *impresa* would be the shadow and the rough sketch. When Taegio celebrated as *Imprese generali* the ten letters of the cabala that represent the attributes of God and the ideal world, and when he accorded the same title to the hieroglyphs that allowed Egyptian priests to embrace at one glance all "things divine,"[66] he was taking up again, after Plotinus and Ficino, the theme of perfect knowledge. It is fairly certain that the hyperbolic celebration of the *impresa* in treatises was possible only in light of the underlying assumption of such a knowledge, which properly belonged to beatific vision; Capaccio, with a casualness that served at least to reveal his colleagues' real equipment, formulated these theories: ". . . essendo l'Impresa un'espression del Concetto, sotto simbolo di cose naturali . . . ma dalla propia naturalezza [elevati], ad esprimere il più occolto pensiero della superiore portione, bisognarebbe che fusse l'uomo un'Angelo, acciocchè potesse a prima vista apprendere, intendere et acconsentire." This comparison with an angel must be taken literally; for only an angel had direct knowledge of the universal, "in quelle tenebre Platoniche nascosto, ove con l'intellettual silentio l'intelletto produce; al producente solo l'intuitiva cognitione . . . si serba, havendo ella solamente di se stessa la teorica di formare, e la prattica di esprimere, e di produrre." If it were possible to have a direct knowledge of someone else's *concetto*, "recondita non sarebbe l'Idea," our

knowledge would not be theoretical, but "divine." Therefore we must find indirect means of expressing the idea. "Quindi nasce la difficoltà di fabricar l'Impresa." The conventions, methods, rules of the various academies allow us, on one hand, to make the idea communicable, on the other to adapt it to particular cases. Just as the sun seems to hide in darkness from whoever attempts to stare at it, the *concetto* eludes whoever tries to seize it "in itself"; therefore the intellect must "make a portrait of itself in what it expresses. "Onde riducendo il discorso a determinate regole nascenti da tutto ciò che la Natura ci insegna, il senso manifesta, e la varietà delle sose ci dipinge, con metodo particolare possiamo intendere le [imprese] fatte, e far le nuove."

Most of those theories are already known to us: the *concetto* beyond image or words; expression conceived as being in its essence veil and clothing ("reflection," "portrait," "indirect means"), that is to say, metaphor; rules as a (logical) instrument for communicating ideas—all this usually accompanied the Aristotelian tradition. But if the dignity of the *impresa* was founded on that of the *concetto*, a product of the intellect whose naked brilliance would be unbearable, and if one grants the author of the *concetto* perfect knowledge— which is immediate, intuitive, and productive as well as passive, therefore of the same nature as God's knowledge of his creatures— the introduction of new, specifically Neoplatonic ideas cannot be denied.

The introduction of those elements transformed the spirit of the *impresa*. The mystical and theological ambitions which we find with the seventeenth-century French Jesuits allowed, and even required, the "dissimilar and inadequate metaphor," preferably burlesque, that was expressly banished by Tasso. The art of pure "comparison," which neglects "pleasure" and "usefulness" for the sake of the "wonder" caused by the intellectual process and the art of expression—that very abstract art found, apart from the *impresa*, in a few poets between Scève and Donne, including Michelangelo and Shakespeare's sonnets—disappears in the seventeenth century: the very school of so-called *concetti* writers now served "delectation," systematically introduced dissimilar images, and thus constituted the counterpart of the didactic and mystical tendency which increasingly overtook the *impresa* after Ercole Tasso. The Baroque developed, systematized, and above all applied this new means of expression. With Ercole

Tasso theory reached its end—at the same time, with a few years' difference, as did the literature inspired by Aristotle's Poetics. These were precisely the years when the Baroque definitely replaced Mannerism in Italy.

This coincidence can easily be explained: the theory of the *impresa* is Mannerist because it assimilates logic to art and art to the act of "realizing" an inner model (and not with science, imitation of nature, or personal expression). It is also Mannerist in its intellectual approach: the model to be realized is a *concetto*, an arbitrary creation of the mind. To these themes—which were at the center of the philosophical thought of the time—Neoplatonism, an essential element of "verbal culture" in the late sixteenth century, added a somewhat superficial varnish, allowing the theory of the *impresa*, insignificant in itself but very favorably "placed," to reflect with remarkable richness and accuracy the awareness which the human mind then had of its own workings.

(1957)

Burckhardt's *Civilization of the Renaissance* Today

The influence exerted on the public and on historians by *The Civilization of the Renaissance in Italy*—an influence almost without parallel in persistence and scope—has sometimes been explained by the work's literary qualities, and especially by the perfect unity of its composition. Nonetheless, the book is only a fragment. Burckhardt himself pointed to its most important omission—the omission of art.[1] This is all the more regrettable since the whole, or almost the whole, of Renaissance life is treated in relation to art: the state, festivals, conversations, domestic economy, war, education, and, above all, the very personality of "Renaissance man." All these are for Burckhardt so many works of art; that is, as he explains it, "conscious and considered constructs, built upon tangible, calculated foundations." But purely external reasons forced the author to remove from his scheme the part which should have been its core. We must not, therefore, trust too much the impression of organic unity that he conveys so masterfully, and we must wonder whether he was right to claim, in the introductory passages of the work, that his "attempt" remains partial and subjective.

Several omissions, other than that of art, strike the present-day reader. We find it strange that it was possible to write a history of civilization (*Kulturgeschichte*) from which technology is almost completely absent, and in which institutions, economic factors, crafts, and the life of the working classes are hardly taken into account. It seems never to have occurred to Burckhardt that one could quite convincingly interpret his "birth of individualism" as a function of the opposition of industrial or financial capitalism to the old guilds; he found economics tedious and would not trouble himself with them. It has been noticed with even greater surprise what little importance he attaches in his book to philosophy; such decisive cultural phenomena

such as Florentine Neoplatonism and the opposing Aristotelianism of Padua are mentioned only in passing and never analyzed. Yet they are at least as characteristic of Italian civilization as poetry, which he treats at length.

Finally—and this is probably the most important objection to Burckhardt's chosen framework—the entire period which he calls "Italian Renaissance," and which stretches, according to him, from the fall of the Hohenstaufen to the Spanish domination of Italy, is considered as one unit; within these wide boundaries, he ascribes common characteristics to all poetry, to all the religious and political life of Italy. Burckhardt, whose genius for intuiting particularity and differences remains unrivaled, becomes completely perfunctory when it comes to outlining historical development. His first part, for instance, includes admirable galleries of tyrants, condottieri, popes classified more or less according to century. But about the transition from free towns to principalities, about the slow disintegration of the patrician oligarchy in Florence and the transformation of its economic foundations he has little to say. Burckhardt the historian is a physiognomist; he presents the Renaissance as he would the genius of a great man. Hence it appears to him as a single indivisible unit, with almost no roots in the Middle Ages and no survival into the Baroque, without internal evolution or influences from abroad, and devoid of any real diversity of tendencies.

One could, by joining those criticisms together, give the impression that his work, written according to such a strangely fragmented plan, presents only a very artificial unity. But such a judgment would be patently unfair. *The Civilization of the Renaissance* is not a descriptive—and even less an explanatory—work.[2] Burckhardt has left unexplored areas whose study could have been only favorable to his theory. He neglects economics and sociology, and refuses to describe wars because his aim is not to fix causes and effects. He overstresses the contrast with the Middle Ages, which is intentional, as we can see from the lectures he gave during the years he was writing his *Renaissance*. In those lectures he acknowledges, for instance, that chivalry was, already in the twelfth century, a factor in the emancipation of the individual which should not be overlooked.[3] He does not, then, hesitate to load the dice rather obviously in favor of this thesis.[4] He willingly sacrifices a few points for the sake of emphasis—not where facts are concerned, of course, but in his judgments and apprecia-

tions. This is a necessity of the historical genre he invented, the requirement of his personal conception of *Kulturgeschichte*. Indeed, nobody before him conceived of writing as a historian about "the predominance of imagination in morality," about the various ways of computing population statistically, about the glory of poets or the taste for public speeches. Burckhardt innovated virtually all his themes. They were, happily, chosen in view of a precise and unique aim that he was the first to propose to historians, that of defining *the attitude of men of a certain epoch as they confront the world.* If we understand that, and avoid being influenced by the usual meaning of the word *Kulturgeschichte*, we are no longer disturbed by the apparent lacunae in his book, nor do we any longer find the points he stresses arbitrary. Bearing in mind certain reservations about his tacit hypothesis of a *Zeitgeist* (a "spirit of the age": a Hegelian concept which, after seducing Taine as well as Spengler, has now been finally consigned to ethnography), we can examine Burckhardt's conclusions without prejudice.

We could sum up more or less as follows the cluster of ideas that seems to constitute the contribution of Burckhardt and his theories:

The Renaissance was not essentially the revival of antiquity, but a deeper and wider renewal of human consciousness and life. It envisaged the physical and social world free of any sort of prejudice; it sought to discover things in a new and positive spirit, and to that end tried to guarantee individuals the flowering of all their gifts and capacities. Renaissance man knew himself to be master of his own life and of society, which he directed with impassioned energy and cold reason. The aim to be attained, for which he believed antiquity offered a perfect model, was the realization of the utmost beauty and harmony through moral greatness, aesthetic enjoyment, or the perfection of political activity. In its origin, according to Burckhardt, this movement was specifically Italian.

As opposed to the "still medieval" northern countries, the Italians managed in the fourteenth century to inaugurate a Renaissance that the rest of Europe would imitate only later. The causes and conditions of this flowering are not clear, but we must probably account for it in the first instance by an unstable and anarchic political situation in which only a resolute and competent individual could survive, one capable of perceiving things just as they were. Thus republics and principalities became the deliberate creations of great political crafts-

men. Burckhardt would probably have conceded that economic conditions could play a role in this process of emancipation, but he did not insist on this point.[5]

The Renaissance, however, had other roots in Italy, which were deeper and more constant. Above all, there was the national character, with the incomparable Italian gift for organizing aesthetically both the setting of everyday life and the style of life itself. A quick mind; perfect reactions; the swift approval of whatever is "well done," of whatever turns out well regardless of its moral value; and, finally, a tendency to act out one's own personality as if it were a dramatic role—all these attributes were for Burckhardt particularly Italian. Finally, the survival of classical antiquity, the presence of its remains, the awareness of Italians that they were themselves still—and despite everything—Romans, permitted Italy that precocious flight that fascinated all Europe.

Burckhardt's image was striking. It placed "the Renaissance" by what could more properly be called "the Reawakening." One does not easily forget his portrayal of a civilization as a kind of infancy—the infancy of "modern man," according to Burckhardt—greeting with confidence and an ingenuous ardor the world of beauty and light which it seemed to perceive for the first time. Petrarch on Mount Ventoux is in a way its symbol. The reader's sympathy is vividly enlisted, even for those noblemen who practiced "crime considered as a fine art"—which, by a gross misunderstanding, caused Burckhardt to be seen as a precursor of Nietzsche complacently indulging an admiration of Cesare Borgia. In describing this genesis of "modern man," however, Burckhardt never forgot that the protagonists of the history he recounted were not children whose naïve vitality excused everything, but people exercising their judgment in conditions similar to our own. He observed their behavior with the wisdom of wide, if vicarious, experience (though he read with singular imagination), and without illusions, without even the illusion of "a realistic" cynicism.

Let us state at once why this image of the Renaissance as a great reawakening can no longer be accepted without considerable reservations. For a start, it assumes an opposition, unsupported by the facts, between the Middle Ages and the Renaissance, and between a fifteenth-century Italy "ahead of its time" and the backward countries of the rest of Europe. The futile and interminable discussion about the "origins" and "chronological limits" of the Renaissance is partly due to

the discovery, in humanistic or "modern" Quattrocento forms, of structures of thought and patterns of behavior that have their roots deep in the Middle Ages. The madness of Stefano Porcari and other Renaissance tyrannicides—except perhaps that of Lorencino, the last of them—is remarkably similar to the enthusiasm of certain Crusaders and to the madness of some knightly vows. The alleged discovery of Livy's corpse in Padua is a story of relics like hundreds of others during the previous centuries. That idealized love (for Burckhardt a sign of individualism) which was always addressed to married women; which was stylized with the help of subtle casuistry, sophisticated courtly rites, and a manner of speech; and which occasionally coexisted with a lively and somewhat coarse sensuousness—all this was, with few changes of convention, precisely the love of the troubadours. And those condottieri who in the popular imagination—unfortunately distorted under the influence of Burckhardt—became the very type of the "Renaissance man" replaced fairly late the foreign leaders of those mercenary bands or companies which roamed across fourteenth-century Italy and among whom the condottieri acquired their training.

Examples like these are numerous. Burckhardt knew them all, and occasionally cited them himself; but he did not consider the similarities important because he focused his attention on the differences. In his eyes an entire world separated knightly honor from Renaissance glory. At present, many consider them as two slightly different aspects of the same phenomenon.[6]

One may continue to debate these issues of perspective, but another objection—against Burckhardt's thesis of the so-called time lag between Italy and northern countries, particularly the Franco-Burgundian territories in the fifteenth century—is far less debatable. For the history of art, the objection applies mainly to the early generations. Nobody can deny the "Gothic" look of Ghiberti or Gentile da Fabriano, or the spiritual affinity of Masaccio's naturalism with the Van Eycks'. If there is precedence, it is often of the north; Sluter came before Donatello. As for the later and refined art of Medici Florence, of Botticelli and Filippino Lippi, some have found even there a Gothic character that they had only to qualify with the prefix *neo-*. Thus the Italian Quattrocento unfolds rather analogously to the fifteenth century of other Western countries. The only question that remains—must we then delay by a century the onset of the Renais-

sance in countries beyond the Alps or, on the contrary, place it a century earlier for Italy?—is no more than a semantic problem all the less interesting as historians tend to deny the Renaissance, in Italy or elsewhere, any innovative character whatsoever. But exaggerations such as these have by now been largely discredited. In any case, we must agree that fifteenth-century Italy did not alone create a Renaissance which it then communicated to the rest of Europe, but, rather, found newer and richer forms that were later adopted by its neighbors. This holds not only for art but for many other aspects of the culture as well.

On political and economic levels, the parallel between the cities of Artois or Flanders and the Italian towns, at least from the thirteenth century, is striking. The brilliant work of Henri Pirenne on Belgian free towns gives reason to believe that there was a deep similarity between the aristocratic classes of those cities and those of the Italian ones, which in turn implies an ever more profound resemblance between the artistic and intellectual cultures they nurtured in both countries.[7] We can easily imagine the place that would have been allotted in Burckhardt's book to the Artevelde had they been Italian. There is no essential difference between Jacques Coeur and Cosimo de' Medici the Elder; they shared the same relish for patronage. Politics, and not only the politics of merchant cities, were inspired by a mentality which has its sources here. If there is anything about the activities of Louis XI of France that would have been impossible in the Italy of his time, it is certainly not his superstitious faith, but rather the wide range of his views: this is Burckhardt's own judgment in one of his late lectures.[8] The new spirit depicted so impressively in *The Civilization of the Renaissance* is in great part the spirit of an incipient capitalist elite, whatever the country of its origin. Admittedly, the men who created the Renaissance were not necessarily members or followers of such an elite, and related economic structures in various cities could exist alongside deep differences in cultural formations: without leaving Italy, it suffices to compare Genoa, Florence, and Venice in the fifteenth century. But the consciousness of the businessman—for whom material and moral possibilities unknown to any human type in earlier societies were unfolding—undoubtedly colored the triumphantly realistic Quattrocento cast of mind.

That realistic outlook is not the only trait common to Italian society and the equally developed northern countries. When Huizinga, in a

celebrated book whose method and aim are very close to those of Burckhardt, undertook to analyze the "style of life" and mentality of the men who determined the cultural climate of France and Burgundy,[9] he found in their aesthetic attitudes, in their way of seeing life as play or a work of art, features that recall contemporary Italy. Unlike Burckhardt, however, he believed that this was the natural corollary not of a realistic rationalism, but of an escapism for which the "knightly" spirit, the pastoral, and a certain type of humanism were the same.[10] Between their (often delirious) creations and real life, claimed Huizinga, there was a fruitless opposition typical of decadent periods; we must therefore speak more properly of a "decline" of the Middle Ages than of a Renaissance.

Obviously Huizinga did not intend to apply this pessimistic doctrine, questionable even on its own ground, to the Italian Quattrocento; it may, however, prompt us to explore the extent to which the aesthetic function was, for Italians also, as much a need of illusion as a form of freedom.

In the part of his book devoted to the state, Burckhardt seems to hesitate between the explanation of phenomena and their description. It was undoubtedly to "explain" the Renaissance by its political history that he fixed its chronological limits between two empires. In that way it comes to encompass a period marked in turn by individualistic anarchy, a balance of forces between large Italian states, and uncertain struggle between two foreign conquerors. During this interregnum, diplomacy and administration became a matter of astuteness and calculation as much as of energy. As Kaegi has pointed out, we must understand the title "Der Staat als Kunstwerk" in the sense of "artifice" or "technical achievement." Burckhardt the wise pessimist displayed no aesthete's admiration for the likes of Cesare Borgia. His vision of Italian life resembled more the struggle for survival that Darwin had recently described, or the state of the American economy in his own time, but with one essential difference: Renaissance anarchy, which was like natural selection, also created values. Burckhardt sometimes endeavors to consider it as a scientist would who "does not judge" (Part VI, introduction), but he cannot master his own imagination, which, sources permitting, instinctively impels him toward the dramatic or even the mythical. He is categorically removed from social Darwinism by his attempt to extract from the struggle for power an aim that transcends it—the service of cul-

ture. But no theoretical scheme can help him in that endeavor, and description wins out over explanation. We might have expected at least one chapter, required by Burckhardt's program and method, on the nature and meaning of such ideological terms as Guelf, Ghibelline, "justice and freedom," Republicanism, Caesarism. These problems, which currently arouse great interest, would have allowed him to study the introduction of spiritual energies into this lawless fight. But in the realm of politics Burckhardt was so fascinated by the concrete human aspect, and at the same time so committed to his conception of the state as a rational creation, that he limited himself in this connection to a single page on Italian patriotism.

We must note, however, that one of the most recent theories about Quattrocento politics and their relationship to culture is strangely akin to Burckhardt's. According to Hans Baron, Florence's victorious fight against Milanese expansion in the first years of the fifteenth century put an end to all attempts at unifying Italy under the power of a single tyrant, and fixed the features of a new ideology: Republican humanism, now reconciled with civil authority and with popular culture, with poetry in the vernacular.[11] This is an acknowledgment, similar to Burckhardt's of the political origins of Renaissance civilization, of the beneficial effect of the fragmentation of Italy, and of the accord between humanist culture and the national spirit. But it would otherwise be best to maintain a certain reserve about Baron's historical construction.

The "development of the individual" may well be the key to the entire system, or at least the notion which links all its aspects. For Burckhardt, whose real aim is the study of a certain consciousness of things, what matters is not so much the register of bizarre characters or forceful personalities, but rather autobiographies and the signatures of artists. Two points are stressed: that an individual's uniqueness—the "Socraticity" of Socrates, as the Scotists would have put it—is more important than his belonging to a particular group or type, and that it must eventually be considered itself as a value. In this respect the concept of glory, through which the individual gives to what distinguishes himself from others a kind of objective existence in the approbation of his peers, differs from medieval honor, which was a certification of conduct conforming in all points to certain impersonal requirements which in the same circumstances all members of a class must satisfy in precisely the same way.

In the background, we find once again the idea of liberation. To see the world and society with new eyes, one must break with the mental habits inculcated by the many groups to which one belongs; such detachment suffices for becoming "oneself." That is why Renaissance individualism is in no way an affectation of uniqueness, but links us with the universalism of Alberti or Leonardo (with the realization of the possibilities of man), and engenders a freedom of spirit attested by mockery and laughter.[12]

These pages of Burckhardt's provoke the customary objections about the chronological and geographical location of the reawakening; the somewhat unhappy use of the phrase "birth of modern man" has been criticized, and so have the famous but obviously too sweeping formulas which, in the opening pages of that section of the book, present as a thesis or as an anticipated conclusion what is in fact only a framework of research. Dilthey's reassessment of *The Civilization of the Renaissance* in the light of contemporary scientific knowledge has been useful on that point. But nobody has ever denied that in the central idea of his study Burckhardt "saw something" that needed to be seen.

This discovery, we are given to understand, was made by intelligent laymen, amateurs, travelers and observers, rather than by scientists in the modern sense. Anglo-Saxon historians of science such as Lynn Thorndike and George Sarton speak of the Italian Renaissance rather scornfully; wherever humanism triumphs, exact research is in retreat. The intuitions of the last Scholastics in these realms lay buried for a very long time: their mathematics and their physics had to wait until the seventeenth century, their logic until the twentieth. Leonardo, who is often invoked apropos the scientific progress of the epoch (Burckhardt could not exploit this, since not enough Leonardo manuscripts had yet been published), is usually in their debt, and more than once misleading in his theories. His science was mainly visual; the laws he was looking for were not numerical but qualitative—what Goethe called *Urphänomene*, archetypes of the workings of nature. He practiced anatomy intuitively, displaying the likeness of human with animal skeletons, suggesting by drawing alone the vegetative character of the growth of the embryo, discovering a resemblance between the expressive facial contortions of man, horse, and lion; he represented mountains like folds of a drapery, hair like a river. He wanted not to establish relationships between measurable

lengths but, as he said, *trasmutarsi nella mente di natura*, to put himself in Nature's place to see how she proceeded; thus he invented a new type of foot just as one would invent a machine.

Praise of mathematics, when it occurred at that time, always referred to pure technique (the development of algebra in sixteenth-century Italy was due to problems set by artisans, gunsmiths, shipbuilders, et al., and not by physicists, nor to the Pythagorean "harmony" which regulates the "musical" beauty of the world). The meeting of natural science—which remained vitalistic, magical, and "curious"—with pure mathematics was never reached. One science only was treated mathematically: perspective. But that was because it required a visual discipline, geometry, and had the visual for its object. Moreover, it was symbolic of the new attitude of man "in face of" the world: learning to create scenic space in an image was at the same time situating oneself "in front of" it, "taking one's distance," and defining with perfect accuracy one's "point of view." The almost aggressive realism and rationalism of fifteenth-century man emerged with particular force in drawings that simultaneously involved spatial geometry and perspective.[13]

The two parts of Burckhardt's book where the absence of chapters on art is most acutely felt are Part III on "The Revival of Antiquity" and Part V on "Society and Festivals." Burckhardt was the first to assign to antiquity a principal role as the model and framework of life. But we must remember, better perhaps than he did, the Protean character of this model. The antique gods strenuously being restored were sometimes given strange forms, either too artificial or too unexpectedly allegorical,[14] which had nothing to do with what was familiar after centuries of academic classicism. An ancient genre was believed to have been revived even by the invention of opera. Fake antiques, mainly fabricated in Padua, often included naïvely reproduced fragments borrowed from contemporary masters. Pastiche was reduced to the strictest minimum—the circular swelling of a veil, for instance —and sometimes, as in the case of the famous child-Cupid by Michelangelo, the surface of a modern work was straightforwardly eroded. Until about 1540 antiquity was viewed more in the light of the present than was the present viewed in its light.

Burckhardt has curiously neglected one of the primary psychological roots of the mania for antiques during the Renaissance—the pathos of a "return to the sources."[15] The task of the humanists was

deemed sacred because its aim was the reincarnation of antique greatness in a "reborn" Italy. The imitation of the ancients was only one, and among the least significant, hallmarks of this state of mind. The artists who were called "second Apelles" did not imitate the works of that painter, and with good reason; Florence, the "second Roman Republic," adopted none of the institutions of her so-called model. The Renaissance was, or saw itself to be, only a process of recovery: after the decadence of barbaric ages, it was necessary to go against the stream and retrieve ancient splendor. In politics this was the dream of Machiavelli, who owed little to the humanists; in art, that of Brunelleschi, who was closer to Early Christian or even Romanesque architecture than to antiquity. Similarly, in religious matters, the yearning of sincere believers was for a return to a primitive faith and to the sources, either by applying philology and its critical method to tradition and the Scriptures, or by preaching an evangelical simplicity in daily life. The watchword of a religious Renaissance became, not coincidentally, one of Luther's vital ideas.

The humanistic and religious mystique of a "return" appears with an almost naïve clarity in Marsilo Ficino's Neoplatonism. He refashioned the whole of Christian theology on the basis of Plato and linked it up again, at a deeper level, with the occult religion of the legendary "ancient sages." Orpheus and Zoroaster contained the essence of the eternal gospel. Burckhardt chose to classify "Platonic theology" as a religious phenomenon, but he might also have treated it as a revival of antiquity, so closely were the two aspects connected.

The pages on religion are among the most accurate and lively in his book. They react against that secularist tradition which pictured the Renaissance as a period of unbelief, somewhat in the manner of the Enlightenment. Since Burckhardt, and sometimes to correct him, this position has been exaggerated. A Franciscan fashion (Thode) attributed all the important achievements of the Renaissance to the spiritual influence of Saint Francis and the Franciscans. Next there followed a fashion for mystic sources, already alluded to in the last sentence of *The Civilization of the Renaissance*. And while Hauser and Renaudet discovered what the Protestant, particularly the French, Reformation owed to Italian humanists, others tried to prove that these Italian counterparts had been the defenders of Catholic orthodoxy against the "philosophical" unbelief of the Averroists (Toffanin). Discussion about the faith of the humanists continues, with

bias, on both sides, and few books can show as successfully as Burckhardt's how and why this vast movement—which included and organically integrated atheism, paganism, "enlightenment," superstition, "pre-Reformation," orthodoxy, theism, and mysticism—could nourish so many controversies.

According to Burckhardt, the entire life of the Renaissance revolves around art, which is its hidden center. We must take this to mean that artistic creation is the ideal and model of behavior, that man is before all *homo artifex*, whatever his actual field of endeavor may be.

How, then, integrate art into *Kulturgeschichte?* Primarily, of course, by presenting it as the framework of life. An admirable article on collectors, a fragment of the unfinished part of the book, shows how Burckhardt would have gone about this: [16] by studying not literary evidence so much as the manner in which the role assigned to the work of art in everyday life influences the scale, subject, and style of the works. Such a method is typical of Burckhardt: he turned to art itself for his answers, as previously he had turned to chronicles and poems.

Few today would share Burckhardt's artistic taste, so uncompromisingly classical that he was wary of Michelangelo and detested the supposedly vulgar naturalism of Donatello. Such was almost exactly the "Weimar taste," the attitude of the old Goethe: very aristocratic, very *connaisseur* (and therefore classicizing), but also very curious about the human values and historical reality expressed in a work (hence the reception accorded to the Gothic and to Rubens. In the end Burckhardt was horrified only by what he found empty, theatrical, affected, or sheerly virtuoso; his *bête noire* was Bernini.

If we put aside the enormous inconsistency in his critical appreciations (how, we must ask, did he fail to notice the theatrical aspects of his friend Böcklin, for example, or the emptiness of some of the antiques he admired?), the orientation of this disciple of Goethe endures; reacting aginst a certain formalism, among whose masters was Burckhardt's pupil Wölfflin, we again enjoy "reading" a work of art as much as looking at it.

The new methods of such "reading"[17] would have delighted the author of *The Civilization of the Renaissance*. The precise knowledge of a whole constellation of historical factors (of the artist, his background, the destination of his work, the circumstances of its commission) and

traditions (iconographic habits, religious or secular symbolism) must aid not merely the deciphering of an image but its *actual placing* within the history of ideas. The results of that method, applied to the Renaissance, have been surprising. Not only can we measure the artistic influence of Neoplatonism or Pythagoreanism, but we may also grasp in its entirety a specific and comprehensive policy of patronage, of the popes or of the Medici. Ancient treatises on art or manuals of painting link art to science and philosophy, and we observe that art was recognized as a fundamental activity of the mind, perhaps as the very prototype of intellectual activity itself—an unexpected confirmation of Burckhardt's theory. The thought of Marsilio Ficino, for instance, has been found to include a complete, coherent, and, hardly transposed or mythified, philosophy of art.[18] And we come full circle when we show that the form and style of the work correspond to its place within the evolution of ideas—and this is often the case in the Renaissance. Thus it has been allowed, for example, that churches with a circular or central plan created around 1500 in Tuscany and Lombardy (whose most magnificent example should have been Saint Peter's in Rome) are not unrelated to a certain Platonic-Pythagorean philosophy ("virtues" of the circle, the sphere, the cube), to a "musical" cosmology (the church being the image of the world and reflecting its harmony), and to the conception of Catholicism as the crowning synthesis of all wisdom.

A favorable circumstance accounts for the striking success of applying the new methods to the Renaissance: the general tendency during that period to identify thought and image. Theorists of art have said innumerable times that drawing is writing: indeed, an interest in pictography, in hieroglyphs (which were mistaken for speaking images), in emblems and frequently extravagant allegories invaded the art of literature. We know of "programs" for frescoes or festival decorations which are fantastically intricate. Behind such extremes stood the archetype of Socrates the painter, the ancient dream of an ideal, nondiscursive mode of thought, of the mind's intuition. Man always believed he could realize that dream in art.

Let me make one concluding remark about the sociology of art outlined in Part V of Burckhardt's book: to become truly the "style" of life, the work of art must renounce its existence in isolation. The easel picture, which began its career with the newborn naturalism, lost its absolute priority in favor of such larger synthetic ensembles as lordly

residences, public squares, festivals, and processions; these flowered first in the sixteenth century with Bramante's Vatican, the Farnesina, and, later, Sansovino's Piazza San Marco. It became the custom to entrust the artistic direction of such large complexes to one master, who simultaneously directed masons, sculptors, and painters; often a minutely elaborated theme insured the iconographic unity of the decor. But in this respect the classic Renaissance was only a beginning; the individual work of art remained in its eyes too much a cosmos to be easily subordinated to the whole. The tendency was solely to "harmonize" the work and its surroundings: the light painted in a picture almost always agreed with the lighting of the place where it was meant to hang, and often the perspective took into account the point of view from which the picture would be seen. Trompe l'oeil in decoration became the rule only later, along with the hypertrophy of the picture frame, illusionistic and intended to deny any real presence to figures represented in a teeming confusion. On a tapestry after Bronzino, dating from the postclassical period now called Mannerist, the living characters have the same consistency as those sculpted in the furniture, painted on the ceiling, or inserted in the ornamental frame of the scene. By becoming "plastic" and placing accents everywhere, art once more turned into decoration, and the work was lost within the new orchestration of luxury.

There is undoubtedly a contradiction between two orientations of the Renaissance which Burckhardt, following Goethe, thought he could deduce from a single root—the positive, open spirit ("the discovery of man and of the world") on one hand, and, on the other, the fictions and new styles that adorned life (the mania for antiques, the idea of glory, Platonic esotericism). It would be easy to find examples of quixotic humanists and liken them to the fancies of Charles the Bold, or to compare the apparition of the hermeticist Giovanni Mercurio da Corregio with the absurdities of the *Minnesänger* Ulrich von Lichtenstein.[19] But going beyond such picturesque stories, we must stress that the schemes and conventions that normally governed the aesthetic organization of life could release a sort of schizoid delirium whose aberrations were sanctioned by cultured circles. The "style of life" achieved was not, then, a triumph over reality, but often a means of escape from it.

During the past few years, the changing and complex relationship

of humanism with the life of the cities has been carefully studied. The services rendered by humanist chancellors to the city of Florence were, around 1400, important enough for Filippo Maria Visconti, the first adversary of the Republic, to acknowledge them. It was not an inconsistency for scholars to join in the "psychological warfare" of the age, since they had themselves become the protagonists of a great movement of reaction against Franciscan poverty and the philosophical disengagement from worldly things.[20] Their historiography and their rhetoric, which seem so hollow in comparison with the chroniclers, were effective enough to inspire conspiracies and tyrannicides; humanism was indeed, at that time, an active unit in the intellectual battle for reality.

But the situation was unstable. During the second half of the century, and in Florence as soon as the Medici came to power, humanism became "contemplative," aesthetic, mystical. Its influence remained decisive, of course, and we can never say enough about the importance, even on the political plane, of what the Renaissance owed to the Neoplatonic Academy. But its own attitude was now more detached. Antiquity appeared for the first time as a dream world, and the attempt to relive it could become comic. The literary cult of Cicero, the would-be classical historiography and politics against which Machiavelli was later to react, Latin eloquence and admiration of the ancients—all became conventions; and Burckhardt describes their decadence and the setbacks quickly suffered by humanists. What the new idealistic speculation had retained of the spirit of discovery was now turned inward; from there it was an easy slide into the occultist eccentricities and "Pythagorean" tinsel of Francesco Giorgi.

The process is familiar. The firm naturalism of the first Quattrocento is not the whole of the Renaissance. In art, in literature, in social behavior—as in humanism—the form according to which reality is organized tends to become a convention, then to become more complex by attempting to improve upon itself, and is finally carried away into idle fantasy. In Mantegna's works, toward the end of the century, we find the real and the fantastic equally strong and inseparable in their opposition, still conjoined; and he is more startling when, like the Surrealists, he plays upon the likenesses of meticulously rendered forms, than when he presents jarring profiles in the clouds. With his younger contemporary, Filippino Lippi, the "recon-

stitution" of an antique altar swerves toward unreality, in defiance of the archaeology that had been so fervently pursued earlier. And Filarete's architectural drawings and delirious schemes show what happens to a mind that is not held in check by practical considerations. The same relish for imaginary "construction," for endless accretions, engenders those monsters in painting from Piero di Cosimo to Ulisse Aldrovandi. Finally, the discovery in antique ruins of that mural decoration which was dubbed "grotesque" liberated artists' fantasy; they learned to link elements of the picture for purely formal reasons, allowing fragments of reality to intervene haphazardly much the way alien materials are applied to canvas in Cubist collages. Grotesque decoration is neither mere nonsense nor Surrealism *avant la lettre*, but an exercise in abstraction and, incidentally, in humor.

Thus, the fantastic in the Renaissance was in every case the product of the activity of a mind acting in a void. In the naturalism of the years after 1400, discovery and its formal organization went hand in hand; but the parting of their ways so early and so successfully would indicate that the situation of the Renaissance was not so radically different from what Huizinga has called the decline of the Middle Ages.

Since Ernst Cassirer's work provided us with a new key to Renaissance philosophy,[21] much has been fruitfully written and debated on this subject, which was more or less neglected by Burckhardt. It is all the more surprising that his incidental remarks should generally be endorsed by those new perspectives.

Burckhardt understood admirably that the central theme of this philosophy, and at the same time its point of contact with humanism, was the meditation upon the powers of man. He outlined, at the end of Part IV, the striking text by Pico della Mirandola, with which it culminates. We have since learned that the sources of such praise of man can be found in the Fathers of the Church (Eugenio Garin), but we are nonetheless convinced of the deep significance of its frequent use from the beginning of the fifteenth century with new connotations, Pico's being the most original. (A parallel with present-day Existentialism is unavoidable: Pico says clearly, in his own way, that man is of all beings the only one in whom existence precedes essence.)

Philosophy, in the Italian Renaissance, was not confined to the universities; something in society itself responded to its currents of

speculation. That is why Burckhardt was able to provide in his book a more or less complete view of the anthropology of the two centuries without ever considering individual systems or schools.

Paduan Averroism, for instance, is only the prolongation of medieval tendencies against which Thomas Aquinas had already fought. But it contained a vital idea: the attempt to consider man as a "product of nature" like others, subordinated to a universal determinism, whose individual soul does not escape destruction any more than his body. This attitude accorded with the Renaissance conception of Nature, with its almost pantheistic trust in the life of the cosmos. Although Burckhardt speaks very little of the professional philosopher who represented this movement, Pietro Pomponazzi, the place he assigns him suffices to prove that he grasped the link between such theories and the phenomena he was studying: the incredulity of the scholars, astrologico-magical superstition (which supposes a theory of the universe as a "great animal" in which everything is connected, everything inheres in everything else, and nothing has a separate existence), and a vitalistic science. From the point of view of the history of philosophical systems, it may seem superficial to link naturalistic or magical determinism, which has its Aristotelian or medieval sources, with the ancient fatalism and critical Epicureanism of the humanists, on the grounds that all these attitudes are antireligious and deny human freedom. In fact such a juxtaposition is illuminating: it shows two utterly different types of scholars, Pomponazzi and Valla, for instance, sharing the same radical and unhesitating determination to return man to reason and restore reason to Nature.

Compared with these variously positive figures, all the currents of Florentine spirtualism seem a great apology for whatever is beyond nature—the soul, Ideas, God. Nobody before Sartre felt so deeply as Pico the complete opposition between natural being and the soul seen as knowledge, freedom, the possibility of disengagement. The world view of the Neoplatonists, however, concludes in a vast order in which natural and supernatural complete each other, and in which man, constituted by all material and spiritual powers, finds a central place and role. Of this imposing whole Bruckhardt studies only minor aspects—religious universalism, demonology, the idealistic theory of love, all of which are accurate, if limited, indications of the leavening part played by Neoplatonism in Renaissance civilization.

Between Pomponazzi's and Ficino's man, we find *homo faber*, the

artisan of the new epoch. He is not entirely subordinated to or entirely free of Nature; instead, he defines himself as a center of action in the cosmos who modifies the reality he encounters. This Promethean (but not rebellious) being is limned in the features of Brunelleschi and Alberti, Sigismondo Malatesta, Francesco Sforza and Julius II, Lorenzo de' Medici and Federigo da Montefeltro. Leonardo and Machiavelli, among others, have described him.

Burckhardt's book was obviously written with such figures in mind. Those for whom the reduction of a period of history to a dominating "type" seems facile and mythological will think he was wrong. But if we set aside this objection of principle and surrender to our impressions of the works of poets or artists, or to the picturesque and fascinating humanity conjured up by so many contemporary accounts, we find some truth in this vision of man awakening to discover that he can see and that he can create. We could not explain what this truth is, since objections, always partial, always accompanied by reservations, and often contradictory, have accumulated to hinder our judgment. But no more could we reject this book, which is so rich and diverse that its detractors have always had to simplify or distort it before they could criticize it. We possess neither a historical truth nor a reference system accurate enough to translate Burckhardt's doctrine into terms that can be judged for truth and error: his book still has the merit of helping us to "see" a civilization with an intensity and power of suggestion which remain unexhausted. It displays, too, that indefinable quality which Burckhardt himself discovered in Machiavelli's *History of Florence*: "Even if each line of the *Storie Fiorentine* could be contested, their great, their unique value as a whole would remain intact."

(1958)

CHAPTER

3.

Form and Meaning

The subtlety and complexity of schemes invented by scholars and *beaux esprits* of the Mannerist period for the deccration of palaces and residences—even for the triumphal entries of sovereigns—were so great that no spectator of average intelligence and culture could hope to understand them in the time he would normally spend looking at them. Concerning the designs for a festive entry celebrating the wedding of Ferdinand de' Medici in 1589, Aby Warburg remarks that even the authors of the printed descriptions seemed unaware of the meaning of the *Trionfo* invented by Bardi.[1] A composition such as Vasari's frescoes in the Palazzo Vecchio admitted as many coherent and parallel interpretations as a text from Holy Scripture: the mythological *istoria* supported physical, moral, religious, or political readings. But for whom? No untutored visitor could suspect, for instance, that the room decorated with the history of Cosimo the Elder was placed, for subtly flattering reasons, just below that of Ceres. The inventor's ingenuity did not pay off either as art or as propaganda.

Aby Warburg invokes, to explain this situation, the law of the genre, and the very definition of "hieroglyphic art." This explanation is valid but insufficient, as it does not account for all the implications of the phenomenon. As Wittkower has shown, Palladio determined the size of successive rooms in his villas through a "fugal" sequence of proportions which the eye, unable to perceive simultaneously in relation, could not appreciate.[2] Better still: when physical conditions impeded the realization of the "Pythagorean" scheme, Palladio diverged from it and even introduced asymmetries that he later corrected tactfully by drawing those buildings, in his theoretical writings, "as they should have been"—which displayed, for a Pythagorean, little regard for visual harmony. Since the ideal edifice, itself unexecuted and impossible to detect behind the real building, was "perfect," the archi-

tect considered that he had met the requirements of rational beauty.³ The extraordinary ideal reconstitution of the temple in Jerusalem by G. B. Villalpando greatly surpasses, in its calculations, any possibility of visual appreciation: "musical" proportions, for example, regulate the relationship between the first-floor metopes and the third-floor triglyphs, or between the metopes of the orders of two successive stories.⁴

The more painting tried to become discursive, the less its form "spoke"; the more architecture attempted to be Pythagorean, the less visual harmony it provided. Thus the perfection of art was located in an "idea" that was not only abstract but silent and hidden, and even—as was sometimes the case—no more than limited or tacitly implied. Beauty, therefore, existed only for a rational analysis, which most often people neither would nor could undertake.

It is tempting to believe that this paradox, common to apologetic art and to Pythagoreanism, is only another form of the well-known penchant of Mannerism to elevate the *idea* above the senses. If the conceptual kernel is everything, painting can be no more than pictorial discourse, and architecture a visual scheme translating, in one way or another, privileged arithmetical relationships.

But such a preoccupation with useless and apparently absurd perfection rested as well upon a positive aesthetic bent, upon a sort of madness for order. Thus the decoration of the Palazzo Vecchio brings to mind those masterpieces which mark the history of music since the polyphonists: compositions "in a key," which exist neither for the public nor for the performer, but only for analysis, and whose real interpretations is by mathematics. This is what determined the Mannerist approach: the contingency of form in relation to the intelligible essence of the work. Meaning was often hung upon form in the most unexpected, roundabout ways. On one of the ceilings of his Aretine house, for example, Vasari painted a fight between *Virtù* and *Fortuna*; as the viewer circles the room, now one, now the other, appears to have the upper hand: symbol of what happens in life.

It would not be absurd to call these intellectualized and learned aesthetics "humanist." Their representatives certainly deserve the epithet: the inventors of such programs of decor were almost always scholars, *antiquarii*, or, at least, *beaux esprits*; the Pythagorean architects were all heirs of Alberti, and Wittkower did not hesitate to dub this trend "humanistic architecture." The theory on which it rested

was always Aristotle's, indispensable for the justification of such compositions. In this theory, the work of art was the practical realization of an idea previously conceived in the mind and imposed with "violence," as the school has it, upon external matter. This process was rational, methodical; its only subjective conditions being that the artist acquire knowledge and *habitus*. It is tempting to believe that the art of Vasari and Palladio was only the application of this doctrine. Moreover, the reaction against the aesthetic approach coincided, in its date and its representatives, with the end of humanism. It consisted essentially in denying the distinction between form and meaning, in depriving meaning of its purely intellectual character; for Bruon, for example, it reduced art to a beauty which consisted in sympathetic charm and the communication of feelings.

But was this reaction of 1600 really antihumanist, and could the art it sought (with some success) to dethrone rightfully lay claim to humanism? It is impossible to say. For on one hand a certain brand of humanism—that of Ficino—secured some of the new theories, but, on the other, to hold classical humanism responsible for the radical separation between the idea and its material "vestment" would do an injustice to one of its oldest and deepest aspirations.

To get things in focus, we may examine, in some significant themes that broach the relation between form and idea, the evolution from the old (roughly speaking, Mannerist) attitude to the new vitalistic and expressionnist aesthetic. The questions can easily be grouped around the aesthetic thought of Lomazzo.

Pythagoreanism and Sensibility

Wittkower's book has cogently shown which convictions and theoretical biases contributed to the making of Renaissance Pythagorean architecture—in which, as Alberti put it, nothing should be included that was not scented with pure philosophy. But by limiting his inquiry, however rightfully, Wittkower avoided a systematic investigation into Pythagoreanism in its concrete aesthetic sense; for its concept was ambiguous: it could refer to beauty reduced to its appeal to the senses, or to an abstract perfection to which the impulse of beauty is blind. Number and proportion might be employed either to rationalize and purify emotion, or, as with musical modes, to arouse well-specified "passions." Pythagorean "proportion" could be either an agreement, or a convention, between quantities—which would have

made it into a particular, if autonomous, case of the universal harmony—or simply an exact visual translation of musical sounds. All these questions, to which precise criteria often allow us to give unambiguous answers, understandably turn on one central question: How, and in what measure, may the sensible as such bear, in art, intelligible number?

Thanks to the *Timaeus* and to musical theory, Pythagoreanism had never been forgotten in the Middle Ages; classifications according to which *musica mundana, humana,* and other kinds of harmony left vocal or instrumental music only a humble last place flourished in the twelfth and thirteenth centuries. The contribution of humanism was solely to apply this legacy to architecture. Vitruvius encouraged this, and it was a strong temptation—conscious with Alberti—to create a "rational" beauty thereby, in both the arithmetical and philosophical senses of the word. When a Renaissance architect talked about the "music" of a building, he was not necessarily trying to convey an aesthetic impression; even less, of course, when he designated relationships of length with such technical terms as *diapason* and *diapentes.* "Consonance" was itself an arithmetical concept; and one did not expect that it corresponded entirely and exclusively to harmonic intervals and to ratios of length that pleased the eye. The ratio a/b was "consonant" when the difference $a - b = n$ was a common divider of a and b.[5] This rule was fairly arbitrary and excessively restricting, as it excluded, for instance, the two thirds, but it had the great advantage of furnishing a formula for beauty. Reciprocally, as Wittkower has pointed out,[6] Alberti accepted in architecture ratios that could not be translated into music without dissonance, but that were arithmetically irreproachable: the succession of two fourths, 4-6-9, or of two fifths, 9-12-16. Thus the three ranges of consonance—arithmetic, musical, and visual—did not coincide exactly, and the first took precedence. The humanist novelty was not to have looked to a mathematical scheme for the secret of beauty—the golden ratio, at least, was already a workshop commonplace—but to have attempted to replace blind "practice" with a rule of beauty guaranteed both by ancient tradition and by philosophy.

This point is of fundamental importance. It was this which made the Pythagorean doctrine very reassuring for many fifteenth- and sixteenth-century authors: it proved the rationality of the world. A sense for beauty became an instinct for the rational; Alberti agreed on this

point with Villalpando, asserting through his trust in reason what Villalpando would rediscover, after the long interval of Mannerism, through a new confidence in instinct.[7] Architectural theorists pretended to ignore the golden ratio, in spite of its harmony and its geometrical foundation, because its beauty was neither rational nor musical, and put into doubt the superior essence of the aesthetic instinct.[8]

The typical formula of Alberti's humanistic Pythagoreanism, at once classical and naïve, rested finally upon the following assumptions, which defined, in the aesthetic realm, the predordained harmony of nature and reason:

• A "consonant" ratio—that is to say, a certain form of simple numerical relationships—was the necessary condition of true beauty; any other acoustic or visual ornament was mere "pleasure of the senses."

• This condition, however, was not itself sufficient, since some ratios that were theoretically faultless might not prove suitable for either architecture or music; moreover, those two arts were not strictly parallel, but two particular and different cases of the universal harmony.

• There was an instinct for the beautiful which showed us this harmony, without the detour of analysis or the aid of controlling measurements.

During the Mannerist crisis this system broke down, and Pythagoreanism changed its meaning. Its weak point was the matter of parallelism between diverse forms of beauty. The dissymmetry of the arts could not be justified; there ensued an attempt to abolish it, which had two consequences: first, mainly with Francesco di Giorgi but also to a certain extent with Cornelius Agrippa, a sort of panmusicalism risked transforming cosmic harmony into an ideal synaesthesia; then, with Palladio and others, a slightly pedantic trust in method took no account whatever of sensation.

This development is easy to follow. The "correspondence of the arts" was soon exploited, especially (as could be expected) in the Veneto. In 1590 the musician Gafurio was called in for consultation on the building of the cathedral of Mantua; in 1535 Francesco di Giorgi imposed upon Jacopo Sansovino a "Pythagorean" project for San Francesco della Vigna. Giorgi tended to contain Pythagoreanism within the limits of the senses; he did not admit, like Plato, a beauty of numbers as such, but only an effective "virtue" conveyed by sensi-

ble beauty. His *De Harmonia Mundi* (Venice, 1525), is one of the most picturesque but least theoretical of the Platonic-Pythagorean magical treatises of the time. The language of music, which he frequently employed to express the distances between the planets in tones and semitones[9] and so on, had genuine meaning for him, for, unlike Alberti, he refused to consider harmonies of numbers which did not pass the test of hearing.[10] The harmony of the spheres itself was audible in principle; a better ear than ours would hear it.[11]

Thus conceived, Pythagoreanism proved not the rationality of the real but its marvelous order—one more "harmony," if you will, in the Leibnizian sense of the coordination of monads. The classical relation between the sensible and the idea was endangered. Fifty years later it was shattered. On one hand the analogy of the arts was tightened up almost experimentally: Zarlino having enlarged the arithmetical notion of consonance to make it fit the evidence of the ears by rehabilitating thirds, Palladio eagerly utilized in architecture the now authorized ratios; elsewhere, as we have seen, even Palladio did not seem to worry about making those proportions accessible to the eye. By insisting several times, in *Quattro Libri*, on the advisability of correcting the dimensions deduced from theory according to the requirements of the ear or of taste, he confirmed a distinction little compatible with the spirit of Pythagoreanism.[12] "Experimental," almost synaesthesic, curiosity, and extrapolation based on a blind theoretical postulate were also mingled in Giuseppe Arcimboldo's invention of a "clavier of color," and in Giacomo Soldati's inquiry into an ideal "sixth order."[13]

Mannerism strongly insisted upon the suprasensible character of Pythagorean harmony. Insofar as it did not belong to any sense in particular, and was neither properly quantitative nor purely qualitative, one could, like Scaliger, see in it an "affectus transvolans per omnia praedicamenta,"[14]—from which, in turn, might be deduced the impossibility of founding an aesthetics upon it: beauty, a sensible quality, had nothing in common with *symmetria*, a relation; the eye did not distinguish, in the luster of a color, the *temperatio* which caused it.[15] But Cardano, against whom those remarks were directed, was equally alien to Alberti's optimism: aesthetic pleasure was for him nothing other than the "delectation" of knowing the *symmetria* of things. The eye understands (*intelligit*) simple proportions; sensible beauty is called by Cardano *cognitum*.[16] Thus the very backbone of

Pythagoreanism is removed, since beauty is no more than the rational
known through the sensible, as one knows a thought through the
words that express it. Cardano, Palladio, and Scaliger all admit—
though with different emphases—the existence of a pure, sensible
beauty which is not an embodiment of numbers (Scaliger), a purely
intelligible beauty which may or may not avail itself of the senses as a
vehicle (Cardano), and sometimes, but almost luckily, an agreement
between the two (Palladio).

Theorists return us, then, to the real situation of Mannerist art by
allowing us to state precisely its connection with humanism: a fact of
experience—the lack of agreement between the different forms of
harmony—has ruined the naïve Pythagoreanism of Alberti, and im-
posed the separation of the intelligible: not as a pure humanistic doc-
trine but as a position of retreat before the surrender.

Pythagoreanism and symbolism, which similarly pose the problem
of the intelligible and art, are also linked by philosophical back-
ground. The philosophy of *proportio* could at the same time invoke
the passage from the *Wisdom of Solomon* (XI, 20) about number,
weight, and measure, quote the *Timaeus* and Eryximachos's speech
in the *Symposium,* and base itself, with Vitruvius, upon the fact that
man is the measure of all things. Thus God, Nature, and man
together created *in re* the exigencies of proportion and the experience
of harmony; and that was why Pythagoreanism, still quite objective
with Alberti, could persist into the Mannerist period with a symbol-
ism and a psychology.

The confluence of these three traditions provided the architects'
symmetria with an enormous theoretical superstructure. From the
human form Vitruvius deduced the forms of the temple and of the
column, established a relatively simple canon of proportions for the
human body, invited its "quadrature," and remarked that its limbs
were the origin of the Roman system of measurement. Upon these
endlessly glossed passages was grafted the theme of man as "model of
the cosmos," from whom were derived not only architectural forms
but elementary geometric figures as well. The God who created the
world of mathematical laws and made man the epitome of all har-
monies was, therefore, essentially an architect—but the architect of a
structure of symbols: "Immo et ipse opifex summus totam mundi
machinam symmetram corpori humano, et totam ei symbolicam fabri-
cavit," Giorgi wrote (III, i, 1). The microcosm was an accord of

beauty with the world and the figurative expression of its constitution. Villalpando, who extended this sort of speculation very far, quite naturally quoted Vitruvius alongside the Scripture.[17] Vitruvius was canonical because he was reason itself; he had, in any case, borrowed all his rules from the Temple of Jerusalem,[18] where they had been realized in an exemplary manner through the inspiration of God. The theme of Noah's Ark entered quite naturally into this context. Philo had shown that its proportions were those of an ideally constituted man (*Quaestiones in Genesium*, II, 1); Augustine went further: this ideal man was Christ, or else the Church, the vessel beyond which there was no salvation (*Contra Faustum*, XII, 39; *Civitas Dei*, XV, 26). Hence the symbolic importance of the analogy between the human form and the plans of churches (Giorgi, Villalpando). The argument came full circle when musical intervals also intervened; this Pythagorean terminology was used to formulate the human canon first by Gauricus, then, with a more precise purpose, by Cornelius Agrippa; Lomazzo carefully reserved it for the perfectly proportioned body (closer therefore to Christ and the Ark) and was content to use a simple numerical notation for derived types. Villalpando introduced musical terms only near the end of his volume III, where he spoke also of the symbolic interpretation of the Temple, in which he discovered a scheme of the cosmos as well as the twelve tribes, the planets, the signs of the Zodiac, the elements, and allusions to Christ.[19]

Pythagoreanism was therefore connected, at least by Giorgi and Villalpando, with that other doctrine of *harmonia mundi*: pansymbolism. But it was nonetheless traditionally linked with the idea of a cosmos governed by mathematical laws. "The rules of arithmetic," wrote Daniele Barbaro, "are those which unite music and astrology, for proportion is general and universal in all things made according to measure, weight, and number."[20] It is just possible that we may find in sixteenth-century texts about divine laws and the sensible world they regulate traces of a development akin to that undergone at the same time by the conception of the relations between harmonious number and beauty. What is certain is that the famous passage in the *Wisdom of Solomon* supported not only a science of nature but an aesthetic of natural beauty which fitted well into the general movement of ideas.[21]

Magic and Art

The second great "model" used to explain art was, after crafts-
manship, magic. In the historical alternation between those two con-
ceptions, which often represented two aesthetic approaches or two
theories of science, the turning point—1600—corresponded to a very
clear and striking re-emergence of art as magic. (Perhaps it is more
correct to speak of discovery rather than re-emergence, for previous
points of contact, however numerous, were largely unacknowledged
or involuntary.)

We can take as a reference—undoubtedly an arbitrary choice—a
text such as the so-called *Alberti Magni . . . de mirabilibus mundi:*[22]
here it is said that the human soul possesses a *virtus immutandi res*
(Avicenna's well-known formula) and can "tie or untie" matter, "alter"
its own body and external things by the strength of its feelings, work-
ing with the help of propitious constellations. It is a matter of energy:
the more ardent soul wins over the weaker one; a matter, also, of in-
nate gift: "Nullus autem est aptus in hoc nisi quem instigat ad hoc
faciendum inclinatio naturalis aut aliquid vigens in eo." The efficacy
of rites celebrated with appropriate passion is similar to the causality
of the soul, and it is good that the sorcerer possess, apart from a per-
manent inclination, a special disposition, and a particularly strong
desire when he is at work. In short, magic is a language of feelings
that is expressed or embodied by means of the imagination. That is
the classic view which we find, with variations, in the writings of Pie-
tro d'Albano, Ficino, Pietro Pomponazzi. And we recognize there,
mutatis mutandis, all the elements of art for which pure Aris-
totelianism could not account: talent, the contagious force of feelings
manifested by the form which expresses them, the role and the en-
chantment of individuality, inspiration. Farther on in Albertus's text
there becomes evident, with sympathetic magic, the essential impor-
tance of that *mimesis* which Aristotle had intellectualized by banish-
ing imagination from his general theory of art.

Before magic thus conceived was recognized as the prototype of the
fine arts, it was made, against Aristotle, into the prototype of *techne*
(in the broad sense of the word), which thus ceased to be a "violence"
against nature and became maieutics, *ars ministra naturae*. The role
of man ceased to be that of creator; he prepared instead the condi-

tions of natural activity, hastened or slowed down its processes, pro-
voked them, helped them along or hindered them. The alchemist,
said Jean de Meung in a poem (in which, significantly, the devices
described have an obscene double meaning), acts through "natural ar-
tifice," that is, he contents himself with setting nature on the proper
path.[23] Ficino, talking about the *vapori, qualità, numeri e figure*,
employed by the magus, alluded to farming and concluded: "adunque
l'opere della Magica sono opere della natura."[24] This compound of
magic and nature, which had a considerable future, later widened
expressly to include the fine arts. G. B. della Porta, in his youthful
writing *De i miracoli e maravigliosi effetti dalla natura prodotti*,[25]
transcribed Ficino almost literally, but placed him in the context of a
discussion about the qualities of the sorcerer, in which he relied upon
schemes proposed by Horace and Vitruvius for the respective cases of
the poet and the architect: a discussion concerning the complemen-
tarity of theory and practice, of innate and acquired gifts, the endow-
ments of the privileged in some measure replacing study.

To the maieutic scholar who, in natural magic, commands nature
while obeying it, corresponded the artist as fowler who, like a bird
catcher, does not "produce" beauty but knows how to capture it. We
are here at the heart of the aesthetic controversy of the Renaissance:
it is a matter of knowing whether Pythagorean numbers and ratios,
the quantitative and qualitative harmony of the parts, constitute
beauty, or whether they are only a "preparation" for it; whether art
consists in the rational organization of its constituents, or in a spiritual
charm inherent in its sensible aspect and in the gestalt.

"Magical" authors often, with a logic that was not always conscious,
resolved to reduce mathematical, or otherwise "ordered," beauty to
the level of mere "preparation," a lure for grace. Ficino said so explic-
itly in a well-known passage of the *Convito*; Cornelius Agrippa ac-
counted for the superiority of song over instrumental music by that of
expression over sole number, and the intervention of a semispiritual,
semicorporeal factor: imagination.[26] Elsewhere, to illustrate the
extra-rational nature of magical charms ("non enim ratione cognoscen-
tem et intelligentem trahere possunt"), he again had recourse to the
example of music, which stirred the passions and made us uncon-
sciously beat time with the songs we hear.[27] He cited love as an ex-
ample of the action of sight upon the *spiritus animalis hominis*, upon
the nonrational imagination, as opposed to the rational.[28] Later,

moved by the same "magical" mistrust of the Pythagorean over-
estimation of the intelligible, Campanella attacked the virtue of num-
bers: they were ideal, not efficient, causes; they served to formulate
the rules of phenomena, and it ensued that Nature proceeded accord-
ing to significant numbers such as three and five—but the number as
such had no "virtue" of its own.[29]

However, the development of this "arithmetical" Pythagoreanism
is not so clearly defined as that of the general theory of the beautiful;
not all authors adorn the former with a theory of expression or of a
purely spiritual magic action. Agrippa himself, when he spoke of the
harmony of the parts of the human body (borrowing heavily from
Gauricus and Cesariano), and Giordano Bruno when he plagiarized
(in his *De Monade*) Agrippa on the virtue of numbers, continued the
original tradition. Francesco Giorgi still worked with a very static
view of harmony, reduced to correspondences and "resonances"; he
was quite remote, in any case, from the followers of natural magic,
most of whom went beyond that stage. As is always the case when op-
posing theories both claim support from a long tradition, the change
of attitude came about slowly, and with fluctuations. The final result,
however, is clear; in Bruno's *De vinculis in genere*, music, love, and
magic, which were already reunited accidentally by Agrippa,[30] now
comingled in a comprehensive theory of "links," which welded
together in the strongest possible manner form and the meaning it
bears.[31] It was a general aesthetic of fascination, carried to its ex-
treme, which, taken literally, would exclude the very possibility of a
theory of art.

The magical interpretation of art was explicitly conveyed by Lo-
mazzo's borrowings from Cornelius Agrippa. Lomazzo's *Tratto
dell'arte della pittura* (1584) and *Idea del tempio della pittura* (1590)
were crammed with quotations and unacknowledged adaptations from
De occulta philosophia,[32] and we may rightfully say that in every case
where Lomazzo proclaimed that conception of art which we have
called "magical," he found confirmation, support, even guidance in
Agrippa. The passage[33] about the psychological effect of colors is sig-
nificant. Lomazzo's remark on the subject is new and very surprising
for his time; I do not know if it was revived by anyone before Goethe
in his *Farbenlehre*. Precise symbolic values had already been at-
tributed to colors in the working out of coats of arms and liveries, and
in the language of gifts;[34] on the other hand, innumerable texts con-

firm that, while the *disegno* represented the intellectual essence, color represented the sensible and affective elements; for a long time it had been reserved for the subjective aspect of artistic judgment, associating as it did "tastes and colours."[35] But despite the vague, time-honored prejudice against dark, "sad" colors, and in favor of "gay," light colors, nobody had yet seen or said that a particular color would engender a particular feeling. Agrippa, though, had classified colors according to their astrological character;[36] it remained for Lomazzo to transcribe this text literally and replace the names of the planets by their traditional qualities: the colors which, according to Agrippa, *Saturnum referunt*, were characterized in Lomazzo's work by the fact that they "generano per gl'occhi nell'animo tristezza, tardità, pensiero, melancolia, et simili"—the classic Saturnian qualities. In the same way, according to the *Picatrix*, it was necessary to dress in black to receive the beneficent influence of Saturn, and a painting in dark, somber hues somehow conjured up the dispositions of the Saturnine spirit.[37]

This, however, was only a single case; the intrusion of magical, astrological, or generally vitalistic models into the reflection upon painting was accomplished in a much broader way. That Agrippa's[38] description of the seven planetary gods was utilized by Lomazzo for his own iconographic needs is only natural;[39] but it is already more interesting that, by virtue of a fairly widespread astrological physiognomy, Lomazzo could enlist it to elaborate his theory of expression. For chapter II, 7, of the *Trattato*, which describes, according to Agrippa, the *moti*—that is to say, the characteristics, and psychical and physical "endowments," of the planets—counseled painters to cull from them their inspiration to create Saturnine, jovial, and other characters; it formed the introduction to a long development that classified expressions of feelings and characterological types according to an evident, if unacknowledged, planetary scheme.[40] In itself, this was nothing new: the Arab and Christian astrologers of the Middle Ages had long applied their science to physiognomy and the study of character. In the special case in which Lomazzo[41] copied from Agrippa, the most recent source was probably *Picatrix*;[42] there was nothing new here except—significantly—the first application of those conceptions to art. Even Pomponius Gauricus, whose *De sculptura* included a long chapter on physiognomy and who was the brother of a famous astrologer, had not dreamed of it. Even more significant is another

adaptation of Agrippa by Lomazzo: a scheme of seven masters, or "governors," of painting, assimilated to the planets.[43] Lomazzo naturally ascribed to them attributes borrowed from contemporary planetary astrology (metals, animals); but he did not hesitate, in characterizing their styles, to transcribe entire astrological passages from Agrippa, modifying little more than the names: Michelangelo is substituted for Saturn, Gaudenzio Ferrari for Jupiter, Polidoro for Mars, Leonardo for the Sun, Raphael for Venus, Mantegna for Mercury, Titian for the Moon.[44]

An examination of Lomazzo's text reveals that his conception of painting's governors was for him first a theory of what he called *moto* (movement, expression, physiognomy, character) and its variations in diverse artists. Such an origin should not surprise, for *techne* according to Aristotle evidently does not account for the two conjoined factors of expression and personal style. But astrology provided a convenient scheme for filling this gap; it accounted not only for objective differences of taste in the public; the classical astrological chart of attractions and repulsions between the planets indicated a priori what would please or displease.

In a fairly complex treatment, into which enter medicine and the psychology of humors, the physics of the elements and physiognomy, Lomazzo elucidates the workings of astral influence upon the appearance, character, and tastes of individuals. His theory is less astrological than magical in the narrow sense of the term, for it is in books on natural magic, and there only, that one might have found a differential psychology based on planetary types and applied to the power of the soul to act, by feeling and imagination, upon the physical world. Thus the picture becomes a kind of complex talisman: first, as the involuntary expression of the painter, it takes on by virtue of the *maniera* the astral properties of the artist; second, it evokes other planetary qualities by means of colors, the proportions of characters, objects represented. Lomazzo was tireless in his classifications (borrowed from a rather limited number of sources), according to which whatever could be painted was attributed to one or the other planet according to an almost totemistic view of the world as propounded by Manilius. And, third, the work of art exerts a sort of sympathetic magic, determined by two principles often asserted by Lomazzo and current in art treatises since the Counter-Reformation, as well as in rhetoric since antiquity and, granting the inevitable differences, in

writings on magic since the pseudo-Albertus: that the representation of an emotion automatically provokes that emotion in the spectator[45] and that the emotion cannot be communicated except by someone who is himself possessed of it.

Lomazzo's complicated system of "captions" had the paradoxical effect of weakening the expressionist aesthetics from which he derived it, and transforming the work of art—at least ideally—back into the intentional translation of an idea. For if a given artist obeys the common law and has a personal style fixed by his horoscope, the ideal, perfect artist instructed by Lomazzo would know how to utilize each of these astrological determinations, or limitations, in the parts of the work where they rationally have their place, giving to each figure, action, or object the apposite form, color, and movement according to astrology and reason, and creating in this way an entirely justifiable work that would be pleasing to all.

This reservation is typical enough. According to Cicero, equal perfection in all genres characterized the ideal orator, the Platonic Idea of the orator. If Leonardo insisted that every painter paints himself, it was only to say that one must study oneself carefully to avoid reproducing everywhere one's own type. As long as the work of art is considered to be a form realizing an image previously conceived, one cannot overcome a prejudice against the *maniera*; Lomazzo's error was to try to combine both positions.

Two general and apparently contradictory principles determined for him the deontology of the painter. The first, forcefully expressed in the *Idea*, chapter II, prescribes a thorough awareness of one's own aptitudes, to avoid going against them and to exploit them fully; this is well-known astrological and magical advice which Ficino had already applied explicitly to the scholar.[46] Lomazzo's second precept, expressed equally strongly in several passages, states the absolute necessity of "conceiving" the work in one's mind before putting one's hand to it, of separating the idea and its execution, and leaving nothing to chance.[47] It is evident in any case that the perfect picture, the creation of an artist devoid of personal style and capable of all styles, is destined to be judged above all by reason.

The hesitation illustrated by these two counsels—the one magical, the other Aristotelian—was not without consequence; for in the first Lomazzo stressed that one must know one's own genius, and not merely rely upon it; that is to say, one must exploit one's talent while

dominating it. This clause gave the last word to Aristotelianism. Individuality remained a limitation and not a value; to cultivate one's style was a matter of modesty, like specializing in landscapes, portraits, or grotesques. The deeper reason was that for Lomazzo form existed as a distinct vehicle of a discursive intelligible.

One could without much trouble multiply proofs for the slow ascendency of magical themes in the intellectualist theory of art. It was not, as we have seen, limited to these years of crisis; in fact it attended Neoplatonism, and that was undoubtedly why Ficino could be copied in the *Idea*. Out of the melancholy Saturnian was born the idea of genius; the poet's *mania* became the *furia*, the spontaneity or freshness that was so esteemed in drawings in the seventeenth century. Ficino's theory of music, in which a sympathetic communication of the soul with the harmony of *anima mundi* took the place of the simple virtue of Pythagorean numbers, was a model of which neither Lomazzo nor Bruno ever lost sight; the accent remained on *moto*, on passion.

Neoplatonists tried to secure themselves against the pure anarchy that was the final result of the subjectivist theory by assigning at least a subordinate role to the rules. They found justification for this in the principles which presided at the creation of the universe, *ordo*, *modus*, and *species*; but their importance was limited to that of "preparations." This essentially magical term applied to the rites or figures which rendered a supplicant or object capable of attracting the influence of a planet or a spirit;[48] it was applied by Ficino to *ordo*, *modus*, and *species*[49] as if to oppose the traditional approach which made of them principles of natural beauty and, with Alberti, of artistic beauty.[50] The chapter in which Vasari described the perfect style of artists since Leonardo owed something—no doubt unconsciously—to this conception of the connection between the rule-preparation and the spirit that intervenes: for the distinctive traits of the new art were, according to him, *buona regola, miglior ordine, retta misura, disegno perfetto*, and *grazia divina*. We recognize in *ordine, misura*, and *disegno* the classical *ordo, modus*, and *species*; and *grazia divina*—which the context identified as *maniera* in any case—was then nothing but the indefinable "true" beauty for which all the rest was preparation.[51] Lomazzo himself, who had been content with copying Ficino's general thesis, here, for once, shrinks from Vasari's critical application.

Plastic Puns

Consciousness of the various possible relationships between form and the meaning it carries was, around 1600, accompanied by a parallel phenomenon concerning the relationship of objects to their own appearance, as it were. Art historians since Pinder have observed that with Mannerism the organization of the pictorial surface deliberately contradicted the illusion of depth, and bent the contours, arbitrarily and ostentatiously, into a play of curved planes. A violent foreshortening was neutralized, for example, in extending its line, on the picture plane, by the contour of an object whose spatial orientation was different or opposite. The result was a clear awareness of the distinction between the thing itself and its apparent form.

This was fairly general strategy, which can be traced in several categories of examples. Thus, in the time of Brunelleschi and Alberti perspective imposed a geometrical look upon the representation of volumes and space, and this coincided quite naturally with a style, a "poetics," of regular volumes and (as has been shown in Piero della Francesca) with the demands of a harmonious partition of the surface; it also precipitated a decisive rise in marquetry, since its technique accorded so easily with that very fixed style, and this accord could not but be exploited.[52] If with Mannerism, on the contrary, rational perspective, the organization of the painted surface, and the new demands of style continued to agree, it was—and we must stress this— by means of an ingenious arrangement: decentralization, an unprecedented choice of distance or horizon, etc. The lines that defined the scenic space still organized the image, but according to a completely different and abstract scheme; their double function was shown as such. Tintoretto often showed how it was possible to utilize such means; but already in his time a new use of perspective, the one which Rubens would prefer, had been introduced by Veronese: the angle of vision played in the service of expression the same role to which it is nowadays assigned by film directors.

Through a device analogous to that of Mannerist perspective, the outline of objects could likewise detach itself, in an intentional double play, from its meaning. Hence the importance of grotesques, which show this abstraction *in fieri*: the curve of a leg had to be only slightly accentuated to become that of a leaf, whose stem turns, by stressing its graphic quality a bit, into the foot of a satyr. For the most part,

grotesques were simply an exercise in "abstract" vision. A step further, and we reach the principle of Arcimboldo's figures: just as in a pun the sound of a word is detached from its meaning, undergoes an autonomous transformation and thus falls upon a new meaning which, "as if by chance," resembles the *Bibliothécaire*. The effect is more striking still when, to discover the profile of a satyr in a landscape, or the head of the cook in a saucepan full of vegetables, it is necessary to turn the picture round or reverse it: for then it is even clearer that the passage from one signification to the other is through abstract form.

The double leap and the shock of recognition are essential here; in Romanesque sculpture, as in Mannerist art, the forms of objects were violently distorted according to the needs of the composition, grotesques abounded, and ornamental motifs were often grouped to outline, by an intentional coincidence, apparently Arcimboldesque figures. But this art was not generally Mannerist, because instead of ornament becoming an "abstraction" freed from the form of things, living things were a fantastic interpretation of the ornamental scheme. Romanesque art did not know the leap to the unreal, from the plane of meaning to that of pure form.

Arcimboldo, we know, was lauded to the skies by his Milanese compatriots, but their praises differed significantly in motivation. In an exchange of madrigals on the Flora made up of flowers, Comanini and Giovanni Gherardini amused themselves mainly by repeating the words *Flora* and *fiori*, under the pretext of celebrating the ingenious union in paint of the goddess and her attributes;[53] their intention was to imitate with words the cascade of flowers or the repetition of motifs that one finds in Arcimboldo's figures: "Questo madrigale imita ben davvero la pittura dell'Arcimboldo," Comanini wrote.[54] This might be called a sensualist interpretation, one in which the artistic impression itself and the formal character of the work are meant to contain, through their own expressive power, the essentials of the "message." On the other hand, faced with a "Hunter" composed of beasts, Comanini launched into a lengthy symbolic exegesis, explaining in detail the reasons, drawn from bestiaries and moral philosophy, why a particular animal has been located in a particular part of the face.[55] The apology adopted the extreme Aristotelian attitude which placed the supreme beauty of the work in the arrangement of the "idea," disclosed to intellectual analysis only. Finally, Lomazzo, in his pre-

sentation of Arcimboldo,[56] never ceased to marvel at the ambiguity of the form: from afar one had the impression of a portrait that was a good likeness, closer one saw it to be composed of objects, also perfectly reproduced, yet the resemblance to the human face did not disappear. Arcimboldo—the painter who best illustrated the crisis of transition from an idealism that negates form to a sensualism that reduces the idea to an expression of form—was simultaneously interpreted from the intellectualist point of view, from the standpoint of pure impression, and as an intentional critic of ambiguity.

The ruin of a certain theory of art gave birth in these years to a renewed general aesthetic. Humanism had posed the problem of the relations between idea and form which expresses it in rhetoric, logic, poetry, and the visual arts; it endeavored to join the "what" to the "how," to find for formal beauty a justification more profound than the need for decoration. But, as far as it went, it never denied that in all these fields "what is expressed" must be present prior to its expression. That is why, speaking simplistically, humanism came to an end in the sciences just as the method of investigation became fruitful by itself, and in art just as the execution—the *maniera*—became an autonomous value. When artistic consciousness reached such a stage, around 1600, it found no art theory that could account for it. There was only the ancient natural magic—that is to say, a general aesthetic unaware of itself, which Bruno hastily developed in the magnificent essay he entitled *De vinculis in genere*.

Artistic experience enters at this point—with rhetorical persuasion, fascination, sympathy, phenomena of allergy, magical prodigies, etc.—into the category of "chains," which are all positive or negative forms of love. They are relations of soul to soul—relations of force, but also of mutuality; for, as Scheler would later say, love, unhindered, naturally engenders love. That is why, according to Bruno, the artist who wishes to move must himself be moved. There is no other recourse. Charm has no objective conditions, no rule; perfect order displeases, and a beautiful form is not necessarily composed of beautiful parts. Subjectivity is total; Voltaire's dictum—that absolute Beauty for the toad is a female toad—had already been used by Bruno, with the sole difference that he took as his example the monkey. The realm of charm and chains is the imagination—which does not mean the unreal, for the imaginary has its own truth ("havet suam species phantastica veritatem"), but spiritual and subjective reality.

How, and in what manner, in these conditions, can artistic form (or, since we have gone beyond the domain of art, beautiful form) still convey a meaning? Bruno denied none of the possibilities we have encountered: "Contemplativi a sensibilium specierum aspectu divinis vinciuntur, voluptuosi per visum ad tangendi copiam descendunt, ethici in conversandi oblectationem trahuntur" (II, 10, 674). But for him these potentialities of the given form, which as we have seen answer in reality to differences in aesthetic and style, were themselves transformed into mere subjective reactions.

(1958)

CHAPTER

4.

Spirito Peregrino

The theme of the soul leaving the body, in dreams or in ecstasy for a migration that most often leads it to the other world or to the presence of the Gods, is very ancient and widespread. In most parts of the world it has been expressed in the institutions of shamanism. We could almost say—although the parallel is severely limited—that the *Divine Comedy* is in some manner a shamanic poem, since the journey through the higher spheres becomes an initiation and a regeneration, a "sacred medicine."[1]

The theme of the migrating soul, in its simplest and most banal form, is related to the belief in prophetic, or divinatory, dreams. The dream is deemed to be true because the soul (or one of the faculties of the soul) has quit the sleeper's body either to be at the events of which it dreams or to hear, from a superior being, the revelation of future events. That is the somewhat crude explanation offered in Homeric poems and certain folktales;[2] more or less rationalized by metaphysics, theology, or astrology, the same view runs through philosophic systems from ancient Stoicism and Neoplatonism to Renaissance naturalism; it has inspired innumerable literary or didactic fictions. For Dante, it is a recurrent and fundamental theme.

Dante was probably introduced to the theme of the *spirito peregrino* by poetic conventions current in his youth. His sonnet "Savete giudicar vostra ragione" contains the explication of a dream of Dante da Maiano's; "e'n ciò provide vostro spirto bene," he says in those lines, thus confirming that it is the *spirito* of his interlocutor which has made the dream, and made it prophetic.[3] The *Vita Nuova* abounds in visionary dreams, most notably the delirium which heralds the death of Beatrice. When the *Divine Comedy* speaks of divinatory dreams, we find again, stated quite naturally and with only a hint of metaphor, the old explanation: ". . . and when our mind,

more a pilgrim from the flesh and less captive to thoughts, is in its visions almost divine . . ." (*Purgatory*, IX, 16–18).*

The soul has revelations in its dream because it is no longer hindered by the corporeal senses—"a pilgrim from the flesh." In the waking state a strong inward concentration must produce the same result: the silence of the external senses allows the imagination, the faculty of dreams and inner visions, to be moved by superior or divine agents:

> O imagination, that do sometimes snatch us from outward things that we give no heed, though a thousand trumpets sound around us, who moves you if the sense affords you naught? A light moves you which takes form in heaven, of itself, or by a will that downward guides it.
>
> (*Purgatory*, XVII, 13–18)

These lines introduce a series of visions that are interrupted, just as ordinary dreams are, by a strong stimulus from without—the light of an angel (ibid., 40–45). The substitution of astral forces ("a light which takes form in heaven") for gods, demons, or other powers—which is directly inspired by Albertus Magnus, or rather by his Arabic Neoplatonic sources[4]—attests to Dante's familiarity with at least some of the philosophical problems habitually posed by that superstition.

But the most important example is the strange proof of the immortality of the soul given in the *Convivio*, II, viii, 13:

> Anco vedemo continua esperienza de la nostra immortalitade ne le divinazioni de' nostri sogni, le quali essere non potrebbono se in noi alcuna parte immortale non fosse; con ciò sia cosa che immortale convegna essere lo rivelante . . . e quello ch'è mosso o vero informato da informatore immediato debba proporzione avere a lo informatore.

The sources of this passage and its exact meaning have been analyzed and discussed at length;[5] Dante was using material from Cicero and Albertus Magnus,[6] or from the Arabs whose opinions Magnus adopted. In all those sources, the primitive mythical content is mitigated by attempts to elaborate some sort of philosophical system. In-

*These and all other lines from the *Divine Comedy* are cited from the translation by Charles Singleton (Princeton, N.J., 1970–75).—Trans. note.

stead of a displaced soul—a naïve concept, easily criticized—they describe a process more acceptable to classical and Christian thought: the silencing of its corporeal shell allows the soul to communicate again with the divine world to which it belongs by right. Albertus held to doctrines fairly close to primitive beliefs (the "daemons" of Socrates and the Neoplatonists), and mentioned the magical theory of humors or temperaments (Avicenna and al-Ghazali). He refuted those opinions, however, and Dante did not use them directly in this context.

But Avicenna's theory was very important for the entire system of ideas entertained by Dante and his circle concerning the *spirito*, particularly in relation to love and imagination. What we have just seen in the passage from *Purgatory* was equally true of all Arabic explanations of astrological influences: they provided a model that could be often applied to other phenomena of "spiritual" activity. Albertus Magnus is once again a witness:

> Omnis autem motor elevatus supra naturam agit in eam et mutat eam, sicut intelligentiae mutant orbem et totam naturam generabilium et corruptibilium; et huius signum dicunt [Avicenna and al-Ghazali] esse fascinationem et virtutes magicas, in quibus (ut asserunt) anima unius operatur in corpus alterius hominis et animam, et impedit operationes ejus et imprimit suas.[7]

This is more or less the mechanism described by Cavalcanti and the poets who followed him—love transported by little migrating spirits, or *spiritelli*. Remainder of his summary of Arabic theories, Albertus pointed out again that the magical or prophetic properties of the soul—its *nobilitas*, as he called it (compare the poets' *gentilezza* and the role it plays in love)—depended on a congruence between them and the separate intelligence, a congruence due to a favorable disposition of the organ of "imagination" ("organum imaginationis optime est complexionatum et compositum et commensuratum") which allows it to capture the light of the intelligence.

Until now I have spoken indiscriminately of soul, spirit, or intelligence, and left aside the question of which of these was in fact believed—for each author and in each case—to be the subject of the migration or supernatural vision. This point was of particular significance in the Neoplatonic tradition, with its theory of the "vehicle of

the soul," or, with Synesius, of the "imaginative pneuma" of dreams.[8] In fact the idea of a luminous pneuma, analogous to star-matter but inhabiting the human body, comes from Aristotle, who located it in the male's semen as a carrier of life and heredity.[9] That idea became immensely popular. The "vehicle" of life transmitted from father to son became quite naturally the "vehicle of the soul" (the term is in Galen); this opened the door to all the ancient beliefs, mentioned in hermetic books and elsewhere, about the ascent of the soul to heaven and its descent through the planetary spheres during its incarnation. (Plato too spoke of $o\chi\eta\mu\alpha$ in a context [*Timaeus*, 41 *d*–42 *d*] that seemed to imply acceptance of these myths.) The link between the *spiritus* and the "romance of the soul" was firmly established in Plotinus, Porphyry, Proclus, and, of course, Macrobius. The philosophical idea of a spiritual container naturally given to all souls borrowed some features from the gnostic, hermetic, and magical idea of a divine body acquired through initiation. Synesius is important because of the place he assigned in this context to imagination. In the end we have a combination of the following themes:

• The soul, which exists prior to the body, acquires a container of subtle matter during its descent to incarnate itself. This is the spirit, within which are inscribed the "gifts" of the planets—the qualities and destiny of the future individual. The posthumous fate of the soul will depend on the purification of its pneuma during its terrestrial life.[10]

• Imagination, the subtle body of the soul, can detach itself from the earthly body, and establish, or re-establish, supernatural contacts, particularly in dreams. Demons, ghosts, and the like are similar to the "spirit of the imagination" ($\varphi\alpha\nu\tau\alpha\sigma\tau\iota\chi\delta\nu$ $\pi\nu\epsilon\tilde{\upsilon}\mu\alpha$) in its vagabond state.

• The vital spirit of the sperm is identical with this container of the soul.

These themes are not easy to reconcile. Variations and compromises arose: for instance, Proclus (followed later by Ficino) distinguished two separate containers. Sometimes the spirit was by nature igneous or aerial rather than astral or ethereal. Often no attempt was made to unite these complex elements into a coherent whole. Thus the Stoics' idea of extending the doctrine of the spirit to cosmology, for example, had a completely separate history, which need not concern us here.[11] As for the connection between the *spiritus* and Galen's "animal

spirits," we shall deal with that later. Let us consider for the moment two aspects of the doctrine which immediately affect poetry and Dante.

In psychological terms, the departure of the imaginative spirit was called ecstasy. The Neoplatonists often spoke of states of ecstasy, and compared different forms of rapture: prophecy (in dreams or otherwise), inspiration, intellectual vision. Plato himself included love among these forms, an association that persisted strongly in Dante and his contemporaries. Vossler has drawn attention to this connection, to the concept of *sinderesi* for Italian poets of that period, and particularly in a strophe from a ballad by Caccia da Castello:

> Ed è luce che luce a virtù dae:
> per amor d'amor fae
> salir l'alma a la santa sinderisi
> per la qual Moisi fu nel monte
> e nel carro Elia portato.
> Non fu mai angel tanto alto creato;
> sol Dio, ella ed amor la fer salita.

The "Chariot of Elijah" is nothing else, according to philosophical exegesis, than the ὄχημα, the igneous pneuma, which, for the pure, carries the soul severed from the body directly to heaven; it is a characteristic image of synderesis, understood in the Middle Ages as the uppermost point of the spirit withdrawn from the body into itself, in an ecstasy which makes it divine. (The whole of Caccia da Castello's ballad seems to be rather an allegory of divine love than a love poem.[12])

The Neoplatonists were not content merely to use the pneuma to explain ecstatic states; it also fitted very nicely with demonology. Porphyry in particular—followed by Psellus—believed that the body of demons was made up of the same substance as the *spiritus phantasticus* of man; this persistent theme from superstition and folklore emerges in belief in the werewolf. Alcher's *Liber de spiritu* (twelfth century) explained how the phantastic spirit of man could leave his body and be transformed into a malignant beast.[13]

It is obvious why such a link between demonology and philosophical anthropology was of interest to the author of the *Divine Comedy*. The episode in the *Inferno* of Friar Alberigo and Branca d'Oria was already

oddly reminiscent of werewolves—the souls of the two traitors were cast into hell immediately after their crimes, while their bodies, animated by demons, continued to live, to their natural end. Dante's commentators quote in that context the passage from the Saint John Gospel about Satan entering the body of Judas—adding, however, that the departure of the sinner's own soul, expelled by the intruder, was Dante's invention.[14] But it also had, if not a source, at least a parallel in the belief that the disembodied souls and spirits of witches wander the world at night in the shape of demonic beasts. Dante's punishment of suicides also enlists this concept of an "exterior soul" separated from the body—in this case from the infernal body; it is an everlasting but painful ecstasy, for, according to the Church Fathers and theologians, the soul has no natural desire but to enjoy its body.[15]

As one would expect, the *spiritus* enters mainly in the general theory about the bodies of the punished souls, which presents remarkable analogies with Porphyry's demonology. The soul separated from the body by death creates, through its *virtù formativa*, a new body that resembles the one it had during its lifetime, but whose matter consists of the "surrounding air" of the place of its punishment.[16] This aerial body or "shadow" may not be a *spiritus phantasticus* in the strict meaning of the term, since it is only created or formed after the death of the subject; but their subtle matters are similar, their spectral natures are identical, and they have the same origin. The *virtù informativa* that transforms air into a specter is the very same power which, according to Aristotle, resides within the spirit of the semen (the classical "vehicle") and shapes the body of the unborn child. The significant link between the specter and the subtle matter of the sperm is enough to show that Dante's theory of the infernal body is connected with the philosophers' demonology. Moreover, the aerial body which Dante attributes to the damned also characterizes Neoplatonic demons—so malleable, Porphyry claims, that they become what they imagine.[17] This is exactly the teaching of Statius's soul in Purgatory— "According as the desires and the other affections prick us, the shade takes its form" (*Purgatory*, XXV, 106–107)—a characteristic which, needless to say, is perfectly suited to the substance of a *spiritus phantasticus*. Porphyry even deals *ex professo* with the soul's body in the next life, and gives a somewhat obscure explanation of its genesis which seems very close to Dante's: the *spiritus* that accompanies the soul during life leaves the body with it, he maintains, and the liber-

ated soul, acting on this *spiritus* through the love and habit of its former body, "attracts" a form that resembles it.[18]

Thus a concept of the migratory spirit is the center of a rationalized and theoreticized complex of myths that comprised the explanation of dreams as well as demonology and beliefs about the posthumous fate of the soul. Dante probably did not establish a link for example, between his argument about dreams in the *Convivio* and the explanation he derived from Statius on how the shade forms in the other world; but if the theme of the disembodied or peregrinating soul is, in all its forms, one of the constants in his poetic world, the aspects of that theme which we have examined allow us to guess that the predilection can be explained by the imagination's role as the nature or substance of the spirit. In the prophetic dream—a stripping away of the non-divine aspects of our own being—imagination seizes truths inaccessible to discursive thought; in the *Inferno*, the imaginary vision of the separate soul engenders a body, sensations, an entire world that transparently reveals all the emotions and desires of the soul. It seemed evident to Dante's contemporaries that the human spirit, liberated and returned to itself, would both attain complete knowledge and create images that were realities; but for Dante, who in both the *Vita Nuova* and the *Divine Comedy* allied poetry very closely to vision, this double power of the discrete spirit, unfettered imagination, would be realized as the ideal model of poetry.[19]

Magic

It was inevitable that the complex of myths concerning the "migratory spirit," worked into doctrinal form by philosophers, should also and at the same time find its way into psychology. To demonology and the metaphysics of the soul was added a theory of fascination—understood as the workings of a spiritual force, or spirit, on another spirit. In principle it was the same type of action as magic intervention or "astral" influence; it could easily be extended to the realm of love understood as fascination with visual or spiritual beauty. The *Theology of Aristotle* excellently sums up all the ideas that allowed poets and philosophers of the Middle Ages—and as late as the sixteenth century—gradually to establish a unified theory of the migratory spirit, including the effects of natural magic, persuasion, love, and art.[20] According to these theories, fascination, natural or "through art," presupposes agreement or opposition between the fascinating

and the fascinated. It takes place not within the rational soul (therefore animals too can exert it or be subjected to it) but within the vital spirits;[21] reason can only prepare the spirit to receive it. In other words, fascination exerts itself on man as a natural being, or as a being who chooses to be natural: submitted to the influence of the stars as to the attraction of Love "Naturalis enim fascinandi vis virum ad mulieris formam allicit illumque cum hac coniugit non loco, sed animo, or to "material" temptations of all sorts: "ostenditur vitia omnia, in qua nostra sponte incidimus, a quaedam animi fascinatione profisci."[22] (Does not the fall of the soul into the body result from its fascination with matter?) All the magical naturalism of the Middle Ages and the Renaissance springs from this conception.

For the Latin-speaking Middle Ages, Avicenna, al-Ghazali, and al-Kindi were the theorists *par excellence* of the magical action of the *spiritus phantasticus*—condemned by some as an error,[23] accepted by others. The *De Mirabilibus Mundi* by the pseudo-Albertus (thirteenth century) explains magic in terms which bring to mind the Romantic view of artistic expression:[24] a stronger soul, better disposed or constituted, gifted with more intense passions and a superior knowledge of the rites or rules of expression, can conquer weaker souls and even demons with its spell; its imagination will overcome obstacles and force other spirits to obey.

The action of an alien spirit was the key that unlocked all the theoretical problems posed by miracles of natural magic, from physical phenomena such as the ostrich egg hatched by the mere stare of the mother to the divine breath which inspired the poetry of the *vates*.[25] The connection between love and magic, as ancient as the practice of witchcraft, lent itself particularly well to this sort of rationalization; it is not surprising, therefore, that Etienne Tempier condemned Andreas Capellanus's *De Amore* along with books on necromancy.[26] The eyes being the doors for the *spiritus phantasticus*, the spell of a glance was explained very convincingly as it fit the superstitions about the *malocchio*.[27] This confirms, as do several other chapters of intellectual history from the twelfth to the sixteenth century, that one of the principal purposes of theories of magic was to pave the way for, or lend its concepts to, a descriptive differential psychology especially in the realms of feeling, imagination, and expression. In Dante's times, it would have been almost impossible to think of love with any degree of psychological precision without referring to models furnished by

magic. It is not coincidental that the migratory *spiritus* was chosen, in the playful form of the *spiritelli*, as a poetic fiction proper for rendering the effects of love in the terms of a pseudomedical scientific façade; behind it we can see the outline of a psychology of ecstasy and fascination, and the entire range, from sorcery to poetic grace, which we cover by the word "charm."

The principal magical aspects of the migrating *spirito* can be found in Dante's episode about the metamorphoses of the thieves (*Inferno*, XXV, 34–151). "To fuse into one person," like Agnello Brunelleschi and Cianfa Donati, or "exchange shapes," like Francesco Cavalcanti and Buoso, is a very classical metaphor of love; and it may be intentional on Dante's part to carry the imitation of Ovid in this passage, as far as a pastiche of his descriptive devices. The punishment of Agnello and Cianfa seems to illustrate literally the sentence on erotic fascination quoted above from the *Theology of Aristotle*. As for the reciprocal transformation of Francesco and Buoso, it brings into play the whole apparatus of the fashionable love poetry of the time: Francesco, in the shape of a snake, pierces Buoso's body at the umbilical point (which may be compared to the arrows of love penetrating the heart); wreaths of smoke leave the eyes of the aggressor and the victim's wound, and become agents of the double transformation (this can be compared to the exchanges of *spiritelli* issuing from the eyes of a woman and the heart of her lover); and all the while the two partners never cease to gaze fixedly at each other according to the requirements of magical or erotic fascination.

Why did Dante choose to have this sinister parody of love played by thieves? Could it be a sort of allegory directly inspired by the *Theology of Aristotle*, theft being understood as the attraction of matter and therefore, in the eyes of the philosopher, fascination *par excellence*? Or, more simply, could it be one of those symbolic chastisements frequent in the *Divine Comedy*: those who have not respected other people's property are condemned to the ever renewed loss of what is for them most important, their own selves? This loss has no other imaginable or representable "model" on earth than courtly or poetic love; this is why Dante had to borrow his scheme from love, at the same time denouncing it as the most intimate and brutal of burglaries: what we would describe nowadays—since for us the notion of property no longer has sacred connotations—as a rape of personality. Lacking a sufficient understanding of the conceptual structure of the *Comedy*, I

propose those two hypotheses without choosing between them, and of course without excluding other possible explanations.

Medicine and Psycho-physiology

There was a time when many speculated upon the passage at the beginning of the *Vita Nuova* in which the narrator's three spirits, vital, animal, and natural—respectively situated in the heart, the brain, and the liver—react in different ways to the sight of Beatrice. We know now that these were borrowed from the terminology of contemporary medicine, and that the three *spiriti* stemmed from a venerable tradition.[28] The boundaries between the medical theory of spirits, the metapsychology of the mind, and the theory of the imagination were shifting ones, and contradictions were sometimes unavoidable. Here is an attempt at an approximate classification:

• According to the largely philosophical or religious concepts discussed above, the spirit was originally astral; it accompanied the individual soul from its descent into incarnation (or from the transmission of life from the father to the infant in fertilization) to its reascent toward salvation; it could leave the body in states of ecstasy.

• According to medical theories, the spirit was the product of the combustion of food; it constituted the most subtle part of the blood. It resided in the heart, where it was called vital spirit, but it was differentiated according to the organs to which it was carried: animal spirit in the brain, as an instrument of the outer and inner senses; natural spirit in the liver, as an instrument of nutrition and of the formation of the blood; radical spirit in the testicles, as an instrument of the "formative capacity" that would fashion the embryo.

• An imagination could be considered as the essence of the entire spirit, according to the first concept (the *spiritus phantasticus*); but for the physicians it belonged more particularly to the animal spirit. In a narrower sense still, imagination was only one of the functions of the animal spirit: it coincided in that case with all, or only one, of the "inner senses."[29]

The medical, naturalist position is summed up most clearly in Albertus's *De somno et vigilia*, together with his *De spiritu et respiratione*. According to his definition, the spirit is the instrument of the soul for all operations concerning the body;[30] it is the seat of the *virtutes*, of physiological and psychological functions. Galen's tripartite

division into vital, animal, and natural spirits (without any reference
to the radical spirit of semen) gave rise to a disagreement over the na-
ture of the distinction: Do we have only one *spiritus* under three
forms according to their functions, or actually three species of a com-
mon genus? On this point Dante seems to diverge from Albertus,
since that opening section of the *Vita Nuova* allows a specific dif-
ference which Albertus does not—the reason for this being probably
the poetic convention of the autonomous *spiriti*.

For the poetry of love, it is naturally the *spiritus animalis* of the
brain—instrument of the outward senses, of imagination and mem-
ory—that has pride of place, together with the *spiritus* of the heart
in which the vital force is found. The two other spirits do not emerge
in poetry—although it is interesting to note that Dante paused at one
point (at the beginning of the *Vita Nuova*) to mention Galen's three
divisions, probably to lend more intellectual weight to the passage, as
if to indicate to his readers in advance that he was aware of the scien-
tific basis for the play on *spiritelli* in which he would later indulge. As
for the fourth function of the physiological *spiritus*, generation, there
is no reference to it in the *Vita Nuova*, nor in the passages from *De
somno et vigilia* used in it.[31] Dante mentions it, however, in *Convivio*
and in the *Purgatorio*; the allusions show that he was álive to this de-
velopment in the theory of the *spiritus*. And Statius explains in his
speech that the same "spirit" which shapes the infant in the mother's
womb also shapes the aerial body of the damned.

Insofar as he was following Albertus, Dante could not take into ac-
count the attempts to reconcile the physiological theories of the *spiri-
tus* with those giving it an astral nature. Although they were more or
less endorsed by Aristotle, Albertus bluntly dismissed such recon-
ciliations, already formulated in antiquity.[32] For Dante it was evi-
dent, in any case, that planetary "gifts" did not externally form a con-
tainer for the soul, in which it was then incarnated. The link between
the spirit and astrology was more complex; the "celestial power" of
the germ was quite distinct from its "formative power" and occurred
at a later stage in its evolution.[33] If the vegetative and sentient souls
are the direct issue of the "spirit" of semen, the fact that this spirit is
consubstantial with imagination is not mentioned, in spite of the be-
lief—widespread to this day—in the power of a pregnant woman's
imagination to influence the child. Imagination here seems to take its

most restricted meaning, and is contained within the *spirito animale*
at the service of the sentient soul.
This is where the link between medical doctrines about the *spiritus*
and Italian poetry is closest. The *spirito animale* which engenders all
of the five senses, emits through the eyes the visual pneuma that will
bring back the images of objects encountered: this ancient idea[34] is
obviously the origin of the *spiritelli* of the glance, which appear so
often in the poetry of Dante and his friends. But the passage from
science to poetry takes place freely and unrigorously. Dante employs
the more picturesque but unorthodox plural *spiriti visivi*[35] (or *spiri-
telli* of the eyes) in the poetic parts of the *Vita Nuova* or in his narra-
tive prose poem, but not in the prose of the commentary; it appears
only once, used somewhat metaphorically, in the *Convivio*.[36] When
he is weighing his words, Dante knows only a single *spirito visivo*,
which comes out of the eyes or runs along the optic nerve to transmit
the image to the *imaginativa*.[37] And naturally he knows that his ex-
planation of fascination, and thus of the effects of love, requires that
all the spirits of the outer or inner senses, as well as the vital spirits of
the heart, be fundamentally of the same nature. This is what comes,
for example, from this text of the *Convivio* about the fascination of
music:

> Ancora la Musica trae a se li spiriti umani che quasi sono prin-
> cipalmente vapori del cuore, sì che quasi cessano da operazione;
> sì è l'anima intera, quando l'ode, e la virtù di tutti quasi corre a
> lo spirito sensibile che riceve il suono.[38]

The Naturalist Theory of the *Spirito* and the Doctrine of Love

Many comparisons have been made between the formulas of love
poetry (especially those used by Cavalcanti and under his influence)
and the physical and medical theories of the *spiritus*; these have been
further investigated in more recent studies. Nobody, of course, be-
lieves that Italian poets were content with putting into verse the views
of Averroist physicians. The often illuminating and satisfying results
one can obtain by comparing physiological explanations and poetic
figures of speech are not sufficient to explain the texts; and it is quite
possible that with at least some poets the formulas borrowed from the

natural sciences combined with a quite different philosophical out-look—Neoplatonist, or more eclectic and vague, made up of tradi-tional beliefs, more or less successful adaptations, misunderstandings, and commonsense ideas, as is generally the case with any "verbal culture."[39]

An early interpretation of the figurative language of poets by means of the scientific terminology of the physiology of the *spiritus* was sug-gested in 1910, with conclusive results, by G. Vitale, who found in Albertus Magnus's writings a detailed explanation of the sigh, the trembling, the fainting, the "mortal wounds" caused by the sight of beauty, and so on.[40] Poets had only to apply to love the description of phenomena which, with Albertus, covered a larger range of psychic life. Cavalcanti's imagery—the *spirito* of the senses or of the wound-ing or comforting glance, the *spirito* as messenger or support of a mental thought, the war of the spirits between themselves or with the heart, the *spiriti* hounded from the body, etc.—can be "justified" point for point; and if the poet sometimes enjoyed rhetorical figures that were obviously not meant to be taken literally (imploring *spiri-ti* . . .), he also liked to show, at other times, that he knew the exact meaning of the terms he used.

We have become more familiar, since Vitale, with the background in naturalistic pneumatology of the poetic philosophy of love; the fatalism and "licentiousness" of Andreas Capellanus, and, even more, Cavalcanti's Averroism, have attracted attention.[41] But we must ask about the meaning of this Averroism for Cavalcanti's conception of love and for all those who adopted his language. The link between love and death and the *mezzoscuro* aspect of Cavalcanti's poetry, could spring just as well—with a few differences—from Arabic Neo-platonism: Denomy quotes several relevant texts in his explication of the philosophy of love in Provençal poetry.[42] Vossler alludes to what he believes to be an aesthetically relevant "Averroism" in several poems by Cavalcanti, Dante, and Cino, in which knowl-edge is described as passive and aroused only by supraterrestrial causes,[43] but I find there only somewhat mystical ecstasies and il-luminations, compatible with the most diverse epistemologies. Their repertory of images and figures of speech seems to include a whole complex of myths, magic, anthropology, and medical doctrines about the *spiritus*, without much discrimination as to the philosophical ori-

gin of the various elements. But what matters is the transformation of those beliefs into poetic imagery through a deliberate process that was probably unique in the literature of Christian Europe at that time. It can be illustrated by a few themes in Cavalcanti and Dante.[44]

1. *The war of the spirits.* A whole theological tradition is taken up with the place of *spiritus* as opposed to *caro*, *anima*, and *mens*.[45] Usually, *anima* is the mouthpiece of *caro*; with intellect not involved because of its superior essence, we have the opposition between *anima* and *spiritus*, between the weak earthly part and the strong spiritual part of man.[46] The battle between the spirits and the heart, which Cavalcanti likes to imagine, bears traces of this topos, but with a reversal of roles due to medical doctrine: the weak, vanquished spirits have been expelled, or the heart, by being wrung, has chased them out of the body.[47] The real fight is in any case not between the heart and the spirits of the lover, but between his spirits and an intruding, alien spirit: Love, or the lady's glance. When this glance is favorable it reinforces the heart's spirits and deposits among them a *spirito di gioia*.[48] Traditional physiology's optical rays are thus changed into beings endowed with good or bad intentions; the lover's vital and animal spirits become characters in a comedy, usually pitiable, imploring, fearful, succored or protected by the dispatch of a ballad or a canzone;[49] in one case, "quel pauroso spirito d'amore/ il qual sol apparir quand'om si more" threatens the fascinated lover, who is only rescued *in extremis* through his *sottile spirito che vede* clinging to his mistress's glance.[50]

Dante shares the freedom of his *primo amico* in the poetic use of these concepts: for him too, the exile of the *spirito* is a convenient motif.[51] (We must remember that the faculty of leaving the body is, on the mythic level of that tradition, the primary characteristic of the *spiritus*.) He pretends to take the physiological description seriously to the extent of using the *lago del cor* as the meeting and dwelling place of the spirits,[52] but he might also have entertained the idea, worthy of a Serafino dell'Aquila, that this "lake" could be dried up by the fiery dart of the lady's glance.[53] A contradiction in terminology between two consecutive sonnets of the *Vita Nuova*, which Dante himself explains in his commentary, shows how metaphorical these anthropological elements were for him: in number 37 the heart plays, with regard to the eyes, the role which in number 38 the *anima* plays

with regard to the heart; in each case the first term stands for reason and the second for desire—as in the conflict between *spiritus* and *anima* for Saint Paul and the theologians.

2. *The sigh.* Identifying the spirit escaping from the wounded heart with the lover's sigh might seem the gratuitous invention of a *concettiste avant la lettre* if it did not have such a well-established tradition. With the "last sigh," one "surrenders the spirit"; Seneca tells us that physicians call asthma *meditatio mortis*, because "Faciet . . . aliquando spiritus ille [the breath] quod saepe conatus est"; Alfred of Sareshel prosaically believes that the soul, in ecstasy or contemplation, often forgets to breathe and must occasionally make up for it by a deeper breath, which is a sigh; Albertus Magnus proposes that the heart constricts, filled with blood and *spiriti*; and Thomas Aquinas gives a similar, very mechanistic opinion, according to which the "great heart" of the young is literally enlarged by the influx of spirits dilated by youthful warmth; cries of pain and gestures of frightened withdrawal are similarly explained by actual movements of the spirits.[54]

In numerous passages in Cavalcanti and Dante, love-sighs are more or less explicitly interpreted in such terms of medical pneumatology. Cavalcanti uses *sospiro* as a synonym of *spirito nel cor* and insists, with a slightly ironical affectation, on the *spiritello*-sigh escaping from the wounded heart.[55] The image of sighs chased out of the heart by Love or by a glance is a familiar one with Dante,[56] and in the last sonnet of the *Vita Nuova* ("Oltre la spera"), he adds a complementary touch by calling the sigh which rises toward heaven sometimes *pensiero*, sometimes *spirito peregrino*.

3. *The lady engraved upon the heart.* The mechanics of spirit-sighs must not make us forget that the *spirito* was imagination; the image of the lady "engraved" by her messengers within the heart or memory (*mente*) brings us back to that concept. Here again traditional pneumatology lent itself so easily to the explanation of apparently natural metaphors ("to be imprinted on the mind") that we can wonder whether this was a fortuitous coincidence or whether the usage did not in fact represent a vulgarization of physiological theory (or, inversely, whether theory might not be a rationalized explanation of a "natural" metaphor).

Andreas Capellanus wrote that *cogitatio*, or meditation, on the inner image of the lady was an essential condition of the feeling of

love. Hence it might be—and has been—concluded that love is born in the *imaginativa*.[57] Cavalcanti mentions a compassionate lady whose *spirito* entered him through the eyes but could not penetrate as far as the second ventricle of the brain to "be depicted on the imagination." Repeatedly he talks of faces imprinted within the heart of the lover; in Ballad XXX ("Quando di morte mi convien trar vita"), Love models desire—as spiritual matter—in the new image of the beloved inside the heart.[58] Such motifs are equally frequent with Dante.[59]

4. *The light of the* spiriti. A pneumatology with scientific pretensions, a specific philosophical background (whether Averroist, Neoplatonic or scholastic), and a natural imagery of the language of love more or less compete with each other within each of the three motifs we have been discussing, as they compete for any explanation of the repertory of metaphors of the *dolce stil nuovo*. By their very ambiguity these symbols eschew arbitrariness—and a good example is the theme of light. We have been told that this theme is essentially philosophical, namely Neoplatonic;[60] but an aesthetics was soon derived from that philosophy, according to which light was supposed to be interpreted—whatever the precise historical meaning we may attach to such "interpretation." Many analyses, some quite celebrated, have tried to prove the real thematic and stylistic influence of the metaphysics of light upon poetry and the visual arts.[61] The attempt to show how the poetry of Cavalcanti and Dante adapted naturalistic views about the luminous pneuma is therefore not incompatible with a philosophical, Neoplatonic interpretation of the same passages, nor of course with the elementary, naïve, common experience of the "radiance" of a smile or the "brightness" of a glance.[62] Doctrines of the *spiritus* are not necessarily the sources of the imagery they may help to illustrate; even when they are, it does not mean that we must attribute to poets the further convictions which their doctrines would imply for the physician or the philosopher.

I have mentioned that according to the Aristotelian tradition, the pneuma of the sperm was considered as a luminous element. Synesius stressed the luminosity of the *spiritus phantasticus*, without which one would be unable to see our dreams. The physiological theory of vision as the emission of rays from the eye assumed that those rays or spirits were endowed with a luminosity emanating from "vapors" of the internal sense; the "experimental" proof for it was traditionally provided by cats' eyes.[63] If we add that spirits were hot,

according to the physicians; sometimes igneous, according to the philosophers (and easily "inflamed" or burning, according to the poets), it becomes even clearer that they must be perceived as luminous.

One might think, therefore, that Cavalcanti is almost trying for exact factual description in this beginning of a ballad (XXVI):

> Veggio negli occhi della donna mia
> un lume pien di spiriti d'amore . . .

It is the very image used by Dante

> De li occhi suoi, come ch'ella li mova
> escono spirti d'amore inflammati.
> (Sonnet XXII, i. 5–6)

The more or less explicit association of the light of the eye (or of the smile, or of beauty) with offensive or benign *spiriti* is too frequent to require any further documentation.

I have suggested that these texts show no firm indication of the theoretical opinions or convictions of their authors. Cavalcanti's amusing way of outlining a genealogy of *spiriti*, from the glance that starts everything to the "mercy" finally bestowed, shows clearly in its ostentatious prolix style (the word *spirito* is repeated fifteen times in fourteen lines) that didactic pretension has been excluded; and the complication of *concetti* often, with him as with Dante, verges upon irony or even burlesque.[64] It would be absurd to ascribe in good faith mythical sources to this pneumatology because Cavalcanti at one point gives to the *spirito* a celestial origin, forgetting that it is a mere vapor of the blood, or because Love, which in the *Vita Nuova* so often orders the poet to compose verses on this or that subject—and according to the *Divine Comedy* goes as far as "dictating" them—is reminiscent of the daemons or spirits of inspiration in antiquity.[65] Dante has explained the reason that made him personify Love while knowing that, philosophically speaking, love is a mere "accident" (*Vita Nuova*, XXV); but the frequent parallels between the behavior of the *spiriti* and that of the god Love (sitting like an archer inside the lady's eye; penetrating with a glance within the lover's heart to chase out the vital spirits, etc.[66]) allow us to include a large part of the pneumatological repertory in the same chapter of poetic mythology. Cavalcanti hints on one occasion that in his verse *spirito* might well be just another name for an "accident": in Ballad XXV ("Posso de gli

occhi miei novella dire") he makes it synonymous with *vertù d'amore*. And when Dante explains the meaning of his verse, he declares openly that the *spirito-anima* war is nothing but a war between two *pensieri*, and that the *spirito d'amor gentile* who speaks to him is likewise only a thought he consents to obey.[67] But this "demystification" by the commentator must not be applied systematically to the entire poetry of the *spiritelli*, any more than explanations according to philosophy and medicine (or poetic fancy) can be used to furnish unambiguous keys to everything.

Poetic Doctrines of Love

It is significant of the two initiators of what is commonly known as the *dolce stil nuovo*, one, Guinizelli, who affirmed the kinship of love with nobility of heart, did not dream of explaining the phenomena of love by a mechanism such as that of the *spiritelli*; and the other, Cavalcanti, author of the "model" of the little spirits, alludes to the ennobling power of love in two poems only, probably written in his youth.[68] Later, and first with Dante, the themes of the *spiritelli* and of *gentilezza* were often combined; they seem, however, to be the product of two not easily compatible doctrines of love.

Obviously Guinizelli did not invent the connection between love and *gentilezza*; neither was he the first to make his lady divine. There is no essential difference between love as he conceived it and courtly love in so-called chivalric poetry. But his theme of *gentilezza* was a composite one, as it was with his Provençal predecessors.

On one hand, the claim that love is a kind of *sui generis* nobility, or that it confers nobility on the lover, was a sort of social claim, quite understandable on the part of knights who courted ladies of a rank superior to their own. Ibn-Zaydun, a Cordovan poet of the eleventh century, conveyed that point very clearly,[69] and there is no lack of similar texts in Christian literature—Andreas Capellanus, for instance. Italian poets of middle-class origins were naturally won over to such a theory; Guinizelli's "manifesto," "Al cor gentile repara sempre amore," contains a passionate stanza against those who equate nobility with lineage; and in the *Convivio*, Dante gives an important place to the polemic against the definition of *gentilezza* he attributes to the Emperor Frederick.

Understood in this way, the identity of love and nobility goes with a certain fatalism, at least insofar as the fatality of love excuses socially

unequal alliances—for instance, in these lines by Bernard de Ventadour:

> Pero Amors sap dissendre
> lai on li ven a plazer

and Puccio's almost identical formula in a sonnet addressed to Dante:

> Solo si pon [Amore] dov'è 'l suo desire
> non cura del più bel nè del migliore,

written in response to a question on the very subject of whether the love of a commoner for a noble lady was allowed.[70]

On the other hand, the theory of the *gentilezza* of love arose in the Platonic doctrine of the ascent of the soul. This did not, of course, exclude social aspirations—in fact both ideas were almost always found together, particularly in Guinizelli's canzone. Still, it had a more interesting philosophical basis. Here the essential part of love is the inner elaboration (*immoderata cogitatio*, according to Capellanus) of a mental image; therefore it is always situated beyond the senses. Beauty is like a seed that grows only upon suitably prepared ground. At least that is how it seems in the "moderate" version of Capellanus and the many poets who took after him. But sometimes, in Guinizelli for instance, it is given a lesser part: "Al cor gentile repara sempre Amore"—a noble soul, it appears, loves spontaneously. The author of the Dantesque sonnet "Molti, volendo dir che fosse Amore" probably thought of Guinizelli when he quoted a definition of love as "ardore / di mente imaginato per pensiero."[71] According to that more extreme version, beauty is only an occasional cause, and love is a quality of power of the noble heart, rather than an effect produced by beauty. When Dante sums up—and exaggerates—Guinizelli's doctrine, the very notion of an outside cause or condition for love is avoided or dismissed as secondary: "Amore e'l cor gentil sono una cosa" (*Vita Nuova*, XX).

In such a context the problem of the fatality of love, or its freedom, does not occur. Admittedly, several lines of Guinizelli's, notably the last ones of his *Canzone d'amore*—the famous answer to God, who has accused him of blaspheming by glorifying his lady—sound like a fatalistic explanation:

tenea d'angel sembianza
che fosse del tu' regno;
no me fo fallo, s'eo li posi amanza.

But Capellanus, who had understood that problem very clearly, had already responded in advance, as it were, in his fifth dialogue, which contained a sort of judgment and a sketch of a *Divine Comedy* of love: the will that does not want to part from the loved object is by definition the freest possible, since it wants only what it wants. In more modern terms: if freedom is not the freedom to commit, it is nothing.

Whatever the efficacy and compulsion of beauty in love, there is a logical link between the acceptance of love as *gentilezza* and the deification of the lady to whom it is addressed: otherwise one could not understand the part she plays in the "awakening of the soul." We are clearly within a Neoplatonic tradition here, and it is not surprising that Denomy could cite so many philosophical parallels from Plotinus to the courtly love of medieval poets.[72] Ascension and purification, the trademarks of Platonic and courtly love, are evoked through *gentilezza;* they are associated with the outline of a sort of discipline or morality—devoid of definable practical application, without presupposed values, without any content,[73] upheld only by a task the lover gives himself, which is intimately connected (more and more closely as his love "progresses") with the "awakening of the soul," with its self-awareness. (Since historians after Vossler have dealt with doctrines of love in a language borrowed from pure philosophy, one can refer here to a transcendental morality of love, and describe in Kantian terms this lack or effacement of objective data, whether real or ideal, and the tendency to build on conscience alone a whole system of aims, values, and obligations.) Capellanus's solution to the problem of the freedom or fatality of love is typical of that tendency to recognize the founding role of conscience in love. The same may be said of Dante's famous explanation to the ladies who were asking him about the aim of his love: formerly, he said, his happiness lay in Beatrice's greeting, now it is in the words which praise her (*Vita Nuova, XVIII*). We must not underestimate the paradox of this formula which internalizes every fulfillment of love; the fact of finding within himself the words to praise Beatrice means for the lover that he has included her in an "adaequatio rei et intellectus," and that the awakening and ascension of the soul has taken place.

It would be an exaggeration to erect a categorical opposition out of the mere difference in orientation between such a doctrine of love and the image suggested by the mechanism of *spiritelli*. If it were taken seriously and literally, that mechanism would indeed imply a medical and deterministic conception such as Dante da Maiano's, or the fatalism of Cavalcanti:

> . . . che solo Amor mi sforza
> contro cui no val forza—nè misura.

Unlike those authors, Guinizelli significantly allowed more scope for the lover's free will.[74] But the complex imagery we find in those works is not an absolutely logical system: already in the *Vita Nuova* the repertory of images taken from the doctrine of the spirits coexists more or less happily with the idea of ennobling and purifying love.[75]

In fact, the scientific or philosophical theory of the spirits was never monopolized by naturalists to the extent of obliterating its original links with the themes of purification and ecstasy—hence the possibility of reintroducing all these aspects, including "Platonism," into the repertory of "naturalistic" metaphor. The *spirito* of the poets was, much oftener than that of the physicians, *peregrino*—chased away by Love, sent as a messenger to the Lady, attracted or fascinated by her. The difference between these forms of ecstasy was immaterial. In effect, positive physiology knew only one traveling spirit—that of the glance; the rest stemmed from the magical or mythical explanation of trance states, freely recaptured or reinvented by poets. The sonnet "Oltre la spera" from the *Vita Nuova* is in that respect the sum of all these elements: we find in it medical mechanistic theories (*spirito* = *sospiro*), a rational or allegorical explanation (*spirito* = *pensiero*) and "shamanic" ecstasy (the ascent to heaven of the wandering spirit, whose vision will be explained, as the reader is invited to conjecture, in the *Divine Comedy*).

Dante's philosophy of love wholly transcended the alternatives of "nobility of heart" and the mechanism of spirits—of Guinizelli and Cavalcanti, or, more roughly, of Platonizing idealism and philosophical naturalism.[76] In the poet's final conception, love is, as we know, a universal, cosmic principle: "Neither Creator nor creature was ever without love, either natural or of the mind" (*Purgatory*, XVII, 91–93); it is a necessary condition for the continued existence of

things. "Ciascuna cosa ha'l suo speziale amore" (Convivio, III, iii, 2). This widening of perspective demands a new definition of love, or rather the revival of a very old definition, which no longer proceeds through psychic causes (as did Capellanus and, unless I am mistaken, all of Provençal and Italian poetry, including Cavalcanti in his canzone "Donna me prega"), but objectively, through its aim: union. Thus, with reasonable beings, "amore . . . non è altro che unimento spirituale de l'anima e de la cosa amata, nel quale unimento di propria sua natura l'anima corre" (Convivio, III, ii, 3).

In spite of obvious difficulties,[77] this universal principle is still identical with the *accidens* of personal affective life; hence the disconcerting character of the incarnate abstraction to whom the lover's prayer is addressed:

> Però, vertù che se' prima che tempo,
> prima che moto o che sensibil luce,
> increscati di me c'ho sì mal tempo,
> entrale in core ormai. . . .
> (Sextine 45, *Amore, tu vedi ben che questa donna*)

This near-contradiction seems deliberate, not unlike the ambiguity of Beatrice being at the same time singular and universal; in the political poems too, Love is lord of justice and presides over the virtues while also sitting within the heart of the poet.[78] Dante can thus meet the question of the fatality of love and the possibility of judging it by moral criteria in a realistic and objectivist manner, as far removed from determinism as from the "philosophy of conscience" outlined by courtly poets. As an instinct, love is necessary and inevitable—but it may be directed by moral reason.[79] Conscience no longer creates values; it admits everything must tend toward ideal perfection (where everything naturally desires God).

The Neoplatonic theory of love is not, in principle, incompatible with such an objectivist outlook. Avicenna's *Treatise on Love* comes remarkably close to Dante's final conception;[80] the concept of a universal love of all beings for God, and of deviations caused by loss of the true goal, can be found in the Pseudo-Denys as well as in the *Convivio*.[81] Guinizelli, like Dante, seems to see the world as moved by a Love substantially the same as that which moves the lover of an

earthly lady, and the celestial Intelligence which revolves around God.[82]

Thus Dante accepted themes from Guinizelli and the Neoplatonists—of ascension through love, of purification and liberating knowledge—that presuppose the universality of cosmic love. But he stressed this universal aspect by putting the objective element of *unimento* in relief and rejecting everything that could invalidate the causality of love, that is, the effective role of Beatrice, or, in a metaphysical perspective, the role of God as it is described in the last line of *Paradiso*, as the object and cause of love.[83]

Such as it is, this collection of elements from concurrent doctrines of love that Dante accepted or rejected seems to reveal a hidden adherence to the ancient theories of *spiritus*. With the reality of causes, Dante safeguarded the possibility of a poetic analysis of the mechanism of love according to the somewhat elaborate psychology of the *spiritelli*; apart from those "small" ecstasies, he also obtained from it a logical foundation for describing the great ones—the visions of *Vita Nuova* and the *Divine Comedy*. He recovered the moral and purifying élan of Neoplatonism, while employing means to express it that Guinizelli could not have provided. The naturalistic background that is welded to—and justified by—the objectivist cosmology of love opens a way for more properly mythical or primitive aspects: the theory of divinatory dreams, the demonology of the *Divine Comedy*, and its Porphyrian conception of infernal bodies.

I naturally do not intend to prove that Dante's philosophy of love may be entirely explained by some sort of atavism, or be attributed to a geniune and instinctive attraction to the doctrines of the pneuma. If Dante the philosopher ever reacted instinctively, it was in his rejection of the consequences, however seductive, of the pure position attributed to Guinizelli.[84] But this return to causes—spirits or no spirits—was imperative; for in Dante's eyes, all realities, all truths, authorities, values are always "already there" prior to consciousness. The sum total of his beliefs and visions were never contaminated by that other philosophy of the spirit which we now call idealism; few thinkers, even in the thirteenth century, were quite so unimpaired by it. The self-assurance of this "poet of rectitude" and his inimitable way of setting lines of the most violent passion in their proper place were undoubtedly due to that. But for that reason, too, other epochs

may occasionally dread that vaguely barbaric element in his
integrity.*

(1965)

*I should like to thank André Pézard for several suggestions, especially for the idea
of introducing the episode of the Florentine thieves in this context.

PART II | PERSPECTIVE AND SCIENTIFIC SPECULATIONS IN THE RENAISSANCE

Utopian Urban Planning

The relationship between urban planning and utopia is obvious and banal. By organizing in detail the material setting of public (and up to a point, private) urban life, one will reinforce or modify certain aspects of the social structure. And when the city in question is a state, as was often the case in the Renaissance, any integrated urban scheme becomes both social and political. Conversely, a utopian who regulates the life of the citizens of his republic is in a position to regulate its setting as well, and relatively few authentic utopias were not accompanied by a geographical map or city plan.

Beneath this implicit kinship, the urban planner and the utopian have a psychological affinity. These visionaries share the assumption that it is possible to change men by organizing the space they move in; history is replete with examples of this belief. But it is worth stressing one of the principal reasons for that somewhat magical strength which city plans have: these projects are also in one respect symbols. From the mandalas, which a Jungian would have to cite at this point, to the strange urban landscapes of Klee, variations upon the elementary forms out of which ideal-city plans are made serve to transform the draftsman into a magus. It is difficult to suppress the thought that the well-ordered labyrinth of Christianopolis had for Andreae the effect—however unconscious—of an exorcism, and that when Campanella transposed his abortive republic into the plastic vision of the City of the Sun, he sensed in himself the beneficent effect which the plan of that city was supposed to work upon its inhabitants.

Descartes wished that towns would express "the will of a few men endowed with reason"; he would not have objected if they expressed man's imagination as well. And this is what I should like to discuss here. True, the invention of urban spaces and their corresponding social relationships are psychologically conditioned in a way that

seems, until the new order, constant in history. In the urbanist-utopian scheme, however, the "projected" image of the self is covered over by other, more direct symbols: models of the cosmos, visual translations of the "plan" of society, not to mention the imprint of the period's artistic style. These are ciphers and significations that can no longer escape history.

The first geographical characteristic of utopias is their isolation; they are lost islands, peninsulas cut off from the mainland by a canal or mountain range. Laws take advantage of those conditions, aggravate them, or, if necessary, substitute for them. Strangers brought by the proverbial shipwreck are isolated or are given an admission test; somehow they have to remain permanently and of their own free will with their hosts. Measures are taken to force those rare islanders sent abroad to return home. For this the requirement made by fiction (to explain the existence of marvelous, unknown civilizations) is not the only reason: Agostini, who projected a future city in his own country of Pesaro, endowed it with a thorough distrust of foreigners; Zuccolo, in an idealized description of the very real and lively republic of San Marino, gave it almost secret laws and removed all strangers.[1] A closed society, and distance in space or time, are the fundamental conditions of the utopian dream. Firpo has shown how such conditions transform the urban planner into a utopian in the case of Filarete.[2] The story of the building of Sforzinda, an ideal town, included the episode of the golden book describing the ancient capital Galisforma—a utopian city. This switch to fiction released its author's dreams: the buildings became monstrous, the hydraulic mania (a constant since Plato's Atlantis) worsened—and the architect became legislator. In earlier chapters Filarete had given imaginary orders to the Duke of Milan and to the best Florentine artists (except Brunelleschi, unfortunately deceased); in the golden book a plethora of schizoid and sadistic fantasies turned spontaneously toward the fundamental and timeless themes of utopia: pedagogy, justice, sumptuary and tax laws. Only matrimonial and eugenic regulations are missing. Plato and Diodorus may have something to do with all this. But it is striking to notice how the architect, as soon as he extends his habits of urban organization to human material, conforms to the laws of the utopian genre while still leaving upon them the mark of his own temperament.

Imaginary kingdoms are naturally built as other worlds parallel to our own—so much so that the "other world" *par excellence*, the land of the dead, was used in antiquity as a model for literary utopias. This utopian world became the product of a Nature *sui generis*, fantastic or philosophical or both, but always revelatory.[3] The climate of these lands was pleasant and healthy; Zuccolo gravely reproached Morus for giving his island of Utopia a noxious atmosphere.[4] This requirement was not only the adoption of a Vitruvian commonplace, endlessly repeated in architectural treatises, but the outcome of a genuine naturalism: even the pious Agostini seemed to believe that a favorable climate "produced" physically, intellectually, and morally superior human beings.[5] Places of happiness—Macaria, Cità Felice, Evandria, Insula Eudaemonensium—almost always provided physical conditions that made man a "good subject" by nature—although moral pessimism was fairly current, as might be expected among Counter-Reformation utopians. Rabelais's Utopians were "naturally" loyal to Pantagruel.[6] San Marino, Zuccolo tells us, was more stable than Sparta because there nature dictated conditions which Lycurgus had to impose artificially on his fellow citizens; the innate incentive which exempted the Thelemites from laws and rules also exempted the Evandrians from reasons of state.[7] The Portuguese navigators described by Bonifacio found conditions suitable for an ideal State ("governo democratico d'une Republica aperta, e commune") in an island whose inhabitants are naturally happy enough to live peacefully in political anarchy and astral religion.[8]

It is no wonder that cities or states produced by a parallel (and ideal) Nature should appear outwardly as a parallel world. The ideal or utopian town was often a reduction of the cosmos; utopian star-worship—a frequent, traditional, and easily understood feature of such a perspective[9]—provided a useful pretext. The seven precincts and the four gates of Campanella's City of the Sun need no comment; the central temple with its cupola painted in the heavens, the two spheres on the altar, the weathervanes, the astrologer-priests, whose number is the same as the hours of the day—all developed and combined traditions that fill the history of architecture; ever since cupolas have been built over churches, people have seen in them images of the heavens.[10] Alberti's temple, where all "must sense pure philosophy," anticipated the painted vault and even the weathervanes of Campanella. The dome of Sforzinda was a cosmos: incrusted in mar-

ble on the pavement was a map of the earth, surrounded by twelve
months; the crisscrossing corresponded to the seasons and the ele-
ments; in the cupola, in mosaic, was God symbolized by a radiant sun
and the nine choirs of angels. The pagan Temple of Galisforma was
entirely meteorological and astral: a hemispheric cupola was lit up by
starlike "eyes," four towers in the direction of the main winds, and
twenty-four chapels around the edifice.

We should not entirely systematize this sort of interpretation—the
division of an ideal town into twelve may well be reminiscent of Plato
(*Laws*, V, 745 *be*), or an allusion to the twelve tribes (as in Samuel
Gott's *Nova Solyma*, which dates from 1648), or done for some reason
of convenience. And the circular form, if it is symbolic, may be an
allusion to the circular Jerusalem of which Tacitus spoke.[11] It is
curious, nonetheless, that the twelve main streets of Vitry-le-
François, a fortified town created after 1545 by a military architect on
a checkerboard plan, were named after the months and the main axes
(set by the compass) after the cardinal points; the central square
"radiates"—i.e., is only accessible by means of its sides.[12] Thus a for-
tification engineer, inscribing within a circle the outline of a perfect
fortress, suddenly recalls the form of an archetypical world.[13]

But the most characteristic obsession of utopian urban-planners was
the image of the sun.[14] Allegedly real site of fable, or simply the
name given to the land in which the fable takes place, or as an ellip-
tical metaphor, the sun (or its rays) has haunted imaginations from
Iambulos to Cyrano, from Campanella to Le Corbusier. In 1564 it
sufficed only for the sky to light up for an instant while the first stone
was being laid for a fortress, for the Tuscan authorities to dream of
making the place into a utopian Città del Sole.[15] Twelve years earlier,
Doni had described, in his *Mondi*, a town that made a sun-design on
the soil: a central temple, a hundred radial streets, circular fortifica-
tion, no transversal roads or concentric streets within. Insofar as we
can imagine such a construction on a correct scale, we can see at once
its absurdity: the widening of the streets toward the periphery (for
there are only rows of houses, no blocks), the roundabout difficulty of
getting from one street to the next. . . . But Doni was not the sort to
worry about such things; and, what is stranger still, he was not even
the first author of this fantasy. A drawing from the early sixteenth
century, once attributed to Fra Giocondo and whose author is now
known as the Anonymous Destailleur, displays the same scheme: a

temple with a cupola surrounded by an indeterminate number of radial streets, double fortifications embracing all. (The practical difficulties, which are the same as in the description of Doni's *Mondi*, are cleverly disguised in the sketch.) According to a handwritten note on the cover, the notebook containing this leaf once belonged to Palladio; it is, therefore, not impossible that Doni might have known it.

Obviously this drawing was meant not to represent an ideal city, but to illustrate a utopia; the sole fact that there is no other public building apart from the central temple immediately brings to mind a theocratic republic or a state religion. A completely absurd detail—houses stuck against the outside fortifications and forming a rampart—points, I believe, to a precise source: Plato's *Laws*,[16] for no sixteenth-century man would have conceived of walls around which one could not walk or bring supplies to its defenders. The magnificence of the temple-palace, the double fortifications, and some strokes of the pen which might indicate rivers, are also vaguely reminiscent of other characteristics of Atlantis. In any case, this draftsman's utopia looks like a variation on Plato, not like the commentary to a specific text.

Campanella had read Doni; the detail of the rampart-houses which we find in the City of the Sun does not appear, however, in *Mondi*, and must have been borrowed directly by the author from the *Law* or *Critias*. The relation among solar utopias in the Renaissance appears therefore as a line running from Anonymous Destailleur through Doni to Campanella, with the direct influence of the same Platonic texts on the former and the latter.[17]

The flowering of "natural" life in utopias does not necessarily mean that conditions of existence are "in conformity to Nature." It is enough for the planner to reject one of Rabelais's optimistic premises such as that of the intrinsic goodness of man, for the ideal State—however much remaining within "Nature"—to require knowing artifice for its realization. This is particularly striking with Stiblinus: the identity of virtue with nature and happiness was an axiom for him, and his Eudemonians, all healthy and beautiful, live "according to nature";[18] but he believed, too, that men are prone more to evil than to good and that the plebeians cannot be trusted.[19] This is not very coherent, but it is very clear. Stiblinus constructed his ideal State along pedagogical precepts and regulations. Patrizzi's *Città felice*, published the same year—1553—is similar.

The sixteenth-century Utopia did not develop smoothly from the

initial optimism of humanism or the "Renaissance" to the pessimism of the Counter-Reformation. Thomas More's Nature needed many finishing touches; Mesnard has underlined the contrast between More's liberal principles and the rather totalitarian organizaion of his State; Zuccolo, in 1625, trusted in man far more than most of his predecessors did. The contrast between utopian houses (grand, open, with gardens) and the houses of the City of the Sun (luxurious but closed, and pressed up against the fortifications) expresses not so much a difference in social structure (More, not Campanella, retained slavery) as a different conception of communal life, born of a new principle of authority disguised here as the scientific spirit. I believe I am being faithful to Firpo's conclusions when I say that, pessimistic or not, vexatious or not, hierarchical or not, utopia departed from humanism only as it became paternalistic. For the Counter-Reformation, Nature, when it was mentioned at all, resembled a Roman family. The external signs of a totalitarian constitution (uniforms, communal meals, controlled marriages, a political religion) are not very telling; they belong to a tradition that everybody uses, liberals as much as others. No, it is the principle of respect for authority, which replaced consent and agreement, that takes the measure of Counter-Reformation "modernity." Nothing could be more revealing than the parallel, so dear to Ludovico Agostini, between civil and religious authority, between priests and physicians—between all those, in fact, who have the duty and power to prescribe what we must do for our greater good.

City plans could not very well translate these nuances of the moral order. The urban planner was compelled to reckon materially with class differences, and he generally found a way of showing who was master of the place; we can expect no more. But he had painters and sculptors at his service, and statues of illustrious men, particularly inventors, did not appear in his cities by chance. Ever since Pliny made known the spiritual devotions practiced by Romans before the portraits of their ancestors, the glorification of heroes tended to become a state religion (or a religion of Humanity). Education by painting—allegorical images, moral "history," emblems, didactic representation of the objects of knowledge—kept pace. Moralists and scientists could therefore be found together in the ranks of those who sanctioned the ornaments of the City: Filarete, Stiblinus, Campanella, Andreae, Bacon.

To express the social hierarchy, utopians had only to borrow from architectural theorists and from the cities before their eyes: in both they found the division by district according to function (labor, administration, religion, residence) and profession. Innovations were rare because unnecessary; we find only one: a distinction made between a plebeian ground floor and a noble second floor in every dwelling (Leonardo,[20] Agostini). There is less originality in the idea of dwelling types for each social class (Filarete), or in the sumptuary laws regulating the embellishment of private houses (Agostini). Egalitarian utopias naturally arranged for uniform apartments which inhabitants would have to sometimes exchange, no doubt as a measure of anti-individualism (Campanella, Andreae).

Towns with a central plan have a simple means of outwardly displaying their system of government: the seat of principal authority is placed in the middle. That is why liberal utopias leave the center empty. Thomas More's island was circular, but a large natural harbor occupied the entire central part, with a very narrow entrance bristling with reefs and guarded by two forts. More's Utopia was a crescent tending toward the form of a ring, a Round Table like that of King Arthur; politically it was virtually a Round Table of equal cities with a capital hardly distinct from its "subjects." The towns themselves, which could not reasonably be ring-shaped, received—for lack of a better idea—the sufficiently democratic form of a checkered rectangle. Rabelais went further: the Abbey of Thelema was a closed hexagon with an inner garden—a poetic and "genteel" version of the ring or the Round Table.

Where the center must be filled, one had to choose between a religious or a secular edifice, or a grouping of the two. The regular city around a temple was, by all evidence, the urban planner's variation on the church with a cupola and central plan. Filarete, who had a predilection for such churches, was also the original inventor of the radio-concentric town—with a composite center, it is true.[21] If the central temple dominated the town, that was because it was governed by priests, and because the authority of the State was holy. Doni and Campanella demonstrated the extent to which such a utopia must be totalitarian. Andreae planted a circular temple-prytaneum in the middle of his town's central square, surrounded by a greatly enlarged college. But, though the structure was similar, the symbolism was different: for Christianopolis was not a sun but a labyrinth—more or less

the labyrinth of medieval cathedrals, already used by Filarete in its square form for the citadel of Sforzinda. The four axial streets of Christianopolis were, moreover, covered by vaults and inhabited stories: the traffic was in a sense underground. One thinks inevitably of the canals of Atlantis, surrounding the three lines of fortifications and subterraneously linked: it is almost the same design. But the idea that mattered most was probably the labyrinth of the cathedrals, whose windings the faithful were said to follow on their knees to reach its center, the circle of the celestial Jerusalem. (This is not to deny the horror that this Papist ceremony must have inspired in Pastor Andreae, if he knew of it.)

In real towns, two centers had to be taken into account, religious and administrative (and sometimes a third, a commercial center, which could be distinct); in the Middle Ages, the resulting "bifocal" plan was fairly common. The "regular," and mainly radio-concentric, cities of the Renaissance, however, little supported such a topographical division; Filarete abruptly stopped the convergence of radial streets at the center, a tripartite complex. The general rule, well represented by Scamozzi's ideal city, was to create in the center a sort of parade ground lined on one side by "political" buildings (palace of government, tribunal, prison, mint), and on the other by a cathedral, the bishop's palace, the chapter house. In principle this demanded a quadrangular shaped center, which was fairly difficult to reconcile in a radio-concentric plan with the polygonal patterns preferred by military engineers for their fortifications; that is perhaps one of the reasons for the irrational persistence of a checkered plan for fortresses.

Military architects always set an observation tower to serve as a headquarters in the vacant space in the center (Maggi, Castriotto, Lorini, the architects of Palmanova, and others) that civilian architects did not quite know what to do with; Filarete announced a central tower for Sforzinda but forgot to mention it in his description. The rich and their architects naturally thought of a princely castle; in one sketch Peruzzi tried to combine a central rectangular *rocca* with radial streets and a polygonal outline—but the design was crossed out, for obvious reasons. The rectangular castle in the middle required either a contour of the same form (Dürer, 1527) or at least, if the city was polygonal, a checkerboard street layout (Vasari the

Younger, 1598). In fact, the seigneurial castle had almost always been built outside the actual city itself; Dürer's was only an apparent exception, for his drawing represented a fortified castle that also sheltered civilian personnel, and not a town proper. Vasari the Younger's proposal to set the princely residence in the center corresponded to the bureaucratization of the State and to the decision taken by Cosimo the Great to live in the Palazzo Vecchio. When Schickhardt suggested to Frederick VI of Württemberg a plan for Freudenstadt with a castle outside, the prince refused and commissioned the building of a town intended to receive his palace in its enormous central square.

Rarely have utopias, strictly speaking, placed a purely civilian building in a commanding position in the center.[22] Ideal towns designed for real lords could tolerate it; but bureaucratic monarchy engendered forms of utopia other than urban plans.

Cosmic or social "models" were not all that determined the form of a utopian city. Practical considerations and the traditions of town planning also had to be taken into account: the ever-present example of medieval towns, the classical ideal touted by the humanists. Is there room for independent stylistic evolution, which would allow us to speak of a "Mannerist" utopia, for instance, as we speak of Counter-Reformation utopias?

Let us first dispose of the military engineers. The perfect city, Plato said, is defended by the strength of its inhabitants. The utopians' imaginative effort went no further than to multiply fortifications; these displayed no trace of the researches of contemporary military architects. H. de la Croix has nevertheless asserted that the polygonal and radial plan, although invented by artists and applied by them to civil and military town planning, was monopolized after 1540 by engineers who wanted to be distinguished from civilian architects. Their spider's-web design, claims de la Croix, which might be considered to be "naturally" utopian (cf. Stiblin), showed itself so well adapted to the needs of defense that it might have been specially invented for it; "practicians" made it into their hobbyhorse, while artists and civil architects toward the end of the century went back to the chessboard scheme.[23]

This theory, however clear and convincing, must be made more flexible as we quit the Italian scene that is de la Croix's subject: in 1527 Dürer opted for a square design (not very practical, we are told)

with perpendicular streets, and for a long time his model was imitated by specialists. But we must note above all that planners, Italian or otherwise, who drew beautiful radiating polygons (their own "ideal cities"), when they had to erect fortresses went back to the square, and to perpendicular streets, which are more convenient for traffic, for division into lots, and for architecture. Around 1600 a compromise was instituted: a polygonal city with perpendicular streets (one sees this in designs by Vasari the Younger and by Scamozzi, towns such as Livorno between 1575–1606, Nancy after 1607, and Charleville, 1608–20).

None of this had anything to do with utopias or influenced them. Paradoxically, utopias looked toward the town planning of the past rather than to the future. The Middle Ages did not leave them many examples of regular towns but rather a stolid ideal of regularity;[24] thus it was that the two main types, the checkerboard and the spider's web, inspired planners. The influence of the plan of Baghdad in the eighth century, a beautiful example of spontaneous utopian town planning, and the memory of Jerusalem, a circular town, according to Tacitus, must have been as negligible for the regular medieval cities as it was for the birth of utopia in the fifteenth century.[25] The perfect radio-concentric plan may well have sprung full-blown in Filarete's mind as it did in Caliph al-Mansur's. It immediately enjoyed a great success: Cesariano and Caporali "rediscovered" it in a text by Vitruvius, appropriately twisted, and Francesco di Giorgio saw military utility in it, one of its great assets. Such success is easily explained: the radial town was simply an urban planner's variation on the central plan in religious architecture—a Renaissance form, and valid as such.

The utopians' second formal innovation was, like the first, the work of an artist, the Anonymous Destailleur, whose literary spokesman was Doni, forty years later: the creation of a regular star-shaped square with a central monument. No significant invention will be found thereafter until the beginning of the seventeenth century, at the time of the Freudenstadt-Christianopolis plan, in which connection a second collaboration of artist and writer must be noted (the third, if we count Filarete, who combined the two functions): Schickhardt and Andreae.[26]

This is not enough to constitute a stylistic evolution, a formally "Mannerist" or "Baroque" utopian urban planning. But we can es-

tablish for sixteenth-century utopians a certain formal preoccupation that does not go against the development in the other arts. The first point is the persistence of urban utopias. This cannot be entirely imputed to the influence of ancient sources, since the example of Diodorus might, in a strict sense, have broken the tyranny of the Platonic model. Neither is it the result of political experience: there were plenty of states that were not cities in the fifteenth century; and the soil was fertile for utopias of universal monarchy—and some such did develop, as we know. The allegorical landscape, the utopia *à clef*, and the political novel, all of which are frequent in the seventeenth century, might just as well have developed a century earlier. That urban, plastic, static vision to which the utopians clung must have been, therefore, the expression of a style.[27]

The vision was, moreover, "regular": an ideal which, if not specifically classical, at least conformed to the requirements of classicism. The town is rarely checkered in form—Morus adopted that scheme, but for equalitarian reasons; Agostini seemed to suggest it, but he wanted lots of equal size for his town-dwellers, and straight streets, but apart from them, the radial plan was the norm, and it included a detail that is stylistically revealing: the configuration of public squares, central or otherwise.

It was exceptional, in the more or less regular towns of the Middle Ages, to have main squares "run through" by an axis of streets; the busiest streets were tangential. Only the *terre murate* of Tuscany generally adopted this type,[28] in which case there was a sort of assimilation of the main square to an inner courtyard, especially when the façades were uniform; but, with few exceptions (Castelfranco di Sopra in Tuscany, Tournay in the Hautes Pyrenees, Bergues in northern France), nobody dreamed of completing this impression by closing the angles of the square. The classical idea, born perhaps in Bramante's mind, was to enclose the square completely by surrounding it with a gallery which disguised the openings of all the streets (for instance, the designs of Vigevano, after 1492; designs for the square in front of the Loreto basilica and for the piazza around San Pietro Montorio; see also the Vatican courtyard).[29] This created a pseudo-*cortile* and echoed, in the organization of empty space, the organization of volumes in the buildings.

In the Mannerist period the fashion changed; openings again were

made, but in the middle of the sides. In this type, which might be called a square run though with closed angles, the façades conform to a single scheme,[30] and the visitor standing in the center sees four (or more) regular fronts pierced with sudden openings where the perpendicular streets emerge. This arrangement, which Lavedan rightly compared with sixteenth-century gardens, is quite typical: it was used systematically in the designs of Vasari the Younger and Scamozzi; achieved in San Carlo alle Quattro Fontane, among others; and adopted by military engineers, despite their principles, for their central squares.[31] From the viewpoint of art, this contrast between the regular outline deployed on a plan and the sudden flight of perspective has long been recognized as one of the main features of "Mannerist space."[32]

We need only to multiply the "run-through" sides of the polygon to arrive at the form of a star, a more classical and less jarring shape. Thus Francesco di Giorgio had already used an octagon crossed by four axes. But on the ground there is something which does not appear on paper about a star, something subtly disconcerting: whichever way one turns, one faces a perpendicular front and a "Mannerist" rupture; this motif accompanies the eye throughout, and always recalls the *cortile*, even in the most open crossroads.

The Mannerist period virtually invented the public square "run through" by closed angles, and the regular star. The styling of a town for the entries of princes could include the motif of a regular crossroads or "crow's-foot"[33]—fragments of star-shaped public squares. A group of three symmetrical streets converging on a square is part of the vocabulary of idealistic town planning. There are the late examples of the Piazza del Popolo in Rome or the square in front of the château at Versailles, but the decoration of Florence for the entry of 1589 already created its look, thus furnishing a model for a stage set often used in the theater—for the theater, festivals, and the ideal city are akin.[34] In the Olympic Theater in Vicenza, the set that occupies three sides of the rectangular stage opens on five radial streets, the two outer ones emerging at the small sides; this very Mannerist scheme induces a view of the stage ideally as part of a circle, complementary to the public amphitheater.

The Anonymous Destailleur and Doni, who introduced the star shape into utopia, and Schickhardt-Andreae, who supplied the formula of the "run-through" central square, conformed to the artistic

style of ideal cities, fortresses, festival architecture, and theater prevalent in their time. When the urban form of utopia disappeared, after 1619, it may well have been in part because the Baroque inaugurated a new way of conceiving forms.

(1964)

6. Pomponius Gauricus on Perspective

I

Within scientific circles and among conservative intellectuals of the fifteenth century, the best claim that the plastic arts had to being placed in the rank of liberal disciplines was their connection with perspective.* While the humanists were impressed by the analogy of painting with poetry and by the testimony of Pliny, professors of philosophy and science, whose judgment naturally conformed more naturally to the standards of medieval culture, recognized that the system of the "seven arts" had left a place open for perspective, and that the arts of design had some right to claim it. The *quadrivium* actually included the application of mathematics to the study of the cosmos and to the field of sound; there was no reason to leave out its application to the field of vision, that is, perspective, or, according to the current definition, "the science of the transmission of light rays."

This consideration explains why encyclopedias and "divisions of philosophy" ever since the twelfth century had introduced perspective into the system of sciences along with music, and did not think of the arts of drawing. This was evidently still true in the case of the young Ficino's *divisio*.[1] But several other documents of the fifteenth century suggest that painters had taken up the argument. Around 1445, in the *Commentariolus de laudibus Patavii*, Michele Savonarola felt the need to apologize to the musicians of Padua for having mentioned the "disciples of perspective," that is, painters, before mentioning musicians; his grandson Girolamo, the preacher, was to adopt the same attitude with less courtesy.[2] Moreover, Padua had a tradi-

*The substance of this article is based on the conclusions of a study group that worked under the direction of André Chastel at the Ecole pratique des hautes études in Paris, in 1958–59, on a critical edition of Gauricus's *De Sculptura*. I am especially indebted to Jean Rudel for his invaluable advice.

tion favorable to the argument for perspective. During the period when Michele Savonarola was teaching medicine, people still remembered the illustrious Biagio Pelacani (Biagio da Parma), who had lectured on the sciences between 1377 and 1411 and whose *Quaestiones perspectivae*, written in 1390, was authoritative. Paolo Toscanelli had a copy of it when he returned to Florence from Padua in 1424; and the anonymous *Perspective*, once published as the work of Alberti, is certainly derived from Biagio.[3] Finally, the Venetian Giovanni da Fontana, who spoke several times of *Blaxius Farmensis olim doctor meus*, owed to him the optical studies which he included in his *Liber de omnibus rebus naturalibus*, and which he doubtlessly used in his lost treatise on painting dedicated to Iacopo Bellini.[4]

Biagio da Parma does not seem to have thought about draftsmanship when, following John Peckham, he developed the principles of perspective. But a generation afterward, the connection between optics and drawing was well established. From Biagio through Toscanelli to the Florentine artists, and through Giovanni da Fontana to Iacopo Bellini, there was a distance to span—as between the *De Musica* of Augustine and the *practica* of the Renaissance composers—but a real effort was made.[5] Without getting into the actual influence of the opticians on the artists, we may observe the widespread conviction that their disciplines were closely connected. Ghiberti copied the writings on perspective; Michele Savonarola joined painting directly to philosophy, through a "perspective" that figured as the fifth science of the *quadrivium* in his system;[6] his grandson Girolamo even seemed to confound painting with perspective during an argument that was identical—curious as it may seem—with certain passages of Leonardo's *Paragone*.[7] When Antonio Pollaiuolo represents *Perspectiva* as the eighth liberal art on the tomb of Sixtus IV, he characterized her with maxims taken from Peckham, but he undoubtedly was thinking of his own trade when he associated this "art" with the disciplines paying homage to the dead pope.[8]

The artists knew, however, that as they codified their perspective into formulas, it became less and less a part of natural philosophy. Alberti and Piero della Francesca practiced methods identical in substance, and they agreed in defining painting as being, in principle, nothing but perspective; but this definition in Alberti's system borrowed the terms and ideas of ancient optics ("intersection of the pyramid"), while Piero abstracted away the last remains of physics in his

system and was satisfied with pure geometry: "La pictura non è se non demostrazione de superficie de corpi degradati o acresciuti nel termine."[9] Even in Padua, famed for its conservatism, Pomponius Gauricus in 1504 expounded an "artificial" (graphic) perspective from which the considerations of the natural philosophers were expressly excluded;[10] a single vague allusion recalled the arguments of the previous century: sculpture was regarded not as "one" of the liberal arts, but as "the eighth." Furthermore, if one can believe Rafaello Maffei, the ancient science of Alhazen and Vitellio included artistic applications and was almost identified with the fine arts.[11]

From these signs it would seem in general that medieval optical-perspective studies, of which Padua was naturally the center in Italy, affected artistic theory for only a short period in the early fifteenth century under the influence of Pelacani, but that they continued to be used as an argument in the quarrels about the dignity of the art until almost 1500. However, "artificial" or graphic perspective was separated from physics and went on to establish, through Piero, a new dignity of art, with Platonizing, or rather, Pythagorizing mathematics.[12] Even ancient perspective was contaminated by this. The responsibility for all these changes rested with humanism and its conception of culture, and it is interesting to consider the culmination of the evolution in Gauricus's *De Sculptura*, written in 1504 in Padua itself.

Pomponius Gauricus had a humanist and Aristotelian background that strongly marked him with the intellectual habits of grammarians and pedagogues: he had no inclination to grant the plastic arts any honors that did not already belong to literature, nor to give to the moderns those honors which rightly belonged to the ancients.[13] During the period in which he wrote, reflection on art was entering a new phase, which might be called "distinguished vulgarization," exemplified by the pages on art in the *Cortegiano*. Leonardo and Dürer were then in the process of crowning the scrupulous technical researches of a century, but art theory, along with the theory of love, was to descend, and it remained for fifty years at the level of a mere conversational topic, of *domandi* (collected and codified around 1550 by Francisco de Hollanda, Varchi, Pino, Doni, and Dolce). This was not a completely sterile period, for the dawn of the historical sense and the rise of art criticism belong to it, but it was a period in which

it was no longer possible for a scholar to employ himself, as Alberti had done, in perfecting artistic techniques: humanists only entered the studios as *"curieux"* or literary advisers.

Gauricus, a sculptor himself, occupied an intermediate position. A large part of his treatise on sculpture is devoted to technical questions, but in spirit it is rather similar to that of Pliny the Elder, sometimes rhetorical, sometimes bluntly descriptive. His criteria of judgment are those of current humanism, and the interest of his chapter on perspective was for the most part to show how this science, deprived of its roots in the natural sciences through a century of artistic application, was now integrated in a new, more literary context, and hence did not teach how to depict the *mazzocchio* but, rather, how to compose an *istoria*.

The artistic function of this humanist perspective resembles what Aristotelian dramaturgy would later call "verisimilitude," a principle of clarity, of rationalization, of unity, and, generally speaking, of evidence rather than of illusion. But for Gauricus this was only the final point, climaxing the traditional system of discipline within the field:

This scheme must be followed point by point, if we are to understand the scope of the arrangement. "Natural" perspective (A) was, as we have seen, set aside from the beginning; this was the first point scored by the "literary" attitude.[14] The subsequent subdivision of "graphic" perspective (B) into construction of space (a) and foreshortening (b) was just a philosophical prejudice, recognizable by the rather "Paduan" manner with which Gauricus justified giving the priority to space,[15] since in perspective, there is no theoretical or practical difference between the construction of the interior of a room and

the foreshortening of an object of the same shape. This is why Piero della Francesca, for example, never concerned himself with "scenic space." If, however, the theoreticians began with a checkerboard ground plane (1), it was because this permitted the correct placing of objects, the measuring of distance, etc. Gauricus told one how to draw a pavement, without a word on how one could do it so as to unify the spatial scéne, and he seems to have been completely ignorant of this question, and even of the idea of a central vanishing point. The few lines he devoted to the checkerboard were, then, a dead end in this respect.*

He was much more at ease in the completely qualitative discussion of the role of the horizon (2), for this allowed him to raise the problems of compositional perspective. The bird's-eye view, with a raised horizon, presented the *istoria* clearly; the worm's-eye view, with a low horizon, was proper for representing celestial apparitions, observers on towers, etc. (curiously enough, Gauricus does not apply this to ceilings). An aesthetic of perspective, rudimentary to be sure, makes its first appearance here in the handbook rules. Let us imagine the battle of Zama somewhere on a plane (the text proposes the top of a desk): nothing is distinguishable if the eye is on the level of the plane; more is comprehended as the eye rises or the plane inclines, and one can see everything from the bird's-eye view. The apparent distance between people is affected by the relative height of the viewpoint: this simple statement is the key to the relations between perspective and *istoria*.[16] No other exact criterion is given to distinguish the three "views" bizarrely identified by terms that will endure, *katoptike* (bird's-eye view), *anoptike* (worm's-eye view), and *optike* (horizontal view). Perhaps Gauricus meant not the position of the horizon relative to the frame, but the positions of the objects relative to the horizon: everything that is above the horizon is perceived in *anoptike*, and that which is below is seen in *katoptike*.[17] In order to define the perspective of a picture, the disposition of its elements (what Alberti calls *compositione*) has been substituted for the geometric system (C). For the horizontal view, at the level of the ground plane, Gauricus offered no rules for the painter, and he suddenly recalled that he was treating sculpture so as to state a principle for creating space through volumes—the flattened perspective in bas-reliefs. This evasion of an

* On the construction system he used, see below, p. 109.

issue led him to a rather surprising definition: "Constat enim tota hec in universum perspectiva dispositione, ut intelligamus . . . quot necessariae sint ad illam rem significandum personae, ne aut numera confundatur, aut raritate deficiat intellectio."[18] We can easily see how Gauricus arrived at this rather strange opinion: the spaces between people depend upon perspective; the clarity of the istoria depends on these intervals, but is also the function of the number and disposition of the figures; these in turn determine the intervals; therefore, the number of people is a concern of perspective. The reasoning is obviously not very sound, but Gauricus expressed no more than an intuitive relation. A "dramatic perspective" undoubtedly existed in the art of the fifteenth century, and at least one of its precepts entered artistic literature when Alberti advised adding to the istoria a pointing figure, who turns toward the public. G. C. Argan has recalled, in this respect, the angel of the Madonna of the Rocks who isolates, as if on an imaginary stage, the group to which he points.

The proof that Gauricus's terminology is not senseless is its survival. Paolo Pino judges that there is "false perspective" when "le figure sono tanto disordinate, ch'una tende all'Oriente, l'altra all'Occidente voglio dir che per ragione alcune scopren la schiena, che dovrebbon dimostrare il petto";[19] and Lomazzo, more verbosely:

> La prospettiva . . . universale è quella che mostra come s'hà da collocare una figura sola secondo il luoco ove si pone, e che circonstanze de havere, come che un Rè si collochi in atto alla maestà reale conveniente, et in luco eminente e soprano, che uno non stia in spatio dove non possa stare o tochi quello che non puo toccare, ne faccia cosa tale la qual facendo occupi quello che ha da far l'altro.[20]

The idea of "compositional perspective" was not the sheer fantasy of a grammarian.

His handling of the "particular perspective," or foreshortening (b), shows a similar progression from the elementary precepts of graphics to the invention of the istoria. Gauricus spoke of flat geometric figures (3), then of regular bodies (4), finally of the human body (5). This last chapter is very logically articulated: first, the procedure for drawing a foreshortened bust; then, a classification of postures followed by notes on equilibrium and on physically impossible positions;[21] and finally a list of the principal movements of the human body, with a

remark on repose (*otium*)—either noble or, as sometimes in Mantegna, humorously vulgar. The lesson stops again, as can be seen, on the threshold of *istoria*.

The very next page, which climaxes his entire chapter on perspective, again confirms the literary orientation of *De Sculptura*. A constant characteristic of the treatise is the adaptation of rhetorical and poetical categories to the plastic arts, but in no other part is this trait so bold. Seduced by the analogy between perspective and *perspicuitas*—a rhetorical term—Gauricus hunted through Quintilian for ideas applicable to painted narrative, and he aptly chose *sapheneia*, *eukrineia*, *enargeia*, *emphasis*, *amphibolia*, and *noema*—evocative names to which he now gave some rather surprising definitions.[22] When it was a matter of illustrating these qualities by works, Gauricus disdainfully rejected artists ("nam quid apud sculptores nostras invenias?") and took all his examples from Virgil.

This is the place to comment not on his choice of categories, but on his new interpretation of *ut pictura poesis*. Such a translation of critical ideas from one art to the other is without parallel before 1504. Before that time, the analogy between arts and letters concerned their status (the legitimacy of imitation) or their purpose (to teach, to move, etc.), but never their structure or aesthetics. The texts that can be found about the "musical" character of proportions are either abstract or technical. The spirit in which Gauricus worked, by and large a critical one, can only be documented by certain passages in Aristotle or Quintilian concerning the similarities of style and artistic temperament between masters of different arts; a current locution, "the colors of rhetoric," might also be cited. But it was evidently necessary to have someone in the false position of a *litteratus* pretending to be an artist for these vague hints to be taken up.

Seen in its totality, Gauricus's chapter on perspective is remarkably daring and timely. The explicit denial of a physical perspective, the parallel orientation of space and volume toward a compositional perspective that encompasses both, and, finally, the analogy with rhetoric constitute very elegant confirmations of current humanist thought, if not always innovations. Quite different, in fact, exactly the opposite, is the technical aspect of the same pages. We can say that when it is explaining the methods or relating formulas, *De Sculptura* exposes fossils. Nonetheless, these fossil elements can give interesting information on the early history of perspective.

II

In the fifteenth-century texts, we are given only a one-sided image of the evolution of technical methods of practical perspective. Neglecting methods whose use can undeniably be seen in actual works of art, they almost always limit themselves to explaining the variants of a single type of construction.

This method has as its principle the reconstruction of the appearance of a particular body via two "parallel projections"—that is, its ground plane and its profile. Let us take as an object the visual pyramid, itself rising up from a checkerboard pavement. The combination of its horizontal plane with its profile results in a foreshortened checkerboard; the main vanishing point is on the horizon (figure 1).

It was clear in practice that if one restricted oneself to the checkerboard pattern, the horizontal plane could be suppressed without any harm. Thus Alberti was satisfied with the profile, which furnished him the heights of the transversals (figure 6). Subsequent simplifications were easy to introduce, notably by shifting the auxiliary construction, which could thus be drawn wholly or partially on the picture itself (figure 2). This is what was done by Filarete, among others, who superimposed the base of the profile on that of the *en face* view; Piero della Francesca's system could be defined by the superimposition of the three elements of the diagram (figure 3).[23] Written sources earlier than Gauricus knew of no other correct methods for the construction of the checkerboard.[24]

The explicit scheme (figure 1) permits an intuitive comprehension of the roles of all the elements involved: the correspondence between the eye (O' or O'') and the vanishing point O; the significance of the horizon (if the point C' of the profile moves toward infinity, its projection on the taglio, or picture plane t will have the height h); the importance of the distance of construction (if the eye is very close to the plane t, the intervals between the transversals vary more abruptly, as shown by the profile; the ground plane shows that at the same time the angle of vision implied by the construction grows too much).

Gauricus's system is generally considered as a variant of this method. This presumption must be reconsidered, however, since Decio Gioseffi, in a recent work[25] has furnished a convincing explanation of Gauricus's very obscure text.

1. Perspective construction of the checkerboard.

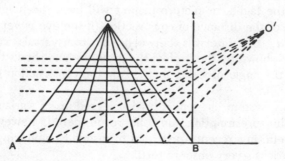

2. Profile shifted over the frontal view of the pyramid.

Gauricus traces (figure 4) first a vertical axis in the middle of the panel, then a horizontal that cuts it and forms the base line (*aequorea*); a point *O* is chosen at an arbitrary distance from the median axis *Z*, with coordinates *d* and *h*: this is to be the spectator's eye. The base is then divided into equal segments (the *piccole braccia* of Alberti).

> Ex . . . vertice (*O*) ducatur ad extremum aequoreae linea sic (*O*1), itidem ad omnium harum porcionum angulos sic (*O*2, *O*3), ubi igitur a media aequorea perpendicularis hec (*Z*5) cum ea que ab vertice ad extremum ducta fuerit (*O*1) se coiunxerunt (*A*), plani finitricis lineae terminus heic esto.

This *finitrix plani*, the horizontal through *A*, is not the horizon line but, after a number of transversals equal to that of the *porciones* of the semibase, the edge of the checkerboard. Gauricus does not explain how to go any further, though the problem is easy enough.

3. Foreshortening of a square, after Piero della Francesca. The Pyramid (with apex A) is drawn directly above the ground-plane BCGF. At the same time, its profile is represented by ABC, with BF acting as a *taglio*. BC*de* is the foreshortened view, *a* the vanishing point. EH = *ed* for any position of *a* on the horizon.

Figure 4 thus shows the profile pyramid superimposed on the base of the pyramid seen from the front. The old *taglio*, or picture plane *t*, thus coincides with the median axis *Z*, and the intersections (*a*, *b*, *c*, *A* on this axis) naturally define the transversals. But the text of

Gauricus does not prescribe limiting the operations to the left side. One has to bind O in the same manner with the *porcionum anguli* 5-9, and to prolong the horizontal through A to the right (figure 5). "Quod si ab aequorea ad hanc finitricem (6-6', 7-7' . . .) ab laterali ad lateralem [the transversals through *a,b,c*] absque ipsarum angulos ad angulos [2-2', 3-3' . . . through the *anguli* or intersections 2*a*,3*a* . . .] plurimas hoc modo perduxeris lineas, descriptum etiam collocandis personis locum habebis."

The checkered square is then ready. An elementary demonstration in geometry can prove that the orthogonals obtained by Gauricus's method should converge in a point situated on the median axis at the height of O, the classical principal vanishing point. The procedure can be justified intuitively in different ways; Wieleitner has shown that the simplest of them is demonstrated in a drawing by Vignola.

It is astonishing that this construction was completed without mentioning the central vanishing point or the horizon; Gauricus seems to describe a thoroughly mechanized procedure, without worrying about mathematical demonstrations. However, the distance point was correctly interpreted, since Gauricus remarked that the *h* represented the height of a man, and *d* the distance from which the checkerboard was viewed. This should be remembered, because it demonstrates that this system is in all likelihood historically independent of Alberti's system. Alberti, contrariwise, seems to have been ignorant of the real significance (almost of the existence) of the distance point; but he knew and well understood the central vanishing point and the horizon. A brief comparison of the two methods will confirm their disparity.

Alberti divided the picture base into reduced *braccia* (figure 6); he arbitrarily chose a central vanishing point and a height for his horizon; he then connected this point with the divisions of the base (a); then, on a smaller scale and a different piece of paper, he traced the profile of the pyramid, situating the *taglio* at a chosen distance (b); finally he copied onto the border of the picture the intervals he had obtained on the *taglio* of the auxiliary drawing, restored to the initial scale. This furnished him with the height of the transversals. The checkerboard was finished, and, as a check, Alberti drew a diagonal which should cut through the corners of all the squares it passed through (c).

The difference with Gauricus was not limited to the theoretical implications of the two methods, for it is especially apparent in the

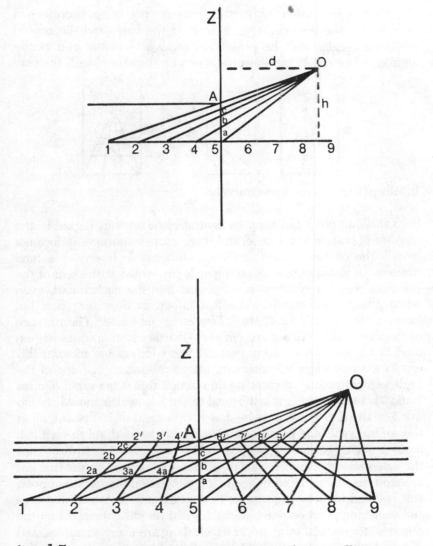

4 and 5. Gauricus's ground-plane constructions (after Gioseffi).

possibilities it offered the artist. The normal Albertian checkerboard was in an A × A format (as many orthogonals as transversals), while the Gaurician checkerboard tended to have a normal type 2A × A (the divisions of one half of the base alone determined the transvers-

als). From this a rather bothersome consequence arose: there would have to be an even number of *braccia* at the base, and the central vanishing point would be present as on a pole at the end of the middle orthogonal.[26] In Alberti's system, on the other hand, the cen-

6. Alberti's ground-plane construction.

tral vanishing point can keep its central place without regard to the number of *braccia* at the base; and, even more important, it does not have to be on the median axis, an indispensable liberty at a time when as an absolute rule all orthogonals converged at the end of the principal passageways or streets opening into the background, even when placed eccentrically. (The first important departure is, I believe, in Tintoretto's *Saint Mark Liberating the Slave*.) The distance of the viewpoint (a free choice in the Albertian system) does not extend in the Gaurician system past half the width of the picture; this entails a rather close viewpoint, at least a 90-degree opening of the angle of sight, and a perspectival diminution that is too rapid (figures 1 and 7). Finally, the last orthogonal to the left (which should, in figure 5, start from 1) can only be drawn with great difficulty as long as the central vanishing point is ignored; and in general, all the left half (away from the distance point) is rather uncomfortable to draw, for the orientation of the orthogonals is there defined by points that are too close together. An accommodating temptation then is to suppress this half and to make the squares in the format A × A, with the central vanishing point on one of the sides and the distance point on the other: a "trapezoidal solution" of which there are many examples, and of which the frequency would be inexplicable within the Albertian construction.

It cannot be claimed, as it sometimes is, that the Gaurician system developed from the Albertian system and improved on it by using the distance point. The natural evolution of a technical procedure never

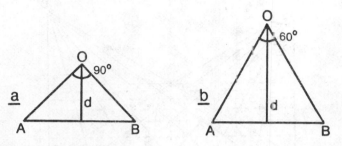

7. Distance and angle of view
a) Bifocal method: distance *d* is equal to half the width AB of the picture; thus the angle of view is 90 degrees.
b) The proper relation, following Piero della Francesca

took such a backward step. Gauricus has to be placed in another tradition, in which the distance point is given at the outset, and where the central vanishing point is only implied: this is what is sometimes called bifocal construction (figure 8). This simply consists in placing two symmetrical distance points to the left and right, and uniting them with the *braccia* divisions of the baseline of the picture. The oblique checkerboard obtained by this means can serve for putting prismatic objects directly into perspective; but it can also be easily transformed into an orthogonal system (the dotted lines in figure 8), and the primitive 2A × A rectangle can easily be extended in all directions. In easel painting, the general and natural tendency of painters is to place the distance point on the margin, that is to say, to use the widest possible distance (half the width of the panel) without resorting to auxiliary constructions and complicated transfers. With frescoes, when several scenes are juxtaposed laterally, the distance point for any one of them can be chosen anywhere on the wall; a nail can be driven at the chosen spot, and then a string can unite it with the divisions on the baseline, which would permit the easy tracing of the diagonals or of the bifocal net (Panofsky).

There is no literary evidence of the existence of this system before Viator's book in 1505, but it is fairly certain today, following Panofsky's old hypothesis, that it was being employed on an artisan level well before that date; this makes understandable the appearance in 1504 of a variant, like the Gaurician procedure.[27]

One has to start with the *Jesus among the Doctors* of the "Maestro

8. Ground-plane construction in the bifocal method.

9. Foreshortening of the square *abcd*, after Gauricus. View "from above": *afgh;* "lateral" view: *ahid.*

Seneseggiante" in the Lower Church at Assisi, where the regular construction of the ceiling coffers has often been pointed out. This regularity is doubtlessly the result of using the bifocal system, for it would not be a coincidence that the two distance points are located on the margins exactly where ringed brackets are still fixed into the walls.

The design of the coffers themselves (each crossed with a transversal) confirms the use of a string in tracing the scheme. The city scene in the Berlin Museum, once attributed to the school of Piero della Francesca, has in its foreground a strikingly similar loggia drawn by the same method.

Again before Alberti's book, about 1428, Masolino (either as a geometric game or in order to save himself work) in his *Story of Saint Catherine of Alexandria* (Rome, San Clemente) employed the distance point in one scene as the central vanishing point of the neighboring one.[28] The mark left in the wall by the nail is, it would seem, still identifiable. Neither of these two scenes takes place in a rigorously unified space, but it can be seen that the artists had—from the shop tradition alone—at least one correct method for foreshortening the checkerboard.

Niccolo Pizzolo, in the Ovetari Chapel of the Eremitani in Padua, painted a tondo depicting Saint Gregory seen rather convincingly from below. Only the coffered ceiling is constructed with the aid of a distance point situated on the circumference, all the rest—the intervals of the orthogonals as well as of the transversals—is irregular. We have here a survival, in 1449, of a shop method absolutely opposed to Alberti's principles.

In all these cases, the bifocal system or the single distance point is applied only to the construction of a checkerboard, without attention to the unification of space. This neglect was, to the theoreticians, probably the major weakness of the system. As it managed without a horizon and even, in principle, without a vanishing point, it did not seem to lend itself to the creation of a complete and rational space. We have seen indeed that Gauricus did not understand this.

It is undoubtedly Paolo Uccello who took upon himself the task of extending the bifocal system to represent a unified space. In his fresco of the *Nativity* in San Martino alla Scala he placed the two distance points on the margins, as has been revealed by the recently photographed *sinopia*; but, contrary to what was done in the *Jesus among the Doctors* in Assisi, for example, he traced the horizon at the level of the central vanishing point that resulted from the perspective scheme,[29] and—although this cannot be seen in the *sinopia*—he treated the parts above the horizon, such as the roof of the stable, exactly in the same manner as he treated the objects on the ground. The only "error," more apparent than actual, is that the distance

points each serve in a part of the fresco as "central" vanishing points. Uccello used here, for a single scene, the method that Masolino in San Clemente used to relate two adjacent scenes.[30] But this liberty can be justified as a protest against the arbitrary postulate of the perspectivists: that the eye of the spectator must be fixed. This fresco, which dates from 1446 or earlier, could be interpreted as a reply to Alberti: Uccello might have wanted to show that the distance point, ignored in *Della Pittura*, could also engender a coherent system, and even had the advantage of dispensing with an auxiliary construction and of taking the mobility of the eye into account as much as possible. The eye should see everywhere on the horizon "central" vanishing points; bifocal construction can at least suggest this by making three.[31] Does this answer to Alberti, if it is an answer, come from a defender of workshop methods, or from a disciple of Brunelleschi? Each hypothesis, we shall see, is possible.

In an often-cited panel, the Urbino Predella of the Profanation of the Host, the second scene (*The Attempt to Destroy the Host*) shows a vanishing point directly on the right margin at the spot which, according to an earlier draft, should serve as the distance point.[32] Is this anything more than an arrangement necessary to make the story clear, the better for us to see oscillation between distance and the soldiers battling at the door? But these vanishing points may be another demonstration of the possibilities of bifocal perspective.

The ensemble of characteristics resulting from the use of two distance points (the $2A \times A$ format, the preference for prismatic bodies seen in oblique setting, an eye-distance equal to or less than half the width of the panel) permit us to say, broadly, that the system was being used before 1435 in a manner sufficiently common to influence a style, and that after this date it lost its importance.[33] But if the style of the Albertian perspective soon became dominant (with its orthogonal checkerboards of the format $A \times A$, its larger vistas, its variably placed vanishing points, and its prismatic bodies seen *en face*), this does not mean that the old procedure became obsolete, for there is at least one nearly infallible hallmark by which it can be detected: the placing of the vanishing points exactly on the edge of the picture. This can still be recognized in the architectural *vedute* once attributed to Piero della Francesca (Berlin and Urbino) and even, according to Sanpaolesi, in Leonardo's *Annunciation* in the Uffizi.

We have said that the Gaurician method is doubtlessly derived

from this earlier method; but it is difficult to know when this happened, for it lacks distinguishing formal characteristics. The checkerboard of an $A \times A$ format in a rectangular trapezium ("half-pavements") and the unaesthetic and perfectly vertical median orthogonals (following the even number of baseline divisions) constitute but uncertain indices. Among the theorists before Gauricus, only Filarete described a method similar to his, but more rational, which might possibly have been deduced from Alberti. As for artistic realizations, there can only be cited and not without reservations, a *Nativity* in Philadelphia (Johnson Collection), attributed by Berenson to a follower of Niccolo di Buonaccorso.[34] The space in this picture is not correctly unified, and its two surfaces in checkerboard, a pavement and a bedcover, are constructed independently, with different "horizons." Even more curious, each of the two is again composed of two equally disparate sections, even though they are supposedly continuous (they are in fact separated by the middle column of the frame). It seems, therefore, that the artist knew a system of putting into perspective a "half-pavement" but did not know how to extend it to a format $2A \times A$, or how to coordinate juxtaposed parts. Now the Gaurician method is the only one in which the two halves of the board are constructed differently, and, thus, the only method that could explain the predicament of this nongeometrically minded painter.[35]

There still remains a question to be answered, if possible, in reconstructing the evolution in which *De Sculptura* has its place. What is the relationship between the workshop-studio tradition of the distance point and the perspective developed by Brunelleschi and Alberti? The sources of Brunelleschi have been sought in architectural practice, in the medieval perspectives, in the *Optics* of Euclid and Ptolemy, and even in the *Geography* of Ptolemy; it will be necessary to add Trecento painting to this list.[36]

About all we know with any certainty comes down to the rather detailed description of the two *vedute* with which Brunelleschi demonstrated his method. His anonymous biographer spends a long time over them,[37] and Vasari adds a few particulars, of uncertain value. The compilation of all these data permitted Panofsky's reconstruction, of which the outlines still remain valid.

The first *veduta* showed the Baptistry of San Giovanni seen from the interior of the cathedral; the painter stood at a distance from the

doorstep equal to half the breadth of the door. Supposing, as seems natural, that the panel represented the whole space seen through the opening, the angle of the visual pyramid ought to be 90 degrees, and the distance point placed on the edge of the painting. The second panel represented the Piazza della Signoria, seen from a corner; the two rows of houses next to the beholder appeared just at the edges of the panel; therefore, again, the angle was 90 degrees or slightly greater, as is normal in the bifocal system. Another indication of the use of this system is that in each of the two panels the center was occupied by a regular solid with planes making an angle of 45 degrees with the picture plane, for the octagonal Baptistry seen from the front can easily be obtained from what White called a prism in extreme oblique setting.[38]

Brunelleschi's biographer gives a detailed description of the mode of presentation adopted for the first panel: the spectator must stand at the point chosen by the painter, facing the door; in one hand, he holds a mirror, at a distance corresponding to the distance of construction; with the other he presses against his face the back of the panel. Brunelleschi had drilled a hole at the exact place of the central vanishing point, and looking through this hole one could see the painting in the mirror. Furthermore, the silvered sky of the picture reflected the clouds above and passed them onto the mirror. When one put the apparatus aside, what appeared—through the door of the cathedral—was a view exactly identical to the one which had been seen through the hole of the panel.

This presentation allows us to conclude that Brunelleschi, contrary to his predecessors, was aware of the existence and meaning of the central vanishing point, as of the distance point, since he knew how to calculate the distance between the mirror and the spectator. The natural conclusion would be that he had used the bifocal system (dictated both by the spot where he stood and by routine), but that theoretic reasoning had led him to extend it to a unified space, when prior to his effort it had only been applied to the construction of checkerboard planes. We can go further and ask why he used a mirror. Parronchi gives a good answer to this question: by using a plan of the piazza for situating the buildings in his panel, Brunelleschi had inverted the sides of his image in his reconstruction (see the diagonals of Barbaro's squares); the mirror corrected this error. This confirms what Vasari said about Brunelleschi's recourse to the plans (and to the

elevations) of the buildings, but it does not excluce the hypothesis that the ground plan had been previously traced according to the old bifocal practice.

But a more serious problem arises: since according to the biographer the first panel was a square with the sides of a half *braccio*, the distance would have had to be extremely short, a quarter of a *braccio*, in order to make the angle 90 degrees. One could avoid this difficulty only by rejecting the double hypothesis that the *taglio* had been chosen at the plane of the door and that the panel represented all the space visible through the opening. But even if we abandon this hypothesis (Krautheimer and Parronchi admit *taglios* only later), the question remains: Why did Brunelleschi choose a composition which demanded the traditional and convenient angle of 90 degrees, if he was not to make use of its advantages?

The solution, difficult no matter what, becomes clearly impossible when we remember that the *veduta* must have appeared at twice the distance of the mirror. So it would have been necessary to hold the mirror at an eighth of a *braccio* from the eye, in order to have a correct representation. To be sure, there exists a subjective compensation for this optical effect, but this complicates the problem still more, for the compensation cannot be quantitatively determined and taken into account by the artist. Moreover, for any distance chosen for the *taglio*, it is impossible to find a distance for the mirror such that the image coincides with the real view offered to the spectator from any point inside the cathedral. There will be always disagreement—either with the way the door frames the view or with the rhythm of transversal diminution.[39]

It is therefore clear that in spite of the claims of the biographer, the first experiment was only partially successful, and it is understandable that Brunelleschi took precautions for the second. He was careful now not to invert the sides, and therefore he could dispense with the mirror; he no longer assigned a fixed distance to the spectator; and he gave the visual pyramid an opening (this time formally attested by Vasari) of 90 degrees, with the central motif placed obliquely. Everything leads us to suppose then, with Sanpaolesi and Parronchi, that Brunelleschi had used the rationalized bifocal system; and this rationalization presupposes an exact awareness of the role of all the elements it puts into play.

The next step, to be credited to Alberti, is easier to understand

since he himself described his method in terms that, thanks to Panofsky, have become perfectly understandable. Briefly, Alberti discarded the workshop practice of the bifocal system, and constructed the checkerboard by the *legittima* method, exactly as any other solid. This was an essential theoretical conquest, even if it implies forgetting the distance point, an apparent step backward. For the development of the style of perspective views, Alberti gained at the same time a complete liberty of choice of the main vanishing point, and an increased facility for the frontal setting; and he condemned the artists, *felix culpa*, to the research of "proportion in perspective," that is, the law of the serial succession of equidistant transversals.

To sum up: the bifocal system, known since the fourteenth century as a studio practice, is the origin of the development of perspective. It appeared under several forms: one of the distance points could be omitted (Pizzolo) or replaced by a median axis (Gauricus); or there could be a fusion of the functions of the distance point and the main vanishing point (Masolino, Uccello). Unified space was empirically constructed around a central vanishing point by Masolino. In the rational and clear perspective of Brunelleschi, the old bifocal system continued probably to serve for the foreshortening of the pavement. Alberti, not familiar with the studios, ignored its use. Despite the efforts of Uccello, who wanted to unify space in a bifocal framework, it was Alberti who held sway for a long time over the theorists; no other system than his was admitted worthy of the attention of a learned master. Only Gauricus had never heard of a central vanishing point. The reconciliation of the two systems had perhaps been attempted by Filarete; Serlio recognized them as equally valid; finally Vignola proved that they were essentially identical.

A brief consideration of the foreshortening methods that make up Gauricus's "particular perspective" (*b*) leads to the same results concerning his theoretical training. He haphazardly collected formulas which were sometimes anachronistic or childish;[40] and he did not seem to suspect that the total perspective, of which he had a vague intuition, also required new technical solutions. In the first lines of the pertinent chapter in his treatise, one encounters a most curious "fossil": inscribing within a circle is presented as the initial operation in all foreshortening construction: "Rotundas igitur omneis rerum formas concisione praestabimus" (p. 204). The sentence is close to Filarete and Viator, who used instead methods of foreshortening

squares in order to "flatten out" the circumscribed circles. These procedures suppose a "spherical" origin of all geometric perspective, undoubtedly on the strength of medieval texts on the propagation of light rays.[41] So Gauricus inscribes his square in a circle, and then draws in, without a discernible constructive purpose, the diagonals and the axes (figure 9). "Diende productis ab hcc uno latere (ab) duabus his lineis (ae, be), eodem spacio circuli (o'e =oa) fiat hic triangulus, quo ex dimidia parte dissecto (fg) totidem rursus ducuntur et heic quot in primo circulo lineas [diagonals and axes] simili racione."[42] The resemblance to an analogous drawing of Piero della Francesca is self-evident, as well as the difference in scientific level. This difference becomes still clearer by the following: in order to find the foreshortening of the square abcd "seen from the side," one has only to prolong ab and cd in parallel until the perpendicular that unites them becomes tangent at K to the circle C.[43] The very idea that the lateral foreshortening of a square could be essentially different from its "superior" foreshortening would have appeared ridiculous to the most mediocre Paduan artist. Gauricus is here really at the level of pictorum pueri, of apprentices, from whom he almost admits to having borrowed his methods. However, the rectangle bhic, which may be considered as the parallel lateral projection of a cube in an oblique setting, can serve as an auxiliary drawing for a complete construction; such examples can be found in Piero, and this is perhaps the point of departure for Gauricus or his source.

The other precepts are on the same level. They are practically always current methods, badly understood or badly explained. Thus, the procedure for drawing an inclined head is described in the absurd manner faithfully illustrated by the drawing of Brockhaus,[44] while the engravings of Dürer and Barbaro, undoubtedly imitating Foppa or some other Italian, show what Gauricus really wanted to say.

A picture executed according to the precepts of Gauricus would give a Trecento spatial depiction: the checkerboard would be correct, but of no help in placing objects; a central vanishing point would be lacking, and the foreshortenings would be anarchic. without consideration of the viewpoint. If Gauricus's checkerboard is of interest in the history of the perspective, his instruction on foreshortening, with its strange anachronism, has worth only as a document in the sociology of art.

III

Gauricus's failure is explained by his training rather than by the inherent difficulty of his problem, which was to extend perspective technique to a general theory of the relations between spectator, space, and plastic representation. This task fell to theoreticians as well as to painters. It remains for us to ask what its concrete problems were, and how they were attacked.

The first problem is the eternal dilemma in all illusionistic and scientific representation of space; the Renaissance has the distinction of becoming conscious of it first. It can be formulated thus: if visible appearance presupposes the subjective transformation of impressions, should one, in art, render faithfully the results of this process—the optical illusions, for example—or should one paint the "causes," reconstructed through reasoning, and leave to the eye the responsibility of operating upon these disengaged elements, of making the same transformations that it would have made on the impressions coming from the model? The first solution is more positivistic, the second more realistic; and holders of the two views opposed each other on several points from the fifteenth century on.

Atmospheric perspective is the best-known example of this difficulty. The perspectivists among the natural philosophers had already written that distance softens contours and rounds off shapes,[45] and Alberti likewise observed that the rays of color "weaken" in transversing distance—from which he wished incidentally to deduce that elongated objects appeared più foschi.[46] It is pointless to recall the innumerable remarks by Leonardo on this subject, but it should be emphasized that his statements rarely resolve the question of whether one had to paint the described effects or not. Evidently Leonardo was in favor of the affirmative, although less radically so than is usually claimed. Zenale, however, had written a very trenchant and methodical polemic in favor of the opposite viewpoint: one must paint, he said, the details of the background with all possible clarity, for the eye will take it upon itself to blur them to the necessary degree.[47]

Exactly the same conflict is found in linear perspective, where it is still a controversial subject for the historians. A decisive work by Panofsky raised the question of "curved space perspective" in the Renaissance, opposed to the costruzione legittima and its derivative or related systems.[48] If we look at a very large plane—for example, a

checkerboard—placed vertically in front of us with its center at eye
level, the outermost parts should undergo a more important diminu-
tion than the center, for they are much farther from the eye and are
seen under smaller angles; a perspective that wanted to take account
of this effect must submit to "Riemannian" deformations. Panofsky
was able to show clear proofs of the attention given to this phenome-
non in the notebooks of Leonardo and in the notices of the *Codex
Huygens*; and John White has furnished striking confirmations drawn
chiefly from the work of Fouquet. Against these theses, Gioseffi
raised the objection (anticipated by J. White, *Birth and Rebirth of
Pictorial Space*, p. 125) that the panel itself is an object whose
marginal parts must appear smaller to the eye than its middle sec-
tions.[49] When the spectator stands in the exact spot assigned to him
by classical perspective, the implied error will be compensated by the
apparent contrary deformation which results during the perception of
the different parts of the work itself, and the effect will be "normal";
whereas an image constructed in curved space perspective would ap-
pear doubly deformed, and consequently incorrect, even for the cor-
rectly placed spectator. On the strength of this fact, Gioseffi tries to
prove that no painter and no theorist of the Renaissance was able to
conceive a curved-space perspective.

Actually, the real question is the same as in atmospheric perspec-
tive. Once subjective phenomena are known, should one copy them
as such, or should one return to the "causes" and let the eye take care
of reproducing the subjective result from these data? Planar per-
spective is theoretically "incorrect," because it does not respect the
proportionality between the distance of an object and its apparent
height; incontestably both Piero della Francesca and Leonardo no-
ticed this.[50] But Piero, after having verified the classical construction
in a particularly shocking case, decided that there was no ground for
worry: "Si che io intendo de dimostrare cosi essere e doverse fare."
Leonardo, on the contrary, made several propositions in order to
neutralize the error: increase the distance up to three times the
breadth of the image (an extreme remedy of which there are few ex-
amples), paint on curved surfaces, paint anamorphoses. But he seems
especially to have speculated about founding a "truer," curvilinear
perspective. In other words, whether they knew it or not, Piero and
the partisans of classical, planar perspective, wished (as on the other
hand Zenale did) to produce a duplicate of the *intersegatione*, such as

it is *per se*, and not as a duplicate of perception. Leonardo dreamed of endowing the image with an intrinsically true perspective—as true as perception—be it "false" for the viewer. Since the artist should "put himself in the place of Nature," reasoning from causes, he should not be satisfied with stopping on the threshold of the cornea: "Nature" continues to operate within the eye, then within the mind, and the painter must follow. Zenale and Piero counted on a spectator "placed in proper conditions" by the distance he takes; Leonardo's spectator is nowhere (because, as Gioseffi has well seen, there is no place from which his perspective would seem correct), but he is also everywhere, for the work takes the place of the eye. The question cannot be resolved, for each party inevitably ends up in the adversary's camp. The objective, scientific attitude, which refuses to reproduce the aberrations and weaknesses of vision, is obliged to count on them for the perception of the work; the analytical attitude that incorporates them into the work must deny the existence of the spectator. The dilemma reveals the profound ambiguity of all perspective in art, not just in the arts of drawing.

The integration of perspective thus comes up against the problem of illusion; but it also collides with the problem of "participation." The precise question upon which the two factions confront each other is that of the connection between the fictional space and the space of the spectator. The more perfect their continuity is, the more the perspective becomes a factor of dramatic illusion rather than a factor of the formal composition.

The Renaissance always proposed in principle a harmonization between the painted space of the frescoes and that of the interior they decorated, but this principle was not rigid. As far as the light direction was concerned, all theorists since Cennini and artists since the Brancacci Chapel maintained the relationship. For the choice of distances, the fluctuations were considerable, and despite one or two examples relying upon the Brunelleschian method (Masaccio's *Trinity* in Santa Maria Novella[51]), there is not very often in the fifteenth century an identity between the *occhio* of the construction and the eye of the spectator. Thus the tendency was against "participation." Alberti gave painters the means of subordinating the choice of the perspective elements to the formal composition, and he treated painting as a "false window" independent of the interior, rather than as a false door opening on the neighboring room. A perspective that wants to be

"probable" must, however, continue the interior; just as, in drama, the rule of the three unities means that the time consumed in the action will approach the time taken to put on the play, and the stage will approach in space the place of action. The Albertian checkerboard and its system of relationships among objects would be improper for a more theatrical painting. Vignola and especially Padre Pozzo got rid of all superfluous apparatus in their methods, in effect; the difference disappeared between the ground plane, the receptacle space, and the foreshortened volumes. Each visible object was put directly in perspective with the aid of lines that united it to the distance point and the main vanishing point. Technically, this was a "compositional perspective," within which everything, object and space, related immediately to the eye—in a word, the solution to the confused aspirations of Gauricus.

The goal was not reached through a straight evolution. Opinions collided for two centuries. When Alberti advised the horizontal view (Gauricus's *optike*) in order to locate the spectator ideally on the same level as the *istoria* (even when the painting is placed high), and when Gauricus advised against it for the sake of clarity, the stake was obviously "verisimilitude." The point was the same in the discussion of *di sotto in sù*, which was attacked as lacking beauty and praised as fostering "dramatic" illusion, and again in Martino Bassi's inquiry in 1562 about the viewpoint to choose for a highly placed bas-relief—a question already discussed before (by Serlio, et al.) and to be discussed later (by Lomazzo). The camp of theatrical and panillusionistic "participation" was not to triumph until the seventeenth century.

Leonardo's invention of the anamorphosis marks a significant stage in the long history of these fluctuations. It came about through a technical problem raised by the too short distances of the first exact constructions. The views were false for the person who moved too far from the panel, but the docile connoisseur risked squinting.[52] Alberti's reform, permitting larger distances, attenuated the flaws of planar perspective. Among other remedies, Leonardo thought of an ingenious and amusing solution recalling both Brunelleschi's first panel and Alberti's camera obscura. He would force the spectator to look at the work by a hole drilled through a partition at the precise "viewing point" of construction. Thus he would create the three ideal conditions of planar perspective: monocular vision, an immobile eye, and an assigned viewing point; consequently, the image painted ac-

cording to classical procedure would seem to conform to "natural" or curved-space perspective. The idea, once conceived, lent itself to a curious development. It could actually be applied to any intersection of any pyramid, even when oblique to its main axis and very near to the eye; the resulting images, unrecognizable from the perpendicular view, would be correctly reconstructed as soon as looked at from the "point of the pyramid." Thus, the anamorphosis was born.[53]

This is the most radical form of nonparticipation perspective. The distance receives an almost magic power. The "false window" becomes a keyhole, the space of the image is more than ever alien to that of the spectator. This is at the antipodes of the painted *mise en scène* and of the dialogue with the public, such as had been instituted in the Farnesina and in the Villa Barbaro, and was to be continued by Padre Pozzo. The anamorphosis denies the spectator, since in itself it is a senseless scrawl, but on the other hand it requires him to create a space of his own, by projecting on a perpendicular plane the image he receives from an oblique plane. We have again, this time in terms of "participation," the fundamental paradox of perspective.

There is a regrettable difference of level between this intellectual achievement and the poor "humanist perspective" of Gauricus, but the simultaneous apparition of the two formulas is significant. The anamorphosis sums up and solves, albeit rather playfully, all the technical problems of linear perspective. Gauricus's outline of "compositional perspective" lacked technical foundations and hesitated between the incompatible demands of clarity and participation, but it was resolutely oriented in favor of narrative or dramatic *istoria*. A set of concepts very useful for the classification of the different tendencies of Renaissance naturalism could be drawn from the opposition of these two conceptions of perspective.

(1961)

Studies on Perspective in the
Renaissance

As in the days when Donatello mocked Uccello's sterile exercises
and when Antonio Manetti accused Alberti of plagiarizing Brunel-
leschi, or when, later, Abraham Bosse battled with the Academy of
Fine Arts, we have, nowadays, a "quarrel about perspective." This
inoffensive discipline has the knack of stimulating imaginations and
periodically inflaming spirits. But nowadays the quarrel involves his-
torians, and no longer inventors.

The Italian translation in 1961 of an old work by Erwin Panofsky,
Die Perspektive als symbolische Form,[1] has given Marisa Dalai oc-
casion to set out in a few pages, but very clearly and correctly, the
problems of perspective as they now appear to the historian, and the
state of the question before and after Panofsky's memorable article
(2).* Whoever wishes to know simply what the problem is in this still
lively controversy can find no better source of information. Her sur-
vey stops around the end of the 1950s, just where our inquiry begins;
among the authors she discusses only two, John White and Decio
Gioseffi, will be mentioned here again, for they dominate in large
measure the present discussion.

The various themes that make up this discussion have often been
confused, and some authors have returned several times to positions
they had already formulated. Here, the easiest way will be to deal
separately, when possible, with questions that can be taken sepa-
rately. I have regretfully omitted writings—occasionally very original
and suggestive—dealing with the stylistic aspect of perspective, with
the different systems of perspective, and with the psychological and
philosophical signification of possible illusionistic devices.

Panofsky's article remains, with the postscripts and developments

* The studies discussed in this chapter are listed in the Notes, pp. 244–45, and
will be referred to by their number on that list.

added by its author, the starting point to which we must always refer.[2] In it he affirmed the plurality of systems of perspective, and showed how each system rested on a particular conception of space and vision; he formulated clearly the postulates of Albertian or classical perspective (monocular vision, the immobile eye situated at a given point facing the object, abstraction of the lateral and vertical deformations of the visual field), and showed how arbitrary these principles are and even, in the case of the third, how contrary to principles maintained by their inventors. He wisely reconstituted the methods employed by artists or suggested, often in very obscure terms, by theorists; and he stressed the stylistic consequences of each of them, the spatial taboos they respected or infringed, the constraints they imposed on the spectator. That inexhaustibly rich article embraces the history of perspective from antiquity to the seventeenth century, north and south of the Alps; we are concerned here only with one of its episodes, however, but a central one: Renaissance Italy.

A biographer of Brunelleschi's, probably Antonio Manetti, assures us that geometrical perspective was invented by his hero and publicly demonstrated by two small pictures—the Baptistry seen through the central door of the Duomo, and the Palazzo Vecchio seen sideways from a corner of the Signoria.[3] This description, which we attribute to Manetti and which Vasari repeats with a few additional details, is very precise, of the sort from which the appearance of the two panels themselves may be easily reconstituted.[4] Unfortunately, however, it tells us nothing of the technique itself. We learn only that the first panel displayed a small hole in the place of the main vanishing point, and that one had to view it through this hole in a mirror, which undoubtedly suggests that the image had its sides inverted. Let us add that the first theoretical formulation of a method of perspective, Alberti's *Della Pittura*, dates from 1435, and that it must represent a notable improvement on Brunelleschi's methods, since the author, who dedicates his treatise with warm admiration to his friend Brunelleschi, nonetheless claims credit for the invention of the method he expounds.[5]

The first, and probably the soundest, hypothesis on the nature of Brunelleschi's method is Krautheimer's (7). Brunelleschi, he says, was primarily an architect, and had for a long time been engaged in the restoration of Roman ruins; he had no painterly preoccupations

and is not likely to have been much inclined toward medieval treatises on *perspectiva*, that is, on optics. He simply reconstituted the Baptistry or the Palazzo della Signoria by viewing the characteristic points through the usual graduated instruments, by recording the readings from each point, and then having planes and elevations serve for the placing of the elements thus obtained. Graphically this is nothing more than the process used by draftsmen who obtained the foreshortening of a capital or a head by beginning from their orthogonal projections. No theoretical knowledge of the nature of the vanishing point, or of the point of distance, or of the pyramid of vision, and so on, was necessary. (Let us remember that in the theory of geometrical perspective, the image is identical with the cross-section of a given point of the "pyramid" of rays extending from the object to the viewer's eye. It therefore depends on the relative positions of the object, the eye, and the section or *taglic.*)

This opinion is quite plausible, and Krautheimer ingeniously, by means of a simple calculation, makes it tally with what we know of the size and contents of the first panel. It does not, however, account for the device of the mirror;[6] and it surely underestimates Brunelleschi's theoretical knowledge: for Masaccio's *Trinity*, whose artificial architectural scaffolding was probably drawn, if not by Brunelleschi himself, at least according to his method, supposes an exact awareness of the role played by the point of distance, which is, moreover, indicated by a nail in the wall on which it is painted.

This second objection is contained implicitly in the writings of Sanpaolesi (especially in 17), a historian who is rather favorable to Brunelleschi and tends to credit him with the greatest possible knowledge and invention. Sanpaolesi, himself an architect and engineer, usually stresses the practical aspects, the technical innovations, and the cunning of his hero. He concurs with Krautheimer in understanding Brunelleschi's perspective more as a method for the visual determination of distances and dimensions than as the artifice of an illusionistic painter. But at the same time he attributes to Brunelleschi all the *costruzione legittima* described by Alberti, and the beginnings of the distance-point method, which was worked out only later, in the sixteenth century, and even the idea of vertical and lateral foreshortening, which was not asserted, at least in theoretical form, until Leonardo.

Parronchi, on the other hand (10), stresses the role of medieval

"perspectivists," whose influence on Quattrocento artists he tries with an abundance of bold hypotheses to find everywhere.[7] He suggests a solution to the little enigma of the mirror, for example, from a theorem of Vitellio's about the reflexion of light—which was in any case not the aim of Brunelleschi's research. But he proposes also another, more convincing and satisfying explanation: the inversion of the sides resulted from the transfer of the elements of the checkered plane of the Baptistry ground onto the foreshortened pavement of that ground painted on the panel. The mirror must have been used as an expedient to correct the error thus introduced.[8]

In the same article Parronchi proposes graphic reconstitutions of the methods used by Brunelleschi in both panels. In the case of the *Baptistry*, we note the use of the plane to transfer the elements onto the foreshortened pavement. But Parronchi does not take into account all the facts of the biographer, in particular about the distance of the *taglio*; and he freely supposes an abridged method for the construction of the transversal lines of the foreshortened pavement, more advanced even than that described ten or fifteen years later by Alberti.

My attempt to bring together, for this first panel, all the information given by the biographer and all the valid consequences deduced by White, Krautheimer, and Parronchi reaches a negative conclusion (6*): the situation of the ideal spectator, the angle of vision through the open door, the dimensions of the panel, and the distance of the mirror are not compatible with the complete illusion vaunted by the presumed Manetti. It was because of the mirror, above all, that the *Baptistry* must have been a partial failure.[9] Brunelleschi was able to get his revenge in the *View of the Palazzo Vecchio*, where he had no recourse to a mirror.

It is generally agreed that this second panel used, for the construction of its perspective, two lateral points level with the horizon, the "points of distance"; each of them was reunited with the many little equidistant divisions marked along the lower border of the panel, the *piccole braccie* that served as a base to the tiled pavement. Thus was obtained a network of two oblique, intersecting pyramidal clusters; if needed, it was easy to add a third of the same height, isosceles and

* See chapter 6 of this book.

median, which represented orthogonal lines converging toward the principal vanishing point.

This system, known as bifocal perspective, rests on a tradition of craftsmanship the first trace of which was found in a fourteenth-century fresco at Assisi. It originally served to represent in perspective any checkered plane such as a pavement, a bedcover, or a ceiling. This very simple formula had a long life; Sanpaolesi recognized it in Leonardo's *Annunciation* at the Uffizi,[10] and Viator published it in 1505. It lends itself easily to the construction of prismatic volumes seen from the side, and certainly explains the frequent use of *oblique setting* in painting before Alberti (White, 18). If the two points of distance are put exactly at the edge of the image—the most congenial solution for an easel painting—there results a somewhat brusque foreshortening, corresponding to the short distance of the spectator and with a wide angle of vision of 90 degrees. This is precisely the angle Brunelleschi used for the two panels, according to White's reconstruction; if we also consider that both represented in the center a large prismatic volume with two receding sides at 45 degrees (*extreme oblique setting*), we must conclude that Brunelleschi must have already availed himself of the bifocal method in his first panel.[11]

John White (18), who is always very attentive to the stylistic import of differing perspective methods, reckoned that the system Alberti described, the *costruzione legittima*, coincided with a change in the conventional manner of fixing the architectural background; there was a rather sudden preference for prismatic volumes observed frontally, and for orthogonal lines flowing directly toward the principal vanishing point. In effect, there is with Alberti no oblique pyramid drawn on the panel but only an orthogonal cluster and transversal lines (parallel to the line of the ground) whose intervals are determined by an auxiliary construction.[12] Thus the *Della Pittura* imposed for a long time a particular taste for, and a particular conception of, perspective; the technique it prescribed, theoretically very clear and transparent, served simultaneously to codify the postulates of so-called classical perspective—the fixed eye, monocular vision, etc.

But it was bifocal perspective—unofficial, as it were, and always peripheral to theory—that permitted the most interesting developments and out of which most hypotheses are nowadays proposed. We do not know the precise moment at which the two lateral points—the

draftsman's simple expedients—received their theoretical explanation as the "point of distance." Brunelleschi probably extended their use from the plane to space; but did he know that their distance from the central vanishing point represented, according to the scale of the picture, the distance between the vantage point of an ideal spectator and the plane of the image? It is now acknowledged that Alberti was unfamiliar with this property of lateral points, but it is as difficult to admit this as it is to doubt that Brunelleschi was aware of it.[13] In any event, we can witness throughout the fifteenth century the gradual evolution of the bifocal system which, in the sixteenth century, became the distance-point method.[14]

Gauricus's system (1504), ingeniously explained by Gioseffi (3), represents, in my opinion, a moment of transition: practically and historically, it was a simplified bifocal construction; theoretically, it could be envisaged either as a somewhat cumbersome form of distance-point construction (3), or as a particular case of the *costruzione legittima*, the *taglio* being transferred onto the median axis (5). The full justification of both methods came later, with Serlio and Vignola.

Credit has been claimed for several Quattrocento artists that they made use of the bifocal system or similar methods—more generally, of the oblique pyramid—in order to obtain a more supple and open perspective than Alberti's, thus infringing on one or the other of his postulates. The discovery by historians of anti-Albertian notions of perspective has become commonplace, and attempts have even been made to find binocular vision, the moving eye, "vision in time," etc., in Ghiberti (11), Uccello (4, 9, 12, 14), and Viator (1).

Parronchi above all, here still relying upon the schemes of medieval perspectivists, has tried to relate the bifocal method to binocular vision. The extracts from Vitellio, Roger Bacon, and Peckham with which Ghiberti filled his third *Commentary* made a conscious polemic against the postulates of Brunelleschi and Alberti. Three reliefs from the *Gates of Paradise*—the only ones that show evidence of geometrical perspective (cf. 7)—are supposed to be finely calculated respectively for the right and left eye of a spectator situated somewhere directly before Ghiberti's self-portrait (11). Such a claim is virtually impossible to verify because of the scale of measurements it supposes.

Everyone now agrees, following White, that Uccello's perspective was an original development, more flexible in its application than the classical system. With remarkable and certainly intentional freedom,

Uccello used a bifocal, or rather trifocal, system (two pyramids originating from the points of distance, the third from the principal vanishing point). Parronchi (9) thinks it is binocular vision, the lateral points standing for two eyes separated in an "ideal strabism," in function of the distance from the picture plane. Gioseffi has ably demonstrated what is really taking place: a sort of seesaw between the functions of the main vanishing point and the points of distance, each of which may be taken for the other. In the most successful example, the *Nativity* in San Martino alla Scala, this culminates in a sort of panoramic vision that approximately expresses the fact that every point on the horizon becomes—when the eye fixes upon it—the "central" vanishing point at which the orthogonal lines converge. Gioseffi cogently stresses that this involves no infraction of the rules of Albertian perspective, nor the invention of a new perspective; his mistake is only to contradict himself immediately by crediting Uccello with improbable anamorphoses, and with an extraordinary experience of stereoscopy by a sort of approximative anaglyph—that is to say, in fact, with binocular perspective (4).

For Brion-Guerry (1), Viator's brief treatise on perspective is a "spiritual adventure" that upsets all the Albertian postulates, introduces the motion and activity of the eye, considers vision "in time," and even states the principle of curvilinear perspective. In fact, Viator's practical method, which was cursory and poorly elaborated (identical, in the end, with that of Uccello's *Nativity*), confirms none of those points: Brion-Guerry recognizes this, and supports her conclusions with only a few phrases from the text which could, in our opinion, take a much simpler interpretation.

Kitao(s) takes up in his turn the idea of a non-Albertian system in an analysis of the "Two Rules of Perspective," a late treatise by Vignola (published posthumously in 1583). In his exposition of the "first rule" (the *costruzione legittima*), Vignola argued against those "who believed that two points were necessary" on the pretext that man had two eyes. Vignola retorted that, in actual sight, the pyramid of vision has only a single point and consequently, one point only is necessary to make perspective geometrical. This did not hinder him, however, from expounding his "second rule," that of the point of distance, and from proving before anybody else that it accorded in principle and in its results with the former. Kitao nevertheless reproaches him for having, with his "prejudice," checked the evolution of perspective

toward a bifocal system, and the development of style toward the use of the oblique slope in the architectonic decor.

We would be justified in asking, first, whether the theorists attacked by Vignola for presupposing "two points" really favored the bifocal rule; [15] then whether verbal clauses like "the subordination of the distance point to the main vanishing point" really were enough to impede a stylistic evolution, especially when the method that graphically gives these points an equal status was clearly expounded and justified at the same time; [16] finally, whether Vignola's "prejudice" was really that—which is to say, whether the distance-point method truly implied a conception of perspective different from the "legitimate" one.

This brings us to the heart of the matter: Was there, among the artists or theorists we have just examined, an actual "anti-Albertian" trend? Theoretically, we would have first to prove that they intended to contravene certain basic postulates, particularly that of monocular vision; this, however, has not—at least to my view—been shown. But there exists a more subtle type of "non-Albertianism": while respecting the three postulates in geometrical constructions, or taking only minor liberties with them, it is possible to suggest, by the choice and disposition of the objects, or the *taglio,* or the distance, etc., some of those realities whose representation the postulates had themselves forbidden—the mobility of the eye, for instance. But that is an affair of art rather than of system. In this sense the question "one or several perspectives" is an idle one: we could, if we chose, say that there are as many perspectives as there are artists or styles; or we could just as well maintain that there is only one, extended or modified by each according to his conception of vision. [17]

This harmless conclusion does not apply, however, to curvilinear perspective, about which Gioseffi has provoked a lively controversy. The elementary principles of Euclidian perspective require that an apparent convergence of parallels be represented not only in depth, as by Alberti's method, but also in width and length. Verticals and transversals also "vanish," and a sufficiently large vertical chessboard, seen from the front, must appear curved, as if projected onto a sphere; hence the name curvilinear perspective.

Panofsky drew the attention of historians to this chink in the armor of the traditional system; he brought out the unwitting lapses or

sophistries of the old theorists who evaded the difficulty, and he noted the first clear formulation of the problem in Leonardo.[18] Later he studied, in the *Codex Huygens*, which is certainly based on manuscripts by Leonardo, the outline of a systematic curvilinear perspective.[19] John White discovered, finally, in the works of fifteenth-century northern artists, particularly in Fouquet, definite traces of lateral and vertical distortions in the direction required by that perspective. White's work (18) is fundamental in more than one way: his analysis, undertaken with the aid of a few simple and well-chosen categories, brings to light, better than ever before, the concrete link between the formal systems, spatial conceptions, and perspectival methods of each artist or period; it yields plausible and sometimes new historical relationships. It was White, too, who collected almost all the illustrative material around which discussion has recently turned. Critics consider him the supreme champion of curvilinear perspective.

Against this curvilinear perspective Gioseffi stands as the defender of the Albertian postulates (3 and 4). A picture executed according to the curvilinear system does not correspond at all to what the eye really perceives—in part because that picture is itself an object of vision, and as such is subjected in vision to the lateral and vertical distortions which it is supposed to represent; there is thus a double distortion, or interference between different distortions. Gioseffi examines Leonardo's texts on curvilinear perspective and finds that they define the technique only to counsel against it: as for the pictures by Fouquet and others adduced by White, he claims they are simply studies through a convex mirror.

Gioseffi was aware that his argument required a specific condition, a *purchè*: the representation of curvilinear distortions becomes superfluous because the spectator's eye takes it up if, and only if, the eye is motionless and placed at the distance and place desired by the painter. Marisa Dalai (2) answered that objection: "Il senso di tutte le indagini e le ricerche sin qui ricordate, il senso soprattutto della sottile analisi condotta dal Panofsky sulla specifità dello spazio prospettico e sul concetto di spazio che vi trova espressione, stanno precisamente al di là di questo 'purchè.' " It is true that, by means of a deliberate sacrifice, painting may be nothing more than an "optical machine" (André Chastel), an instrument of illusion; in that case it

may well condition the spectator to trust to the workings of his deceived vision. The pure case of that radical conception of painting is anamorphosis, in which a drawing that has been distorted to the point of illegibility—a projection on an oblique or curved surface— becomes clear if one observes it from a particular angle or through a correcting apparatus. According to Gioseffi's justification of it, Albertian perspective basically becomes a sort of anamorphosis, because its undeniable marginal "errors" correct themselves for the "right" spectator placed in the position designed for him. One could reply as Sanpaolesi does (16) by considering Albertian perspective as a simple theorem of projective geometry, one with neither privilege nor "flaws," since it does not compete with perception; this way, at least, different systems are not excluded and condemned. But this would mean forgetting that perspective was studied by and for painters who pretended to "imitate nature," and even to deceive the eye— Brunelleschi as much as anyone. It is therefore historically justifiable to define this invention as an attempt to render the result of vision, without worrying overmuch about the result of that result—that is to say, about what takes place in the vision of the picture itself. In this third hypothesis curvilinear perspective is superior to Alberti's. And this was probably Leonardo's attitude, if we consider his position in an analogous debate: he assigned to distant objects a uniform bluish tint and blurred contours, despite Zenale, who claimed, somewhat like Gioseffi, that the eye would itself be responsible for that operation if the objects were painted sufficiently small. The aim is not to elicit a correct vision by means of indirect devices but, rather, to fix the result of vision itself. The artist deals in science, not theater.

Historians have focused mainly on Leonardo. Nobody doubts that Leonardo envisaged curvilinear perspective. But did he recommend it for painters? White thinks he did; Gioseffi thinks not. In fact, although Leonardo very probably wrote a treatise on the system, he employed it in not a single picture. Pedretti, in an article characteristically filled with new information and ingenious conjectures (15), cites this verdict: "Cosa più disputativa che da usarsi." Leonardo advised painters to avoid the difficulty by adopting sufficiently great distances; by all evidence, for him the painting was not an optical machine to be seen through a hole. But if he elected such a compromise, it was for aesthetic reasons, as was his counsel against excessively

foreshortening figures; this does not, however, affect the principle of the thing. He recounted to Caporali that he used a perspective *con due vederi*.[20] Pedretti, who exhumed that phrase, begins at the accepted hypothesis that he meant curvilinear perspective, that he tried to reconstitute it graphically *con due vederi*. He then connects Leonardo's curvilinear perspective with his experiments with parabolic mirrors and his astronomical observations and measurements; this is important, as it demonstrates that in Leonardo's mind the representation of measurements with angular coordinates (also used in topographical or archaeological surveys) led naturally to the curvilinear system. A last piece of evidence offered by Pedretti in favor of the actual existence of that system is no less interesting: the Urbino engineer Baldassare Lanzi had constructed a visual apparatus to project perspective on a cylindrical surface. Lanzi is also known as a scenographer, and the only important ancient text on the painting of perspective is precisely that of Vitruvius on theater decor—a text which, as Panofsky observed, must almost inevitably be interpreted in favor of the curvilinear system.

A difficulty for that system crops up, just as with Lanzi, in the fact that it required projection onto a curved surface—a spherical dome or, more strictly, a cylindrical wall. Did it have further to be transformed into a flat picture, and, if so, how? Corrado Maltese (8) has proven that the *Codex Huygens* envisaged two methods: either unrolling the surface (in the case of a cylinder, like Lanzi's drum), or reprojecting the picture onto another, flat surface. He aptly remarks that this problem arises for Mercator and for geographical maps on a large scale. He also tries to interpret a text by Leonardo himself (E, f° 16 v°) as a proposal for the projection of large surfaces, viewed according to curvilinear perspective, on a "herringbone" system of orthogonals.

We know, especially after Pedretti,[21] that Leonardo was the initiator of anamorphoses. If curvilinear perspective was the only system that refused to assign a fixed point of view to the spectator (vision defined by the point of construction is false, as Gioseffi showed), anamorphosis represents its extreme opposite, since the point of view fixed in advance is absolutely imperative. Perspectivists after the Renaissance adopted this second direction: not only for anamorphoses proper, whose extraordinary history has been reconstructed by Bal-

trusaitis,[22] but for the painting of ceilings, vaults, scenographies, etc.—indeed, by all those who, in the seventeenth century, believed that Circe and the peacock epitomized the essence of art.

To this brief survey I should like to add an article by Boskovits (19). This summary of a thesis written in English is remarkably well informed about sources as well as the recent bibliography. The author seems fully at ease in textual comparisons and observations on vocabulary, often accurate and striking (for instance, he notes the thought-provoking fact that Alberti does not employ the term *prospettiva*). The method of perspective drawing was, according to him, derived from workshop-studio practices and, in the case of Brunelleschi, from architectural geometry; medieval optics played only a secondary and late role. The period of mathematization, which came in tandem with the aesthetics of harmony and clarity, lasted until Piero della Francesca; then perspective changed its character, became more pictorial, psychological, and illusionistic. Boskovits treats technical questions only in passing and in the most general terms; he does not offer any new solutions and often abstains from judging the old ones. My main criticism is that he integrates too quickly craftsmen's formulas for perspective, workshop geometry, and *misure* in general, which appreciably flaws his view of the evolution of perspective.

(1963)

PART III

AESTHETIC AND METHOD

| # Thoughts on Iconography

The question What does it represent? is often embarrassing for the art historian, and an entire branch of knowledge—iconography—seeks to furnish him with many possible means to answer the question with certitude. The difficulty is not, at least in principle, merely the identification of objects appearing in a work; most often it only begins once such a first, called preiconographic, reading, is completed. The inquiry into the subject or theme of a work immediately and necessarily leads us from the problem of representation to the more general problem of meaning, or levels of meaning, in the figurative arts; that is why I venture to deal with it here, limiting myself—let me quickly add—to a paraphrase of a fundamental essay by Panofsky on the subject.[1]

First, there is the elementary obvious fact that it is not always possible to establish a nonequivocal correspondence between a figurative work and its "subject." Consider, for instance, a painting of the 1880s representing the corner of a room, a man in an armchair reading the *Journal des Débats*, a mantelpiece with a Louis XV clock and a vase of flowers, a mirror on the wall, part of a window, and so on. Of all these objects, which is the "true subject" of the picture? We can imagine titles as various as *Study of an Interior*, *Portrait of Monsieur X*, *Journal des Débats*, or *Louis XV Clock*. The painter himself may have hesitated over his "principal" intention, or decided that it was of no importance; but the critic or historian, if he wishes to understand, must then take account of this hesitation or refusal. It is not irrelevant to know that the portrait of Whistler's mother is entitled *Composition in Grey and Black*. The idea we have of the meaning of the work is related to the idea we have of its title: was it a provocation, a manifesto, a sincere translation of the artistic intent, a declaration meant to confuse? It is also historically significant—although self-evident—that such a question could absolutely not have occurred to a Dürer.

Sometimes the different subjects of a work are superimposed in stages. Let us take a thirteenth-century sculpture, representing— "preiconographically" speaking—a bearded old man with a knife and a kneeling boy whom he hugs to his heart. That is all a native of the Amazon with no knowledge of our religions would see. The average educated European immediately understands its second level of meaning: it is Abraham and Isaac. For the theologian or historian who comes across this group in a certain context on the porch of a Gothic church, this meaning alludes to a third, typological one: God sacrificing His son.

It is clear from those examples that the correct identification of the objects represented is not enough to determine the meaningful content, and we still have a choice among several legitimate interpretations; our decision depends on our historical knowledge (in the case of the *Study of an Interior*), on our idea of the intention of the artist or of the patron who commissioned the work. In any case, the initial question What does it represent? obviously calls for a second one: How can I know what it represents? or put differently: How can I seize, among equally possible meanings of a work, the right one, and how can I know it is the right one?

In practice, obviously, the problem is rarely posed in those terms, and when it is, the answer must similarly be practical and concrete. But nothing forbids us from reflecting upon principles. I propose to analyze here, from a purely descriptive point of view, different levels of meaning or categories of subjects; then the objective means of interpretation we have at our disposal; and, finally, the point at which the effort to decipher reaches into the famous hermeneutic vicious circle: one must have understood to understand.

I

The interpretation of a figurative work as a rule begins, according to an order that seems logical, by the simple "preiconographical" identification of the objects represented. In Panofsky, which I shall use here as a scaffold, this first level is called the primary meaning.* Two characteristics define it, roughly speaking: it is not conventional or learned, but calls upon the common or daily experience of the art-

*We do not have to trouble here with Category III, where the entire work, with its different layers of meaning, becomes the symptom or expression of a civilization or of a basic mental attitude; my inquiry concerns only what is intentionally signified by the mode of representation.

Object of interpretation	Act of interpretation	Equipment for interpretation	Controlling principle of interpretation
I. *Primary* or *natural* subject matter: A) factual, B) expressional; the world of artistic motifs	*Preiconographical description* (and pseudoformal analysis)	*Practical experience* (familiarity with objects and events)	*History of style* (insight into the manner in which, under varying historical conditions, objects and events were expressed by forms)
II. *Secondary* or *conventional* subject matter: the world of images, stories and allegories	*Iconographical analysis* in the narrower sense of the word	*Knowledge of literary sources* (familiarity with specific themes and concepts)	*History of types* (insight into the manner in which, under varying historical conditions, specific themes or concepts were expressed by objects and events)
III. *Intrinsic meaning* or *content:* the world of "symbolical" values	*Iconographical interpretation* in a deeper sense (*iconographical synthesis*)	*Synthetic intuition* (familiarity with the essential tendencies of the human mind) conditioned by personal psychology and *Weltanschauung*	*History of cultural symptoms* or "*symbols*" in general (insight into the manner in which, under varying historical conditions, essential tendencies of the human mind were expressed by specific themes and concepts)

ist and his public; and it belongs to images or representative figures, not to the models represented.

Those statements are obviously and in fact deliberately imprecise, and I shall have to return to the considerations they raise. But for the moment, let us remember that "to signify meaning" means, on this level, "to represent by the means proper to the figurative arts."

The secondary meaning—still following Panofsky—is properly iconographical. It differs from the first by requiring from its interpreter a certain amount of literary or historical knowledge, and by belonging not to the representative forms but to the things represented.[2]

The two characteristics thus used to distinguish between the two levels of meaning are not of the same nature; one is accidental and relative, the other constant and essential. One spectator may know through direct experience a medieval piece of armor, an exotic animal, or a living person whose image he sees; another knows such

things only through books, or through the catalogue. The difference between primary and secondary meanings is subjective, therefore, from this point of view; but it is not so according to the second criterion—the marble shape that represents an eagle and the eagle that represents Jupiter belong to logically distinct categories. The two criteria may therefore disagree, which compels us, without straying too far from Panofsky, to look closer at what happens between the two stages of his scheme.

Panofsky has stressed that the "primary," simplest, identification, of the type "this represents a chair," is not always the *first* act of interpretation, and is in fact conditioned by our previous knowledge of the stylistic conventions pertaining to the cultural milieu of the artist. At a certain degree of stylization the representative or figurative form tends imperceptibly toward a conventional symbol. (This is the case—to take but one instance among thousands—with the roof spires of Kanaka dwellings in New Caledonia, where only a trained eye can recognize the stylized form of a human head. It can even, through a series of metamorphases, become pure ornament, as in the Gallic coins derived from Greek or Roman coins. The geometrical decoration of Susa ceramics in the fourth millennium B.C. suggests a cosmological scheme—with the earth in the center, the ocean around it, clouds and rain; but we would be at a loss to say when and for whom these elements, in principle all figurative, had a primary meaning, or only a secondary meaning, or any meaning at all; in any case, for us their primary meaning appears only after we have recognized the cosmological scheme of the group, that is to say, *after* the secondary meaning.

This reversal is not always conditioned by a high degree of stylization. For example, let us imagine this scene of science-fiction: a Martian scholar finds on deserted Earth Grünewald's *Resurrection* and carefully interprets it as a primitive space rocket. The example is extreme, but it highlights the simple truth that one cannot even recognize all the primary meanings of a Resurrection if one ignores Christian tradition concerning the event. Panofsky gives the analogous example of a small luminous child hovering in the air; this can be, in different cases, a little angel, a soul ascending to heaven, a miraculous apparition, the vision of one of the painted characters, or, in the context of the Annunciation, Jesus becoming incarnate in the Virgin—that is to say, a different "object" in each case. We may conclude that

the knowledge of traditions and historical events must often precede
the primary identification.[3]

It is thus clear that we cannot absolutely define the "point of depar-
ture" or the *first* interpretative process. And it becomes even clearer
that even the line between primary and secondary meaning is flexible
and "relativist."

Panofsky classifies the representation of gestures and expression
among forms with a primary meaning. It is evident indeed that each
of us understands them by daily experience. But one may neverthe-
less believe that laughter and anger are being mimed or "signified"
by the painted characters, and not represented directly by forms and
colors on the canvas; in this sense there is a transition toward the sec-
ondary meaning.

One step further, and we come to historical painting, to which
Panofsky assigns a secondary meaning. I may indeed know and name
all the objects represented in David's *Oath of the Horatii* and yet be
unaware that it deals with an oath of the Horatii: this secondary
knowledge is derived from books, and the painting does not show,
strictly speaking, the heroes of the story, but models who posed in
David's studio and mimed the event. But how shall we classify an-
other historical painting by the same artist, *The Coronation of Napo-
leon*, in which the characters represented are authentic portraits of
the people who took part in the ceremony? Would we find there only
primary meanings for the sole reason that the work is the "portrait of
an event"?

In truth it is a question of the status of the individual represented
in art. In principle, and with rare exceptions, we may recognize only
classes of objects, not individuals, as having primary meaning: this is
an apple, an old man, a landscape, a battle. The individual features
lent to the objects or events represented are part of their appearance,
not of their meaning. When the artist's intention was really to repre-
sent one particular thing or fact and when he expressed that intention
in the title of the work—*Narni Bridge*, *The Battle of Arbelles*, *Mon-
sieur Bertin*—this individual connection may be understood, accord-
ing to Panofsky, as a secondary meaning carried by the primary one. I
see the picture of a seated man; this seated man "is" (I learn from the
label) Monsieur Bertin. The two levels of meaning are so distinct that
they can even be divorced: we shall always call *Gioconda* a portrait of
which we know with all necessary certainty that it does not represent

Mona Lisa del Giocondo. *The Gioconda* (or Mona Lisa) has become the name of the portrait, distinct from the name of the model.[4]

But there too, we become entangled in inextricable subtleties, for we must distinguish between:

a) the subject faithfully reproduced without reference to its becoming an element of meaning (that is the case, for instance, of still lifes and studies);

b) the subject faithfully reproduced, reference to it being an indispensable element of the meaning ("portraits" in the wide sense of the word: of men, landscapes, or, in "graphic reporting," of events);

c) the subject, represented from imagination (history paintings like Delacroix's *Battle of Taillebourg*).

We would then find a pure primary meaning in *a*, an incontestable secondary meaning in *c*, and indeterminacy in *b*. But the boundaries are even more fluid than this indicates: how can we know whether a still life representing game (*a*) may not in fact be a souvenir of the hunt (*b*)? Faced with such subtle nuances, which cannot be controlled, it is preferable to classify all representations of the individual together in the limbo between the two levels of meaning.

Consider, for example, a *Sacrifice of Iphigenia* in which Zeus and Artemis appear. We recognize them through their features, like old friends. Are they then, from the point of view of meaning, representations of the individual? Are they portraits? Yes, no doubt, if they figure in myths and legends; no, if they become allegories, like the Mercurys of banks and stock exchanges. But it becomes impossible to give an answer when fable and allegory coincide, as for instance the painted divinities in Rubens's *Life of Marie de' Medici*.

Objects like the unicorn and the caduceus correspond to imaginary individuals like the Olympian gods. As characteristic forms they belong to the lower level of meaning, as universals to the secondary level. But the figurative form refers directly to the universal one, and not to a meaningful object, which is why the two levels coincide.

This observation also holds when we find a quasi-object instead of an imaginary one, a formal scheme bearing meaning as if it were a represented, recognizable thing. The *Madonna of Humility* or the *Sacred Conversation* are groups of figures that have become symbolic as groups, whatever the component parts may look like. Signorelli was able to paint a Sacred Conversation with antique figures and a God Pan in the place of the Virgin; the atmosphere of lyric and sol-

emn piety survived the substitution. When Soviet filmmakers and painters used to show Stalin meditating in his study with an empty chair opposite him, it was immediately understood that the chair represented Lenin, the absent half of the consecrated couple.

It is easy to multiply examples. The method, which we might call figurative metaphor, is as common as the metaphor of language and fulfills much the same function: to suggest, on the basis of a formal resemblance, a revealing parallel. The *pietà* type has been invented as a dramatic counterpart to the *Virgin and Child*, and we can easily see what religious meditations could be inspired by this parallelism of composition; Baron Gros's *Napoleon at Eylau* is full of allusions to Trajan's Column and to antique sarcophagi, thus giving a Roman aura to the French emperor's gestures;[5] the traditional shape of Christian churches evoked the design of the Cross, of funeral monuments, and, later, of the structure of the cosmos; numerous female portraits, between Raphael and Corot, were constructed around a reference to the Mona Lisa.

This type of meaning has a special status. It is not conveyed by the visible forms in the picture, except indirectly, through a reference to something else; nor is it conveyed by the model objects either, which, in fact, receive meaning from their own form. This is an intermediary case, therefore, like several others we have already come across; but mainly it is a different case, already on the threshold of a new realm—that of nonexplicit, wordless meaning.

Let me first summarize the results of this somewhat laborious inquiry:

One cannot state that, in principle, simple, primary meanings are understood directly, independent of stylistic conventions and of more complex or secondary meanings. According to Panofsky, a comprehensive knowledge of historic tradition intervenes at this point.

Between primary and secondary meanings, we find a whole range of indeterminate or intermediary significations, notably: a) the register of expression (gesture and mimic); b) reference to the individual ("portrait" in the wider sense); c) the allegorical individual and the symbolic imaginary object (antique gods, unicorns, etc.); d) the formal type as a quasi-object (figurative metaphor).[6] The fact that it is impossible to classify these categories of meaning rigorously is explained by: the possibility of a divergence between the two criteria used to distinguish between levels of meaning; the fact that meaning may be car-

ried, albeit in different ways, both by the representative form and the object represented.

II

I have thus far limited the discussion to "vocabulary"-type significations, implying precise, definable relationships of one to one (or one to many, or many to one) between signifier and signified. But in the poetics of the figurative arts, an important role is played by a whole class of nonexplicit, almost unconscious, symbols in which the object and its meaning seem almost to fuse. Half-peeled lemons whose rind falls down in a spiral—a frequent motif of seventeenth-century still lifes—appeared to Claudel as the signature of time and the unrolling of life. This interpretation is unforgettable because it touches a truth, even if Heda or Willem Claesz never thought of it. In the packs of cards, dice, and guitars that fill the canvases of French Cubists, some have recognized Mallarmé's binomial factor of chance and numbers, or construction and games.[7]

Among many such examples one is particularly famous: Saint Joseph making mousetraps. This motif is employed by the Master of Flémalle on one of the panels of the *Mérode Altarpiece*, whose central theme is the Annunciation. Those mousetraps are a very complicated iconographical symbol; they suggest the incarnation, a trap laid by Christ for the Devil and Death who, taking the bait of a flesh-and-blood body, permitted the Savior to descend to Hell, to break open its doors and deliver the Just from Limbo. This is a bold metaphor, let alone a strange kind of theology, but the idea—implicit with several of the Church Fathers—had just been taken up again by Gerson and enjoyed a certain popularity. In an altarpiece which also bears other traces of Gerson's influence, this mousetrap placed near an Annunciation, in the hands of Saint Joseph, guardian of the mystery of Christ's birth, seems by all evidence to be an intentional allusion, an iconographical symbol of the classic, explicit type. The historian to whom we owe this discovery, Meyer Schapiro, adds the following comment upon it:

> In a poem about a beautiful maiden beside a pious old husband who is making a mousetrap, we would sense a vague,

suggestive aptness in his activity, as if his nature and a secret relation to the girl were symbolized in his craft.[8]

In spite of its bookish character, then, the mousetrap symbol has a sort of poetic truth; this was also so, according to Schapiro, of most other religious symbols adopted by the artists of that circle. The *Mérode Altarpiece* could be decoded on several levels, even entirely profane or psychoanalytical ones: the result will be, *mutatis mutandis*, very similar or analogous to the degree to which the symbols are true and natural. The naturalism of fifteenth-century Flemish painting could absorb so many religious symbols because it was a poetic naturalism that tended spontaneously to discover emotional lines of force and the essential symbolism of the objects represented.[9]

It appears, from these examples, that nonexplicit symbolic meaning is not easily separable from the style; if the painters of Baroque ceilings had put dice and guitars everywhere, nobody would have dreamed of interpreting it as the sign of an unconscious, Mallarmé-like poetics. Indeed, an underlying symbolism is more often linked with forms than with objects. Figurative metaphors may serve as illustrations, yet in that case they evoke, at least allusively, a representative content. Abstraction seems clearer when the law of a given genre intervenes to establish or define the poetic value of an image. There is a sort of mute but effective symbolism in Poussin's handling of a Biblical scene according to the formulas of bucolic antiquity. The power of that device is revealed in the breach, when the rule is deliberately broken in parody or in its complement, comic heroics: we see, according to the primary meaning, an old middle-class dotard, a drunk, and a foot soldier, while the composition bears, by its form, the secondary meanings of Jupiter, Bacchus, and Mars. (Such an effect can also be obtained through representative contents, such as the anachronisms dear to Scarron. But this return to the secondary meaning in its usual sense is of course a regrettable possibility.)

In sum, there exist two principal forms of iconographical meaning that cannot be reduced to the "vocabulary" type: natural or nonexplicit symbolism in which the sign and signified tend to fuse, and which helps largely to determine the poetics of a style; and the vaguer, more abstract symbolism of forms and compositional schemes, whose main purpose is to establish a level of dignity, and whose prin-

cipal domains are the figurative metaphor and the law of the genre. The latter leads us to the threshold of an iconography of styles.

III

After the question about the subject: What does it represent? comes the question concerning methods: How do I know what it represents?

Again we shall be guided by Panofsky's scheme, with its distinction between: a) the mental apparatus available for the work of interpretation (previous knowledge of the objects represented, symbols used, possible iconographical subjects; b) the terms of reference furnished by historical tradition (familiarity with modes of representation, stylistic conventions, usual iconographical types in a given setting). My paraphrase will tend once again to show mainly the transitions between the categories—and first, to bring the two categories closer together.

The reading of primary meanings seems at first glance a very different operation according to which art one is dealing with. Some civilizations seem to accept almost as natural a sort of dictionary of forms or formulas corresponding to the objects to be represented. This vocabulary can indeed change, but not, as a rule, to bring the stylistic formulas any closer to visual appearances. To interpret such works it is enough to know the vocabulary; the mental apparatus is therefore almost entirely reduced to terms of reference.

Inversely, in arts that aim at "the imitation of nature," and whose stylistic evolution is often largely determined by the progress supposedly achieved in that direction, the ideal would be a condition in which terms of reference become superfluous and are reduced to a mental apparatus. One begins with the idea that it is possible to transpose perception into a manufactured form, and in that operation to make only the strict minimum of necessary sacrifices, determined by the technical means at one's disposal; one admits that for each technique there is one *optimum* solution that will finally be imposed upon all.

One need no longer criticize this assumption, especially after the analysis of it in Gombrich's well-known book,[10] where it is shown that the path from perception to "likeness" implies a series of choices none of which presents, or can present, a total "objective justification"; and that those successive, or alternating and self-excluding,

choices influence even what the public takes for its naïve vision of reality. There is no "naïve vision," any more than there is a "best" artistic approximation of reality. The identification of objects represented in an art with naturalistic pretensions therefore depends less on a previous historical understanding, at least in principle; theoretically, there can be no mechanical and unequivocal reading of meanings, for there is no interpretation without preconception.

Granted that all primary meanings have been duly deciphered, Granted, too, though still without conceding it in principle, that this can happen without knowledge of the work's secondary meaning or of the stylistic conventions of representation. To proceed then to the interpretation of the secondary meaning, deemed entirely or partially unknown, one must avail oneself of a stock of knowledge necessarily gleaned (this is an important point) from the appropriate historical context. To successfully decipher the event represented in a historical painting, one must know the event, but one must also know in advance where to look for it; one must know, in other words, what subjects were possible or impossible in a given period, for a given circle, for a given genre of painting. Likewise, if the painting is symbolic or allegorical, one must naturally know in advance some of the symbols employed or at least symbols akin to those one might guess are being used. One must also have a general view of the nature of the symbolism practiced in the given milieu—the possible or impossible sources, permitted or forbidden applications. And a vocabulary of formal types is indispensable; one must be able to decode the meaning of a type encountered in a work, and at the same time know what were the actual or realizable types for the artist and his public.

Panofsky reasonably insists on the existence of a sort of circle: the knowledge of historical tradition (or "term of reference") is acquired and always completed by the "mental apparatus" while on the other hand guiding its use. The correlation is so tight, in fact, that one may well ask if the two functions can be separated: for both types of knowledge are used for research as well as for verification. The terms of so-called reference are also terms of exploration, and the mental apparatus can also serve to verify what has been suggested by the knowledge of a historical tradition.

It makes sense to carve out a separate place for a different principle—more logical and formal, essentially regulative, but often in fact heuristic; we could call it a principle of unity, that is to say, a rule

according to which one must always prefer the interpretation that offers most inner or outer coherence and best integration of the data, corroborated by the greatest frequency of cases of the same order or by analogy with already-known cases. For example, although we know that the unicorn gazing at itself in a mirror held out by a young girl is a symbol of chastity, when we see this motif on a set of tapestries (*The Lady with the Unicorn*) in which other passages refer to hearing, taste, smell, and touch, we must conclude that in this case it is a symbol of sight—the requirement or coherence winning over the vocabulary of historic tradition. In a *Wedding of the Virgin* by the Master of Flémalle, the Temple of Jerusalem in which the priests of the Ancient Law officiate is a Romanesque building, while the wedding is celebrated in front of a magnificent, unfinished Gothic portal. Coincidence or a willed symbol? A statistical check confirms, indeed, that in fifteenth-century Flemish art the Romanesque style symbolically corresponded to the Ancient Law and the Gothic style to the New Law. Again, logical coherence and statistical frequency of the motif have shown that the traditional carnation in portraits of the northern Renaissance is a symbol of Passion; but in the buttonhole of a person painted by Van Dongen, we do not doubt—again for reasons of coherence—that it is there purely as a dash of red.[11]

If we reduce this extreme example to more ordinary proportions, we come to what is probably the most important practical problem in iconographic work: How far must we go in interpretation and when must we stop? The principle of logical unity can be carried too far, as many examples of "overinterpretation" show, and frequency of occurrence may itself be an argument against symbolic interpretation. After painting innumerable portraits with carnations, how many artists still remembered the meaning of that flower? In the end they probably adopted the carnation simply as a studio habit "because it was done." But it is very difficult to know when the memory faded. We constantly find ourselves before the same imprecise and delicate question, and the same slightly scandalous need to decide what was and was not "possible" for a period, a milieu, or a given artist. Fifteenth-century Flemish painting disguises symbols as household accessories: must we, then, interpret all accessories as symbols, and if not, where must we stop? The drolleries in medieval manuscripts have, according to the milieu, more or less literary or symbolic allusions: Bosch had many; sixteenth-century Italian "grotesques" proba-

bly none at all. But to say this is to say that in each case we pretend
to know the limits of the "free play of imagination" (or the gratuitous
pleasure of evocative description) that artists allowed themselves, or
were allowed.

Thus we find, in this area of means and methods of interpretation,
a situation similar to that which we encountered in the field of mean-
ings: a continuous passage from elementary forms to superior forms,
and the reciprocal conditioning of the two ends of the chain. The
application of plain knowledge of the vocabulary type (things, forms,
or symbols) more or less implies a background of principles that are
both heuristic and regulative; and those principles, which have a dou-
ble logical (analogy, coherence, frequency of occurrence) and histori-
cal (integration into the spirit of a given milieu) connotation, lead di-
rectly to the boldest hermeneutics.

IV

There is nothing very difficult or paradoxical about the circular
relation between the simple and the complex aspects of figurative
expression. An almost identical relation exists between the meaning
of words and the meaning of the sentence they compose; there, too,
the whole illumines the parts, and there too, style provides a guiding
thread with a double heuristic and regulative role.

Let us stress those cases that allow us to grasp fully the priority of
style as the factor determining the horizon of iconographic work. My
examples deal not with a codified style—a combination of more or
less conventional signs with a representative function—but with the
differential style that in each work can translate precise and unique
intentions. Thus can we establish the characteristics proper to the
relationship between hermeneutics and tradition in the field of
iconography.

My inquiry will proceed through two stages: first a general view of
the understanding of artistic styles, or "connoisseurship," then its
application to the problems of iconography.

It is remarkable that all disciplines that have individual expression
as their object—graphology, psychoanalysis, art history—are com-
pelled to take as a working hypothesis, never verified, a most rigorous
psychological determinism. They are obliged to do so by definition,
precisely because they take individual expression as their object and

must, at least for a while, study it *as an object*. (Psychoanalysis in fact transcends that attitude when it becomes a therapeutic method, and art history when it resorts to judgments of value and quality, before and after the work of attribution.) The writings of the most connoisseur-like art historians are filled with sentences such as: "This drawing reveals the outlook and vision of a sculptor; it cannot be attributed to X who is a luminist painter." "Because of its much freer manner, this painting must be dated at least five years later than is usually done." "This facial expression is an unfailing characteristic of such and such an artist, and the attribution is moreover confirmed by a motif of folds that is found in his other works." The connoisseur forces himself not only to recognize the stylistic characteristics of a master or of various phases in his evolution, but also to say which characteristics can be imitated and which cannot, which are permanent and which may disappear, what is the chronological order of their appearance; no connoisseur hesitates to assert that such and such an artist, at a given period, "could not have done" this or that. Naturally it can happen that connoisseurs differ in their opinions, but any reader of such controversies knows that they are not mere battles of words, even if the authors are naturally reluctant to give formal demonstrations.

Thus the connoisseur and the critically minded art historian display, at the same time and through the same intellectual process, *a)* an amazingly subtle understanding, an intuition of individual characteristics that is almost untranslatable into words, and *b)* a hypothesis concerning naturalistic work that verges on mechanism. The intuitive understanding and psychological determinism go together and mutually condition each other, as in all sciences of individual expression. I need not discuss this paradox further here, but we shall encounter it again in iconographical work, where the style of a work must furnish the key to its meaning.

I mean "key" in its musical sense: the style indicates how the significant terms must be read. There is even something almost like the conventional notation of the clef, and that is the law of the genre. A *Holy Family in a Landscape* is distinguished *toto genere* from a *Landscape with Holy Family:* the former belongs to sacred art, the latter to landscape painting. A nuance of style, often deliberately slight, is enough to change at once the subject, the artistic genre, and the ultimate intention; and sometimes the artist remains intentionally ambiguous. One may ask whether Velázquez's *Mars* is a *Study of a Sol-*

dier Dressed as Mars or a Mars parodied in the figure of a soldier: according to the degree of humor we find in it or the degree of fascination with the picturesque, we have two entirely different subjects.[12] Portraiture and religious painting often overlap, as, for instance, when a character is represented as Saint Jerome; stylistic reasons alone almost allow us to classify Reymerswaele's *Tax Gatherers* as portraits, as allegories of Usury, or as genre paintings. As a rule, a mixture of artistic genres or a wavering between two genres is intentional: since a genre expressed the level of dignity or "nobility" in art, a deliberate blurring or effacing of its limits was an act of vandalism, a parody, or a revolutionary protest—or at least a marked demythification of certain accepted values. We know how Caravaggio was judged by his patrons for having transgressed the laws of the religious genre.

But those laws only, as it were, institutionalize a more general dependence between style and subject. I gave the example of a man reading the *Journal des Débats* in front of his fireplace. The "real subject," if there is one, would depend on the treatment. An insistence on space and on effects of light, joined to quick brushstrokes, would suggest the title *Study of an Interior;* if, on the contrary, the face is highlighted and the character presented with a certain seriousness, it is a *Portrait of Monsieur X;* some subtler signs, particularly the glance, might eventually make us think of a self-portrait; if the viewer has the impression that the artist was interested in some small striking effect of color or form, he will not be surprised to find a title like *Journal des Débats* or *Louis XV Clock.* Obviously, all this does not exclude hybrid or intermediate cases, such as portraits that are also scenes of domestic life (Menzel or Vuillard).

Of course such distinctions do not always correspond to real problems for the art historian. There was a time when artists had no compunction about changing the genre or subject of a painting without taking account of the style, simply by adding or removing an inscription, a halo or an attribute.[13] In the nineteenth century, after the end of Romanticism, the association between style and genre was gradually replaced by an association between style and subject—to such an extent that it finally became clear that many naturalistic or impressionistic works had nearly as many possible subjects as there were possible points of view to judge them from.[14] The question becomes serious only when there is a real iconographical enigma, that is to say,

when one must decide how far to go in deciphering symbols, and what place one must allow for the artist's gratuitous invention.

In such cases the analogy with the problems of the connoisseur-historian becomes complete. Relying on his experience—which ideally should be rich—but with virtually no possibility of demonstration, the iconographer must give his verdict: that the apparently realistic accessories of a given picture "cannot" be there simply for the sake of disinterested description since, given the moment or the milieu or the speculative temperament of the artist, such freedom would be inconceivable. Or, on the contrary, that one need not search for symbolic meanings in the decorations of such and such a manuscript; at best one need look for only a few semipopular literary allusions, since the style indicates the ambience of a convent little inclined to such explorations. There are many famous examples of works that are the subject of endless discussions, such as those by Hieronymus Bosch or Michelangelo, because their iconographical reading largely depends on an initial intuition about how much coding one should expect, or rather—which comes to the same—about the artist's Weltanschauung.

Only in those extreme cases, when iconography becomes the work of the connoisseur, does it also become truly a hermeneutics in the sense given to this word by philosophers. As long as iconography is a semantics, it requires "feedback" and a circularity of method. But when the very meaning of the signs and the level of significance at which one stops depend on a key that is no longer a clearly definable sign or operator, we enter the properly hermeneutic circle which precedes comprehension.

But what kind of hermeneutics? I shall conclude this account, already so replete with diagrams and lists, with a final chart of the different types of hermeneutics and their distinctive characters.

A. Disciplines that study individual or singular expression, such as graphology and some aspects of art history, iconography, stylistics in literary history, etc., present a number of common features:

1) their proper subject is the singular, as far as it stands out from tradition or from the common fund; the relation between the expression studied and the tradition from which it stems is similar to the relationship between figure and background in gestalt psychology. A tradition considered in itself is detached from another, more general background (for instance, one can make a graphological analysis of the

Type of hermeneutics	Understanding of the expression of the singular	Understanding of the tradition	Historical understanding
Object of hermeneutics	The phenomenon of expression as distinct from tradition	The tradition underlying expressive phenomena	Singular expression and tradition
Hermeneutic way	Interiorization of the object	Objectification of experience	Syntheses of interiorization and objectification
Central paradox	Understanding results in objectification	Objectification annuls understanding	The understanding of history is itself historical

writing of an epoch); but it is always approached as a singular "phenomenon of expression";

2) their subject is approached frontally, or from the outside; hermeneutics must make an effort to "enter into the spirit" of what it studies;

3) success leads paradoxically to a sort of objectification of the very spirit one has penetrated. Its reactions become predictable or, at least, subjected to a very simple law.[15] This is what prevents hermeneutics from sinking into pure *Erlebnis*.

B. The hermeneutics of living tradition (mythical, religious, political, etc.) are found at the opposite pole:

1) their object or "figure" is what was the "background" in the previous case;

2) this object is approached from within, by an effort of thought that establishes a distance where in principle (in a limiting case which is no doubt ideal) there was none;

3) full success would contradict the point of departure, since its result would be to treat an accepted tradition as mere historical news or phenomenon of expression. The student of hermeneutics must, therefore, guard both ends of the chain, according to the paradox summed up by Ricoeur's formula: myth "makes us see."

C. Between those two extremes, there is a whole range of historical disciplines that require comprehension:

1) they can move freely in both directions between the "background" and the "figure," produce a monograph on a work, or reveal from a succession of facts an underlying tradition of which those who experienced it may have been unaware (the Baroque, for instance, or Mannerism);

2) they presuppose, at the beginning of the hermeneutic process, a mixture between precomprehension and exteriority in variable proportions;

3) they are subjected to a similar "circle of historical understanding" but in a sense opposite to the usual circles of understanding. Apart from the general fact that one must always have understood to understand (the solution comes somehow before the problem), we come across the additional paradox here of the historicity of historical understanding itself (the problem is found, again, somehow in the solution). Investigation approaches type A, to the extent in which the historicity of understanding differs from that of its object, and type B to the extent in which they tend to fuse; all intermediary situations are possible.[16]

In truth there are only intermediary solutions, because all hermeneutic science, even that of the graphologist (A) or that of the performer of a rite in a primitive society (B), is always more or less caught up in history. But hermeneutic disciplines generally find it difficult to define their place at that level, or their exact degree of historicity. In the case of art history, in particular, all theoretical problems, like the one we just discussed, are reduced to the one and basic question: how to reconcile history, which furnishes its point of view, with art, which furnishes its object?

(1963)

CHAPTER
9.

Judgment and Taste in
Cinquecento Art Theory

For the visual arts, consciousness of artistic individuality was a late acquisition. Certainly the public knew, long before 1500, that there existed good and less good artists; it even knew that art was as much a matter of innate gift as training, and that a master could excel in some "part" of art and fail in another. And about the middle of the fifteenth century some artists affirmed as a plain fact of experience that it was possible to recognize distinctly the "hand" of each master; then, in the ambience of Florentine Neoplatonism, the current adage *ogni dipintore dipinge sè* was interpreted for the first time as a doctrine of expression.[1] But the definitive discovery of the artistic temperament and the crucial assertion that, in the case of great masters, the personal character of the work can have a value of its own, belong mainly to Cinquecento aesthetics, where they are best traced in the oft-told history of the word *maniera*.[2]

This process of the acquisition of critical awareness has literary sources and models: Politian, Pico, Aretino These are not the only ones, however, as we realize if we consider semantic evolution parallel to that of *maniera:* I refer to the transformation of *giudizio* into *gusto*. The discovery of individuality in expression demanded and presupposed individuality in the appreciation of works of art; *maniera* and *gusto* are complementary. But this complementarity and its deeper causes are rarely mentioned in literary criticism, nor have they reached art criticism through the customary channel of letters.[3] They come instead from a third field, natural philosophy, and primarily from those of its disciplines that especially concern the soul—astrology, the theory of temperaments, magic, and their more worldly and subtle forms: the theories of love, of female beauty, of persuasion, of musical moods, of melancholy genius. There we find the principle and explanation of the affinity between a soul and a thing or

between a soul and a soul. From this point we may establish a relationship between styles and tastes, even unite them within the concept of "productive taste" or within that strange equivalence once proposed by Poussin, *stile, maniera, o gusto.*[4]

Without lingering over the literary or philosophical/scientific sources or background, I shall attempt to describes the stages of contact, and of semantic contamination, through which *gusto* gradually replaced *giudizio.* I shall also try to see what this process meant for Cinquecento aesthetics. One might think at first that it denoted a triumph of irrationality and sensualism: the intellectual faculty of judgment, as a metaphor for artistic understanding, is ousted by the most immediately sensual, the most irrevocably subjective of the five senses. But this interpretation, which is not wrong, is too schematic, and must be much nuanced to fit reality.

Giudizio

For the Renaissance, judgment was not a purely intellectual act; it belonged to a domain intermediate between the mind and the senses. It related the sensible particular to the intelligible universal or, inversely, the universal to the particular; it was in that respect similar to the *aestimativa* of animals, to their faculty of "judging" objects and feelings instinctively or emotionally. Judgment as an act was in the last analysis an immediate reaction to things perceived, and must not be confused with a proposition deduced from other propositions. But this immediate reaction could be rationalized—in the sense that reasons might be found for it.

Less important were the variations within this logico-psychological doctrine, the distinctions, which vary according to author, among *cogitativa, scrutinium, imaginativa,* etc.—all faculties more or less attached or assimilated to *judicium.* It suffices to note that for traditional philosophy the concept of judgment implied at the same time immediate perception and virtual reason—that is, an ambiguity or polarity that we find again in the aesthetic concept of taste. "Antinomies of taste," according to Kant's *Critique of Judgment,* reproduce in their own way the traditional antimonies of *judicium.*

Among the quasi-synonyms of *judicium* only one is of interest to this study: *discretio.* This faculty or power had its day in art theory and nearly took the place eventually assigned to *gusto.* The power of

distinguishing is, like judgment, halfway between sensitivity and intellect;[5] its field of application begins where deduction leaves off. We know the importance of *discrezione* to Guicciardini, particularly in the final edition of his *Ricordi:* in the face of a political reality too complex to be fathomed, too much at the mercy of chance to be foreseen, reason is lost; but *discrezione*, a quasi-reason, can be used as a sort of compass. Without abstract precepts, this faculty is not strictly speaking obtainable; one cannot be *discreto* at will. It is significant that in the theory of art *discrezione* tends to be substituted for *giudizio* in Venetian circles of 1550—that is, at the height of the anti-academism inspired by Aretino: authors of that period repeated that one must not blindly apply Vitruvius's canons to all the figures in a drawing, but rather adapt them to the particular case with *giudizio e discrezione*—those terms being, according to Pino and Dolce, synonymous.[6] Lomazzo's *Idea del Tempio della Pittura* (Milan, 1590) is built entirely on the notion of *discrezione*, defined as the third term between theory and practice, or as the critical consciousness that adapts means to ends.[7] An extremely strange analysis by Campanella about *discretio spirituum*, the intuitive knowledge of souls, is very close to our conception of taste, and even employs the same gustative metaphor, while applying to the description of that faculty traditional commonplaces about art in general.[8]

But while from the beginning *discretio* occupied an ambiguous and mediating position, the aesthetic sense of *judicium* oscillated between a narrow assimilation to pure intellect and a no less narrow bringing down to the particular (temperament of the artist, nature of the concrete task). We should try to mark the stages between those extremes and fix the intermediate positions; but we must remember that this is not a linear evolution, but rather an ever-open range of possibilities where the old and the new coexisted despite a certain tendency toward the empirical solution. (Moreover, not all Renaissance senses of *giudizio* fit within this range.) The range is more or less as follows:

According to a Platonic—or, more exactly, Augustinian—tradition, judgment in the liberal and fine arts was a sort of anamnesis. For example, we possess by nature, said Ficino, the perfect images to which we compare the works of artists: "Quomodo rursus structurae, musicae, picturae et artium ceterarum opera necnon inventa philosophorum, multi etiam in his artibus non versati probarent saepissime recte et reprobarent, nisi illarum rerum forma quaedam esset et ratio

illis a natura tributa?" A little closer to experience, Alberti assimilated judgment to an interior, innate sense, which was nonetheless still *ratio* and not simply *opinio;* the possibility of deriving it from the Ideas remained vaguely open: "Ut vero de pulchritudine judices non opinio, verum animis innata quaedam ratio efficiet. . . . Unde autem is animi sensus excitetur et pendeat etiam non requiro funditus."[9]

Even Leonardo conserved a distant trace of this Platonism when he wrote, in a famous passage, "quando il giuditio supera l'opera, essa opera mai finisce di migliorare."[10] Serlio, about 1546, observed that there were many discussions to decide whether *giudizio* was acquired or innate, and he proposed a compromise solution: that was to recognize certain rights of empiricism.[11] With Persio, in 1576, judgment finally turned its back on intellect: it presupposed knowledge, but was directed toward the *parte appetiscente;* a simple intermediate faculty, it has none of the creative and natural spontaneity of *ingegno*—one could be judicious without being ingenious, and vice versa.[12] One step further and we are at the opposite pole from Augustine and Ficino: *giudizio* does not appear as the recollection of ideal rules, but, on the contrary, as the faculty of discarding such rules, when and where necessary. Judgment is, then, the exact equivalent of Guicciardini's term *discrezione.* We find this use of *giudizio* as the source of appropriate license by Raffaele Borghini, and also for poetry, by Tasso;[13] which creates a bridge toward the "prudence" which adapts universal art to concrete example, and toward the famous *bisogna avere le seste negli occhi* of Michelangelo, with the auxiliary ideas of *facilità, grazia, arte di nasconder l'arte,* etc.[14]

To identify *giudizio* thus understood—that is to say, as close as possible to the contingent particular—with "taste" as we understand it today, we need only add to it one feature: diversity according to temperament. The acknowledgment that "judgments" about beauty are irremediably diverse is one of the persistent commonplaces of all treatises on love, beauty, and grace; Castiglione had already deduced from it that there was no absolute perfection in art.[15] Occasionally the difference of tastes, always explained by complexions and astral influences, came to be called a difference of *giudizii.*[16] In any case it was recognized throughout the sixteenth century as an accepted fact, just as worthy of attention as the diversity of styles corresponding to individual temperaments, or to different periods or circles.[17] Thus the way was prepared for the equation of *giudizio* with *stile.*

This equation implies the concept, strange to us, of a "productive judgment," in other words, the confusion between *giudizio* and *ingegno* already suggested by Alberti and Ficino and criticized by Persio and Valdes. Leonardo had explained the likeness between the painter and his figures by the intervention of a creative judgment which, *inanti sia il proprio giuditio nostro*, fashions the body it is going to inhabit.[18] But the use of *giudizio* as an expressive or creative faculty seems above all specifically Venetian.[19] Aretino, around 1537, opposed this "natural judgment" to "art" as one opposed innate gift to acquired practice: "Guardate dove ha posto la pittura Michelagnolo con lo smisurato de le sue figure, dipinte con la maestà del giudizio, non col meschino dell'arte. E perciò fa da uomo natu-alone. . . ."[20]
(Perhaps we should understand in the same way Serlio's remark, quoted above, concerning whether *giudizio* was innate or acquired. Serlio was Aretino's friend in Venice before he left for France.) Another letter of Aretino's in which judgment was called *figliuolo della natura, e padre del arte*, identified that faculty with artistic personality, with a particular temperament, which must be followed: "Giudicio, dico: ché l'altre cose [other people's works] son buone per vedere gli ingegni degli altri, onde il tuo si desta e si corregge. . . . Chi non ha giudizio non conosce se stesso, e chi non conosce se medesimo non è conosciuto d'altri, e chi non è noto ad altri anulla il suo essere."[21]
Following in Aretino's footsteps, Pino understands *giudizio* as innate talent, or talent perfected by its exercise: ". . . in questa part [judgment] ci conviene aver la natura e i fati propizii, e nascere con tal disposizione, come i poeti; altro non conosco. come tal giudizio se possi imparare. E ben vero ch'isercitandolo nell'arte, egli divien più perfetto, ma, avendo il giudicio, voi imparerete la circonscrizione. . . ."[22]
Outside Venice we find the association *giudizio e ingegno* in Vincenzo Danti, without being quite sure yet whether he wanted to establish a difference between the two words or not; Armenini, however, clearly stated that *disegno* (meaning invention) is conceived *dall'animo e dal giudizio*;[23] all readers in 1587 understood that this *giudizio* that generated ideas could only be *ingegno*.
This sense, which now seems aberrational, is in fact explained by the contamination of *maniera*: any faculty which characterized a person belonged to the order of expression, and therefore *giudizio*, because it is personal, must be the same as style.

Gusto

Gusto met *giudizio* on the aesthetic plane after having itself moved halfway across the ground that separated their respective meanings. In its proper, original sense this term might be understood either as a faculty of the sentient soul ("taste distinguishes flavors") or as a quality of the perceived object ("the taste of orange"). It was the latter that first lent itself to metaphors or critical language, at least in Latin. Thus Quintilian: "sermo prae se ferens in verbis proprium quendam gustum urbis;" or, in humanistic texts: "Sed velim in templo . . . nihil adsit, quod veram philosophiam non sapiat (Alberti)"; "Male doct[i] . . . qui . . . omnia exigunt ad Ciceronis gustum" (Politian).[24] But when the same Politian uses *gustus* figuratively as a subjective faculty ("Nec enim gustus idem omnibus, sed suum palatum cuique"),[25] he still feels the need to explain this liberty.

In Italian, *gusto* very soon acquired the meaning of desire, impulse, penchant: In the *Divine Comedy*, Pier delle Vigne is driven to suicide by his *disdegnoso gusto*; Adam ate the apple out of *ardito gusto*.[26] Often this "taste" was used as a substitute for "satisfaction of taste"; in French the word *goût* retained in that case a slightly critical flavor ("*déguster*"), but Italian, probably influenced by Spanish, turned *gusto*, into a mere synonym for pleasure or pastime around 1600.[27]

Those meanings provide only a general background, a summary allusion to the immediate affective awareness that justifies the metaphor of critical "taste." Campanella, who had exploited the etymology *sapor-sapientia*, talked of *gustus* as a form of knowledge; in a well-known extract from the preface of his *Metaphysics*:

> Novam condere metaphysicam statuimus, ubi . . . reducti sumus ad viam salutis et cognitionem divinorum, non per syllogismum, qui est quasi sagitta qua scopum attingimus a longe absque gustu, neque modo per authoritatem, quod est tangere quasi per mamum alienam, sed per tactum intrinsecum in magna suavitate, quam abscondit Deus timentibus se. . . .

Campanella's naturalistic attitude, his defiance of syllogism and authority, and his appeal to personal experience all correspond, *mutatis mutandis*, to the naturalistic attitude, the defiance of rules and can-

ons, and the appeal to artistic instinct by those critics who launched the concept of *gusto*. This confident acceptance of a subjective and incommunicable value is akin to the old idea of natural magic.

In the sixteenth century, *gustare* sometimes already implied discrimination: "la mirabile perfezione delle [statue antiche] chi gusterà e possederà a pieno, potrà sicuramente correggere molti difetti di essa natura."[28] There was also a vague awareness of a link between *gusto* and personality; thus Doni on drapery in painting: "questi panni sono tutta gratia e meaniera che s'acquista per studiare una materia fatta d'altro maestro, che più t'è ito a gusto che alcuno altro."[29]

Taste, therefore, indicated a personal affinity of the artist with the master he must follow to form the sort of style that suited him best, particularly as regards those accessories for which there was no valid rule (*sono tutta gratia e maniera*). Lomazzo, in chapter II of his *Idea*, developed at length and ponderously this pedagogical maxim: one must choose one's master according to one's tastes, in order to develop one's own personal *maniera*. We are on the threshold of "productive taste," a seventeenth-century notion that, as we have seen, was prepared by the productive *giudizio* of the Venetians. Taste determines style, which is a sort of involuntary self-portrait of the artist. Thus all leads to the identification of *maniera* and *gusto*—as Poussin said, according to Bellori.

But if *gusto* usurped the place of *giudizio*, it immediately took on its intellectualistic inheritance. The first example that one is tempted to quote as evidence is perhaps ambiguous: it is Filarete congratulating his patron for having distinguished between the Gothic and the antique: "Signiore, la Signoria Vostra comincia a gustare et a'ntendere."[30] Filarete may not have considered the two verbs as synonyms, and may have distinguished between motivated judgment (*intendere*) and mere pleasure (*gustare*). But when Vasari wrote that Michelangelo "ebbe giudizio e gusto in tutte le cose,"[31] he obviously meant to bring the two notions together. Such an intention is even clearer with Lomazzo, who said frankly, concerning divergences of opinion on female beauty: "giudizio ossia gusto della bellezza."[32] On connoisseurs and art lovers, called *intendenti* and sometimes *giudiciosi*,[33] Giulio Mancini bestowed—perhaps for the first time—the name of *huomini di gusto*.[34] It is clear, in the light of such antecedents, that their taste must have been as much, or more, a matter of

discrimination as of pleasure. The question of the rationality of appreciative judgment was posed for *gusto* as it was for *giudizio*;[35] for the first time we find the paradoxical idea of a normative taste:

> Il buon gusto è si raro
> C'al vulgo errante cede
> In vista, allor che dentro di se gode.[36]

Buon gusto, buona maniera: there lies the whole problem of Mannerism, and later of Academicism. *Gusto* is irreducibly personal, the expression of immediate subjectivity, but it cannot exist without a normative character; in the same way, *maniera* is the expression of a psychic structure but is nonetheless affected by an absolute aesthetic value. It is true that *gusto* and *maniera* may also reflect the "personality" of a group, a milieu, a current of thought, an epoch. Is this to say that one can treat the normative pretensions of "good taste" as a mere social convention and eventually dismiss it as such? Some *scapigliati*, such as Aretino, Giordano, Bruno, seem to have thought so. Mannerism and Academicism could not admit this radical doctrine, however, and were thus placed with the difficulty of having to give *ab extra* a valid foundation for what they called perfection. At a time when philosophers were more than ever pondering the problem of living truth, artists were grappling with the problem of personal beauty: it was the same contradiction *in adjecto*, the same antinomy, as unavoidable and insoluble for one as for the other.

The history of oscillations between "indisputable" taste and "good taste" taught by academies filled the ensuing centuries. It lasted as long as the conception of art as an imparting of emotion or message; for taste was, by its simultaneously individual and social character, both expressive and normative, both the vehicle and the natural means of understanding between artist and public. But the social function of taste soon smothered all other functions. Twentieth-century Expressionism, no longer believing in communication distinct from expression, became quite logically an art of deliberate bad taste. More recently the idea of message has been dismissed and replaced by that of invention; so taste seems excluded from great art. And where it still reigns, in decorative and industrial arts, in fashion, and so forth, it has lost its original aesthetic meaning; it is no longer the

expression of an individual temperament: on the contrary, it is a language of artistic sensibility shared by a circle of connoisseurs—not much more than an impersonal means of understanding among similar people.

(1961)

CHAPTER **10.** | Notes on the End of the Image

A "living" image does not resemble its model; it aims not to render the appearance, but the thing. To reproduce the appearance of reality is to renounce life, to confine oneself to a view of reality that sees nothing but appearance, to transform the world into a shadow. Plato recounts that the ancients chained the statues of Daedalus, fearing they might take wing; and they were archaic works. We hear nothing of the kind about the Venus of Praxiteles, which was nevertheless the lifelike portrait of a well-known hetaera. It is true that this stone led the love of a young man astray, as a licentious novel might have done; the trompe l'oeil does away with the marble. But it does not create a woman in its place; it creates a vision.

If we wish to render "what we see," we must reproduce Maya's veil, for we never perceive but our own perceptions. The green or violet shadow on the temple of Rubens's peasant may be faithfully observed, but it is certainly more fanciful than the gray shadow on the arm of Ingres's model. The pursuit of visual truth snares illusion: in art, if not elsewhere, empirico-criticism leads to idealism. The faithful image of an illusory image is not even a thing, it is (and this is said not at all pejoratively) a play of effects on canvas or bronze; Impressionism's last word can only be decoration. The art that pretended to ape nature virtually lost its gamble when it began to seek likeness.

Against each innovation felt to be revolutionary and each wave of naturalism in Western art, part of the public protests: it's a real parody! Thus, unintentionally, it underlines the continuity of traditions beneath the apparent ruptures, for parody at least preserves the look, the general aspect—let us say, a form—of its object.

The critical role of parody is precisely to release the forms, to empty them and prove their emptiness by applying them haphaz-

ardly. Consider Aertsen's monumental cook holding her skewered chickens as Saint Catherine holds her wheel on a triptych panel: this is scandalous, parodic naturalism. But it permits every painter thereafter to see that the sacred forms of sacred art are found in daily life and warrant genre scenes as beautiful as altarpieces. Similarly, an informal or Tachist painter "mocks the public" (he parodies the very practice of art), but allows every newcomer thereafter to make art just by looking at torn posters. Thus conscious of its means, art advances, like mathematics, by successive abstractions and generalizations (which are, needless to say, so many inventions)—with the difference that to the artist these departures appear critical and negative.

This applies even to the work of the respectful disciple who imitates and perhaps exaggerates the style of the master. We have known for a long time that "mannered" is objectively a sort of criticism; it signifies that in the end anybody can do as well as the great man—provided he is shown the way.

The cult object that has become a museum piece—that is to say, form and meaning and, at best, evocation of atmosphere—is a parody, a benevolent god behind glass smiling, always with the same consoling compassion, on people who demand nothing of him. The same goes for the Dadaist object intended to make the bourgeois howl, which at present other bourgeois seriously contemplate, taking notes. More generally, everything placed in a museum become *ipso facto* its own parody, put there to eternalize a gesture from then on empty or untenable. But the metabasis is so complete that one has to be a boor to see that it is comic.

All intentionally new art is a parody of the preceding to the exact extent to which it makes use of it; and all art that has outlived its time becomes self-parody. Desacralization and misreading are the motors of artistic life, as inseparable from creation as from judgment.

Academicism may be defined by the axiom that every work of art is the approximate solution of a task that calls for an ideal solution, the critic's role being to compare these two solutions.

History offers a great variety of formulas for the perfect model against which success or failure in art is measured. Some of those formulas—the earliest—were naïvely objectivist: the work was confronted with external reality (the myth of the mirror) or with ancient perfection. Next, the touchstone was internalized, while remaining a

concrete image: it was "the idea conceived within the intellect" and more or less betrayed, one believed, by execution. There were other, more subtle versions that brought in history and convention: the "law of the genre," for instance, requiring one style for the noble land-scape, another for still lifes, and so on. The ideal solution would then require, beyond a prescribed general arrangement and beyond cor-rect technique, a certain element of style. In those epochs when art was supposed to convey emotion from the artist to the public, the work was judged by comparing the ostensible feelings of its creator with those experienced by the critic; or one considered whether the artist had been able effectively to express his personality, somewhat as one had once considered whether he had properly rendered the movement of a horse.

The drawback of this distinction between the real being of a work of art and its hypothetically perfect being was inescapable, until the extreme limit of concessions at last was reached. Impressionism, Symbolism, and Expressionism, in accord on this point, demanded of art only that it should propose a state or moment of a reality that is no more psychical than physical, no more matter than memory, no more art than life.

But there, too, something that was not of the work cropped up within it. Admittedly, it presented itself as a lived moment, an imme-diate encounter, a revelation, an act; but, independently of the object represented, we recognized the experience it was for us as having al-ready existed beyond all art—a memory, an archetype, a key on our keyboard which only awaited that hand. In this sense, to understand the work still meant to penetrate beyond it. The monistic demand which is at the root of every aesthetic attitude did away with that last trace of division within immediate, pure, artistic revelation.

The rejection of academicism thus led, slowly but surely, to the rejection of any *terminus ad quem* for the work; a Tachist canvas is nothing more than itself, and cannot be measured against anything. Such a situation rules out, first, academic criticism (which is like cor-recting projects for school competitions, proceeding by comparison with an ideal prototype established by the professors). A closer look, however, reveals that it aims at the essence of all art criticism as well: however one tries, one cannot judge a work attentively without hav-ing to extol an elegant solution, criticize dullness, admit to emotion or

indifference, to a feeling of rightness—in brief, without implying, however remotely, an idea of what that work should have been.

In turn, the death of criticism brings in its wake the death of the work of art as a possible object of aesthetic appreciation. At present art is elsewhere than within that which serves as its pretext—but it is before, and not behind, the work: in the glance that poses it, in the mechanism that produces it, in the invention of such mechanisms, and so on.[1] That is where we are now: on one side the "ideal model" posited by the academic dichotomy, unreal but in the end inseparable from all art criticism and every work; on the other, art as intention or act (of the artist, or the public, or both together), at once the foundation and the negation of its products.

Far from experiencing before the empty canvas that fearful and chaste respect of which Mallarmé spoke concerning the blank page, the contemporary painter acts out before it a sadistic rage: he stains it, soils it, streaks it, erases it, hurls solvents and acids onto it, burns it or tears it with a knife. Then he carefully picks up what remains and takes the object to a dealer.

This contradiction underlines a fundamental difficulty: contemporary art being what it is, the work only exists through a paradox, as if despite itself, by negating itself. Some have drawn the obvious conclusion; I have been told of a sculptor who exhibited a tower full of dynamite and, at his *vernissage*, exploded it. Others have found more subtle and ingenious ways of impugning the work as the creation of one who wishes to communicate. Never mind! one cannot monumentalize more than once the refusal of a monument. The 1962 avant-garde lies not in such inventions—Dada already said all there was to be said on the matter—but rather in what is beginning under our very eyes to substitute itself for the work of art.

Before us an art devoid of external likeness, without any ideal model, ever ready to disappear as it advances from parody to parody-of-parody, denying itself to the point of sometimes existing only in the form of its own contradiction. Is it doomed?

The blows directed against art aim in fact only at two of its aspects, the image and the work. But these do not exhaust art, and the task of art remains.

The art work is no longer an in-itself; it is the end of a certain process that may, in the retrospective view of the visitor to a gallery, be called artistic creation. But it is the process, not the product, which counts. To demonstrate that the work is a break and not a goal, the controlling will of the artist is replaced by chance (Surrealist, Tachist, electronic). In this way one suggests that any phenomenon has two sides, one natural, according to causes, the other artistic, according as it is seen.

Hence the second "relativization" of the art work; it is also the conclusion of the act of looking that constitutes it as such. That is how we can find pebbles, roots, torn-up posters, sardine cans—all exhibited with the master's signature. It appears that any passer-by is a M. Jourdain who makes art—on the condition that we tell him so.

But such art is empty and without discrimination; to this extent everything is, or is not, art. If we want to find a content for that intentionality (I use Husserl's term advisedly), we must add the third "relativization" of the work: its ordinal character. Contemporary masters, as has been observed, work by series and "periods"; it has also been noted that it is no longer possible to judge a painting or sculpture without knowing who made it and in what spirit. Each important master "adds" his mark, defines his "contribution"—to what? To what can only be the movement of art as a whole, toward its progressive clarification, which is here, to use Marcel Duchamp's title, the bride stripped bare by her bachelors; it is this movement that gives meaning and eventually relative value to any invention or discovery, to the new gestures of each artist or school. By this historical bias criticism recovers some advantages it lost at the level of the art work itself.

To define the collector's mania, one must ascribe to it an object that is a pure correlation of the collecting intention but not one likely to arouse the impulse to possess—neither usefulness nor beauty, nor the value of material or labor. It must be an affair of ordinary stuff like a piece of paper, but rather rare, classifiable by series, and endowed with a vague element of individual history ("This one comes from Nepal"; "That one dates from 1759, one of the first which . . ."). No collection is otherwise possible. These ideal conditions are realized in the case of postage stamps, which allow us to come up with the necessary "findings": either concerning the psychology of the collector (the alliance of pedantry and passion, the greedy taste for possession and

the prodigious taste for prestige) or concerning the inevitable transformation of the collection's value into aesthetic value ⟨the "beauty" of a complete series or symmetrical arrangement, the "evocative power" of an object charged with individual history; rarity becoming "quality").

Modern art, insofar as it is deliberately avant-garde, has a revelatory function analogous to that of philately. It renounces all that justifies, that is to say, obscures it: the model, the work, the image, the human work of fabrication, ingenuity, beauty—all these are bracketed. There remains only the "artistic" intention, without support, without creator, without admirer, without purpose. Currently, painting and sculpture have no longer two or three dimensions but one only, which may be called now depth, now time:[2] the intentional dimension from which they arise.

But, just as with philately, the pure collecting intention creates a psychology of the subject, an economic value for the object, aesthetic norms and tastes; so that the sheer search for the intention of "art" and its successive findings produce history, sociology, economics, and values. In fact, this search is anarchic: if we wished to block out summarily and simultaneously all that the various schools have bracketed, we would kill the intention together with its correlates. Whether the recovered work is, or is not, the end of the intention of "art"—as the beauty of the postage stamp is the end of the philatelist's collection—only history can tell. For by vitiating the work, art has now been irrevocably plunged into history.

(1962)

The Eclipse of the Work of Art

The attacks made by various contemporary artistic avant-gardes of our time—from those which condemn only beauty or figurative representation to those which want to bury easel painting or even art itself—converge finally upon one limited, precise, but often poorly recognized object. The target, in one form or another, over many successive revolutions, is the embodiment of values, the monument, the *bibelot*, the would-be construction, the would-be symphony, the object of contemplation—in short, the "work." If an art could be conceived that did without works (it had been attempted), no anti-artistic movement would be found to protest. It is not art they condemn, but art's object.

Malraux's well-known thesis in the *Musée imaginaire*, according to which we make for ourselves a "domain of art" out of things that were never destined to belong to it, is only half the truth. Of course, the sort of ideal glass behind which we set a fifteenth-century Burgundian Virgin and a set of Javanese puppets side by side, so as to judge them "aesthetically," is a modern idea; neither the authors nor the first viewers of those "works of art" would have understood our approach. This is obvious and requires no comment. But, as Walter Benjamin remarks, the very factors that justify it account at the same time for a somewhat contrary tendency that is no less basic: the isolation provided by "the glass" has in our time been shattered. The photographer removes the Medici statues of San Lorenzo from their niches and shows us their backs, which nobody had seen since Michangelo put them in place; he goes up in an airplane to "take" the cathedral of Chartres from an angle that could never have been foreseen by any of its builders. And those photographs, pinned on a wall, are with us as we talk business or politics. The sacred character that originally belonged to the funerary monument or the Christian cathedral has been

much forgotten, but the aesthetic "sanctity" of the work, visited in situ and not without sacrifice, after long lectures by Ruskin, has resisted the test of reproduction no better. We are prepared to admire the work of art, but not to remove our shoes in front of it. Instead of an invisible glass, the distance imposed by respect, there is now between the work and ourselves a distance rather similar to that which Brecht wished to establish between his plays and his public: he wanted spectators to smoke and eat in the theater.

We must not blame this all on reproductions; it is not the fault or merit of the photographer and printer alone that we no longer make a religion of the art work. It would be easy to look for other, more general causes, but let us first consider (and this will lead us to contemporary art) the wider meaning of such a refusal: our repugnance at certain embodied values. To make an object sacred because of its associations, however discretely, is reminiscent of saluting the flag, keeping family mementos, believing in transubstantiation, or, at best, the strange predilection of collectors and historians for "the object which"; in short, it is bourgeois. The widely held view that formal beauty is the sign of a successful embodiment forces us at the same time to reject beauty, the art work, and its cult; we refuse further to caress with our glance the "finished" surface that encloses the precious essence.

It is easy in theory to attack the work of art, and the problem is rather to create art without forswearing that attitude. For a start there is a well-known formula, practiced for centuries: parody, desecration, all the artistic wrappings of anti-art. Brouwer, Courbet, and others attempted it by attacking anew an area or aspect of art that the public identified with art itself. They ended by showing indirectly, and sometimes despite themselves, that "art" was elsewhere and could go on. If this game is repeated again in our time, we can expect the adversaries of the work of art, by exhausting the resources of parody, to prove cogently in their turn that art escapes these assaults because it cannot be reduced to objects of contemplation set before our eyes.

Let us consider the anti-art par excellence: Dada. Going one step beyond the Futurists, whose noisy iconoclasm had exalted the efficient and powerful machine, the Dadaists assigned the useless, ironic, and contradictory machine to art. Against the work of art's belief in itself, as an object whose qualities and whose real power give

it a legendary aura, Marcel Duchamp invented the opposite: at the flick of a switch, the *sic jubeo* of the "Readymade," he launched a legend capable of raising the indifferent object to the level of art. With the *Bride*, he pretended to work on an arbitrary, adventitious, unfinished, and mutilated nonwork, and in fact he wove its legend, the only real epiphenomenon capable in the end of usurping the masterpiece that was supposed to support it.

These acts, which were successful, aimed expressly at the art work. In their wake are found the inventions of pop art, or an "avant-garde" whim such as the proposal that "Beware, work of art!" should be inscribed on all grocery items (Spoerri).

Another Dada innovation seemed to go even further: the systematic use of chance. Here the target was incontestably the entire art itself. Strictly preserved tradition, older than Plato and Aristotle, assimilated art sometimes to an intentional process, sometimes to inspiration or an act of expression, but in any case radically opposed it to chance. By attacking this axiom the Dadaists—for the first time in history—deliberately struck their heads against a brick wall.

The inevitable came to pass: nowadays chance has full citizenship in the work of art, but a domesticated form of citizenship. A way has been found to limit the damage inflicted on the embodying work and to use tamed chance to disclose new aspects of art beyond the work itself. Examples present themselves in profusion: with the Surrealists, the metaphysics of desire and occultism rob the distinction between inspired process, intentional process, and fortuitous juxtaposition of any meaning; the "work" is thus replaced by the event, but its author—desire—is an artist in the most classic sense of the word. With automatism, internalized chance falls back into the habits of an old tradition that it helps to clarify: what was once inspiration, or "necessary" self-expression, now becomes a play of accident and spontaneity, unpredictable but directed, which the deeper self conducts and, in principle, wins. In other cases, such as Schoeffer's machines or Calder's mobiles or aleatory music, objective chance does intervene, but at the level of execution. The real "work of art" is the device that engenders the fortuitous variations. This is not the directly perceived object of much-vaunted aesthetic pleasure, but the artist acknowledges it with his signature, having "created" it in the classic manner, like any other work of art. One could go on: it is

clear that chance has not killed art, but that on the contrary we have gained a displacement or extension of ideas about artistic production, the artist, and the art work. With each case the notion of art has been made more supple, and it has always guarded, and even conquered, realms that the loss of works does not impair, and upon which chance has no hold.

Along other lines of development things are simpler. It is easy to list the blows inflicted from all directions upon the rights of art works, and always for the sake of a rather mysterious "art" (different each time) that is beyond or behind them.

The need to break with the work of art has been widespread since the beginning of this century; it has often been deep and sincere. Still, artists could not shake the feeling that it was a death wish. Only the Dadaists, attested specialists in suicide, endeavored to satisfy it directly. For a long time, the pioneers of abstraction chose the wrong targets. Having renounced figure and subject, some of them, notably Kandinsky in Munich, took music as their model: if painting did not have the same consistency as a symphony, what would preserve its status as art? Later the Russian Constructivists, de Stijl, and the Bauhaus introduced the architectural model (but with a direct thrust, this time, against the art object, and particularly against easel pictures: their tendency was toward the total work, the building). Finally, in the years after World War II, especially in Paris, abstract painting took figurative painting as its model—in which connection we may properly speak of abstraction by means of representation: in the relation between background and figure (in the circle of Hartung, Schneider, Soulages), in expressive values, in light, in volume. For many young abstract painters André Lhote's counsels fit like a glove. In New York, Hans Hofmann offered future nonformal painters his translation of the best of the European figurative tradition into the language of abstraction.

Then, quite suddenly, a new abstract art took wing. It resembled no model of any art, resembled, in fact, nothing known—it was no longer a work. First De Kooning, following Gorky, replaced the idea of a painting as finished product with the work in continuous transformation, superseding itself, altering its own meaning, and incorporating its own play of chance and spontaneity. (Rauschenberg has

shown that this road can lead on to new developments.) But as we all know, the most radical blow against the work of art came at virtually the same time from the action painters.

We have since had an almost uncontested reign of "plastic happenings," introduced under different pretexts. The dilemma remains as acute as in the Dada days: the happening must incarnate the refusal to incarnate. The "preserved" trance of some Abstract Expressionists and the "preserved" environment of pop art are equally impossible creations. When Pollock hung on a wall the canvas on which he had danced while covering it with paint, he assisted at the conversion of an experience into a work of art. Without exaggerating the import of that metamorphosis, without repudiating it, and without using it as an argument against the method or the work, we must admit that this gesture includes at the minimum a certain inner contradiction. In pop, with artists of lesser range, we find a similar contradiction, but more external and obvious: Lichtenstein is a downright aesthete—and a superior one—and Larry Rivers an academic. The tension between environment and work is not kept alive.

Although visual art only occasionally provides genuine "plastic happenings," it is nonetheless as far removed from the production of objects as any other contemporary trend. It does not culminate in paintings or reliefs, but in acts of perception. The dilemma of "preserving" is avoided. It matters little whether it moves or not, whether the colors alter as the retina tires; the important point is that in these near-objects there is almost no material support to speak of, and the optical illusions occur in a space that cannot be localized in relation to the colored surface (which distinguishes them from the celebrated "hole in the wall" of Renaissance artists). This is an art of vision, not of lines, colors, fictitious volumes, and works in which these are combined.

The villain of the piece, I mean the Renaissance, invented the notion of art on which we still live, though less and less well. It conferred on the production of objects—which has always been the acknowledged raison d'être of the artistic profession—that solemn investiture of which we may rid it only by ridding ourselves of the object at the same blow. We dream of an artist without privilege, an engineer (Tatlin), an artisan (the first Bauhaus), or in any case an equal of his public (pop art). De Stijl wanted to abolish the very profession.

The Dadaist-Surrealist current tended to exempt the artist from the production of objects; they demanded only that he *be*, or—what is harder still but was brought off by Craven and Crevel—that he liquidate himself.

These attacks upon the Renaissance legacy are almost unanimous, albeit contradictory; but they do not prevent us from continuing to build upon that legacy the entire social and economic organization of artistic activity. Galleries and museums, competitions and prizes, commerce and criticism still pretend to believe that artistic value is something deposited in works and visible only within them; we still behave as if the best artist was the one who produced the best works. Marcel Duchamp was needed to contradict flagrantly all these fictitious principles, while nonetheless serving the organization that exploits them. But the exemplary value of an artist lies rather in what we call his "contribution" and sometimes simply in his line of development, rather than in the aesthetic quality of his works taken individually. It is difficult, if not impossible, to judge a work without knowing "where it comes from." What would Brancusi's egg be without its history, and without all of Brancusi? Everybody senses in the Abstract Expressionist the contradiction in spirit between the mistreatment of his canvas at work and the lavishing of his attentions upon it for its exhibition: a reflection of the contradiction between art for oneself (the experience of the road traveled) and art for others, bound to the fetishism of the work.

No new or coherent conception has yet arisen that would allow us, in practice, to overcome this dilemma. But there are indications (which we should not overestimate) that the values once attached to the art work, and which nobody wants any longer, have in some sense been transferred. The unfolding in time of the art of each important artist, of each group, and even more, of great collective experiments or schools—such unfolding presents in effect certain symphonic characteristics in which we can recognize the extension or substitution of the artistic values of yesteryear. We have almost unconsciously acquired the habit of historicizing every new object and of embracing historical development in one comprehensive glance, judging it according to its richness, its synthetic power, its quality of invention, the importance of the problems tackled, the justness and boldness of the solutions. There are indubitably aesthetic criteria in such a context, of course; and at the same time purely historical considerations

of time and priority become artistically relevant (just as, because of the interest and attitude of collectors, the rarity, or authenticity of a signature, or attribution to a great name, effectively augments the beauty of a work). This shift from absolute artistic value to a historical "value of position" springs also from the anxiety to be current, which is as widespread with contemporary artists as the concern for anatomical accuracy or the fear of anachronism in historical painting once was. In fact, the obsession with the value of being up to date and the ambition to achieve priority are almost incompatible: a watch which is on time cannot move faster, but a generation's values, especially in matters of art, have rarely been compatible each with one another.

It seems that this "historicization" of the value incarnated in the work of art has begun to influence even the material machinery of our artistic life. The manner in which public exhibitions are organized, the interest of museums and collectors, the vocabulary and formation of critics—all take it into account. But the crisis of the work of art is not overcome by these means alone, and the crisis of the concept of art is far from being resolved in this way.

This is not the place to insist on the more concrete but necessarily partial solutions we encounter at every point of contemporary artistic activity—the various syntheses of the arts, particularly in connection with architecture and environmental arts; the means used to incorporate chance, movement, and the spectator's action into the art work; the programmed spectacles presented as art works. . . . The crisis of the work of art is nothing but iconoclasm, and the great ironic inventions of Dada have more than once contained within them the alphabet of a future art.

I do not mean to assign everything that is valid in present-day art into the single framework of the offensive against the work of art; to try and make it the "central problem" of art in our time would be a losing bet. But the importance of this problem, especially since the end of World War II, is not entirely fortuitous.

An aversion to all forms of fetishism is a distinguishing trait of the contemporary elite, among whom we number artists of the first rank. The art object, however, is seen—by an illusion that may be necessary or intrinsic—as a bearer of values, or as value incarnate; thus it appeals irresistibly to the fetishist character. Whoever wishes to reduce values to the (conditioned) human action that creates them must

therefore demystify the work of art. Curiously enough, Existentialist philosophers and phenomenologists, whose natural task this should have been, have hardly applied themselves to it; but artists, more directly exposed, have reacted faster, with all their need for freedom. Jacques Vaché refused to "drag the work of art behind like a ball and chain"; experience should not be transformed into a thing, a lived act into an object of contemplation. Many intellectuals of our generation understand this well. And those who cannot but drag works of art desire at least that they be springboards rather than balls and chains; hence the loophole of which we have spoken, "historicization."

Can one imagine a state of affairs in which art could dispense with works of art? Or can one imagine works of art that would not be incarnations of values and congealed experience? Before we can be sure that the eclipse of the work of art is only an eclipse, we must be able to rule out a priori these two eventualities.

(1967)

Modern Painting and Phenomenology

It has become fashionable to recognize in many contemporary artists, including the most outrageously avant-garde, a shared participation—conscious or otherwise—a sort of practical thinking of art about itself. Jean Hyppolite, for instance, has written that painting sometimes tends to become "painting of painting," rather than the production of autonomous works.[1]* In essays on contemporary masters, particularly the younger ones, and in prefaces of exhibition catalogues, it is always a matter of self-awareness, return to origins, exploration through painting of the very act that constitutes form or meaning. This may be only the contamination of the language of criticism by the language of phenomenology, which, as we know, meant to be a *universale Selbstbesinnung*; it would, then, be a mere affectation, without meaning or consequence, like the constant allusions— found in the same literature—to Plato, the mystics, Marx, Einstein, and the atom. To my knowledge only one philosopher has expressly wondered about this problem; he has produced some observations of a general but nonetheless interesting nature about the resemblance between Husserl's reflections on consciousness and the new forms of art.[2] At least twice in France, however, phenomenology has entered the arena of art criticism in full force: with Sartre and Hyppolite on Lapoujade, and with several essays by Merleau-Ponty, particularly on Cézanne. Finally, and this probably means that most intelligent and clear-sighted critics—either favorable like Paulhan or skeptical like Duthuit—write as if phenomenology, which they do not name and do not seem to have thought of in this connection, furnishes the key to the intentions of recent painting. With such material, completed somewhat haphazardly by a few artists' writings, I shall try to collect

* The books discussed in this essay are listed in the Notes, p. 255.

the elements which justify the "phenomenological" metaphor for a great part of contemporary art.

It has been rightly suggested that the debut of modern art was marked by the disappearance of what we shall call reference—the real or ideal object against which the work used to be measured. Art's reference changed through the centuries: a previous work was to be imitated, an external model faithfully rendered, an internal, preconceived idea had to be realized, the laws of a genre or of some aesthetic norm had to be satisified, or the artist's feelings or personality simply had to be expressed in a convincing and communicable way.

None of this is any longer relevant. Jean Paulhan attributes this revolution to so-called "informal" artists: "Painters, before our time, had ideas, then made pictures out of them. . . . But nowadays it's the other way around."[3] Sartre believes that reference disappeared with the figure: " 'Figurative' has three aspects: a pilot reality against which the canvas pretends to confront, the representation of it given by the painter, the 'presence' which is finally submerged in the composition. It is understandable that this trinity may have seemed troublesome: it is!"[4] More generally, and better, Merleau-Ponty has compared reference in painting to the linguistic or literary prejudice of "a correct form of expression assigned in advance to each thought by a language belonging to the things themselves." According to this prejudice, the "recourse to speech which precedes speech prescribes for the work a certain point of perfection, achievement, or fulfillment which will henceforth compel the assent of all, as in the case of things perceived by our senses."[5]

The slow agony of reference began well before the disappearance of the figure: perhaps after the discovery of perspective, which assigned a fixed point of view to the spectator and thus transformed the work of art into a "subjective" experience; or with Leonardo, who treated the work as an accident and almost as a veil that masked the only reality worthy of interest, the artist's *ingegno*; or with the Baroque, which took account for the first time of the simultaneity and circular relation between the work and the idea it was supposed to reproduce. It would be easy to show that since the advent of naturalism reference has taken more diversified forms, as its internal contradiction ineluctably grew greater.

This contradiction is, in the end, epistemological, comparable to the logical impossibility of knowing the object of knowledge; how can one postulate, beyond the image, a nonfigurative norm, a *telos* of figuration, against which the image is measured? Sooner or later, such terms of reference have to be placed within the work itself; we must finish with any thought that placed outside itself a subject and an object, and whose last word, already unsure of its initial postulate, was psychologism in philosophy and impressionism in art. The next step, after all such inaccessible realities have been removed, is the sole description of the intentional structures in perception and in acts of consciousness in general—Husserl and Cézanne.

Merleau-Ponty has proposed the Husserlian image (of course, his own as well) of Cézanne as the painter of perception rather than of the perceived.[6] This idea is seductive at first, and sources seem to confirm it. We are intrigued by Cézanne telling Gasquet that his ambition was to paint "sensible trees" or "what there is in common between trees and us": "Would it not be the realization of that part of nature which, appearing before our eyes, gives us the picture? Sensible trees—and in such a picture is there not a philosophy of appearances more universally accessible than those tables of categories, than your noumena and your phenomena? Looking at it one would sense the relativity of things to oneself, to man."[7] Husserl's phenomenology also claims to be a "philosophy of appearances," rejecting the distinction between phenomena and noumena, and producing instead the thing itself, sensible in its relativity to the knowing consciousness.

Merleau-Ponty proposes frankly to employ the art of Cézanne and his successors as an illustration of his own theories of perception.[8] He makes an "archaeology" of it, in the etymological sense of this word dear to Husserl: "The artist appeals from the already constituted reason, within which 'cultivated men' confine themselves, to a reason which would embrace its own origins." "One may search within the pictures themselves for a figurative philosophy of vision.[9] Visual perception (which is never, in fact, limited to the visual alone) is not a sort of picture that another picture could reproduce, just as knowledge is not the copy of a world already given. Vision is the coexistence of my body with the world, a circuit in which the act of painting intervenes—like phenomenological reflection—as a third element, to clarify the reciprocal connection of the other two: 'This precession of

what is above what one sees and causes to see, of what one sees or causes to see above what is, that is vision itself.' "[10]

The words "and causes to see," which appear twice in this sentence, unceremoniously insert painting into the phenomena of perception. For anybody other than Merleau-Ponty this would be unacceptable; it would be to forget that the work of art has its own autonomous reality, that it belongs to a separate history, that it plays a part in communication. This objection has less force here, in the case of a philosophy which itself stresses that perception, expression, and history share a common problematic whose formal outlines are drawn in the philosophy of language.[11]

In the details of his analysis (which we shall not pursue here) Merleau-Ponty finally "deduces" with remarkable accuracy several formal characteristics of Cézanne's painting, or of the painting of those who attempted, after Cézanne, to paint the experience of things rather than their appearance, supposedly transferable from the retina to the canvas. But this is not the only possible tack, even in the realm of figurative art. "Reference" may be overstepped in another way, by eliminating completely the character of an image which had for so long clung to all figurative painting; that was the aim of Cubism. (Never forgetting that we are not trying to compose *Parallel Lives* of philosophy and painting, only to discover what the philosophical framework allows us to extract from the evolution of art.)

There was certainly a common aspiration, despite a slight time-lag, between the youthful excesses of "objectivist" phenomenology and Cubism. At that time, so the story goes, philosophy students at a German university had to devote an entire semester to practical exercises on "the essence of the mailbox." How can we not think at once of Boccioni's *Analysis of a Carafe*? Analytical Cubism and its waltz around a fruit bowl are less reminiscent of a mathematical explanation of the fourth dimension than of Husserl's description of the perception of objects through "aspects" (*Abschattungen*) attached to a core never perceived. If the vocation of painting is the evidence of things, analytical Cubism is its last word, according to Husserl's definition of the absolute evidence of an object: the "fulfillment" of all the intentions aimed at it.[12]

Cubism, however, is merely the antechamber of objective phenomenological painting. For a long time, since the Symbolists, a sort of

Lullism of the arts, part algebra of forms, part universal system, had been in the offing. Phenomenology in its youth presented itself as the sketch of a system, of a collective work that would methodically describe the world according to evidence more binding than that of abstract physics. Similarly, there were imagined or written "grammars" and complete systems of art forms—the Bauhaus, Schönberg, and even Valéry seemed to believe in them. The Bauhaus program in particular presupposed an alphabet of essences that would be experienced at the same time. In Kandinsky's version (we shall talk about Klee later), this point of departure immediately excludes figuration: a portrait is, or presents, the image of the model, but a yellow triangle is not the image of a yellow triangle—it is the triangle itself. It "fulfills" the intention in absolute, nonabstract, evidence: "Form itself, even if it is abstract and geometrical in appearance, gives out an inner sound, is a spiritual being, with qualities which are none other than that form. A triangle . . . is such a being with a spiritual fragrance which belongs to it alone."[13] This fragrance is not simply subjective impression; the proof is the music of colors: "One could probably not find anybody who would want to render the impression of bright yellow by the low notes of the keyboard."[14] The correlation of bright yellow and high notes, is, as philosophers would put it, a law of essence. There is nothing in the world which "says nothing."[15]

The reign of this happy and abstract Cubist objectivity did not last (In the same way, later, the enthusiasm for *zu den Sachen selbst* and *Wesensschau* cooled, and phenomenology became a philosophy more of consciousness than of meaning.) The advent of the blot and trickle in painting might be explained by the fact that the "triangular" situation of artist/geometrical being/spectator still seems obscurely of a piece with the ancient "reference." The blot at least introduces a dynamic link between the terms: for if it is true that the blot is not the "image" of an identical blot, it is not, for all that, really and uniquely itself; it covers something, it bursts, it summons or suggests another form. A geometrical figure can have direction and movement; it can, as with Vasarely, play tricks with the perception that fixes it; but it always remains "that very thing," sense and perception together, while the blot is "something which . . ."

Hyppolite was thinking of nongeometrical abstraction when he stated that painting becomes "the presentation of its own reflectivity"; he found in it a "self-awareness . . . a fundamental self-surpassing"

which he explicitly compared to phenomenological reduction; and Lapoujade describes less the "mechanisms of fascination" announced by his title than the intentional course of painting, its reification, its progress.

As early as 1927, in the last years of objectivist phenomenology, a thesis written in Berlin by Werner Ziegenfuss formulated very clearly the principles of phenomenological aesthetics.[16] In the name of reduction, it rejected expressionistic doctrines and values (which suppose, as a thing given in advance, the "personality" or the "inner reality" to be expressed) as well as objectivism of essences and values. The proper realm of aesthetics is the aesthetic experience, the *Erlebnis* in which personality defines itself through its creative acts of the senses. Ziegenfuss's little-known study elicits certain basic objections, notably because of the radical opposition it establishes between logical "reality" and aesthetic "sense" or value, and because of its astonishing assertion that any act that gives meaning belongs to aesthetics; nonetheless, it remains that the aesthetic realm is defined as a modality of the intentional act.[17]

A painting that has carried out its phenomenological reduction finally comes to itself, to its own aesthetic truth. The requirements of expression or imitation are only so many masks. Hence, with the rejection of the mimetic image one arrives at the need to encompass, by continual invention, an immediate, intentional lived experience that admits no images. Merleau-Ponty has recognized this analogy of art with phenomenological analysis: "Modern painting, like modern thought in general, compels us to admit a truth that does not resemble anything, that is without an external model, without predestined instruments of expression, and that is nonetheless a truth."[18] And Lapoujade: "Abstract art may be for us a revelation, inasmuch as it approaches . . . the most direct relationship we can have with the world. And also for the simple reason that it reintroduces primary uncertainty into our universe of consciousness."[19]

Jean Paulhan's short study *L'Art informel* offers the most concise and energetic expression of those ideas. First he establishes the disappearance of "reference" and of the idea preceding the work. A reversal has occurred: the work now "turns its back on us" and now precedes its meaning. (We think of Tapiès's walls, of Burri's bags.) "Nature"—or what trace we find of it within the forms of art—is unfinished and ambiguous, in the throes of a metamorphosis: it is all, ex-

cept reference or model. To avoid the slightest suggestion of that process articulated by idea, realization, and effect, the informal artist paints before he thinks, by reflexes, splashes, or irrational gestures; otherwise he simply signs a readymade.

The reality to be apprehended in such acts is, according to Paulhan, something that happens "in limbo," "where thought is not distinct from things."[20] Within, or rather below, each act of our mind there is—like the black spot of the retina—the immediacy of undifferentiated experience: a reality to be pursued, though we know it to be beyond our grasp, since by objectifying it in concepts, or in mere perception, we denature it. To show ("obliquely," says Merleau-Ponty) the level at which thought is still what it grasps, to arrive at the not-thought below time, impossible to eliminate, which moves with thought like the shadow above which one cannot jump, is the salutary task of the informal, according to Paulhan: to replace the ground under our feet, even if we possess an inner King Midas who threatens to transform everything we look at, including our own reality, into an idea.

Paulhan has a way of calling up ideas and philosophical systems without naming them, like grand figures who appear in historical films without being introduced to the audience and off-handedly utter the well-known remark that betrays their identity. Does he expressly refer to Bergson, James, Russell, Plotinus, and Heraclitus to build up amateurishly, with commonplace ideas, without blinking, the only philosophy that accords with his purpose? The object of his description is obvious: it is the painterly equivalent of phenomenological reflection, the attempt to reduce the grinding mechanism of reference-artist-work-spectator to the linear dimension of intentionality. This is an absurd effort, since it goes against the nature of art as creator of works, but nonetheless a logical one, since the transactions and communications among ideas, things, and consciousness which are implied or supposed by the traditional "nature" of art never can be justified.

It is easy—perhaps too easy—to show that an art that undertakes to satisfy the impossible requirements of a phenomenology of itself "must" present characteristics of the informal. Once "reference" is abandoned, the work can measure itself only against itself; criticism is

no longer possible, since commentary, however understanding or faithful, places alongside the painting something with which it is compared; there is no longer any effect, since effect is aimed at a third party and thus introduces an alien point of view into the intentionality of the creator; there is no longer any work, since the work is, despite everything, a reality opposed to the consciousness that poses it.

One can illustrate this situation in the history of art since Dada a thousand ways. The exclusion of the image, of critical norms, and of the spectator have long since become the fashionable premises of all avant-garde activity: hence blots and streaks, shock and disgust. Formal beauty, so detested by Sartre, is linked to the structure of a "balanced," "constructed" object, and above all to the nature of the intention that poses it before oneself to "have" it. The informal poses nothing, and possesses nothing; it is obliged to be ugly.[21] The haste of which Paulhan speaks is, like action painting, a way of substituting a unique act of making for the traditional articulations of "creation." The unity of experience and act is the symbol *par excellence* of ungraspable immediacy, of the passing and irrecoverable: hence the elimination of any repeatable elements—geometric signs or figures— in favor of the simple impression of a trance.

Admittedly, this impression cannot be finally eliminated; the very condition of art—and of anti-art as well—is opposed to it. But with the exception of the Dadaists or Neo-Dadaists, who invited the public to witness not an exhibition but the destruction of their works, one cannot escape the ludicrous contradiction evident, for instance, when an artist signs, preserves, exhibits, and sells an object which he has just stamped upon or lacerated with rage. Of course this limit of absurdity is only a critical point, a moment to overcome; as such it is both logical and fruitful, since it leaves at least the example of a process that persists in "teaching itself," like all artistic invention: such as the look that transforms the torn-up poster into a work of art, or Marcel Duchamp's silence after his proposal of readymades.

But the essential task of this reflection *sui generis* is not to fix an intentional act without destroying it. The phenomenological reduction must reveal an intentional structure masked by the reality of the object. Putting the work between parentheses must, in the same way, disclose the entire "limbo" of the aesthetic, as Paulhan puts it.

This was attempted three times in the course of the twentieth cen-

tury, in three different ways. Surrealism established itself—very correctly, we would say—in an intermediary or ambivalent realm in which the imaginary and the real were indistinguishable; under the more or less naturalistic guise it borrowed from Freud, from the magicians, and from Marxism, it conferred on the artistic act the function of constitutive intentionality, on the unconscious that of transcendental subject, and on chance that of "passive intention." On the other hand, cybernetics and the theory of information were used to merge physical phenomena and aesthetic communication in a mutual assimilation: any natural event may be interpreted formally as the transmitting of a message; physical description and semantic explanation are equally valid ways of considering any process, and the same theory of information embraces both. Traditional semantic aesthetics can be transformed by a suitable reduction into an aesthetics of information; hence electronic painting machines, etc. The part played by chance no more disqualifies those exercises than it invalidates Surrealism. In the *époché* of the artist who created these machines, everything is a sign and nothing is; instead of the imaginary world revealed by Breton, there appears—neutral and ambivalent, like surreality— the world of schemes of transmission, probability, diffusion, and classification.

Chance—the real matter of the worlds of artistic reduction—also governs Tachism. It is here the other side of art, as the causal relationship is the other side of signaling in the case of the aesthetic theory of information. This ambiguity suggests a strange organization of what could be conceived as an emotion incarnate in splashes, or as matter transparent to emotion, or as an impersonal trance; Zen Buddhism has been adduced to provide this limbo with a conceptual backbone.

If we compare the unconscious of the Surrealists, the cybernetic laws of chance, the material emotions of Tachism, we find singular resemblances among them. In all three cases, the essence is that neutral state in which the distinction between nature and the artist, chance and meaning, becomes a mere question of viewpoint. No doubt there are dogmatic syntheses that hide rather than reveal the original undifferentiation they replace; but they are valid at least as slightly exaggerated metaphors of the world of constitutive intentionality revealed by the reduction into the indissoluble correlation between the self and its objects.

If it is true that contemporary art contains a phenomenology which it does not heed, this lack of awareness will be reflected in misconstruals in the declarations of principle made by both artists and critics. It is tempting to substitute the "Readymade" of some ancient and familiar metaphysics for the phenomenology that hides behind its own shadow. Surrealism, information aesthetics, and Tachist Zen are a few obvious examples; they have the merit at least of closely linking a form or school of art to a well-defined philosophy. The standard apology or criticism finds it more simple to assimilate modern art to a more or less expressionistic solipsism, or to a Platonism of essences (of course Husserl's philosophy encountered similar misunderstandings). G. Duthuit, in his anthology *L'Image en souffrance*, proposes to show that these two interpretations—of which he is critical—are united by a common "idealism" that cannot be reconciled with the nature of art.

Professions of solipsist faith are not lacking. Duthuit quotes this sentence by the American painter Clyfford Still: "The requirements of communication are only presumption and impudence." [22] But if Tachism is a message that cannot be communicated, geometrical abstraction and Cubist essentialism are, for Duthuit, "painting without dialogue." [23] It would be fair to say with Duthuit to young Americans that if their art is only expression, they would do well to put more trust in "mirages": "Experience, otherwise, would only awaken in us one echo, one gesture, always or nearly always the same, as a plant, in its spontaneous creation, always produces the same flower." [24] And it would be no less fair to reproach Brancusi for the inconsequence of his Platonism, for a compromising facility with the figurative allusions of his sculptures, allusions that are as alien to those pure forms as the reflection of the museum attendant on the polished sides of the bronze *Bird*. But this would be as irrelevant as interpreting Mondrian's art in the light of his utopianism and his interest in Rudolph Steiner, Léger's art in the light of his Marxism, André Masson's art in the light of his Zen; at best one must take the opposite path. Tachist works are not the fruit of a plant—the "personality"—that only expresses through strange spasms a given structure called its essence; they are successive moments of an endeavor which, from invention to invention, from artist to artist (and also from school to school), approach as closely as possible, by negative means, the intentionality in

the act of painting. Brancusi's eggs are not images of an Idea of the egg—no more than Giacometti's figures are insufficiently trimmed wires—but concrete reflections, always reworked and repolished, of our own desire—Platonic or Oedipal—to possess the egg.

Merleau-Ponty, in his article in *Temps modernes,* has dealt justly with Malraux's expressionistic interpretation of contemporary art, and his response is equally valid, *mutatis mutandis,* for the solipsist interpretation of Tachism and of geometric abstraction: "Modern painting poses a problem that is quite different from the return to the individual: the problem of knowing how we connect with the universal through what is most particularly ourselves." It remains to be seen if in practice this objection is unfounded. Since Ziegenfuss, who saw in abstract art the illustration of a theoretical heresy (the imperialism of the aesthetic attitude, the view that the mere subjective and gratuitous intention could make any object aesthetic), all those who rebuke the moderns for their subjectivism condemn them at once to be misunderstood: their art contains no meaning, therefore one may do with it what one wills—it becomes "decor." A hundred times since then abstract artists have been treated as gifted decorators; so much so that some of them, geometric painters in particular, were finally persuaded, and tried to be utilitarian or useful.[25]

But must we resign ourselves to such mutual misunderstandings? To escape them, we would have to admit, instead of the false dilemma between Platonism and chance, the existence of the "limbo" in which art takes place. Duthuit rightly deplores its lack of range: "The outside world and the inside world that allows us both to distinguish ourselves from things and to cling to them must have been reduced to nothing. The question is then to know what place art can have within the narrowed compass of this order."[26] If, as Merleau-Ponty claims, Cézanne really paints perception, and if, as Jean Paulhan claims, informal painters try to define an original reality in which thought is not distinct from things, art has then indeed, easily or not, been moving for more than sixty years within that narrowed compass.[27]

Jean Paulhan is, inexplicably, not content to leave the field of artistic intentionality in the state he first described. After telling how informal art mimes, suggests, and hands over to us the original truth it seems to possess, he conjures up a contradictory *ex machina:* "If your analysis is correct, it is due not only to yourself and to your mind but

to the same movement within things that brings about the event you perceive." The answer, however, is rather the reverse: in fact the microphotographs of organic tissues or crystals resemble many contemporary works of art. But we are astonished to see emerging in this way, in place of the original undifferentiation between consciousness and its living object, a pretended structural analogy between the object (in itself) and the intentional act of painting (surreptitiously retransformed into the copy of an "inner model"). Is it simply a careless pretext to show a few beautiful photographs? Or Socratic irony? Or, like a book beginning with "L'on," one of Paulhan's mysterious affectations?

Since one must not put too much trust in metaphysics and other ways of giving *ab extra* meaning to "painting of painting," it is understandable that the accusation of solipsism should seem to find the Achilles' heel of contemporary art. With the exception of a few haughty extremists, artists even more than critics are ingenious at showing that meaning is born from the very premises of abstraction. It is, however, difficult to show this in view of the similarity we have so far observed with phenomenological reflection.

The question of the other's consciousness does not arise so long as the work is merely relative to the consciousness which presents it, which may be either that of the creator or of the spectator, since there is no comparison between consciousnesses and no privilege in *Erlebnis*. We know that passing from the "world for oneself" to the "intersubjective world" is a crucial moment for phenomenology, and a rather difficult one.[28] Intersubjectivity transforms the world I experience into "the" world pure and simple, since it allows me to perceive an object as perceived at the same time and from a different point of view by another. The equivalent of this step in painting is the idea of the public and the effect to be produced upon it. From the moment the painter constitutes an alien consciousness as alien, painting within a closed circuit of intention is replaced by the idea of the manufacture of works. It seems, indeed, that all that was shoved out the door may re-enter by this window: reference, the work, even beauty. (In the same way, intersubjectivity has sometimes been an escape route of Husserl's philosophy.) Only one sort of effect easily escapes this consequence: negative effects, shock of works that, violent or not, in their novelty resemble nothing known. Inventors who could be called

absolute—of whom our century has seen a great number, from Pica-
bia to Rothko—figure in this grand movement of the reflexive return
of art into itself, but at the same time they also produce objects that
offend; the other consciousness is present for them because it is ex-
cluded, and can only understand on the rebound. When the shock
has been assimilated, the work learned and made into a method, the
effect dissipated, there remains as the only valid contribution of each
of those inventors the accuracy of the reflection—a value which does
not, in principle, depend on the other. We have not crossed the
threshold of an intersubjectivity that supports the meaning.

Most often painters who are eager to retain and to transmit to the
spectator a definite meaning, if possible one contained or indicated by
a title, all the while still holding open by abstraction the whole range
of forms and possibilities, manage all this by the idea of a com-
munication with objects, below or above the images and the plane
which separate the artist's consciousness from the natural object. This
belief, which avoids the hated choice between outer and inner
worlds, takes the form, with Bazaine, of a simplified monism,[29] or
with Azo Wou-ki—with more reservations—of a very curious monad-
ology of painting consciousnesses.[30] Similar examples can easily be
found; one of the best, and nearest to the concrete experience of the
painter, is provided by Klee's lectures at the Bauhaus, which have
been beautifully published after notes left by the artist and his pupils,
along with other texts and accompanied by a film of illustrations.[31]
Klee's thought oscillates fruitfully between a wide naturalism and an
idealistic conception of pictorial language as pure creation.

He begins his lectures by speaking of chaos, of cosmic forces, of the
I they embrace and orient; even thought appears as a sort of cosmic
principle and artistic creation as a special case of organic growth. One
could suspect in this a panvitalism that guarantees, by decree of the
philosopher, universal communication and a feeling for freely and
spontaneously created forms. But luckily this is not the case. It soon
becomes clear that art is knowledge and "makes you see" ("die Kunst
gibt nicht Sichtbares wieder, sondern macht sichtbar"). Art teaches
forms, their qualities of orientation, emotion, energy, and the quali-
ties of their conjunctions. We are led, then, to believe that Klee's ap-
parent naturalism is only a metaphor describing in objectivist lan-
guage the pictorial elements and their field of action; and we glimpse
another obstacle, logical idealism. But that too is avoided. Klee makes

it quite clear that there are no forms, ideal or otherwise, identical to themselves—there are only functions. For the so-called "elements" we feared are substituted process, situation, suspension. Space itself, says Klee, is a temporal notion. We are at the opposite pole from *Einfühlung*: Klee paints rhythms, signs, tensions—by whatever means— as freely as he can; as we know, he does not hesitate to use the signs of writing, exclamation marks; then a meaning emerges. (Even when Klee first proposes a reality to "render" we always have the impression that it is itself a kind of surplus come from God knows where to fulfill his intentions.)

The enchanting meanderings of this pedagogical romance between cosmic feeling and the philosophy of consciousness finally situate, without defining it rigorously, an art in which abstraction and meaning condition each other. That is the very situation which Lapoujade, seconded by Sartre and Hyppolite, has tried to justify in philosophical terms.[32]

Sartre accuses figurative art of being more or less the painting of a class.[33] The painter keeps the object at a distance, at the end of his gaze; he claims the privilege of being the one who looks, thus degrading his model into a spectacle and a thing. The revolution of abstraction allowed Lapoujade to strike a blow for freedom and paint common experiences (at once, his own and shared) as experiences and not as appearances; thus he finds the meaning unifies the colored signs on the canvas. Sartre does not explain the conditions that make this phenomenon possible, but merely postulates it: "Such, I believe, is Lapoujade's deep conviction: painting is a means of great communication. He believes that solitude does not suit painting and his paintings have convinced me of it."

Lapoujade himself ends his *Mécanismes de la fascination* with a chapter on meaning. He seems to contradict himself in his summation: painting must signify, he says, because a language entirely reduced to its reality as a thing, an "unsignifying" language, would be useless and absurd. But it cannot signify in the mode of figuration, since appearance and likeness are for us empty (and, he adds, the slightest hint of likeness already exposes it to all the criticism directed against figurative art). From where does meaning come, then? From the fact that the work, reduced to the zero-degree of figurative signification, nonetheless has a presence, a reality. The painter "relies on painting's own reality" (on style) to find on the canvas the reality it

designates, so that his painting may be "the existence—for the use of the painter—of this reality, re-created in the abstract exercise of painting."[34]

If this pictorial language cannot be reduced without absurdity to its pure, unsignifying reality, we cannot see how meaning, other than figurative, can originate out of this impossible reality. Lapoujade himself, in any case, certainly makes good use of figurative allusions he condemns. The subtle commentary of Jean Hyppolite's preface rescues the situation through a shift of emphasis.

Let us take, for example, conceptions of style. Malraux, arguing against old psychologistic prejudices, underlined the fact that style is first and foremost creation and expression (individual or collective). Merleau-Ponty has in turn attacked this substantialist objectivism and reduced style to the truth of perception as a personal experience—which is, we might say, a characteristic definition of a transcendental philosophy of consciousness, incarnate or not. On the other hand, Lapoujade and Hyppolite rightly emphasize the materiality of the picture. "Expression transcends its intent in a way which is always unexpected";[35] style is precisely the way of giving to the language of art—with all the accompanying risks—the resistance of matter. Art cannot but end up as a presence, as a thing—while remaining meaning insofar as it is the living commentary of a living experience. To believe that meaning can fill that presence is an illusion, but a necessary one, and "which is precisely painting itself." In sum, just as phenomenology always tends toward the ideal and absurd limit of an eye which would see itself (reflection merging with consciousness), abstract, signifying painting lives on the doubly impossible postulate of a meaning which would entirely pervade pure presence. Neither more nor less, as Lapoujade and his commentator put it, than the illusion of absolute knowledge.

Thus the art we were discussing, when it tries to give definite meanings to particular works, escapes contradiction only to arrive at an impossible premise. This comes from its sovereign tendency to go beyond "works," to which an incarnate meaning would give an unacceptable permanence. Observers—or at least most of those we have quoted—agree moreover, in remarking that the work is no longer an achievement, but a moment. Series are painted, not canvases; an artist is judged by his evolution rather than by what he exhibits.[36]

We have now used, probably for the first time in this article, the word "judged." It appears (but this is not the place to wonder why) that whatever has been lost by the isolated work has been transferred to the series and to development; critical judgment is hardly possible at all except before such wholes. If an abstract canvas has no distinctive meaning in itself, at the risk of falling back into "reference," the process of abstraction or its "researches," as they are called, always do. According to Paulhan, it is the "Informal," rather than this or that informal work, which defines and obliquely illumines the reality menaced by ideas. One might suggest that modern art, which seems to be done with art works in the classic sense, has nevertheless been building, over the last fifty years, an enormous and magnificent cathedral unfolding in time.

(1963)

Thought, Confession, Fiction: On A Season in Hell

A philosophy that consisted in searching untiringly for solutions to problems that have hardly changed since its inception would be distinguished from science only by its futility. But nobody any longer believes in such a philosophy; philosophy must instead transcend itself, on pain of ceasing to be. But there have been always only two possibilities of self-transcendence: subjectivity and history.

For one, as for the other, philosophical thought is abolished, like theology in simple faith, like poetry in silence, like the novel in the fictional diary, like morality rethought *ab initio* within conventional wisdom. But the danger is obvious. What will remain of "historicized" aesthetics if history, like a library shelf, classifies Zhdanov's directives under the rubric of *art criticism?* Facticity would swallow up philosophy, which would become a kind of affidavit: "This happened" or "I am thus." For a discipline seeking to transcend itself, hope of survival lies only in the success of a simultaneous and reciprocal operation: to transform into itself that into which it has vanished; to make all of history into philosophy (idealism); to make of silence poetry, because it is a poet who has renounced writing. If theology in truth transcends itself to become childlike faith, then it is faith which becomes theology.

Some contemporary philosophers consider their task defined by such a possibility: to realize the suicide of their discipline. For us that means transcendence into subjectivity: thought must become confession, but what is confessed must be, in its own way, a theorem, not a "particular" example illustrating a "universal" theorem. The solution cannot be found, of course, in a mythic or learned synthesis of the universal and the particular, but in a redefinition of truth. It is not enough to declare that all that exists is rational for a truly philosophical journal or diary to be possible, but it is enough to admit that

"to be true" is to "manifest oneself"; then a journal is in principle a valid way of discovering the essence.

This postulate has carried Existentialism very far. We are concerned only with its corollary: that the manifestation of subjective truth is not just any monologue, but the monologue of an actor. To be true is to play a role (all that is true shows itself on the world's stage); we might almost say that to be true is to be fictive.

Since Descartes (*larvatus prodeo*) all philosophers whose thought has been a more or less disguised diary have existed by trying out characters. Recall only the dialogue between Jean-Jacques and Rousseau, between Kierkegaard's pseudonyms, between Nietzsche's mythical mouthpieces. There have been also more hidden fictions, more discreetly adopted roles—for these we would have to go back not to Descartes, but further, to Plato or Augustine.

When, in the diary, philosophical thought transcends itself into both subjectivity and history, it can maintain itself only through fiction. Only fiction can "manifest" or make "patent" the essence, and avoid the peril of pure facticity; its immanent truth is the precision of what it sees and the way it expresses it.

With some authors, of course, the invention of a character is a mere screen, and borders upon allegory or fable—they run the risks, respectively, of "moralized" myth (Plato), or of schizoid dramatization (Kierkegaard). Let us, however, consider a case which is difficult to contest, in which subjective thought, facing its final consequences, has become poetry, and poetry, silence: let us see what *A Season in Hell*, which recounts all this, owes to its "mask." (We do not aim at a reasoned exegesis of the *Season*; a necessarily debatable summary, like all attempts at translating Rimbaud into conceptual schemes, must give us rather a point of departure, however inadequate.)

"Pagan Book" or "Negro Book" are the names Rimbaud gives in his letters to those "few hideous leaves of [his] notebook of a damned man." It is the story of a pariah, of an outcast, rather than of a damned man in the proper and legal sense of the word. "I belong to an inferior race for all eternity." He is predestined to see the gates of the City of God close in his face; he can only try tirelessly, and in vain, to find the way out, and the three or four reasons to hope.

The first is that the Gospel is not valid for him: "Priests, teachers, masters, you are mistaken in bringing me to justice. I never

belonged to this people; I never was a Christian [. . .] I have no moral sense; I am a brute: you are mistaken." But a response is already there: "I am a slave of my baptism. Parents, you have made my misfortune and made your own." "I had been damned by the rainbow."

A contrary sophism pretends that his awareness of being a sinner, his humility, are the very signs of his election: "I am a beast, a savage. But I can be saved. You are only false savages, you mad, ferocious, avaricious . . ." This is an illusion, however, and Rimbaud knows it: "Am I deceived? Could charity be the sister of death for me?—Finally, I shall beg forgiveness for having fed on lies. And move on."[1]

Another hope is gratuitous salvation: "I have received on my heart the blow of grace. Ah, I did not foresee it!" But too often anticipated in his imagination, this cannot come to be. "Continual farce! My innocence would make me cry. Life is a farce played by all."

The last, most radical solution would be to deny heavenly "justice" in the name of good sense, since it is unjust. But here he encounters the most singular obstacle: the fact that the very faculty of reasoning is closed to him because, for the entire century of the Enlightenment which employed it, and for the entire middle class from Louis-Philippe to Thiers, reason itself is "Christian": "M. Prudhomme was born with Christ."

When Rimbaud speaks of the Gospel, God, or Grace, it is always as something of a metaphor; he means, along with religion, the whole Order from which he is excluded—science, work, democracy, morals. His Trial is as general, and his Castle as real, as the others', although he does not react in the same way.

A *Season in Hell* is, then, the predicament of an outcast, thought by an outcast; and this entire thought can be reduced to the history of attempts at escape, to the anticipation of all possible salvations. The book is not composed; it recalls rather the buzzing of a fly within a bottle. One would expect, therefore, to find it akin to pure confession, to a nonphilosophical "journal." But its pages do not follow one upon the other, and one cannot imagine them bearing successive dates; they are, rather, aspects of the same thing, facets of a gem that one tries to imagine entire. There is something in this narrative which seems retrospective, almost atemporal. "A few little cowardices

en retard," Rimbaud says; is he already further along, and where is he then, as he writes about them?

When Rimbaud abandoned poetry, in the guise of a solution, he "settled down" so radically and so fiercely that it looked more like self-punishment; Aden, upon which he finally fixed, was certainly the most infernal of all the places he knew. *Coup de grâce* or otherwise, he undertook his *embourgeoisement* like a saint his mortification. Which is to say, he was not "converted" to Order, but rather chose Order as the last phase, the logical self-transcendence, of his position outside the law.

Despite literary appearances, *A Season in Hell* was not, historically, a farewell to literature; it has been established that Rimbaud later wrote still more *Illuminations*. (Not to mention the publication of *A Season* through his own efforts, and even the buying of works by Goethe and Shakespeare: historians have all the proof of this relapse.) It was not even a farewell to a vagabond life; in later years Rimbaud traveled more than ever, and committed in the tropics the most antibourgeois act of all: desertion. Whence, then, comes the definitive character of a book written in the midst of transformation? It is generally considered "prophetic," and indeed its dreams very much resemble what their author later lived through; but that is simply because these confessions carry as an underlying thread their final outcome, the meaning of what they tell. And they can do so only because they are no more dreams than narrations, no more true than false, but precisely: fictions.

The *I* of that confession does not exist; who is he? "Without even using my body to live, and lazier than a toad, I have lived everywhere. There isn't a family in Europe unknown to me." Only a few biographical notes recur, like leitmotifs: the admiration of the child for the "stubborn convict over whom the prison always closes again"; the systematic experience of the disorder of all the senses" to expand the frontiers of poetry. The two chapters in which alone the "absence of descriptive or instructive faculties" is not complete are both, in fact, called "Delirium." (Similarly, or inversely, in the fever of his last illness, if one may believe his sister Isabelle, Rimbaud "confused everything—and with art.") Obviously an imaginary being is narrating his season in hell.

From the beginning, he chooses to present himself through a gallery of imagined "antecedents": pilgrim to the Holy Land, leper, mercenary, sorcerer; he sees himself now or in the future as a convict, a colonial, a Negro submitted to baptism at the hands of the landing Whites ("Bad Blood"). He entrusts Verlaine with the telling of the story: "It is a demon, you know, it is *not a man.*" "I saw the whole setting with which, in his mind, he surrounded himself; clothes, sheets, furniture; I lent him weapons, another face. I saw all that touched him, as he would have wanted to create it for himself." "He hasn't a single acquaintance. . . . He wants to live as a sleepwalker. Would his kindness and charity alone give him the right to live in the real world?" "One day perhaps he will disappear miraculously; but I must know it, if he is to ascend to some heaven, if I am to see something of my little friend's assumption" ("Delirium I. The Infernal Bridegroom"). This device is in fact one of the best indications of the structure of the book and of its continual masquerade—Rimbaud consents to report his own gestures, laughs, sayings—only through the mask of his "companion in hell," but this companion is himself again: confessing, growing impatient, dazzled by his friend's mirages (we must not forget that Rimbaud's poetic art aimed above all at dazzling itself), thirsty, reaching the pit of self-contempt, impure, and delirious. As literature, in these pages, Rimbaud exists only through Verlaine's eyes, but this Verlaine is only a double—or rather half—of Rimbaud. This is the perfect illustration of the celebrated "*I* is another."

Fundamentally the story of A *Season in Hell* could be considered, on the plane of pure abstraction, as an analysis of the "magus." In the midst of hell he is all-powerful: "I possess all talents—There is nobody here yet there is somebody [. . .]—Do you want Negro songs, houri dances? Do you want me to disappear, to dive after the *ring*? Do you? I shall make gold, potions." But this magic is solipsistic: "I shall be silent about it: poets and visionaries would be jealous. I am a thousand times the richest, let's be as avaricious as the sea." All is contained within these words; the seer's gifts cannot be shared. Even Verlaine, the foolish Virgin, dares not hope that his friend will stay with him, does not know whether he will really ascend to a "heaven"; only out of bravado does he tell him "I understand you." "The Alchemy of the Word" magnificently illustrates one

of the aspects of the impasse: cultivated delirium leads, from discovery to discovery, to the despair of "hunger", then, when the veil of forms and colors is torn, to the inexpressible sun at the heart of darkness: "At last, o bliss, o reason, I stripped the sky of its azure, which is blackness, and I lived. . . . In joy I take on the most comical and perplexed expression:

> It is found again!
> What? Eternity.
> It is the sea mixed
> With the sun."

But at one blow, at this extreme limit, beauty, formless, now, and the reputed promise of happiness, is necessarily called upon to keep its word. "Happiness was my fatality, my remorse, my worm. . . . Happiness! Its bite, as sweet as death, warned me at cock crow—*ad matutinum*, at the *Christus venit*—in the darkest cities." We learn nothing of what happened afterward. Enigmatically the page ends: "It passed. I know today to salute beauty." Does that mean that happiness is abandoned, and beauty classified, somewhat sarcastically, among imaginary satisfactions? Perhaps.

The other "development" of the notion of the Beautiful is summed up in a few lines of the prefatory page:

"Once, if I remember rightly, my life was a feast at which all hearts were opened, at which all wines flowed.

"One night, I sat Beauty on my knees—And I found her bitter. —And I cursed her.

". . . Lately, finding myself on the verge of uttering my last croak, I dreamed of recovering the key to the ancient feast, where perhaps I would find my appetite again.

"Charity is the key.—This lofty thought proves that I was dreaming!"

It would not be difficult to transcribe this itinerary (and also the previous one) into Hegelian terms; they are indeed the successive moments of a concept. But this assimilation of beauty with childhood, the revolt which followed because beauty was not sufficient, the attempt, finally vain, to substitute charity for it—all this is also the entire story of the being who, in *A Season*, calls himself *I*: the impossible escape and the impossible submission to the spirit which requires the *I* to be in the West are only, respectively, the failure of beauty

and the ineluctable obligation to link charity and Christ with M. Prudhomme.[2] The last word, when he who calls himself "a magus or an angel, dispensed with all morality" finds himself "back on the ground, with a duty to seek," announces the complete reduction of things to their nakedness, the dismissal of the sun without which they are only what they are, and the determination to limit oneself henceforth to "truth in a soul and a body."[3]

It looks, in sum, as if the same dialectic controlled, in this sharp and transparent little book, the story of the imagination that tumbles into the real, of the outcast who clashes with modern society as with the City of God, of Beauty which is neither the happiness promised nor the charity mimed. A play of mirrors sends us back from one theme to the other, so that in the end the terms themselves are effaced by the mechanics of their transformations. If, in the page entitled "Flash of Lightning," we replace work, which is the subject, by prayer, the substitution is successful almost to the point of banality— these different realms are interchangeable with regard to the play that is unfolded within them. Rimbaud, like Descartes, is hostile to the *distinguo*. No wonder that the "historical" *I* should have been the first to disappear behind a being, or rather behind several created beings: *A Season in Hell* is an abstract book.

This is obviously an exceptional case. The fictive element does not always intervene with the same urgency, nor with the same success, as the meeting point between a confessional journal and ahistorical thought. We must take into account the fact that the object here is the dialectical transformation of a few notions—which favors the pseudo-temporal form of the narrative; that, on the other hand, reprobation can only be thought by the reproved if his point of view is "outside," or fictive—hence the masks; that, similarly, an inner contradiction, or the false position of a *written* farewell to literature (which is, in the end, the false position of all literature as such, but enlarged and made more striking) requires such artificial devices as anticipated confession, equivocation between morality and art, and so on; that, finally, an autobiographical fragment, if it is to be at the same time a criticism of the imaginary, can be neither pure narrative nor pure meditation.

Those favorable conditions are not, however, all accidental. By the sole fact of language, confession, and above all the confession of thought in the act of making itself, is already and always at once ab-

stract reflection and fictive creation. And if, in personal history, the essence can be revealed only by the invention of a role, by an artificial mask, that is because here truth is *essentially* linked to artifice. We shall briefly explain why.

In the realm of fiction there is not truth, only *justesse*. Apart from imaginary creations, this term applies to solutions, judgments, measures, appreciations, expressions, metaphors, images: in short, the precise, as "valid" as the true, takes its place whenever the aim is not to arrive at the heart of the object in itself through a usually careless metaphysical leap, but, rather, to study the relation between an experience and the response it evokes, a personal invention within the framework of a system of accepted premises. Thus precision is, as it were, the objectivity of a subjective decision considered as such. One might wonder if in the end "truth" is not a particular modified form of precision, marred by an unfortunate objectivist bias. It is clear, in any case, without going any further, that philosophy faced with subjective history can lend to it no other universal value, no other means of access to the essential, than *justesse*—which, as we have said, is concerned exclusively with human creations. Therefore precise fiction is one of the natural habitats of the philosophical journal. Q.E.D.

(1959)

NOTES

1. The Theory of Figurative Expression in Italian Treatises on the *Impresa*

A Chronological Table of the Principal Italian Treatises on and Collections of Imprese, 1555–1613

Complete bibliographic information can be found in Mario Praz, *Studies in Seventeenth-Century Imagery* (Studies of the Warburg Institute, 3), II (London, 1939–47).

1. Paolo Giovo, *Dialogo dell'imprese militari e amorose* (Rome, 1555).
2. ———, *con un ragionamento di Messer Lodovico Domenichi, nel medesimo soggetto* (Venice, 1556).
3. ———, *con un discorso di Girolamo Ruscelli intorno all' inventione dell' imprese* (Venice, 1556).
4. Scipione Ammirato, *Il Rota ovvero dell'imprese* (Naples, 1562).
5. Girolamo Ruscelli, *Le imprese illustri* (Venice, 1566); ed. consulted: Venice, 1580.
6. Alessandro Farra, *Settenario dell'humana riduttione* (Venice, 1571). Part VII: "Filosofia simbolica, ovvero dell'imprese."
7. Bartolomeo Taegio, *Il Liceo . . . dove si ragiona dell'arte di fabricare le imprese*; Vol. II (Milan, 1571).
8. Il Materiale Intronato (Girolamo Bargagli), *Dialogo de'giuochi che nelle vegghie sanesi si usano di fare* (Siena, 1572).
9. Luca Contile, *Ragionamento . . . sopra le proprietà delle imprese* (Pavia, 1574).
10. Giovanni Andrea Palazzi, *Discorso sopra le imprese* (Bologna, 1575).
11. Scipione Bargagli, *Dell'imprese* (Siena, 1578); ed. consulted: Venice, 1594, with the addition of second and third parts.
12. Francesco Caburacci, *Trattoto . . . dove si dimostra il vero e novo modo di fare le imprese* (Bologna, 1580).
13. Giulio Cesare Capaccio, *Delle imprese* (Naples, 1592).
14. Torquato Tasso, *Il Conte ovvero de l'Imprese* (Naples, 1954); ed. consulted: *Dialoghi*, ed. Guasti, 3 vols. (Florence, 1858–59), III, 361–445.
15. Andrea Chiocco, *Discorso delle imprese e del vero modo di formarle* (Verona, 1601).
16. Ercole Tasso, *Della realtà, e perfettione delle imprese* (Bergamo, 1612); ed. consulted: Bergamo, 1614, not mentioned in Praz's bibliography.
17. Horatio Montalto (Cesare Cotta), *Assertiones . . .* (lost; cited in Ercole Tasso's *Risposte*).
18. Ercole Tasso, *Risposte . . . alle assertioni del M.R.P. Horatio Montalto* (Bergamo, 1613).

In the following notes, references are given to these works according to their number on this list.

1. Claude Paradin's *Devises Heroïques* (Lyons, 1551), which included the *imprese* of several illustrious personages.

2. The Lyons edition of Alciati's *Emblemata* became widespread after 1547. The popularity of "devices" in Lyons was due in large part to Gabriel Simeoni, Alciati's correspondent, who produced an illustrated reissue of Paolo Giovio's *Dialogo* (1), enriched by *imprese* of his own creation, in Lyons in 1559; this work was translated into French the same year. His own "devices" were published, together with Paradin's, in Latin, and in French, by Christophe Plantin, in 1562 and 1563 respectively (several subsequent editions). He is also the author of a dialogue on that subject (Lyons, 1560); unedited *imprese* (Florence, Laurenziana, ms. Ashb. 1367) are mentioned by Toussaint Renucci, *Gabriel Symeoni*, (Paris, 1943), pp. XVIII and 202–212.

3. Bargagli (11) p. 2.

4. *Negozj del Secolo XVI* (Florence, 1903). Apart from Politian and Sannazaro, *imprese* from Marcantonio Epicurio, Molza, Caro, and Rota were in great demand, but nobody before Giovio had thought of publishing them in book form.

5. K. Giehlow's old and well-known work *Die Hieroglyphenkunde des Humanismus in der Allegorie der Renaissance* (*Jahrb. der kunst hist. sammlg. d. all. Kaiserhauses*, XXXII [1915]: 1–232), already turned up in fifteenth-century symbolism all the elements found in the *impresa* of the sixteenth century.

6. Giovio, *Dialogo*, p. 6.

7. Ruscelli (5), p. 208.

8. Palazzi (10), pp. 116–17.

9. Ammirato (4), p. 14.

10. For instance, a pearl followed by a T and a leather sole: "Margherita te sola di coramo."

11. M. Praz, *Studies in Seventeenth-Century Imagery*.

12. Praz gave a hint, however, which we shall amply confirm (I, p. 50): "Shall we be accused of exaggerating if we say that while Platonism in the sixteenth century had dwindled into treatises on love and to the idle and more or less paradoxical questions discussed in them for the uses of polite conversation, Aristotelian dialectics had in the same way degenerated into argument . . . over witty pastimes such as devices?"

13. Palazzi (10), p. 102.

14. Bargagli (11), p. 41.

15. Tasso (18), p. 103.

16. Ibid., p. 21.

17. Ruscelli, *Discorso* (3), p. 124.

18. Giordano Bruno, *De compositione imaginum*, *Opera latina*, II, 3, pp. 106–111 (Ediz. Naz.).

19. Palazzi (10), pp. 4–5.

20. Bargagli (11), p. 14.

21. Taegio (7), f⁰, 5 r⁰ sq.

22. Caburacci (12), pp. 15 et seq.

23. Taegio (7), f⁰ 5 r⁰.

24. Roger Bacon, *Opus maius*, Jobb (London, 1733), p. 358; quoted by Prantl, *Gesch. d. Logik im Abendlande*, 4 vols. (Leipzig, 1855–70), vol. III, p. 127, n. 576.

25. Giordano Bruno, *De compositione imaginum*, quoted pp. 89–90. See ibid., pp. 101–102 about *formae, simulacra, signacula*, which are at the same time the "vehicles" and the "chains" of divine action. They produce natural effects as well as sentient and rational human knowledge.

26. Contile (9), f⁰ 2, r⁰.

27. Bargagli (8), p. 194.

28. Capaccio (13), I, f⁰ 23 r⁰.

29. Ibid., f⁰ 73 r⁰–74 v⁰.

30. Montalto's *Assertiones*, which probably dates from 1612 or 1613, has been lost; but Ercole Tasso's *Risposte* (18) give fairly significant extracts from it.

31. Contile (9), f⁰ 2 v⁰.

32. Chiocco (15), p. 376.

33. Farra (6), f⁰ 274 r⁰.

34. Caburacci (12), pp. 12ff.

35. The widespread conviction that this constitutes a reaction against the "formalism" of medieval schools calls for a few reservations. For, in this sense, humanist logic is only an extension of medieval tendencies: the *artes inveniendi* were already "arts" and, we might say, topics; the diffusion of Lully's theories after the end of the fifteenth century is of significance in this matter. The principal contribution of medieval logic—the theory of *suppositiones*—deals not with forms of thought, but, more "concretely" than Aristotle, with the grasp of thought on reality.

36. Caburacci (12), pp. 12ff.

37. Ibid., p. 26: the assimilation of certain types of *imprese* with the orators' *exempla*; the assimilation of the "ornamentation" of *imprese* with that of speeches.

38. R. W. Lee, "Ut pictura poesis," *Art Bulletin*, XXII (1940): 197–269.

39. Zuccaro, *L'idea de' pittori, scultori ed architetti*, 1607 (ed. consulted: Rome, 1748).

40. Cesare Ripa, *Iconologia* (ed. Siena, 1613), II, 115, s.v. Pittura.

41. Michael Majerus, *Atalanta fugiens* (Oppenheim, 1618), 214 pages. See preface.

42. *"Petrarchism is really a sort of picture language."* Frances Yates, "The Emblematic Conceit in Giordano Bruno's *De gli eroici furori*," *Journal of the Warburg and Courtauld Institutes*, VI (1943): 101.

43. Bargagli (11), p. 38.

44. Ibid., p. 43.

45. Ammirato (4), after Ercole Tasso, p. 127.

46. Thus, Arnigio, *Rime e Imprese dei Accademici Occulti di Brescia*.

47. Ammirato (4), p. 10.

48. Contile (9), f⁰ 31 v⁰.

49. Tasso (16), p. 24.

50. Ibid., pp. 59, 96, 360, 363, etc.; Caburacci (12), p. 29; Palazzi (10), p. 101, citing a definition by Francesco Lanci da Fano.

51. Ruscelli (5), p. 3.

52. Ficino, *De triplici vita*, III, 21; *Opera*, Basel (1576), p. 563.

53. For instance Paleotti, *Discorso intorno alle imagini sacre e profane* (Bologna, 1582), f⁰ 63 r⁰.

54. Bargagli (8), p. 190.

55. Capaccio (13), f⁰ 71 r⁰.

56. Tasso (16), p. 83.

57. Contile (9), f⁰ 29 v⁰–30 r⁰.

58. For instance Ercole Tasso (16), pp. 393–94.

59. Farra (6), f⁰ 271 r⁰,–v⁰.

60. "Icones symbolicae," *Journal of the Warburg and Courtauld Institutes*, XI (1948) 162–92. The Jesuit Christoforo Giarda composed a discourse on the frescoes of the library of his college (*Liberalium disciplinarum Icones Symbolicae Bibliotecae Alexandrinae* [1626]), in which he assimilated painted allegories with Platonic Ideas and hyperbolically vaunted their pedagogic and moral power. E. H. Gombrich's analysis explains such extravagances by putting them back in their historical context and spiritual ambience, which is that of Neoplatonism, with its peculiar conception of symbols and images—a conception of which his article gives the classic summary.

61. Farra (6), f⁰ 157 r⁰.
62. Ibid., f⁰ 269 r⁰–270 r⁰.
63. Ibid., f⁰ 269 v⁰.
64. It is "a similar or adequate sign or image" (Tasso (14), p. 386). Cf. "Hiérarchie céleste" in Pseudo-Denys, *Oeuvres*, translated and commented upon by Patronnier de Gandillac (Paris, 1945), p. 191: poetry uses similar images, but theology can only employ dissimilar images to express God by negation and contrast.
65. Tasso (14), pp. 386ff.
66. Taegio (7), f⁰s 3 v⁰ and 4 r⁰.

2. Burckhardt's *Civilization of the Renaissance* Today

1. Werner Kaegi, *Jokob Burckhardt, Eine Biographie*, vol. III (Basel-Stuttgart, 1956), pp. 687ff.

2. Which shows how wrong Geiger's editions are: painstakingly to complete chapters chosen with such freedom would be like mathematicians taking π with ten decimals to work out the circumference after measuring the diameter by guesswork.

3. Kaegi, *Jakob Burckhardt*, pp. 687–700.

4. For instance, in the chapter about wars as works of art or in several remarks about satire in Italy and in trans-Alpine countries, on sexual morality, on the supposed decline of superstitions in the sixteenth century, or, at the beginning of the second part, the proof that all aspects of Italian political life must have contributed to the emancipation of the individual.

5. Since then Alfred von Martin (*Soziologie der Renaissance* [Stuttgart, 1932]; English translation, *Sociology of the Renaissance* [New York, 1944]) has attempted to build up a "Renaissance sociology" in the spirit of Burckhardt, inspired by him while completing his theories. The mainspring is found to be—as could be expected—nascent capitalism.

6. The thesis of a continuous development within which the Renaissance appears merely as the last episode of the Middle Ages has been developed with obvious exaggerations by J. Nordström (*Moyen Age et Renaissance*, French transl. [Paris, 1933]; original edition, in Swedish [Uppsala, 1929]).

7. Cf. on this subject J. Lestocquoy, *Les Villes de Flandre et d'Italie sous le gouvernement des patriciens* (Paris, 1952), a book with a thesis, which, admittedly, only deals with the beginning of the period which concerns us here.

8. Burckhardt, *Historische Fragmente* (Stuttgart, 1942), p. 75.

9. Huizinga, *Le Déclin du Moyen Age*, French translation (Paris, 1932); original edition in Dutch (Haarlem, 1919); new French ed. by the Club du Meilleur Livre (October 1958).

10. In the case of humanism, Huizinga only used France as an example (chap. XXII) but suggested that the case of Italy was not altogether different.

11. Hans Baron, *The Crisis of the Early Italian Renaissance.* 2 vols. (Princeton, 1955).

12. It is surprising that Burckhardt should not have quoted some of the discussions about originality and imitation in literature (Politian, G. Fr. Pico): the principle of individuality is better formulated there than anywhere else.

13. On the deep meaning of perspective for Renaissance artists, compare Dagobert Frey, *Gotik und Renaissance* (Augsburg, 1929), and Erwin Panofsky, "Die Perspektive als symbolische Form" (*Vorträge der Bibl. Warburg*, IV, 1924–25).

14. Jean Seznec, *The Survival of Ancient Gods in the Renaissance* (London, 1939), has shown that nonetheless those figures are a sincere attempt to reach the "authentic" image conceived by the Ancients.

15. The following lines are a partial summing up of the somewhat eccentric thesis of K. Burdach, *Vom Mittelalter zur Reformation* (Halle, 1893), and "Vom Sinn und Ursprung der Worte Renaissance und Reformation," *Sitzungsber. d. preuss. Akad. d. Wiss.,* XXXII, 1910.

16. *Die Sammler,* ed. H. Trog in the posthumous volume: *Beiträge zur Kunstgeschichte von Italien* (Basel, 1898).

17. Cf. its account in the introduction of Erwin Panofsky's *Studies in Iconology* (New York, 1939).

18. André Chastel, *Marsile Ficin et l'art* (Geneva-Lille, 1954). Cf. by the same author, "Art et religion dans la Renaissance italienne (*Bibl. d'-Humanisme et Renaiss.* VII, 1944, 7–51).

19. On Palm Sunday, 1484, the strangely dressed Knight Mercurio da Correggio solemnly entered Rome and preached the imminent coming of a new Messiah, the Pimandros (the main character of one of the dialogues by Hermes Trismegistus). See an account of that event reprinted in the collection *Testi umanistici su l'ermetismo* (Archivio di Filosofia [Rome, 1955]). Ulrich von Lichtenstein retells, in his autobiography, the exploits inspired by his great love—among others, his journey, dressed up as "Frau Venus" with two large braids hanging down from his helmet, to challenge to a duel all those who might doubt that his lady was the most beautiful in the world.

20. The political system they served was, in spite of its mottoes of freedom, justice, and Republican equality, one of the most totalitarian plutocracies which ever existed, solidly built on an official ideology in which we cannot distinguish good faith from hypocrisy and cynicism.

21. Ernst Cassirer, *Individuum und Kosmos in der Philosophie der Renaissance* (*Individual and Cosmos in Renaissance Philosophy*) (Leipzig, 1927).

3. Form and Meaning

1. Aby Warburg, "I costumi teatrali per gli intermezzi del 1589," in *Gesammelte Schriften*, I (Leipzig-Berlin, 1932), pp. 280–82.

2. Rudolf Wittkower, "Architectural Principles in the Age of Humanism," *Studies of the Warburg Institute*, 19 (London, 1949); see in particular pp. 110–15.

3. About the Vitruvian commentary of Palladio's friend Barbaro, who also influenced him, Wittkower writes (ibid., p. 122): "Those who work through Barbaro's chapter on proportion . . . will put it aside with the conviction that this man expected and saw in a building proportional relationships which are outside our range of perception." This is a slightly ambiguous statement; it need not be taken to mean that men from the end of the sixteenth century had a particularly acute feeling for harmony; we have just seen, according to Wittkower himself, that Palladio could sacrifice harmony quite cheerfully. The demands of theorists addressed only the "idea" of the building.

4. G. B. Villalpando and H. Pardo, *In Ezechielem Explanationes*, 3 vols. (Rome, 1596–1604); see Vol. II, p. 449 (quoted by Wittkower, p. 107) and pp. 443–58.

5. See, for instance, Daniele Barbaro, ed., and commentary of Vitruvius's *Architecture* (Venice, 1556), p. 147.

6. Wittkower, p. 102.

7. Alberti, *De re aedific.*, IX, 5: "Ut vero de pulchritudine iudices non opinio: verum animis innata quaedam ratio efficiet." And further: ". . . naturae sensu animis innato, quo sentiri diximus concinnitas." Villalpando, vol. II, p. 18, claims that he showed his master Juan de Herrera, the architect of the Escorial, his reconstruction of the Temple of Jerusalem, in which he extracted from the texts of Holy Scripture a perfect model of rationality, musical harmony, and Vitruvianism *avant la lettre*: "Is cum primum has nostras descriptiones perspexit . . . ingenue fatebatur, aliquid divinae sapientiae in ipsa se architecturae proportione subolfacere, ita ut etiam si descriptiones ipsas tantummodo vidisset, audissetque a nemine . . . eas sacris litteris contineri; nihilominus ipse facile iudicasset, ab humano ingenio excogitatum non fuisse eiusmodi aedificium, sed a Deo infinita sapientia architectatum."

8. This silence on the part of theorists accounts for Wittkower's mistaken claim (p. 95): "It is probably true to say that neither Palladio nor any other Renaissance architect ever in practice used irrational proportions. . . ." This is to forget, for example, the Cancelleria façade. Another workshop device, the so-called Gothic triangulation, insofar as it was considered an example of an irrational style, gave rise to controversies in connection with the finishing of San Petronio in Bologna.

9. Francesco di Giorgi, *De harmonia mundi*, I, 8, 16; cf. III, i, 1, the expression in musical terms of the canonical proportions of the human body.

10. Ibid., I, 3, 13.

11. Ibid., I, 8, 16, and 19.

12. See the same attitude expressed clearly by Barbaro, p. 59, and especially p. 105, about the celebrated problem of ancient monuments which do not conform to the rules of Vitruvius.

13. Scamozzi, in *L'idea dell'architettura universale* (Venice, 1615), III, pp. 220–21, retains, like Arcimboldo and Soldati, a firm trust in the aesthetic value of the correspondence between music and architecture, and does not hesitate to suggest after Giorgi, that the different proportions can move the passions in the same way as musical modes; on the other hand—and that is characteristic of the Mannerist epoch—he proves his dogmatic preconceptions by "deducing" logically the number, and partly the appearance, of Vitruvian orders.

14. Scaliger, *Exotericarum exercitationum libri* (Frankfurt, 1601), exercit. 300, 1, 895.

15. Ibid., 2, 896.

16. Geronimo Cardano, *De subtilitate libri*, XXI (Paris, 1551), f⁰ 232 r⁰–v⁰.

17. All those motifs appear, well organized, in Villalpando, vol. III, 465ff.; cf. vol. II, 20, and the polemic against those who dare to reconstruct the Temple of Solomon without knowing Vitruvius.

18. Vitruvius, III, 436–37; "Omnes basilicae construendae leges ex hac una Salomonis mutuata est Vitruvius. And vol. II, 144: Vitruvius borrowed from the Bible "non sententias modo, verum etiam fere verba."

19. Villalpando, vol. III 449, 458, 465–83.

20. Daniele Barbaro, *In Vitr.*, I, 1, p. 16; cf. also p. 57: "*Divina è la forza de'numeri tra loro con ragione comparati, né si può dire, che cosa sia più ampio nella fabrica . . . [del] mondo . . . della convenevolezza del peso, del numero, e della misura, con la quale il tempo, lo spazio, i muovimenti, le virtù, la favella, lo artificio, la natura, il sapere, e ogni cosa . . . divina, e humana, è composta.*"

21. This famous triad has also been given a moral or noetic meaning, which is in fact closer than the other interpretations to its original meaning in the context. The line from the *Wisdom* did not, in effect, allude to the passages about the Creator which are usually quoted with it (Isaiah, xl, 12; Job, xxviii, 25) but to Leviticus, xix, 35: "Nolite facere aliquid in iudicio in regula, in pondere, in mensura." God does not figure here as an architect, but rather, if we want to give him a symbolic occupation, as a controller of weights and measures. From this *iudicium* is derived the comparison between music and justice, both founded, according to Sieur Pibrac, on number, order, measure, and enthusiasm (*Discours* [1572]; cf. Frances Yates, *The French Academies of the XVIth Century* [London, 1947] pp. 106–107); similarly, Villalpando writes: "Mensurarum ponderumque iustam rationem a Deo iniungi . . . quod . . .

aptissima iustitiae symbola sunt" (II, 332–33). To reinforce his intellec-
tualized and moralistic interpretation of the triad, he interprets as follows the
text quoted from Leviticus: "You must not falsify judgment the standards of
length, weight, and measure . . ."

22. An apocryphal text of the thirteenth century printed in Italy after 1478;
consulted, *Alberti Magni speculum astronomie* (Lyons, 1615', see pp. 56–60.

23. Jean de Meung, *Remonstrances de Nature à l'Alchymiste errant* and *Re-
sponse de l'Alchymiste* (ed. consulted: *Roman de la Rose* [Paris, 1735], appen-
dix)

24. Marsilio Ficino, *Convito*, VI, 10 (Florence, 1594), p. 166.

25. G. B. della Porta, I, 1, f° 1 v° (Venice, 1560); cf. II, 2, f° 35 r°.

26. Cornelius Agrippa, *De occulta philosophia*, II. 25 (ed. Lyons, 1555, p.
259): "Cantus quam instrumentalis sonus plus potest, quatenus per har-
monicum concentum, ex mentis conceptu, ac imperioso phantasiae cordique
affectu profisciens, simulque cum aera fracto ac temperato, aerium audientis
spiritum qui animae atque corporis vinculum est, motu facile penetrans, af-
fectum animumque canentis secum transferens, audentis affectum movet af-
fectu, phantasiam afficit phantasia, animum animo, pulsatque cor, et usque
ad penetralia mentis ingreditur, sensim quoque mores infundit; movet prae-
terea membra atque sistit, corporisque humores." This is a melange of Fi-
cino's musical theories (cf. D. P. Walker, "Ficino's spiritus of Music," *Anna-
les Musicologiques*, I [1953, 131–51] and views derived from the
identification of *spiritus phantasticus*, "subtle" envelope of the thinking soul,
and the animal spirits of the blood, on one hand, and the poets' *spiritelli* on
the other.

27. Ibid., II, 60.

28. Ibid. On the opposing *phantasia* and *ratio*, which is derived from the
Stoics, see Ficino, *Theol. plat.*, VIII, 1.

29. See, for instance, "Magia e Grazia," in *Theologicum über XIV*, ed. R.
Amerio (Rome, 1957), p. 204.

30. See Agrippa, *De occulta philosophia*, I, 5, pp. 103–104, the curious expla-
nation of love.

31. Love, especially according to the Neoplatonists, was predestined to play
an important role in that context. Through its cause (beauty) it pertained to
art, through its workings and its effects (sympathy, fascination, ecstasy), to
magic. An ancient belief attributes to magic the power of creating love; on
the other hand, an analogy with love allowed theorists of art to acknowledge
certain realities which could not otherwise be justified—the diversity of
tastes, for instance (Lomazzo, *Idea*, chap. xxvi). It is therefore not surprising
that love should have become, in Bruno's *De vinculis in genere*, the proto-
type of any "link" or charm: "Diximus . . . quemadmodum vincula omnia
tum ad amoris vinculum referantur, tum ab amoris vinculo pendeant, tum
in amoris vinculo consistant" (*Op. lat.*, III, p. 684).

32. Lomazzo names Cornelius Agrippa only once, in a sonnet deriding the *Grotteschi*.

33. Lomazzo, *Trattato*, II, 11, pp. 201–202.

34. Among the fairly copious literature on that subject, we may cite: Fulvio Pellegrino Morato, *Del significato de'colori* (1535); Lodovico Dolce, *Dialogo nel quale si ragiona . . . de i colori* (1565); Coronato Occolti da Canedolo, *Trattato de' colori* (1557; re-edited with added appendix about gifts, 1568); Girolamo Rinaldo, *Il vago, e dilettevole giardino* (second ed., the only one I could obtain, 1593). We must add passages about color in *imprese* books, Ariosto's commentaries, etc. Cf. A. Salza in *Giorn. stor. di letterat. ital.*, 38 (1901), pp. 310–63.

35. Cf. Alciat, *Emblemata*, CXII: "In colores" with the commentary by Franc. Sanctius (ed. Lyons, 1573), pp. 348–49: a short list of the symbolic meanings of the various colors, ending with a reminder of the relativity of judgments in that matter.

36. *De occulta philosophia*, I, 49, 102.

37. We must note, however, that at two points Lomazzo abandons a purely astrological scheme to show a certain independent spirit of observation: yellow, gold, and pale purple, the colors of the sun, engender in the soul—besides the classical "solar" dispositions—visual attention ("fanno l'uomo intento nel guardare"); white, the color of the moon, "genera una certa semplice attentione più *melancolica che altrimenti.*" Here, as in several other cases, the adaptation of themes from magic has put Lomazzo on a path which he could follow further on his own.

38. Agrippa, *De occulta philosophia*, I, 52, 109ff.; cf. the epithets and attributes quoted II, 59, 335–38.

39. Lomazzo, *Trattato*, II, 7, 120–25, and partly VII, 12, 545–78.

40. *Ibid.*, II, chaps. ix–xv. We recognize respectively Saturn, Jupiter, Mars in the chapter titles: IX, *De i moti della malancolia, timidità, malignità, avaritia, tardità, invidia, rozzezza e ansietà;* X, *De i moti della fortezza, fedeltà, giustitia, divotione, meastà e constanza;* XI, *De i moti dell'audacia, robustezza, ferocità, orrore, furia, ira, crudeltà, impeto, rabbia, asprezza, terribilità, ostinatione, sdegno, impietà, ingiuria, odio, superbia, vanità e ardimento.* What follows also conforms to the traditional images of the other planets.

41. *Ibid.*, II, 7, 120–25 and, for Saturn, VII, 6, 545.

42. Agrippa, *De occulta philosophia*, I, 52, 109–110. Fritz Saxl, *Antike Götter in der Späterenaissance* (Leipzig, 1927), p. 17 and n. 1, cites the description of Saturn as proof that Lomazzo borrowed from *Picatrix;* unless, he adds, there should be an intermediary source. I have been unable to consult the manuscripts of *Picatrix,* but there is nothing in the passage in question which Lomazzo could not have found in Agrippa. It is true that part of

Agrippa's view also occurs in G. B. della Porta, *Caelestis physiognomonia* (Naples, 1603 [II, 1, 19]), with Messahala indicated as a source; but, at least according to the two editions of Messahala I have been able to see (Venice, 1519 and Nuremberg, 1549), this reference is inaccurate.

43. Their names were suggested to Lomazzo by the *Cortegiano*, I, 37, which cited five artists different in their styles, but equally great. Lomazzo has—justly—replaced Giorgione by Titian, and has added two Lombards to reach the number seven.

44. Virtually half of chap. XII of the *Idea*, on the seven types of *moto*, is an almost literal translation from Cornelius Agrippa, III, 38, 465–66. Thus, for Saturn, in Agrippa: "Per Saturnum [accipitur] sublimis contemplatio, profunda intelligentia, gravitas iudicii, firma speculatio, stabilitas immobileque propositum." This becomes in Lomazzo: "il Buonarroto ha espresso i moti della profonda contemplazione, dell'intelligenza, della grazia [*sic* for *gravità*], del guidizio, della ferma speculazione, del saggio proposto, ed immobile." Moreover, in chap. IX of the *Idea*, the Vices engraved on the pediments of the governors' statues follow the list of malevolent planetary influences according to Agrippa, III, 38, 469; finally, in chap. XXXIII of the *Idea*, a new short characterization of the seven is again borrowed from Agrippa's planets, II, 28, 279.

45. Lomazzo, *Trattato*, II, 1 and *Idea*, chap. xx.

46. *De vita coelitus comparanda*, chap. II (*Opera*, p. 533): "Exigua igitur praeparatio . . . sufficit coelestium numeribus capiendis, si modo quisque ad id praecipue se accommodet, cui est praecipue subditus." Chapter XXIII, pp. 556–68, has for its title: "Ut propere vivas agasque, in primis cognosce ingenium, sidus, genium tuum, et locum eisdem convenientem; hic habita, professionem sequere naturalem." Cf. also the following chapter: "Qua ratione literati cognoscant igenium suum, sequanturque victum spiritui consentaneum." Cf. Cornelius Agrippa, 67, 156, cited below, n. 50.

47. *Trattato*, VI, 54, 481–86.

48. See, for instance, Ficino, *De vita coelitus comparanda*, II, *Opera*, p. 533.

49. *Convito*, V, 6, passage copied by Lomazzo, *Idea*, xxvi, and for another part by Bruno, *De vinculis*, III, 18.

50. *De re aedif.*, I, 1. They lose their quantitative character in a statement by Cornelius Agrippa, I, 67, 156, which, although strictly limited to rites of magic, is curious for gathering together several of the themes which were to become, eighty years later, important discoveries of the theory of art: "Et est generalis regula in istis, quod omnis animus qui est magis excellens in suo desiderio et affectu ipso, efficit sibi res huiusmodi magis aptas, efficaces ad id quod appetit. Oportet igitur quemcumque volentem operari in magia, scire et cognoscere suae ipsius animae proprietatem, virtutem, mensuram, ordinem et gradum in potentia ipsius universi."

51. See also the relationship between number, order, measure, and enthusiasm in Pibrac, *Discours*.

52. A. Chastel, "Marqueterie et perspective au XVe siècle," *Rev. des arts*, n°. 3 (1953): 141–54.

53. Reproduced by Lomazzo, *Idea*, chap xxxviii, and Comanini, *Il Figino* (Mantua, 1591), p. 32:

> Son'io Flora o pur fiori?
> Se fior, come di Flora
> Ho col sembiante il riso? e s'io son Flora. . . .

54. *Il Figino*, loc. cit.

55. Ibid., p. 46ff.

56. Lomazzo, *Idea*, chap. xxxviii.

4. Spirito Peregrino

1. Most tales of journeys to the other world, or visions of the other world, have a certain initiatory quality or invite a "conversion" (in the wider, Neoplatonic sense of the term). This is true even outside the Christian context: cf. the story of Er the Armenian, or the *Liber Scalae Machometi*. But it would be wrong to consider them as a diluted and more literary form of the shamanic heritage; they lack the fundamental idea of the divine body acquired by the shaman during the course of initiation—an idea that we find even in Renaissance magic. The quality in the *Divine Comedy* which reminds us of shamanism is precisely that which distinguishes it from the rest of the literature of other-worldly visions: its ambition to bring the historical and real world into the system which by right must govern it, and into the order which redeems it.

2. M. O. Buhociu has called my attention to one such tale in Rumanian folklore (P. Ispirescu, *Legende* [Bucharest, 1872], pp. 119–23), in which a dove, issuing from the head of the sleeper, acts out for the sake of a friend (who is awake) the adventures dreamed by the former. The tale ends with the discovery of a treasure at a place indicated by the bird.

3. *Rime di Dante*, ed. Gianfranco Contini (Turin, 1946), p. 27 (sonnet 1A). I shall refer throughout to this edition for the text and for the numbers of the poems.

4. Albertus Magnus, *De somno et vigilia*, lib. III, tr. i, cap 9. (This text can be found among the *Parva naturalia*, vol. V of the *Opera* [Lyons, 1651], pp. 64–108.) The Arabic source of Albertus is not acknowledged. Cf. Bruno Nardi, "Dante e Pietro D'Albano," in *Saggi di filosofia dantesca* (1930), pp. 58–61. Nardi also cites, p. 58, n. 2, the thesis condemned by Etienne Tempier: "Quod Deus vel intelligentia non infundit scientiam animae humanae in somno, nisi mediante corpore caelesti."

5. Compare, apart from the ad loc. commentary of the Busnelli and Vandelli edition, the passage from Nardi cited in the preceding note, "and by the same author the essay "L'immortalità dell'anima" in his collection *Dante e la cultura medievale* (Bari, 1949), pp. 284–308, and also "La conoscenza umana," especially p. 174, n. 20.

6. *De divinatione*, §I, 63:

Cum ergo est somno sevocatus animus a sosietate et a contagione corporis, tum meminit praeteritorum, praesentia cernit, futura providet; iacet enim corpus dormientis ut mortui, viget autem et vivit animus. Quod multo magis facit post mortem cum omnino corpore excesserit. . . . § 64: Sed tribus censet [Poseidonius] deorum adpulsu homines somniare, uno, quod prodeat animus ipse per sese, quippe qui deorum cognatione teneatur, altero, quod plenus aer sit immortalium animorum, in quibus tamquam insignitae notae veritatis appareant, tertio, quod ipso di cum dormientibus conloquantur. . . . § 110: Altera divinatio est naturalis, quae physica disputandi subtilitate referenda est ad naturam deorum, a qua, ut doctissimis placuit, haustos animos et libatos habemus. . . .

But Dante could not ignore Cicero's reservations concerning the opinions he was reporting.

Albertus Magnus, *De somno et vigilia*, lib. III, tr. i, cap. 8–9.

7. Ibid., cap. 6.

8. About the formation of this concept, see C. R. Kessling, "The ὀχημα-πνεῦμα of the Neoplatonists and the "De insomniis of Synesius of Cyrene," *American Journal of Philology*, 43 (1922): 319–30; Proclus, *The Elements of Theology*, ed. E. R. Dodds (Oxford, 1933), Appendix II (pp 313–21): "The Astral Body in Neoplatonism." About its development in the Middle Ages, see Robert Klein, "L'imagination comme vêtement de l'âme chez Marsile Ficin et Giordano Bruno," *Revue de métaphysique et de morale* (1956): 18–39 (reprinted in Klein, *La Forme et l'intelligible* (Paris, 1970), pp. 65–88).

9. Aristotle, *De generat. animal.*, II, 3, 736 *b*.

10. See Robert Klein, "L'enfer de Ficin," *Umanesimo e esoterismo, Atti del V Convegno internazimale di studi umanistici* (Oberhofen, September 1960), *Archivio di filosofia*, 2–3 (1960): 47–84 (reprinted in Klein, *La Forme et l'intelligible*, pp. 89–124).

11. The difference between Aristotelian pneumatology and Stoic panvitalism was well established by Werner Jaeger, "Das Pneuma im Lykeion," *Hermes*, XLVIII (1913): 29–74. There is in Philo of Alexandria a Stoico-Neoplatonic doctrine in which the pneuma serves as a bridge between a theory of prophecy or ecstasy and a panivitalistic cosmology of the "breath." The World-Soul as pneuma is found in the School of Chartres and even in Ficino, who also discusses the distinction between the World-Soul and an eventual "pneuma of the World-Soul" considered as its link with matter, and in some way its imagination. Cf. D. P. Walker, "Ficino's *spiritus* of music," in *An-*

nales Musicologiques, I (1953): 131–51; and his "Spiritual and Daemonic Magic," *Studies of the Warburg Institute*, 22 (London, 1958) part I. The principal historical interest of the doctrine of the cosmological pneuma consists in its occurrence in the theology of the Holy Spirit.

12. For the text, see the *Canzoniere Chigiano*, ed. Molteni-Monaci (Bologna, 1877), pp. 67–69 (I have corrected *falir* to *salir*); and cf. Vossler, *Die philosophischen Grundlagen des süssen neuen Stils* (Heidelberg, 1904). For the interpretation of "the Chariot of Elijah" as *spiritus*, I can cite only a late text—the *Alverotus* dialogue by Niccolò Leonico Tomeo, in *Opera* (Paris, 1530), III, 34.

13. The *Liber de spiritu et anima* attributed to Alcher is published in the *Patrol. lat.*, XL, col. 779–832, among the works of Augustine: it has also been attributed, notably by Vincent of Beauvais, to Hugh of Saint-Victor. The introduction to the Migne edition refutes those two attributions and suggests, with good reasons, the name of Alcher. The treatise itself is made up of borrowings from diverse and sometimes contradictory sources, but the exact source of chapter XXVI and of the passage which concerns us here has not been identified.

14. *Inferno*, XXXIII, 118–47 and Saint John, XIII, 27. The resemblance between demonological myth and certain poetic fictions about *spiritelli* is obvious (love entering by force into the heart of the lover and expelling his life or his vital spirits). See also text, p. 70, concerning the punishment of thieves.

15. *Inferno*, XIII, 93–108. A traditional theological argument to justify the dogma of the resurrection of the body. Cf., among others, Tertullian, *De resurrectione carnis*, cap. 7.

16. *Purgatory*, XXV, 79–108. This passage is commented upon in my "L'Enfer de Ficin"; see n. 12.

17. Quoted by Dodds, *The Elements of Theology*, p. 319.

18. Porphyry, *Sententiae* (ed. Mommert, Teubner, 1907), XXIX.

19. M. W. Bundy, in *The Theory of Imagination in Classical and Mediaeval Thought* (Urbana, 1927), pp. 225–56 (chap. xi: "Dante's Theory of Vision"), interprets Dante's poetics as a theory of imaginative vision and of the visual expression of realities "seen" (or intuitively apprehended), whether of the sensible, intelligible, or divine order. Bundy's demonstration is summary and not always convincing, but the idea deserves to be considered.

20. The edition cited is *Libri XIV qui Aristotelis esse dicuntur, de secretiore parte divinae sapientiae secundum Aegyptios* (Paris, 1571); see lib. VI, f°49 r°–54 v°. We know this to be an epitome of Plotinus, written in the sixth century and translated into Arabic in the ninth. A. J. Denomy has shown its importance for the medieval theory of love. (For a good exposition of the system of natural magic transmitted by the Neoplatonists, directly or through Arab

writers, to mediaeval and Renaissance Europe, see Walker, *Spiritual and Daemonic Magic*, pp. 75–85.

21. Ibid., Dicimus virum iustum fascinationis vim non recipere in ea animi parte in qua rationis est principium . . . [sed]id in ea illi accidere quam cum universo animalium commune habet. . . . Nititur enim fascinator in spiritum animalem agere" (f⁰ 52 v⁰).

22. Ibid., f⁰53 v⁰, f⁰54 r⁰.

23. Egidio Colonna, *De erroribus philosophorum*, ed. Koch (1944), §6–7. *Errores al-Kindi*: ". . . Quod substantia spiritualis per solam imaginationem potest veras formas inducere. . . . Quod per solum desiderium spirtualis substantiae, formae inducuntur." §16. "De erroribus Algazelis . . . Ulterius erravit circa actionem animae nostrae, ponens animam per imaginationem nostram operare in corpore alieno." Albertus Magnus, *De somno et Vigilia*, quoted, lib. III, tr. ii, cap. 6, about images penetrating from outside into the mind of a sleeping man: "Secundum Avicennam et Algazelem non tantum a caelestibus fiunt huiusmodi motus sed etiam ab animalibus: quia illi dicunt animam unius imprimere per modum fascinationis in animam multorum aliorum, sed hoc per philosophiam probari vix potest." Walker, *op. cit.*, p. 149, n. 2, mentions a similar disagreement between Giovanni Francesco Pico and al-Kindi, remarkable because of the naturalistic explanation and the link with cosmic pneumatology: "Imaginationem deinde ponit [al-Kindi] radios habere, mundi radiis apprimi conformes, quod fieri ut facultas ei sit in rem extrariam imprimere, quodque in ea concipitur actualem, ut inquit, existentiam habere in spiritu imaginativo, quapropter extra produci posse quod conceptum est . . ." (G. F. Pico, *De rerum praenotione*, VII, vi–*Opera omnia*, Basel, 1573, p. 651). According to Walker, Pico refers to al-Kindi, *De radiis stellecis*, or *Theoria artis magicae*, ms. Harleian. 13, British Museum, f⁰ 168 v⁰–169 r⁰.

24. *Alberti Magni speculum astronomiae*. The edition consulted is Lyons, 1615.

25. H. Leisegang, in *Der heilige Geist* (Leipzig-Berlin, 1919), pp. 70–71, quotes a curious passage from Horace (*Carmen Saeculare*, II, 16, 38–40) in which the "subtle spirit" of Greek poetry seems to have preserved, in the tamed form of metaphor, something of its primitive pneumatological meaning:

> mihi parva rura et
> spiritum Graiae tenuem camenae
> Parca non mendax dedit.

26. This association has been evoked in connection with the question of naturalistic licentiousness, and of Averroism in courtly love and in Andreas Capellanus.

27. G. Federzoni, "La poesia degli occhi da Guido Guinizelli a Dante Alighieri," in *Studi e diporti danteschi* (Bologna, 1902), pp. 77–123, reconciles the belief in the *malocchio* with the poetry of the glance, such as *trono, saetta, colpo, dardo*, in the authors mentioned. Walker, *Spiritual and Daemonic Magic*, p. 33, n.1, quotes a text characteristic of the attitudes of a magician summoning a planetary spirit: "His omnibus addit, quod quidem plurimum valere putaret, vehementum imaginationis affectum, a quo more praegnantium spiritus huiusmodi signatus charactere cum per meatus relinquumque corpus, tum maxime per oculos evolitans, quasi coagulum cognatam coeli vim fermentat et sistit (Cattanio da Diacceto, *De Pulchro*, in *Opera* (Basel, 1563), pp. 45–46. Walker comments: "This elaboration . . . derives evidently from the usual explanation of fascination as caused by an emission of noxious spirit from the operator's eyes."

28. Carducci refers to the *Liber de spiritu et anima* which he attributed to Hugh of Saint Victor and which is now ascribed to Alcher (see above, n. 13). Boffito, "Il 'De principiis astrologiae' di Cecco d'Ascoli," in *Giorn. stor. della lett. ital.*, *Suppl.*, VI (1903): 1–73, has observed that this is a much more widespread commonplace, and quotes Vincent of Beauvais, who gives Hali as his source (but who also knows Alcher's text, which he attributes to Hugh); Flamini, "Un passo della Vita nuova e il De spiritu et respiratione d'Alberto Magno," in *Rassegna bibliogr. della lett. ital.*, XVIII (1910): 168–174, and especially G. Vitale, "Ricerche intorno all'elemento filosofico nei poeti del dolce stil nuovo," in *Giornale dantesco*, XVIII, 5–6 (1910): 162–85, have given a more general view of the question and named Albertus Magnus as Dante's most immediate source. See also, more recently, E. Bertola, "La dottrina del spirito in Alberto Magno," in *Sophia*, 19 (1951): 306–312, who, without referring to Dante, quotes several extracts from Albertus whose meaning is very close to the beginning of the *Vita Nuova*; for instance *Summa de creaturis*, pars II, tr. i, qu. 86 and 41: "Spiritus enim ad operationem nutrimenti formam ab hepate, sed ad operationem motus et sensus formam accipit a cerebro, et ad operationem vitae formam accipit a corde."

29. Concerning the different significations of the word *spiritus* and their interconnections, see the outstanding article by M. D. Chenu, "Spiritus, le vocabulaire de l'âme au XIIe siècle" (*Revue des sciences philosophiques et théologiques* XLI [1957]: 209–232) which cites, among others (p. 226, n. 62), a text from *Summa philosophiae* by Pseudo-Grosseteste (ed. Baur, p. 480): "Nominatur [imaginatio] a diversis diversimode, ut ab Avicenna virtus formativa, a divo Augustino vero spiritus, secundum quam etiam visionem spiritualem fieri dicit." These lines probably contain the most radical assertion of the identity of the *virtus formativa* of semen with imagination, and with *spiritus* in general. The text of Augustine quoted by Grosseteste (*De Genesi ad litteram*, VII, 13), which only sums up for the sake of exegesis the medical opinion of the time, has become a classic source on the subject. There is also a passage from Alcher, *Liber de spiritu et anima*, cap. xiv: "Convenientissima autem media sunt carnis et animae: sensualitas carnis, quae maxime ignis est; et phantasticum spiritus, qui igneus vigor dicitur," which is very interesting

for the link between imagination, the "spirit" of the physicians, and the "spirit" of Neoplatonic anthropology. *Igneus vigor* is in fact a reference to the *Aeneid*, VI, 730 (Anchise's speech in the underworld), and its identification with the *spiritus phantasticus* presupposes the Neoplatonic interpretation of this classical text, in which hell is only a symbol of matter, and imagination the instrument of posthumous retribution. See further my 'L'Enfer de Ficin" (n. 12 above) pp. 121–22, and P. Courcelle, "Les Pères devant les Enfers virgiliens," in *Archives d'histoire doctrinale et littéraire du Moyen Age* (1955) pp. 5–74, who cites (p. 45) Alcher and Isaac de L'Etoile.

30. Albertus Magnus, *De somno et vigilia*, esp. I, i, 4 and I, ii, 1–4. "Est igitur [*spiritus*] instrumentum animae directum ad omnes operationes eius . . . et est vehiculum vitae et omnium virtutum eius" (I, i, 7). *De spiritu et respiratione:* "Spiritus non est medium quo anima coniungatur corpori, eo quod sine medio unita est ei sicut omnis perfectio suo perfectio suo perfectibili . . . sed potius spiritus est, per quem omnia operantur in corpora opera vitae" I, i, 8. (The polemic against the conception of the *spiritus* as a *medium* might well be directed against Alcher—see preceding note.)

31. But Albertus speaks of it: ibid. III, i, 6–8, and elsewhere. The *De spiritu et respiratione* replaces Galen's tripartite division with another: animal, natural, and radical spirits. The vital spirit, discarded here, is in fact restored to its primary and superior role as common source for the other three: "[spiritus vitalis] in cerebro accipit sensus et motus formam," etc., as in the text quoted in n. 28.

32. Treatise X in *Corpus hermeticum* maintains, for example, that the pneuma of the seven spheres, in the wake of the incarnate soul, flows with the blood into the members. A similar opinion by Hierocles, *In carm. aureum*, is quoted by G. Verbeke, *L'Evolution de la doctrine du pneuma, du stoïcisme à Saint Augustin* (Louvain, 1945), pp. 369, 371. Albertus Magnus, *De somno et vigilia*, I, 1, 7: "Quod autem quidam dicunt, quod spiritus sunt de natura corporis caelestis, est omnino absurdum: quia corpus caeleste non intrat per substantiam in compositione alicuius corporis generabilis." This "absurdity," which was nevertheless accepted by many physicians and by Jean Fernel, ended, with Harvey, by exploding the whole doctrine of the *spiritus* of the blood. Cf. D. P. Walker, "The Astral Body in Renaissance Medicine," *Journal of the Warburg and Courtauld Institutes*, XXI (1958): 119–33.

33. See, apart from *Purgatory*, XXV, the *Convivio*, IV, 21, with the ad loc. commentary by Vandelli and Busnelli and Nardi's remarks, "Origine dell'anima umana" (*Dante e la cultura medievale*, pp. 260–83). The question of genesis is inseparable from that of the individual differences among men; Dante's eclectic solution is inspired by Albertus, *De somno et vigilia*, III, 1, 6–8. (Walker, in the article cited in the previous note, seems to attribute it to Fernel.)

34. Galen, *De placitis Hippocr. et Plat.*, VII, 615 (ed. Müller). The idea, reinforced for Christians by the authority of Saint Augustine (De Genesi, n.1,

p. 214), was also popular with the Arabs. Vincent of Beauvais (*Speculum nat.*, XXV, 29) quotes Hali on the spirit of the eyes: "Cum et ipsius spiritus natura sit quae et aeris igne illuminati, facilis est foras agendi." The contrary opinion, about the passivity of the eye in vision, also had ancient and medieval supporters.

35. This is not, to my knowledge, endorsed by Albertus.

36. II, ii, 1–2, about the *gentile donna* who consoles Dante on the death of Beatrice: "li spiriti de li occhi miei a lei si fero massimamente amici."

37. *Conv.*, II, ix., 4–5. The *imaginativa*, in this passage, includes all the inner senses.

38. Ibid., II, xii, 24; see also *Purgatory*, IV, 1–2. The passages from Thomas Aquinas quoted in the commentary of the *Convivio* by Busnelli and Vandelli refer to the *potentiae animae* and *intentiones*, and therefore bear only a distant relation to the medical pneumatology discussed here.

39. When Vossler posed the problem sixty years ago (*Die philosophischen Grundlagen*), he realized that it is necessary to refer, beyond precise theoretical sources, to one or several "surrounding philosophies": to conventions of love, to the demands of Christian morality. A more or less mystical Neoplatonism and a more or less licentious naturalism remained in the background. The contradictions that resulted, according to the author, found an outlet in allegory, which somehow neutralized love ("es kann keinem Zweifel unterliegen, dass die Liebesdichtung des dolce stil nuovo prinzipiell symbolisch zu deuten ist," p. 71), without excluding, however, the existence of a doctrinal compromise based mainly on Albertus. A position similar to Vossler's was adopted by D. Scheludko, "Guinizelli und der Neuplatonismus," in *Deutsche Vierteljahrsschr. für Literaturwiss. und Geistergesch.*, XII (1934): 364–99. According to Scheludko, the *dolce stil nuovo* included a Platonic theory of profane love as an occasional cause of the awakening of the soul: in this way poetry could get around the obstacle of Christian rigor without losing the right to insist upon sensual beauty and the feeling it aroused.

These two works have been followed by many studies concerning the Latin or Arab sources of doctrine, and with illuminating results, but the writers have not always remembered that pinning down origins too narrowly was in this case an error of method.

40. G. Vitale, "Ricerche intorno," p. 44, n. 2. See, along the same lines, Bruno Nardi, "L'amore e i medici medievali," in *Studi in onore di Angelo Monteverdi* (Modena, 1959), pp. 1–28, particularly on *De amore heroico* by Arnaud de Villeneuve, and on an exchange of sonnets between Dante Alighieri and Dante da Maiano.

The Albertus Magnus is *De motibus animalium*, I, tr. ii, caps. 4–7; *De anima*, II, tr., iv, cap. 9.

41. On the condemnation of Capellanus, see M. Grabmann, "Andreas Capellanus und Bischof Stephan Tempier," *Speculum*, VII (1932): 75–79; and Denomy, "The De Amore of Andreas Capellanus and the Condemnation of

1277," in *Mediaeval Studies*, VIII (1946): 107–149. We know how important Capellanus's little book was for shaping and codifying the main points of the theory of love. In a sonnet by Gianni Alfieri, "Guido, quel Gianni ch'a te fu l'altri'ieri" (no. 7 in Luigi Di Benedetto's ed., *Rimatori del dolce stil novo* [Turin, 1944]—which we shall use for the poets of that group), "Gualtieri," that is, Andreas Capellanus, simply becomes synonymous with Love. The questions he discussed, undoubtedly according to earlier conventions, govern Cavalcanti's canzone "Donna me prega"; his definition of love reappears, in its main outlines, even in a sonnet attributed to Dante ("Molti, volendo dir che fosse Amore, n°. 79 of the Contini ed., placed among the *dubbie*): love is a passion of desire, natural to the soul, and aroused by a beautiful object. Vossler has analyzed very aptly this rather curt, descriptive definition, which makes it difficult to allow love for a beautiful soul in an ugly body, and even denies (Capellanus did not hesitate to accept this corollary) that a blind man is capable of feeling love. The "innate" character of that passion (*passio innata*), however, permits the discarding of extreme naturalism, authorizes the thesis of ennobling love, and, almost in passing, reduces to almost zero the so-called novelty of the solution Scheludko attributed to Guinizelli.

The Averroist connections of Cavalcanti are firmly established; we do not feel that Nardi's interpretation of the canzone *Donne me prega* has been disproved, in its essentials, by the controversy which it aroused. Nardi's thesis is expounded in "L'averroismo del 'primo amico' di Dante" (*Dante e la cultura medievale* [quoted], pp. 93–129); cf. also "Di un nuovo commento," ibid., pp. 130–52; and his "Noterella polemica sull 'averroismo di Guido Cavalcanti," in *Rassegna di Filosofia*, III, 1 [1954]: pp. 47–71. See Guido Favati's answer, "Guido Cavalcanti, Dino del Garbo e l'averroismo di Bruno Nardi," in *Filologia romanza*, II (1955): 67–83.

42. A. J. Denomy, "An inquiry into the origins of courtly love," *Mediaeval Studies*, VI (1944): 175–260, and "Fin' Amors: The Pure Love of the Troubadours, Its Amorality and Possible Source," ibid., VII (1945): 139–207.

43. Vossler, *Die philosophischen Grundlagen*, pp. 80 et seq., about sonnet VII ("Io vidi li occhi") by Cavalcanti, sonnet "Oltre la spera" by Dante (*Vita Nuova*, XLI), and ballad LXII ("Lasso, ch'amando la mia vita more") by Cino.

44. Neither the literary use of exotic "marvels" nor the transformation of gods into poetic ornaments can be compared, since in both cases Christian authors adopted an ancient literary tradition that was known to them. The decorative or semidecorative use of supposedly scientific data is a new departure, whose only possible analogy is the mutual borrowings of religious and profane literatures, above all of the poetry of love.

I shall confine myself to Cavalcanti and Dante because the list of examples would become needlessly long if I added other poets from the group. Cavalcanti is cited from the edition by Luigi di Benedetto.

45. See the article by M. D. Chenu quoted above, n. 26, which gives the texts relevant to this question.

46. Hugh of Saint-Victor, *De unione corporis et spiritus*, *Patr. lat.*, 177, col. 291: "Prima divisio est inter animam et spiritum, hoc est inter voluptates carnales et spirituales"—or, differently, Thomas Aquinas, *S. theol.*, I, qu.97, a. 3. (Cf. Chenu, op. cit., p. 223, n. 50): "Anima rationalis est anima et spiritus. Anima secundum illud quod est comune ipsi et aliis animabus, quod est vitam corpori dare. . . . Sed spiritus dicitur secundum illud quod est proprium ipsi. . . ."

47. *Rime* by Cavalcanti, ed. quoted, VIII, v. 9–14, 19–22, 48–52; XII, v. 6; XV, v. 13; XVI; XXIII, v. 12–15. In those passages, particularly VIII and XVI, *anima* often refers to the sum of all the *spiriti*, which conforms with the tradition of the vital spirit.

48. Ibid., XII (sonnet: "Un amoroso sguardo spiritale"), v. 11.

49. Ibid., VIII, envoi.

50. Ibid., XXI (sonnet: "Veder poteste, quando vi scontrai").

51. For instance, *Rime*, no. 19; or nos. 66 and 71, classified among the *dubbie*.

52. Ibid., canz. 20 (*mezzo del cor*); Contini, *Rimedi Dante*, refers to *Inf.*, I, 20 (*lago*) and *Vita Nuova*, II, 4 (*segretissima camera*), and to the *Rime dubbie*, no. 61 (*lago*).

53. Ibid., no. 61 (*Rime dubbie*).

54. Seneca, *Epistolae*, 54. Alfredus Anglicus (Alfred of Sareshel), *De motu cordis*, ed. Clemens Bäumker (Münster, 1923), p. 27: "Atque horum omnium in propatulo evidens signum suspirium, quod est omissi haustus a mente defixa in multitudine restauratio. Cum enim alicujus conceptioni seorsum vacet anima tanquam ab aliis abstracta, aëris quoque attractionem intermittit, constante tamen calore caeterisque instrumentis. Quiescit igitur interim et respiration Hanc dispositionem natura non sustinens laeditur. Anima igitur respirans uberius multitudine redimit, quod omisit in numero." Albertus Magnus, *De motibus animalium*, I, ii, 4 (passage quoted by G. Vitale). Thomas Aquinas, *S. theol.* Iᵃ IIᵃᵉ, qu. 40, a. 6 and qu. 44, a. I, ad 2. Quoted by Chenu, op. cit., p. 225, nn. 58 and 59.

55. *Rime* XVIII (sonnet "S'io prego questa donna che pietate"), v. 10; XIX (sonnet "Io temo che la mia disaventura," v. 9–11); XXXIII (ballad "Era in pensier d'amor quand'i' trovai"), v. 14–16.

56. *Vita Nuova*, sonnet c. 34; *Convivio*, canz. II, v. 34–36; *Rime*, sonnet XIX; canz. XX, v. 5–7 (about the "last sigh"); sonnet LXVIII, whose attribution is doubtful.

57. That is one of the opinions rejected by the author of the Dantesque sonnet no. 79.

58. XXVII (Ballad "I' prego voi di dolor parlate"), v. 18–24. XXVIII ("Vedete ch'i son un che vo piangendo"), v. 13–20, and XXXIII ("Era in pensier d'amor quand'i' trovai"), v. 39–42. Also, Cino da Pistoia, sonnet XXV ("Bene

à forte cosa il dolce sguardo"), v. 9 sq.—The "soft glance" penetrates the heart and

> Formasi dentro in forma e sustanza
> di quella donna. . . .

59. *Rime*, canz. VII ("La dispietata mente, che pur mira") v. 20–22; sonnets XIII ("Volgete li occhi a veder chi mi tiene") and XXIV ("Voi donne, che pietoso atto mostrate"), and also canzone XX, v. 43–45, and the *Detto d'Amore*, of doubtful attribution, v. 256–59.

60. Bäumker, *Witelo* (Münster, 1908) (Beitr. z. Gesch. u. Philos. d. M.A., 3, II).

61. On theoretical aesthetics and on poetry, see E. De Bruyne, *Etudes d'esthétique mediévale*, 3 vols. (Bruges, 1946), III, 3–29; on painting, see provisionally the summary by W. Schöne, *Uber das Licht in der Malerei* (Berlin, 1954).

62. Scheludko, in "Guinizelli und der Neuplatonismus," cited above, suggests this possibility for Guinizelli's poetry.

63. Chenu, "Le De spiritu imaginativo de Rich. Kilwardby," *Rev. des Sc. philos. et théol.*, XV (1926): 507–517, quotes, p. 510, a manuscript by Kilwardby (Balliol College, n°. 3, f° 36 b): "Natura . . . sicut indivit oculo cati lumen ad illuminandum medium in tenebris . . . sic spiritui ymaginativo, quia remotus est ab aliis luminibus . . . disposuit lumen internum sibi debitum."

64. Cavalcanti, Sonnet XXIII ("per gli occhi fere un spirito sottile"). Dante, in Sonnet 8 ("Non mi porri ano già mai fare ammenda"), longed to kill the spirits of his eyes because, while gazing at the Garisenda tower in Bologna, they did not show him a passing lady. See also canz. VII, v. 56–65, about Love's arrow, which has blocked the entrance to his heart.

65. Sonnet VII ("Io vidi li occhi, dove Amor si mise"), v. 9–10:

> Dal ciel si mosse spirito in quel punto
> che quella donna di degnò guardare.

See also Cino da Pistoia, canz XXXVI ("L'alta speranza che mi reca Amore"), v. 63–64, where he counsels the canzone he dare not call his own:

> di che ti fece Amor, se vuoi ben dire,
> dentro al mio cor che sua valenza prova.

This is not more peremptory than Plato's *Ion*—in its ironic and polemical tone—about the "inspired" character of poetry.

66. *Vita Nuova*, XI, and XIV; *Conv.*, canz. III, v. 18–20; *Rime*, ballad 29 ("Voi che savete ragionar d'Amor"), ballad 34 ("I' mi son pargoletta"), the end.

67. *Conv.*, II, vi, 7 and II, x, 4, commentary on lines 12 and 42 of the canzone.

68. This was pointed out by J. E. Shaw, *Cavalcanti's Theory of Love* (Toronto, 1949), p. 117. We must remember to reckon with the passages of the canzone "Donna me prega," where the association between love and *virtù* or *valore* is maintained. In Guinizelli's case, too, some reservations are in order because of his metaphors for the glance, such as *colpo* or *trono*.

69. Passage quoted by Denomy, "An inquiry," p. 230; the poet who is speaking is in love with a noble lady: "It has been no hindrance to us that we were not her equal in nobility, for in affection there are sufficient reasons for equality" (from the French translation by H. Pérès).

70. Bernard de Ventadour, quoted by Denomy, ibid., p. 189. Contini, *Rime di Dante*, n°. 58A.

71. Ibid., n°. 79 (doubtful attribution).

72. Articles cited above, n. 42. Denomy wisely observed that a parallel with the Christian mysticism was out of place and that he had to resort to Platonic philosophy and its Christian or Arabic adaptations. But on one point he misunderstood the formal character of the so-called doctrine of love, which is a series of questions or problems to be discussed in poems, *tensons*, or courtly *ragionamenti*, rather than a collection of theses. Thus he narrowed down too precisely—to a treatise by Avicenna or a few other works of the same kind—the "source" of the troubadours' "doctrine."

73. Hence the strange reproach of "amorality" which Denomy levels against courtly love.

74. Cf. Nardi, "L'amore e i medici medievali," cited above, no. 40. Cavalcanti, Canz. VI, "Fresca rosa novella," conclusion; cf. Dante da Maiano to Dante Alighieri:

> E ben conosco o mai veracemente
> che 'nverso Amor non val forza ned arte
> ingegno nè leggenda ch'omo trovi.
> *(Rime di Dante,* 4)

Guinizelli, notably in the rather unconventional sonnet "Chi vedesse a Lucia un var capuzzo" (no. XXII of the Tommaso Casini edition, *Le rime dei poeti bolognesi del sec. XII*, in the collection "Scelta di curiosità letterarie," 185 [Bologna, 1881]).

75. In any case the *spiritelli* of the *Vita Nuova* become, in the course of the book, more like figures of speech; they are used more and more rarely. On the other hand, the subjectivist doctrine of love is not entirely adopted, since—this is the least one can say—Beatrice is always the effective, and not only the accidental, cause of love. Thus Dante prepares his own original solution to the conflict.

76. Dante's original contribution has been well analyzed by Mardi, "Filosofia d'amore nei rimatori italiani del Duecento e in Dante" (*Dante e la cultura*

medievale, pp. 1–92). As for Guinizelli, who is not pure "Guinizellian" in the sense I give here to the epithet—his attitude deserves separate analysis.

77. One must distinguish between: *a*) love defined as *unimento*, according to the *Convivio* (in which case it is a real, objective phenomenon concerning two distinct material or spiritual beings); *b*) love defined as a universal principle coexistent with being and pertaining to each thing in particular; *c*) love as an "accidental" desire or will of the individual alone (that is, courtly love, codified by Capellanus, without the ontological implication of *b*, and whose essence, contrary to *a*, is the subjective process and not the objective aim).

78. Canz. 47, "Tre donne," and sonnet 48, "Se vedi li occhi miei di pianger vaghi."

79. *Purgatory*, XVIII, 13–72 and sonnets (reply to Cino) 51A and 52 (passages on which Nardi comments).

80. See the English translation of this treatise, by E. Fackenheim, published as a postscript to Denomy, "Fins d'Amor," *Mediaeval Studies*, VII (1945): 208–228: "In all beings, therefore, love is either the cause of their being, or being and love are identical in them" (p. 214). The uplifting desire of love is innate in all men; it can deviate into physical love, but its rightful orientation leads to intellectual love, and the love of God is its natural end.

81. Cited by Denomy, "An inquiry," p. 218.

82. Guinizelli, "Canz. d'amore," str. 5. Dante, Canz. 37, "Amor che movi tua vertù dal cielo."

83. The passage in *Vita Nuova*, XVIII, about the "aim of love" of Dante for Beatrice undoubtedly marks the extreme form of Dante's "idealism"; it is closely linked with the homage to Guinizelli (*Vita Nuovc*, XX). It is easy to see how this position differs from the definition of love as *unimento spirituale* in the *Convivio*, and it might be considered as one of the ideas of his youth which Dante later discarded.

84. See the preceding note.

5. Utopian Urban Planning

1. L. Zuccolo, *Dialoghi* (Venice, 1625), p. 168 (*Della città felice*): "Qui non vengono forestieri a corrompere nostri costumi. . . ." p. 172: the republic of San Marino "desidera di stare oscura . . . vuole che le regole del suo governo stieno occolte." Cf. ibid., p. 214: "I vagabondi stranieri non si lasciano entrare in Evandria." Travel restrictions and limitations upon entering are also found in Morus, Andreae, Bacon. In *l'Histoire des Sevarambes* by Vairasse, a late work (1675), the citizen sent on a mission must leave his three children behind as hostages. Most Utopias give long descriptions of multiple fortifications, canals, moats, deserts, etc. Cf. for instance Antonio Brucioli, "Della Republica," in *Dialoghi* (Venice, 1526), f° 36 r° and 37 r°–v°.

2. L. Firpo, "La città ideale del Filarete," in *Studi in memoria di Gioele Solari* (Turin, 1954), pp. 11–59.

3. These features appear in Hellenistic literature, where utopia is partly myth, partly Land of Cockaigne, and partly philosophy; see J. Bidez, "La Cité du Monde et la Cité du Soleil chez les stoïciens," *Bulletin de l'Academie Royale de Belgique*, cl. Lettres, 5th ser., vol. XVIII (special edition [Paris, 1932]), and L. Gernet, "La Cité future et le pays des morts," *Revue des Etudes grecques*, XLVI (1933).

4. Zuccolo, "Della Republica d'Utopia," in *Dialoghi*, quoted p. 244. Morus wished to leave to men the glory of having conquered at least one unfavorable natural condition.

5. L. Agostini, *La republica immaginaria*, ed. L. Firpo (Turin, 1957), p. 83: "L'aria di questi paesi suole per natura produrre uomini temperati ne'vizi, docili in ogni sorti di scienza, civili nella pace, amici d'ogni uomo . . . ben avezzi all' obedienza."

6. Rabelais, *Tiers Livre*, chap. I. That is why, in fact, Pantagruel is successful in colonizing Dipsodie, while for Charlemagne a similar attempt has disastrous results.

7. L. Zuccolo, "Della Republica d'Evandria," in *Dialoghi*, quoted p. 238: "Non conoscono Ragion di Stato, senon quella, la quale detta loro l'honestà e la giustizia."

8. Bonifacio, *La republica delle api* (Venice, 1627).

9. The traditional and logical relation between utopia and astral cult has been underlined by J. Bidez "La Cité du Monde."

10. Such was the subject of an exhibition entitled *Symbolisme cosmique et monuments religieux*, Musée Guimet (Paris, July 1953).

11. De Marchi, a fortification engineer (*Della architettura militare* [Brescia, 1599, but written about 1540]) apologized for not using that design; "secondo lo stile moderno," he said, a polygon is better.

12. Lavedan, *Histoire de l'urbanisme*, vol. II (Paris, 1941), p. 80.

13. Giacomo Lanteri, *Due Dialoghi . . . del modo di disegnare le pianti delle fortezze . . .* (Venice, 1577), quoted by H. de la Croix, "Military Architecture and the Radial City Plan in 16th-Century Italy," *The Art Bulletin*, XLII (1960): see p. 281, n. 74. "Oltre di cio, (come vogliono i Filosofi) era di mestiero, che il mondo havesse una forme simile al mondo archetipo, quale era la idea della divina sapientia, prima che questo creasse che noi vediamo; onde non essendo in Dio principio nè fine, convenevole cosa era, che il cielo parimente havesse una forma senza principio e senza fine, quale è la forma circolare. La onde dico che (al parer mio) tutte le fortezze, o città che più s'avicinano a questa forma nel recinto delle loro mura siano piu perfettamente forte, che quelle che si discostano" (*Dial. Primo*, pp. 27–28).

14. About the relation, in Greek and Hellenistic antiquity, between the utopian-Elysian other-world and the country of the Sun, see the numerous references in Gernet, "La Cité future."

15. G. B. Adriani, *Istoria de' suoi tempi* (ed. Venice, 1587, II, p. 1292) recounts the ceremony of the laying of the first stone and the appearance of the sun during the divine service; "onde stimandosi che cio no fosse senza il favor del Cielo, la terra si chiamo Città del Sole." L. Firpo, *Lo Stato ideale della Contro-Riforma* (Bari, 1957), p. 247, claims it must have been a "paradisiac and erudite" city whose official language must have been Latin.

16. Plato, *Laws*, VI, 778 *d*: "As for city walls, Megillus, I'd agree with the Spartan view that they should be left lying asleep and urdisturbed in the ground." And 779 *a b*: "If men are to have a city wall at all, the private houses should be constructed right from the foundations so that the whole city forms in effect a single wall; that is, all the houses snould be easy to defend because they present to the street a regular and unbroken front. A whole city looking like a single house will be quite a pretty sight, and being easy to guard it will be superior to any other for safety" (Translated by Trevor J. Saunders [London, 1970].) Cf. *Critias*, 117 *d e*: "When crossing the outer bridges—which were three—one found a circular fortification. . . . This rampart . . . was entirely covered with numerous houses, huddling together."

One may also deduce that the number of streets on the incomplete drawing should be twelve, from the corresponding towers on the outer fortifications. In *Laws*, VI, 745 *b c*, we find this number 12 and a rule that enforces the radial division of the state territory: "The legislator . . . must divide the country into twelve sections. But first he ought to reserve a sacred area for Hestia, Zeus, and Athena (calling it the 'acropolis'). . . . He will then divide the city itself and the whole country into twelve sections by lines radiating from this central point. . . . The legislator must then mark out five thousand and forty holdings, and further divide each into two parts; he should then make an individual holding consist in two such parts coupled so that each has a partner near the center or the boundary of the state as the case may be. A part near the city and a part next to the boundary should form one holding, the second nearest the city with the second from the boundary should form another, and so on."

17. H. Geymüller, *Les Du Cerceau* (Paris, 1887), was the first to mention the drawing by the Anonymous Destailleur. It is he who quotes the sentence *fu di Andrea Palladio* and supports the attribution to Fra Giocondo, while admitting an Italian model which the architect might have imitated in Paris, shortly after 1502 (p. 115). Around 1567–68, Jacques Androuet I Du Cerceau in turn copied Fra Giocondo's drawing. The attribution has been contested by H. de la Croix, in "Military Architecture," because he does not believe that a military engineer like Giocondo could have drawn such outmoded fortifications; he evidently does not realize that this was a utopian absurdity, not

a project made obsolete by contemporary techniques. Fra Giocondo's well-known fluency in classical culture makes plausible both Geymüller's attribution and the hypothesis of a borrowing from Plato. This begs a comparison with Doni, but against the idea of a direct influence there is the fact that the first edition of the *Mondi*, although lavishly illustrated, gives no picture of the ideal city. I only know of one, in the 1578 French edition, obviously inspired by the text itself rather than the anonymous drawing or its copy by Du Cerceau.

18. Stiblinus, *De Republica Eudaemoniensium*, ed. Firpo (Turin), pp. 79 et seq.

19. Ibid., "Perspiciunt prudentissimi viri, omnes promptiori ingenio esse ad nequitiam, quam ad virtutem" (p. 108). About the plebeians, see pp. 110 et seq.

20. Leonardo's idea (ms. B, fº 16 rº) was the following: two levels of traffic, corresponding, not so much to different social classes, but to two different functions of the street. Another sketch (ms. B, fº 37 vº) gives the ideal town an underground network of canals that permit boats to serve the houses directly, through their cellars. It is evident that Leonardo was interested only in the system of conduits; for him, they posed problems of the same order as double-spiral staircases, brothel corridors, and, most extremely, the famous *nodi*. See L. Firpo, *Leonardo architetto e urbanista* (Turin, 1953).

21. The development of "Bramantesque" churches was mainly due to Florentines living in Milan: they were, after Filarete, Leonardo and Sangallo, who had met Bramante at the Sforza court of Lodovico il Moro.

22. One notable exception is the heretic Brucioli, a radical democrat who grouped all the public buildings around a centrally placed people's assembly.

23. H. de la Croix, "Military Architecture."

24. The contrast with Muslim towns, with their tortuous streets and numerous blind alleys, is striking. The Spaniards of the Reconquista period proudly opposed their own regular cities to them. See Brunschvig, "Urbanisme médiéval et droit musulman," *Revue des Etudes islamiques* (1947): 127–55; E. Lambert, "Les anciens quartiers musulmans dans le plan de la ville de Lisbonne," *Compte rendu du XVIe Congrès international de géographie* (Lisbon, 1949, 1951): 297–99; E. W. Palm, *Los origenes del urbanismo imperial en America* (Instituto Panamericano de Geogr. e Hist. [1951]), p. 7.

25. They are usually cited from Volume I of Lavedan's *Histoire de l'urbanisme*. But Baghdad was far away, and Tacitus practically unknown before Boccaccio. Lavedan's note on the old town of Baghdad is very interesting as an illustration of cosmic and social models of the ideal city: . . . "Perfectly circular, surrounded by three walls and opening through four gates in the direction of the cardinal points. The Caliph's palace and public buildings occupied most of the area in the center. They were defended by the smallest wall. Private dwellings were crowded between this and the next wall. Then

there was a free space between the last two" (p. 276). The great builder Caliph al-Mansur believed he had invented this design, and justified it significantly: "A round town has this superiority over a square one: that in the latter, if the king lives in the middle, some districts are nearer him than others, while a round town, however it may be divided, is equidistant everywhere. There is no extra space on either side" (Al-Khatib's Chronicle, quoted by Lavedan, p. 277).

26. Schickhardt was given the commission for Freudenstadt in 1599, but first produced several projects different from that which was finally accepted and which is almost identical with Christianopolis. Andreae's book did not appear until 1619, but the authorship of the plan is undecided between the duke's architect and the utopian pastor, who were both notables of Stuttgart and must have exchanged ideas.

27. Bacon, whose Nova Atlantis probably dates from around 1623 (it was published posthumously in 1627), provides a sort of photo-negative: he insists on rites, festivals, and costumes, but makes do with vague adjectives for describing the buildings, and says not a word about town planning. His imagination was drawn only to movement; even the division of labor between the wise men of Domus Salomonis, for instance, is made not according to the different sciences, but according to the successive phases of the scientific elaboration of experience: mercatores, depraedatores, venatores, fossatores.

28. G. Münter, Idealstädte; ihre Geschichte vom 15ten zum 17ten Jhdt. (Berlin, 1957); revised edition of Die Geschichte der Idealstadt, in Städtebau, XXIV (1929). Lavedan omits the terre murate.

29. There is a medieval precursor: Montauban.

30. A somewhat precocious example is Gattinara, 1524–26; but the square there, which is a very elongated rectangle, gives the impression of a widening of the main street.

31. The central square usually reproduced the polygonal outline of the fortress. In the interests of defense, the bastions had to be easily accessible from the center for reinforcements and supplies. Since the bastions were situated in the angles of the walls, the streets had to radiate from the corners of the square; but in several cases (sketches by Bonaiuto Lorini, designs of Vitry-le-François, Palmanova) they were drawn like apothems, in the "Mannerist" fashion, starting from the middle of the sides.

32. H. Hoffmann, Hochrenaissance, Manierismus, Frühbarock (Zurich-Leipzig, 1938). Similar ideas had been put forward by Pinder and by M. Hoerner.

33. Perhaps the first example of it was at the wedding of Francesco de' Medici in 1566, for which Vasari masked the narrowing of a street by a large decoration with two symmetrical arches: the procession walked under one of them to get into the Via Tornabuoni, while the other one was blind and painted with a symmetrical trompe-l'oeil street. The commentary praises at length his subtlety for intendenti (Vasari, Opere, Milanesi ed., VIII, 539).

34. We find many proofs in *Les Fêtes de la Renaissance*, Colloque international du C.N.R.S. (Paris, 1956). T. E. Lawrenson's contribution is entitled "Ville imaginaire, décor théâtral et fête"; that of André Chastel, "Le lieu de la fête." In the texts and discussions we find sentences such as: "The ambiguous character of the place of the festival is due to its presentation of a real but transfigured space" (Chastel, p. 421); "One sees clearly that the ancient city is superimposed on the real town" (F. Yates, p. 422); "There is a superimposition of the real place and the imaginary place" (Lawrenson, p. 423).

6. Pomponius Gauricus on Perspective

1. Ficino's two manuscripts, *De divisione philosophiae*, were published by Paul O. Kristeller, *Studies in Renaissance Thought and Letters* (Rome, 1956), pp. 56 and 95ff. An optical treatise, prepared when he was twenty, has not been identified with any certainty. On the parallel between "perspective" and music considered as applications of the quadrivium, see Thomas of Aquinas, *Sum. theol.*, I, I, 2, 3.

2. The text of Michele Savonarola is in Muratori, *Rer. Ital. Script.*, XXIV, 15, col. 1170: "Cumque de pictoribus commemoratio tam gloriosa a me facta fuerit . . . cum perspectiva picture mater habeatur . . . nonnisi ego cum animo ferre musica visa est, eos videlicet sic obticuisse illustres musicos, qui et urbi nostre non parvo accesserunt ornamento." On Girolamo Savonarola, see n. 7 below.

3. This is the manuscript Riccardianus 2110. On Pelacani and Brunelleschi, see A. Parronchi, "Le fonti di Paolo Uccello," *Paragone*, 89 and 95 (1957), and "Le due tavole prospettiche del Brunelleschi," ibid., 107 and 109 (1958–59). L. Thorndike, *A History of Magic and Experimental Science*, IV (New York, 1934), p. 72, reports that copies of Biagio's *Quaestiones* were still being made in 1428, 1445, and 1469.

4. Giovannida Fontana, *Liber de omnibus rebus naturalibus*, appeared under the name of Pompilius Azalus (Venice, 1544), see fol. 74v. On this book and its true author, see Thorndike, *A History of Magic*, pp. 150–82. The few words of Fontana about his lost treatise include a remark (which one finds again in Leonardo) about atmospheric and luminous phenomena.

5. For instance—to stay in the Paduan fifteenth-century milieu—a pupil of Biagio, Prosdocimo de Beldomandi, an astronomer and mathematician, also wrote technical treatises on music (*De contrapuncto, Libellus monocordi . . .*).

6. Michele Savonarola, ed. cit., col. 1181: "Neque parvi facio pictorie studium, quod singulare decus urbis existit, cum ad studium litterarum et bonarum artium pre celeris artibus adhaereat, cum pars sit perspectivae quo de proiectione radiorum loquitur. Hec enim philosophiae pars est."

7. Girolamo Savonarola, *Opus perutile . . . de divisione scientiarum* (or *Apologeticus*) (Venice, 1542), p. 9: "Inter mathematicas autem et naturales

scientias quaedam sunt scientiae mediae ut . . . perspectiva quae de linea et magnitudine visuali tractat. Et Musica de numeris sonoris et eorum proportionibus considerat"; p. 17: "At perspectiva simpliciter videtur esse dignior musica, et quia objectum visus est nobilior objecto auditus, et quia stabilius est." Leonardo too would call painting a "semimathematical science" and pity music, whose harmonies died as soon as they were born. The manner in which Savonarola defined perspective and spoke of its "solid" objects shows that he was thinking not of rays of light, or of images in mirrors, but of art.

8. L. D. Ettlinger, "Pollaiuolo's Tomb of Sixtus IV," *Journal of the Warburg and Courtauld Institutes*, XVI (1953): 258–61, contests this point, because the figure is characterized as a physical science. However, the two meanings do not exclude one another (see above, notes 7 and 8, and below, note 14). The figure on the cover of the *Antiquarie prospettiche Romane*, dedicated to Leonardo, holds an astrolabe, just like the Perspective of Pollaiuolo; yet it is a symbol of archaeology. Scenography appears as a subdivision of physical perspective in several encyclopedists (Politian, *Panepistemon*, R. Maffei, *Comm. Urb.*, I. xxxv). Gauricus was perhaps the first to separate it completely (see below, n. 10).

9. Piero della Francesca, *De prospectiva pingendi*, ed. G. Nicco Fasola (Florence, 1942), p. 128.

10. Pomponius Gauricus, *De Sculptura*, ed. H. Brockhaus (Leipzig, 1886), p. 192. The perspective of the philosophers did not interest him: "que quoniam plurimos nacta est graecos et latinos scriptores, estque aliquando ab hac nostra remotior, non est mihi propositum vos edocere." Already in the *Cronaca* of Giovanni Santi, written between 1482 and 1496, perspective was treated as a "new" science: "Nè in terra in altro secol più veduta" (L. xxii, c. 96, str. 108), "è invention del nostro secol nova" (ibid., str. 111) (ed. Holtzinger [Stuttgart, 1893], p. 188). This could only mean artistic perspective. In Mattioli's vision of the liberal arts (*Il Magno Palazzo del Card. di Trento* [1539]; ed. Melzi d'Eril, in *Ateneo Ligure* [1889], see p. 17), Geometry was followed by Architecture and Perspective, which in turn governed Painting and Sculpture; again, Optics was forgotten.

11. R. Volaterranus, *Comm. Urb.*, 1, xxxv, cap. "De optice et catoptrice": "Optice quoque, quam nostri Perspectiva communi vocabulo appelant, Geometricae subjicitur arti. . . . Usus huius disciplinae nimirum in plerisque rebus elucet. In metiendis aedificiis. In architecturae picturaeque ratione. In umbrarum corporumque positione, cum saepe non rationi partium neque harmoniae, sed aspectui sit inserviendum. Postremo ad deprehendendam coelestium, tum aliorum corporum varietatem, veritatemque, tum reflectiones, refractionesque eorundem." Mirrors and refraction, once such important topics in the Perspectives, are mentioned only at the end, and artistic interest is dominant. ("In metiendis aedificiis" concern the measuring of the remains of ancient monuments; see the cited *Antiquarie prospettich Romane* of the "Prospectivo Milanese.") Maffei's list of the great "perspectivists" of the past contains only Greeks and Romans and one modern, who was an art-

ist: Petrus e Burgo Sancti Sepulchri. It was as if Alhazen and Vitellio had never existed.

12. The revealing article by Wittkower, "Brunelleschi and 'Proportion in Perspective,' " *Journal of the Warburg and Courtauld Institutes*, XVI (1953), emphasizes the theoretical and aesthetical importance of the idea of proportion after Brunelleschi's and Alberti's perspectives, but it does not establish that anyone before Piero thought of connecting it with geometrical speculations of a wider scope.

13. A comparison with Gauricus's predecessors is significant from this point of view. Brunelleschi's biographer put the perspective science of the ancients in doubt; Alberti and Filarete frankly denied it; Gauricus, on the contrary, proposes them as models (Alberti, *Della pittura*, ed. Mallè, p. 74; Filarete, *Traktat über die Baukunst*, ed. W. v. Oettingen [Vienna, 1890], pp. 619–21; Gauricus, ed. cit., pp. 196–98).

14. See n. 10, above. The innovation, although negative, is so much the more remarkable since the author's brother, Luca Gaurico, a true "physicist," edited the *Perspectiva communis* of Peckham in the very year of the publication of *De Sculptura*.

15. Gauricus, *De Sculptura*, "Omne corpus quocumque statu constituit, in aliquo quidem necesse est esse loco. Hoc quum ita sit, quod prius erat, prius et heic nobis considerandum . . ." (p. 192). Incidentally, Hans Kauffmann said (in a discussion of the communication of H. Siebenhuener, "Die Entwicklung der Renaissance-Perspektive," *Kunstchronik* (1954), pp. 129–31) that Gauricus was the first to conceive "pre-existent" space as the subject of perspective, before the foreshortening of volumes. He was, in fact, preceded by Filarete (I. XXXII, beginning) and by Alberti, who treated the floor plan in his first book under *disegno*, and foreshortening in the second, under *componimento*.

16. "Constat enim tota hec in universum perspectiva dispositione, ut intelligamus, quacunque ratione spectamur, quantum ab alio aliud distare aut cohaerere debeat. . . ." (p. 200). The *"rationes spectandi"* of this text are the three views, bird's eye, horizontal, and worm's eye. Gauricus's formula is derived from Pliny (*N.H.*, XXV, 80), who defines as follows Asclepiodorus' *mensurae*: "hoc est quanto quid a quoque distare debeat," which is always interpreted as if it meant perspective.

17. See his p. 202: "Hanc vero triplicem rationem spectandi a pictore quisquis ille fuerit animadvertimus semel perbelle adservatam; ita enim Danaen composuerat ut si prospiceres, avaram ipsam puellam stupescentem videres. Sin suspicere, Iovem iamiam e nubibus descensurum impluvio putares, sin vero despiceres, proximas regiones aurea conspersas grandine mirare."

18. Page 200. The words omitted in this passage are given above, n. 16.

19. Pino, *Il disegno*, ed. Pallucchini (Venice, 1946), p. 74.

20. Lomazzo, *Idea del tempio della pittura*, beginning of chap. 23. On the idea of a "perspective" created by the *istoria*, see the last pages of G. C. Argan, "The Architecture of Brunelleschi . . . ," *Journal of the Warburg and Courtauld Institutes*, IX (1946): 96–121. After having shown that Brunelleschi's architecture illustrates the spatial concepts formulated by perspective, the author explores its analogy with the regulations of *istoria* in fifteenth-century opinion. The texts given of Gauricus, Pino, and Lomazzo confirm the correctness of this intuition for the Cinquecento as well.

21. An observation about tight-rope walkers recalls here the analogous preoccupations of Leonardo. The theory of "possible" movements is also conceived as a chapter of "perspective" by P. Pino (*Il Disegno*, p. 73), whose opinions on this part of the art are in general very close to those of Gauricus.

22. Gauricus assures us that he borrowed the terms from Hermogenes (p. 214); actually, they come from Quintilian, VIII, 2–5 (see also IV, 2; VI, 2; VII, 9–10; IX, 2 and 4), where most of the Virgilian examples illustrating the terms are also found. Hermogenes furnished only *eukrineia*, used by Gauricus (one wonders why) instead of what Quintilian called *ornatus*.

23. Filarete, *Traktat*, pp. 603–607; Piero, *De prospectiva pingendi*, theorem XIII.

24. Attempts had been made, however, in a different direction: a principal vanishing point was put in the chosen place, and an arbitrary height was fixed for the first transversal (corresponding, in principle, to the apparent depth of one "small braccio" of the base); then an arithmetical key to the diminution of intervals between the successive transversals was sought. On this device, obviously inaccurate because it does not take the distance of the beholder into account (in general it breaks the diagonal of the checkerboard), see Wittkower, op. cit. This means was perhaps employed sometimes for *cassoni*, judging from the only indication easily verifiable in photographs, the fact that the broken diagonals approximate a regular curve. It is known that Alberti denounced as inexact one of those arithmetical keys, i.e., the consecutive diminution of the intervals in the proportion 3/2. In passing, may I point out that in all Italian editions of *Della pittura* there is a small error which still baffles commentators and translators: the meaningless terms *superbi partienti* are read for *super-bipartienti*, which in Boethius's arithmetic means the proportion 5/3; Alberti expresses the relationship between two successive intervals, a and b, by the formula $(a+b)/a = 5/3$, which implies $b = 2/3a$. The Latin text had *proportio subsesquialtera*, that is, 2/3 or b/a, which is another way to define the same succession.

25. Decio Gioseffi, *Perspectiva artificialis* (Trieste, 1957), pp. 89–93; see Gauricus, pp. 194–96. Panofsky ("Die Perspektive als symbolische Form," *Vorträge der Bibliothek Warburg*, 1924–25 [Leipzig-Berlin, 1927], pp. 320–23) refuted the first explanation of this passage by H. Brockhaus, Gauricus's editor, who believed he found in Mantegna's frescoes in the Eremitani a practical illustration of the solution he proposed. Panofsky wanted to see the

Gaurician text as a confused but faithful description of the Albertian procedure, which led him to suppose that Gauricus had understood the use of the main vanishing point without having stated it. Gioseffi's interpretation has the advantage of doing without this hypothesis. Gioseffi remains convinced, however, that the procedure he describes can be explained as a development from Alberti; this view, which seems erroneous to me (see text, p. 115), results from his refusal to recognize an artisan tradition independent of Alberti.

26. See, for example, the *cassone* of Bartolomeo di Giovanni with *Joseph and Potiphar's Wife*, Cambridge, Fitzwilliam Museum: Schubring, Cassoni, no. 395.

27. The transition from the bifocal to the Gaurician system is made very easily by replacing the second center with a median axis.

28. R. Oertel, "Die Frühwerke des Masaccio," *Marburger Jahrbuch für Kunstwissenschaft*, VII (1953). Parronchi, "Le misure dell'occhio secondo il Ghiberti," *Paragone*, 133 (1961), asserts that Ghiberti used the same procedure for two neighboring reliefs of the Gates of Paradise; the small reproductions in *Paragone* do not give the reader convincing visual proof of the argument.

29. In the fresco in Assisi, the foreshortening of the vaults of the side aisles of the Temple has no relationship with the perspective of the coffered ceiling. The unification of space by means of a main vanishing point seems to have been tried at first independently of the distance point system. Masolino drove a nail in the center of his paintings, and considered every straight line that connected it with the sides as an orthogonal. In the Branacci Chapel, he realized first that this nail defined the horizon, and saw the advantage of placing it above the center (R. Longhi, "Fatti di Masolino e di Masaccio," *La Critica d'arte*, IV–V [1939–40]).

30. The analysis of the fresco in San Martino alla Scala was made by Paatz, *Rivista d'arte*, XVI (1934), and corrected by John Pope-Hennessy, *Uccello* (London, 1950), pp. 152–53; the *sinopia* was first reproduced by Parronchi, "Le fonti . . ." *art. cit.*, and interpreted by Gioseffi, "Complementi di perspettiva, 2," *Critica d'arte*, XXV–XXVI (1956): 105–108. Theoretically the construction of San Martino alla Scala is irreproachable, and there are not, actually, several main vanishing points; but the disconcerting effect—due to the orientation of the objects toward the distance points—suggests this polemical, anti-Albertian intention. (See also the *Nativity* engraved by the Master Na. Dat.)

31. This is also what Hieronymus Rodler meant when he suggested the multiplication of the "main" vanishing points (*Eyn schön nützlich büchlin und underweisung der Kunst des messens* [Simmern, 1531], fol. F. iii. Panofsky has been the first to draw attention to this passage).

32. See the proof in Gioseffi, *Perspectiva artificialis*, loc. cit.

33. For the extreme oblique setting of the prisms, see the remark of John White, *Birth and Rebirth of Pictorial Space* (London, 1957), p. 129. The predilection for small distances has often been noticed and explained in various ways; the practical reasons become clear if one admits the pre-Albertian preponderance of the bifocal system, in which only distances smaller than half the breadth of the image dispense with auxiliary constructions. Too rigid deductions must be avoided, however; a very short distance, as in the *Foundation of Santa Maria Maggiore* of Masolino, results from the construction described in n. 30; a work constructed with the aid of the bifocal system, according to all opinions, as the *Christ and Apostles in the Temple* attributed to Andrea di Giusto (Philadelphia, Johnson Collection), has, however, a distance greater than half the width of the painting.

34. B. Berenson, "Quadri senza casa. Il Trecento senese " 2, *Dedalo*, VI, (1930): 342ff.

35. The deduction is not certain. The painter constructed his scheme with a straight-edge or string, but he painted it with a free hand, altering the fundamental construction. Moreover, there are few bare surfaces: the vestments and a phylactery cover a great part of the pavement, doubtlessly with the purpose of hiding the flaws. But it does not seem to me that the irregularity of the construction can be attributed to any of the other nonorthodox attempts suggested for the checkerboards of the Trecento by Miriam S. Bunim, *Space in Mediaeval Painting and the Forerunners of Perspective* (New York, 1940).

36. Besides the cited works of Panofsky, Siebenhoener, Farronchi, Gioseffi, see especially Krautheimer, *Lorenzo Ghiberti* (Princeton 1956), pp. 24ff., and Sanpaolesi, "Ipotesi sulle conoscenze matematiche . . . del Brunelleschi," *Belle Arti* (1951: 25–54. J.-G. Lemoine, "Brunelleschi et Ptolémée," *Gazette des Beaux-Arts* (May–June 1958), is not convincing. For the influence of medieval perspectivists, see also White's excellent chapter on Ghiberti's Third Commentary, op. cit., pp. 126–30. In fact, we cannot doubt either the preponderant role of Brunelleschi's architectural and archaeological training, or the influence of optics and geometry (for the notions of proportionality, visual pyramid, intersection); I shall only try to show, following Sanpaolesi and Parronchi, that the bifocal system of the painters is also inolved in Brunelleschi's invention.

37. Anon., *Vita di Filippo di ser Brunellesco* (Florence, 1927), pp. 10–13 (the text is usually published under the name of its probable author, Antonio Manetti). The rather long passage that interests us here is reproduced and given different interpretations by Gioseffi (*Persp. crtific alis,* pp. 74ff. and 83), Parronchi ("Le due tavole" art. cit.), and White (op. cit., pp. 113–21).

38. Gioseffi tried to interpret the biographer's description of the second panel in the sense of a frontal view of the Palace, but it seems impossible to follow him on this point.

39. In other words: the complete illusion, as desired by Brunelleschi, depends on three conditions: with respect to distance, the image must be painted for being viewed at an angle equal to that under which the objects would appear to the beholder; with respect to scale, the painting must have the same absolute size as the intersection of the pyramid at the distance of construction; and with respect to framing, the painting must show the same portion of the visual field that appears to the beholder from the chosen place. These three conditions are incompatible in Brunelleschi's first experiment, as described by the biographer.

Having arrived at these negative conclusions, it would be perhaps proper to explain why I am unable to agree entirely with any one of the reconstructions proposed until now. Unfortunately, I am afraid this would prove too long an enterprise; anyway, I hope that my debt to the authors cited above, n. 36, will be obvious to the reader.

40. Gauricus involuntarily confirms, *De Sculptura*, p. 202, their primitive character: "Altera vero perspectivae pars, que singulas considerat rerum pariciones, est quidem illa vulgaris, pictorunque pueris usitacissima. . . ."

41. Viator, chap. V: 'Omnes [figurae quae ponuntur pro elementis] a spherica tamquam a matre originem trahunt. Nam trigonus et tetragonus (qui maxime perspectivae deserviunt) ab ea deducuntur, seu per eam instificantur." For fig. 11–12, see Viator, chap. VII: for Filarete, see *Tracat.*, ed. cit., p. 582 (fig. 10) and also p. 615 (figs. 13 and 14), showing different applications of the method. The medieval texts are, for example, Roger Bacon, *Multiplicatio specierum*, II, 8, cited (for a different purpose) by Parronchi, "Le fonti, 2," p. 7. Bacon was discussing the "spherical" diffusion of visual images emanating from an object: "Quoniam vero in sphaera possunt omnes figurae corporales et regulares intelligi . . . atque licet proprie inscribi aliae [quam regulares] non possunt per definitionem inscriptionis, tamen valent figurari in sphaera omnes. Quapropter . . . omnis multiplicatio speciei secundum quamlibet figuram potest reperiri in multiplicatione sphaerica quam facit."

42. Gauricus, *De Sculptura*, p. 204. A comparison with Filarete and Viator explains that the useless axes and diagonals are here again "fossils." Viator had sensed their relation with the three pyramids, and Filarete at least used them as guides for tracing the flattened circle.

43. Gauricus, ibid.: "Esto praeterea si voluerimus idem in latus spectari sic: Ducantur de iisdem ambobus lateribus [*ab, cd*] diametri spatio [up to the level of *k*] in directum lineae [*bh, ci*], nam heic tanquam compressura cogetur, hoc modo."

44. Gauricus, ibid., pp. 208–210: "Esto hic M. T. Ciceronis vel C. Caesaris facies ad perpendiculum discriminatrice linee nullam declinans in partem. . . . Punctus autem quo terminatur frons, aristotelico more sit *a* [Gauricus seems to remember the use of letters in the *Organon*], in interciliis oculorum heic sit *b*, in extremis heic naribus *c*, heic in mento sit *d*, vertex *e*, gula inferior *g*. Mutetur inde prospectus, et ad medium usque horizonta [zenith?]

tollatur, dirigaturque acies in signum hoc ubi sit littera *s*, hoc modo. Ducatur nunc linea directa *a b* ad *s*, sic, reliquae ibidem hae, suo intervallo, similiter sic. En ut perpendicularis que modo fuerat, nunc obliqua Quin et caeterae partes intra suas continebuntur lineas sic."

45. For example, the anonymous author of the *Perspectiva*, MS Riccard. 2110; cf. Alberti, *Opere*, ed. Bonucci (Florence, 1847), IV, pp. 101–102.

46. Alberti, *Della pittura*, I, 10.

47. Cf. the testimony of Lomazzo, who had seen the manuscript, in *Idea*, chap. 30 (Milan, 1590, p. 107): "Nel qual proposito mi sovviene del Zenale, il qual accennava diversi fatti, dicendo contra l'opinione d'alcuni pittori valenti del suo tempo [evidently Leonardo] che tanto le cose finte lontano vogliono essere finite, et proportionate quanto quelle dinanzi, per questa ragione, che la distanza che si piglia di tutta l'opera essendo troppa per le cos più picciole che vi son dentro, fà che s'ingrossa l'aere; e però le più picciole figure manco si scorgono che le più grandi, e tanto più andando avanti niuna cosa benche finitissima non si può vedere se non gli si va appresso, secondo la sua ragione. Diceva ancora che in una distanza di dieci braccia, sopra un foglio di carta scritto d'un medesimo inchiostro, non si potrebbe vedere la lettera minutissima che pur è negra in sua proportione, e se ben si scorgerà alquanto non pero si potrà leggere, per l'abbagliamento. Ma una più grande che pure non è più nera dell'altra, vederassi bene, et una maggiore di queste si leggerà. Il èche tutto averrà per la multiplicatione del negro, che per essempio viene a servire in tutti i colori."

48. Cited above, in n. 25.

49. This objection had been anticipated by White, in *Birth and Rebirth of Pictorial Space*, p. 125. See Gioseffi, *Perspectiva artificialis*, pp. 6–14 et passim. And see the review by M. H. Pirenne, *Art Bulletin*, XLI (1959): 213–17, which agrees in essence with the physiological parts of Gioseffi's thesis. An accessory remark, however, reveals the weakness: "The important fact that the spectator as a rule looks at the painting with both eyes and from the 'wrong' position does raise problems of great psychological interest. There seems to be an unconscious psychological compensation for the 'incorrect' manner in which paintings are almost invariably looked at" (p. 216). Since ordinarily one overlooks the perspective deformations of paintings, it does not seem possible, as Gioseffi would have it, that artists could make a conscious use of the very deformation which corresponds to the "correct" point of view; especially, since this point of view is often beyond the reach of the spectator, as in highly placed frescoes, etc.

50. Piero della Francesca, part II, theorem XII (and fig. XLIV in the cited edition), takes the example of a closely viewed colonnade parallel to the picture plane: "che le colonne più remote da l'occhio venghino di più grossezza che non sono le più propinque, essendo poste sopra de equali base." For Leonardo, see especially the fragments Richter 90, 107, and 109. The texts of Piero and Leonardo have been paralleled by Panofsky, op. cit.

51. Kern, "Das Dreifaltigkeitsfresko des Masaccio," *Jahrb. d. preuss. Kunstsamml.*, XXVI (1913): 36. It is not even certain that any artist between Masaccio and Leonardo was aware of the real significance of the distance point (for Leonardo, ms A, fol. 42r, see Ivins, *The Rationalization of Sight*, Metropolitan Museum of Art Papers, 8, 1938).

52. It seems true that one expected the spectator to station himslf at the distance indicated by the construction. Brunelleschi's anonymous biographer, having explained why, in his opinion, the second *veduta* contained no apparatus constraining the spectator to put himself in the "right" position, continues: "Lasciollo nella discrezione di chi guarda, come interviene a tutte l'altre dipinture negli altri dipintori, benchè chi guarda ogni volta non sia discreto."

53. For anamorphosis in general and for Leonardo's invention of it, see J. Baltrusaitis, *Anamorphoses ou perspectives curieuses* (Paris, 1955), and C. Pedretti, *Studi vinciani* (Geneva, 1957), pp. 68ff. I was unable to find F. Basoli, "L. da V. e l'invenzione delle anamorfosi," in *Atti soc. dei nat. e matem.* di Modena, LXIX (1938).

7. Studies on Perspective in the Renaissance

A List of the Works Discussed in This Chapter

1. Brion-Guerry, L. *Jean Pèlerin Viator. Sa Place dans l'histoire de la perspective* (Paris, 1962).

2. Dalai, Marisa. "La questione della prospettiva," in: Erwin Panofsky, *La prospettiva come "forma simbolica" e altri scritti* (Milan, 1961), pp. 118–41.

3. Gioseffi, Decio. *Perspectiva artificialis* (Trieste, 1957).

4. ———. "Complementi di prospettiva," in *Critica d'Arte*, XXIV (1957): 468–88, and XXV–XXVI (1958): 102–139.

5. Kitao, Timothy K. "Prejudice in Perspective: A Study on Vignola's Perspective Treatise," in *The Art Bulletin*, XLIV, 3 (Sept. 1962): 173–94.

6. Klein, Robert. "Pomponius Gauricus on Perspective," in *The Art Bulletin*, XLII, 3 (Sept. 1961): 211–30. (See chapter 6 of this book.)

7. Krautheimer, Richard, and Krautheimer-Hess, Trude. *Lorenzo Ghiberti* (Princeton, 1956).

8. Maltese, Corrado. "Per Leonardo prospettico," in *Raccolta Vinciana*, XIX (1962): 303–314.

9. Parronchi, Alessandro. "Le fonti di Paolo Uccello," in *Paragone*, n°. 89 (1957). 3–32 and n°. 95, 3–33.

10. ———. "Le due tavole prospettiche del Brunelleschi," ibid., n°. 107 (1958), and n°. 109 (1959), pp. 3–31.

11. ———. "Le 'misure dell'occhio' secondo il Ghiberti," ibid., n°. 133 (1961), pp. 18–48.

12. ———. "Paolo o Piero?" in *Arte antica e moderna* (1961): 138–47.

13. ———. "Il 'punctum dolens' della costruzione legittima," in *Paragone*, n°. 145 (1962), pp. 58–72.

14. ————. "Una Nunziatina di Paolo Uccello," in *Studi urbinati*, XXXVI, 1 (1962): 1–38.

15. Pedretti, Carlo. "Leonardo on Curvilinear Perspective," in *Bibliothèque d'Humanisme et Renaissance*, XXV (1963): 69–87.

16. Sanpaolesi, Piero. "Studi di prospettiva," in *Raccolta vinciana*, XVIII (1960): 188–202.

17. ————. *Brunelleschi* (Milan, 1962), see pp. 41–53.

18. White, John. *Birth and Rebirth of Pictorial Space* (London, 1957).

19. Boskovits, M. "Quelle ch'e dipintori oggi dicono prospettiva," in *Acta historiae artium Academiae Scientiarum Hungaricae*, vols. VIII (1962): 241–60, and IX (1963): 139–62.

1. Guido Neri's introduction to the Italian edition of 196. stresses the parts played by Ernst Cassirer's philosophy, and through it, by Kantian epistemology, in the background of Panofsky's ideas. But Neri errs in applying mechanically to Panofsky the objections raised by contemporary phenomenology against Kantianism in general. Panofsky's acknowledged borrowings from Cassirer are not indispensable to his argument, and as regards Kantianism, he seems somewhat in agreement with Brunschvicg's views.

2. The additions are: "The Friedsam Annunciation and the problem of the Ghent altarpiece," in *The Art Bulletin*, XVII (1935): 433–73; "Once more the Friedsam Annunciation," ibid., XX (1938): 418–42; "The Codex Huygens and Leonardo da Vinci's Art Theory," *Studies of the Warburg Institute*, XIII (London, 1940); *Early Netherlandish Painting* (Cambridge, Mass., 1953), pp. 1–21; *Renaissance and Renascences in Western Art* (Stockholm, 1960), pp. 118–45.

3. The *Life of Brunelleschi* dates from about 1480; the author assures us of having seen and touched the first of the two panels. A statement of Filarete's from about 1463 confirms the tradition that makes Brunelleschi the inventor of perspective. The two panels can be dated around 1418–19 (Sanpaolesi, 17) or, at the latest, 1424–25 (Parronchi, 10), but in any case before Masaccio's *Trinity* in Santa Maria Novella, which applies the system.

4. Mainly White (18); Krautheimer (7); Sanpaolesi ("Ipotesi sulle conoscenze matematiche, statiche et meccaniche del Brunelleschi," in *Belle Arti* [1951] and 17); and Parronchi (10). Gioseffi (4) mistakenly suggests another interpretation of the second panel, according to which the Palazzo Vecchio would be seen from the front.

5. Sanpaolesi (16) and Parronchi see in Alberti, however, nothing more than a mere plagiarist; Gioseffi (3), on the contrary, thinks that the first painting, at least, presupposes no geometrical method of perspective.

6. If Brunelleschi wanted simply to force the spectator to see the panel from the required distance and position, a kind of camera obscura would have been more efficient, without the inversion of the sides and without the troublesome diminution due to the mirror image appearing at twice the distance of the mirror.

7. See also 10. We know that Ghiberti read medieval treatises on perspective. On the other hand, the best teacher of medieval optics in Italy, Biagio Pelacani, who taught in Padua, was well known to Toscanelli, who was Brunelleschi's scientific adviser. Another pupil of Pelacani, Giovanni da Fontana, wrote a treatise on painting, now lost, which was dedicated to Jacopo Bellini, who, as we know, was very interested in linear perspective. About Pelacani, see the documented studies by G. Frederici Vescovini, "Problemi di fisica aristotelica in un maestro del XIV secolo: Biagio Pelacani da Parma" (*Rivista di Filosofia*, LI [1960]: 179–82 and 201–204) and mainly "Le questioni di 'Perspectiva' di Biagio Pelacani di Parma" (*Rinascimento*, XII [1961]: 163–243).

8. We must also mention Gioseffi's hypothesis (3), according to which Brunelleschi painted his view of the Baptistery directly on a mirror, without any "rule," or geometric construction of any kind. This would explain, among other things, the need for a second mirror to correct the image. For objections to this theory, cf. 11 and 17.

9. Kitao (5) has attempted to find a way out by supposing that the panel represented only part of the view framed by the door of the Duomo; this hypothesis somewhat contradicts the text of the biography, but is plausible insofar as the hole in the panel did narrow the angle of vision. But his conclusion is the same: either the biographer is mistaken, or Brunelleschi's experiment was not a complete success.

10. Pietro Sanpaolesi, "I dipinti di Leonardo agli Uffizi," in the anthology *Leonardo: Saggi e ricerche* (Rome, 1954), pp. 27–46.

11. With the reservation that, as we pointed out earlier, the first experiment is not clear. The visual angle could have been smaller than 90 degrees. About a second difficulty, see below, n. 13.

12. This interpretation of Alberti's text goes back to Panofsky. It has been contested—wrongly—by Parronchi (13).

13. Without discussion Sanpaolesi (16) and Parronchi (10) admit it. Krautheimer (7) and probably Gioseffi (3) doubt it. If Brunelleschi knew the property in question, that is to say, if he was fully aware of the distance-point method and practiced it at least in the second panel, why was Alberti's much more complicated method so successful, and why was there more than a century's delay before it was progressively rediscovered? If he was ignorant of it, all the while practicing the bifocal method, how could he account for distance? And if he did take account of it by using the *costruzione legittima*, in what lies Alberti's originality?

14. Kitao (5) denies that the bifocal system was the origin of the distance-point method; he only sees it as a *minor factor* in the elaboration of that method. If we admit—something nobody has ever doubted—that some theoretical clarification is needed for its development, and therefore also knowledge of the central vanishing point, we cannot then see any basis for Kitao's objection. He proposes as more probable origins of the distance-point

method, the "workshop methods of the north." Yet if one thing is clear from Viator's procedure, it is that it derives—as Viator himself has shown—from Uccello, i.e., from the "enriched" bifocal system. Workshop methods were quite the same in the north and south.

15. Vignola's context rather clearly indicates the opposite. A statement by Caporali, commented upon by Pedretti (15), leads us to think that we are dealing with partisans of curvilinear perspective. In any case, we see no reason why partisans of the bifocal system should have invoked binocular vision to justify their theory; and Vignola himself had no cause to attack a method, binocular or not, which he describes a few pages later as perfectly monocular, legitimate, and more or less identical with the "first rule."

16. The author's views on the "oblique" stylistic tendency of Mannerism and the "frontal" tendency of the Baroque are a bit cursory.

17. It is interesting to see how Gioseffi (3), starting with the firm conviction that there is only one perspective—the true, Albertian one—comes finally, under the pressure of facts, and carried away by his own hypotheses, to recognize licences and marginal researches in which the mobility of the eye, the oblique *taglio*, binocular vision, etc., play a part—and which would satisfy any anti-Albertian. His conclusion (4) is not far removed from what we say here.

We should also note an attempt to place Alberti himself among the non-Albertians. The Uccellesque play of the functions of the main vanishing point and the distance-point would certainly appear in the famous "Barberini panels" if we considered them—which would be very plausible—as the wings of an altarpiece whose missing central section would naturally measure twice their width. This remark is based on Parronchi's findings, in an article which attributes both panels to Alberti. The author, starting from a slight irregularity in the drawing of the right-hand wing, reaches completely different conclusions about the perspective scheme and the overall dimensions (A. Parronchi, "Leon Battista Alberti as a painter," in *Burlington Magazine* [June 1962]).

18. Panofsky has attempted to recover curvilinear perspective from a text by Vitruvius, and rather systematic confirmations of it in Roman frescoes. These views open another, equally complex, debate, in which we shall venture no opinion.

19. See reference in n. 1, above.

20. Is this the one condemned by Vignola as binocular?

21. Pedretti, *Studi vinciani* (Geneva, 1957).

22. Baltrusaitis, *Anamorphoses ou perspectives curieuses* (Paris, 1955).

8. Thoughts on Iconography

1. The introduction to his anthology *Studies in Iconology* (New York, 1939). Richard Bernheimer's posthumous book *The Nature of Representation* (New

York, 1961) presents, in chaps. XI–XIV, a remarkable analysis of signification and representation in works of figurative art; I shall refer to it often. But Bernheimer's point of view is broader than my own and frequently goes beyond iconography: from the beginning (p. 157) he establishes a distinction—which is relevant to what follows—between the "subject" proper, or the iconographic program accepted by the artist, and the "motif" chosen or treated by him for artistic reasons; thus the question of the genesis of the work interferes with the question of its mode of signification. We want to keep strictly to the latter.

2. From the table we can see that Panofsky makes use of a third distinction: primary meanings involve objects and events; secondary meanings involve themes and concepts. But this distinction may be omitted here, since both are in any case subsumed under what has been established as the first criterion: for instance, historical subjects known only through literature have secondary meanings, according to Panofsky, although they are events and not concepts or themes.

3. Panofsky, *Studies in Iconology*, p. 16: "In whichever stratum we move, our identifications and interpretations will depend on our subjective equipment, and for this very reason will have to be corrected and controlled by an insight into historical processes the sum total of which may be called tradition."

4. In fact, the distinct dimensions of meaning that we may find in the painted or sculpted image of a person are even more numerous (see Panofsky, *Studies in Iconology*, p. 6, n. 1, and Bernheimer, *The Nature of Representation*, pp. 234–35). Usually the title or name given to the work indicates which of those dimensions was, for the artist or now for the public, primary:

(a) Representation of a human figure, with no importance attached to the identity of the subject: "nude old man," etc.

(b) Identity or personality of the subject—named or unnamed, known or unknown—particularly interesting to the artist, the arrangement and style usually revealing that interest: *Portrait of an Unknown Man, Portrait of Monsieur X, Mademoiselle Rivière*.

(c) Representation of individualized, but imaginary and conventional, features, of a mythical figure or historical character whose actual appearance is not known: "Hercules," "Saint Paul."

(d) Double meaning of the subject represented (superimposition of *c* over *b*: *Mrs. Siddons as a Tragic Muse*.

(e) False, imaginary, or conventional identity of the subject absorbed into the identity of the art work as an object: *The Otricoli Zeus, The Man with a Glass of Wine*, the *Mona Lisa*.

There is no need to create a special category for Arcimboldo-type portraits or other composite or double-meaning pictures, which are in fact the combination of two different images, and not the imposition of two meanings upon the same image (cf. Bernheimer, pp. 226ff.).

5. J. Walter McCoubrey, "Gros's *Battle of Eylau* and Roman Imperial Art," in *The Art Bulletin*, XLIII (1961): 135–39.

6. Panofsky points out the importance of the formal type as a possible key to the secondary meaning. But he seems to consider it merely a key, and not as the autonomous bearer of an element of meaning. Bernheimer, *The Nature of Representation*, pp. 172ff., adopts a diametrically opposed point of view, since he treats the iconographic type as if it were a signification of meaning in itself and not merely a significant form; he calls it *designated subject* to distinguish it from the *denoted subject* or iconographic program. This would mean that a sculpted *pietà* refers to the *"pietà* type," as much as it refers to its *denoted subject*, the Virgin with Christ's corpse. This seems, to our mind, to bring in one logical entity too many. The *"pietà* type" is only a signifying form of the group formed by the Virgin and the dead Christ; it is not a common subject for all *pietàs*—no more than the pyramidal composition is the common subject of the *Virgin of the Rocks* and the *Belle Jardinière*.

7. Paul Claudel, *L'Œil écoute* (Paris, 1946), p. 48; André Chastel, "Le Jeu et le sacré dans l'art moderne," in *Critique*, nos. 96–97 (May–June 1955).

8. Meyer Schapiro, "*Muscipula diaboli*. The Symbolism of the Mérode Altarpiece," in *The Art Bulletin*, XXVII (1945): 183–37. There existed another version of the mousetrap metaphor which is obviously more primitive and closer to myth: God the Father tied the body of Christ to the cross like bait on a hook; thus he could catch Leviathan when fishing. This image, widespread among Arians, is still found on some Runic stones.

9. Some other types of nonexplicit, more or less natural symbols would include: differences of size between characters according to their metaphorical "grandeur" or the importance of the part they play in the story represented; the expressive value of lines, forms, or colors, inasmuch as it adds, by modifying them, to the meanings conveyed by the representation. For this last type of meaning Bernheimer (pp. 229ff.) reserves the term "visual metaphor."

10. E. H. Gombrich, *Art and Illusion* (London, 1960).

11. About the symbolism of Romanesque and Gothic in Flemish painting, see Panofsky, *Early Netherlandish Painting* (Cambridge, Mass., 1953). About the carnation in portraits, see Ingvar Bergström, "On religious symbols in European portraiture of the fifteenth and sixteenth centuries" in *Umanesimo e esoterismo*, Atti del V Convegno Internaz. di Studi umanistici (Padua, 1960), pp. 335–44.

12. The example of Velázquez's *Mars* is given and discussed by Bernheimer, *The Nature of Representation*, pp. 184 and 187.

13. For instance, the portrait of *Emperor Maximilian with His Family* by Bern. Strigel was transformed, through the wish of the buyer and with the help of simple inscriptions added by the artist, into an altarpiece representing the parentage of the Virgin.

14. The titles suggested for our imaginary example of the newspaper reader correspond to the respective points of view of the "artistic problem," of artistic truth or of the special effect; the different possible styles indicate which of those points of view the artist adopted, and which was consequently the "real subject" that interested him.

15. Artistic or literary history always assumes the greatest possible unity in the expression of an individual; for attributions, everything is dismissed that does not refer to his style, narrowly defined by the known documented samples. If several landmarks, dating from relatively distant periods, show markedly different characteristics, they are bridged by a supposed "evolution of the author" that is always assumed to be as direct and continuous as possible. In practice those postulates result, like Kant's transcendental freedom, in an empirical determinism.

16. A very clear, subtle, and exhaustive analysis of the different "circles" in historical sciences, and particularly in art history, is provided by Panofsky in "The History of Art as a Humanistic Discipline," reprinted in *Meaning in the Visual Arts* (New York, 1955).

9. Judgment and Taste in Cinquecento Art Theory

1. On this notion of the unintentional self-portrait, see G. F. Hartlaub, "Das Selbstbildnerische in der Kunstgeschichte," *Zeitschrift für Kunstwissenschaft*, IX (1955): 97–124, who quotes, among other things, Cosimo the Elder after "Politian's Diary," Matteo Franco, Savonarola, Leonardo (on whom see also, on that subject, Gombrich's interesting remarks, "Leonardo's Grotesque Heads," in *Leonardo: Saggi e ricerche* [Rome, 1954], pp. 199–219) and a witty remark of Michelangelo. The theme of the work as a moral self-portrait, which we find in Savonarola, is particularly emphasized in a text by Ficino (*Opera*, I, 229), quoted and commented upon by Gombrich, "Botticelli's Mythologies," *Journal of the Warburg and Courtauld Institutes*, VIII, (1945): 59, and by Creighton Gilbert, "On Subject and Not-subject in Italian Renaissance," *The Art Bulletin*, 34, 3 (1952): 202–216. André Chastel, *Art et humanisme à Florence au temps de Laurent le Magnifique* (Paris, 1959), pp. 102–104 (cf. also by the same author, *Marsile Ficin et l'art* [Geneva-Lille, 1954], pp. 65–66) discusses all the data and considers them within the historical context; moreover he adds the pertinent theme: "the painter must become what he wants to reproduce" (Dante, *Convivio*; Benivieni, *Canzone d'Amore*, with the ad loc. *Commentary* by Pico della Mirandola), a notion that becomes identical, in Leonardo, with the idea that "any painter paints himself." This series of examples could be rounded off, for the Quattrocento, with a Brunelleschi sonnet directed against a bad painter who paints figures as mad as himself (see A. Pellizzari, *I trattati intorno alle arti figurative*, v. II, 1 [Naples, n.d.], and A. Parronchi, "Le 'misure dell'occhio' secondo il Ghiberti," *Paragone*, n. 133 [Jan. 1961]: 47 and n. 28). There is more material for the sixteenth century, but it has been little examined by Hartlaub: following the roughest line of interpretation, whether an artist may avoid putting self-

portraits everywhere, see Paulo Pino, "Dialogo di Pittura," in Barocchi, ed., *Trattati d'arte del Cinquecento*, vol. I (Bari, 1960), p. 133; Gilio da Fabriano, "Degli errori de' pittori," ibid., vol. II, p. 48; or, with more imagination and a hint of humor, Vasari, *Vite*, in a sentence from the first edition, deleted in the second edition (medieval sculptors had a *"tondo"* mind, hence the "roundness" of their works; vol. I [Florence, 1550], p. 333); cf. also his explanation of the bewildered air of Spinello Aretino's figures, *Vite*, ed. Milanesi, vol. II, p. 284. About the moral self-portrait in the sixteenth century, see Gallucci, the translator of Dürer's *Vier Bücher* [*Della Simmetria de i corpi humani* [Venice, 1591]) in the preface (not paginated). Dante's and Pico's version occurs again in Cellini's letter to Varchi about the *paragone* (Barocchi, ed., *Trattati d'arte*, vol. I, p. 81). Finally, we must cite a *symbolum* by Achille Bocchi: Socrates, whose hand is guided by his Daemon, painting a self-portrait (*Symbolicarum quaestionum libri V* [Bologna, 1555], p. vi, symb. III). Leonardo's version—according to which the soul that forms the body of the artist also forms, along the same ideas or models, the figures drawn by his hand—may be partly derived from Ficino, *Opera*, I, pp. 178 and 300.

2. Marco Treves, "Maniera, the history of a word," *Marsyas*, I (1941): 68–88; G. Weise, "Maniera und pellegrino, zwei Lieblingswörter des Manierismus," *Romanistische Jahrbuch*, III (1950): 321–404; N. Ivanoff, "Il concetto dello stile nella letteratura artistica del' 500," *Quaderni dell' Ist. di storia dell'arte dell'Univ. degli studi di Trieste*, no. 4 (1955). John Grace Freeman, *The maniera of Vasari* (London, 1867), is only an inventory of the passages from Vasari in which this word figures.

3. The part played by literary theory and criticism in the theory and criticism of art is now well known. Present research in this field owes much to R. W. Lee's article, "Ut pictura poesis," *The Art Bulletin*, XXII (1940): 197–269, dealing mainly with the second half of the Cinquecento. Since then research has gone as far back as to Alberti.

4. Croce underlined the phrase *gusto produttivo* in the basic pages he wrote on the history of *gusto* in *Estetica*, 4th ed. (Bari, 1912), pp. 221–24). Poussin's text is quoted by Bellori in his life of the painter (*Vite dei pittori, scultori ed architetti moderni* [Pisa, 1821], vol. II, p. 205).

5. Thomas Aquinas, *In Arist. De anima*, 3, 14ᵉ "discretio opus est intellectivae et sensitivae partis." Cf. also *In IV Sent.*, 47, 1, 3, 2c and 4c: *judicium discretionis* used as a synonym of *judicium discussionis sive examinationis*.

6. Paulo Pino, "Dialogo di pittura," p. 104: "ma qui ci concorre la discrezzione, ch'è intesa da me per buon giudicio"; and Lodovico Dolce, "Dialogo della Pittura," in Barocchi, ed., *Trattati d'arte*, vol. I, p. 180: "Aviene anco che le figure scortino. La qual cosa non si può fare senza gran giudico e discrezione."

7. See Lomazzo, chaps. III and XVIII. One must read *discrettione* for *descrittione* several times in the text. A lapsus of Lomazzo's in chap. I, p. 4 (Milan, 1590) shows that the *Idea* was first conceived as an introductory book of the

Trattato published in 1584 and should probably have been called *Libro della discrezione.*

8. T. Campanella, *Magia e grazia* (*Theologicum liber XIV*), ed. Romano Amerio (Ediz. naz. dei class. del pensiero ital., II, 5 [Rome, 1958]): see p. 9, art. 1–2, pp. 147–58. It is first a matter of innate *discretio*, which is essentially concerned with the identification of good and bad spirits; it is comparable to the sense of taste somewhat as we would nowadays talk about "flair": "non enim discurrendo cognoscit vir spiritualis utrum daemon an angelus . . . sibi suadet . . . aliquid; sed quodam quasi tactu et gustu et intuitiva notitia . . . quemadmodum lingua statim discernimus saporem vini et panis." Unlike Thomas Aquinas, Campanella claims that this is no illumination, but a permanent faculty, a sixth sense ("sensu quidam parturiens subito bonam aut adversam affectionem"), which can also be applied to the knowledge of human nature and of other minds. This innate discretion is therefore necessary to "prelates, princes, and apostolic men"; Campanella even wonders, without coming to any conclusion, whether it can be reinforced by practice, as talent can. Whereas innate *discretio* resembles taste and inborn artistic gift, acquired *discretio*, whose first aim is to distinguish truth from inspired falsehood, is similar to an art: it is an exercise with its own rules (from the Gospel), its own requirements of historical knowledge (about the prophets, the impostors, and fanatics of the past); it cannot dispense with experience and practice ("parum valet speculatio sine praxi": painting is quoted as an example); the *discretus* must be instructed in many sciences, such as astrology and medicine, and must possess the highest moral qualities. This entire discourse is an adaptation of well-known commonplaces found in the introductions of treatises on any of the arts.

9. *Convivium,* VI, 12. Ficino cites *Menon* as proof, but his real source is Augustine's *De musica.* The tradition includes John of Salisbury's *Metalogicus* (I, 11; Parr. lat., CIC, 838–39) in which judgment, *examinatrix animi vis,* is identified with *ratio* and is supposed to provide the foundation of the liberal arts, whose laws it establishes.

Alberti, *De re aedificatoria,* IX, 5.

10. *Trattato della pittura,* Cod. Urb. 1270, f⁰ 131 v⁰; ed. P. McMahon, 2 vols. (Princeton, 1957), n. 439. Later there was frequent talk of the "idea conceived within the mind" so perfect that the hand is incapable of achieving it. But Leonardo wrote *giudizio,* not *idea;* the work, according to him, must always be preceded in the artist's mind by a *critical function* and not by a ready-made *ideal image.*

11. S. Serlio, *Tutte l'opere d'architettura* (Venice, 1619), book VII, p. 120. The manuscript of book VII was sold by the author in 1550; it seems to have been edited around 1546 (Dinsmoor).

12. Antonio Persio, *Trattato dell'ingegno dell'huomo* (Venice, 1576), pp. 77ff. For a similar distinction between *ingenium* and *judicium* by J. de Valdés, see E. R. Curtius, *European Literature and the Latin Middle Ages* (Princeton, N.J., 1953).

13. Raffaele Borghini, *Il Riposo* (Florence, 1584), p. 150; Tasso, "La Cavaletta ovvero della poesia toscana" (*Dialoghi*, ed. Guasti, 3 vols. [Florence, 1858–59], vol. III, pp. 101 and 94ff.).

14. Many texts and references can be found in R. J. Clements, "Eye, Mind, and Hand in Michelangelo's poetry," *Publications of the Modern Language Association*, 69 (1954): 324–36, which, however, tends to take the "judgment of the eye" too far toward "interior vision." With Armenini, this judgment is nothing but the aptitude to evaluate correctly the size of members represented in foreshortening (*De' veri precetti della pittura* [Ravenna, 1587], p. 96); on the other hand, with V. Danti ("Il primo libro del Trattato delle perfette proporzioni," Barocchi ed., *Trattati d'arte*, vol. I, p. 233), *misura intellettuale* and *seste del giudizio* are judgments about the functional capacities of various parts of the human body according to their proportions. (Cf. Tolnay, "Die Handzeichnungen Michelangelos im Codex Vaticanus," *Repert. f. Kunstwiss.*, 48 [1927], pp. 181–82.) According to Cinquecento theorists, interior vision is never judgment, but rather invention, a creation of the *concetto*. Judgment is assimilated to ideal vision only in Ficino's strictly Platonic and Augustinian theories (see above, p. 163 and n. 10).

15. Examples from Leone Ebreo and Varchi quoted by Barocchi, ed., *Trattati d'arte*, I, p. 89, n. 1. On this particular subject there is an abundance of sources. And see Castiglione, I, 37.

16. Pino, p. 132: "Sono varii li giudicii umani, diverse le complessioni, abbiamo medesmamente l'uno dall'altro estratto l'intelletto nel gusto, le qual differenzia causa che non a tutti aggradano equalmente le cose." One should perhaps understand the word *vario* after *medesmamente*.

17. Gallucci, for instance; in the fifth book he adds to his translation of Dürer's four books on proportion, op. cit., f⁰ 125 v⁰: the canons of beauty vary according to authors and periods, "pero deve il saggio pittore bene, e diligentemente intendere, e considerare quello, che qui è scritto della bellezza, e poi accomodarsi all'universal opinione de' suoi tempi, e della sua etade per non parere egli solo sapiente fra tutti gli altri, ch'altro non farebbe ch'acquistarsi nome di passo, il quale giudicasse bella quella cosa, che da tutti, o di quei tempi, o di quella cittade è riputata brutta."

18. Cod. Urb. 1270, f⁰ 44 r⁰–v⁰, ed. quoted, n. 86.

19. S. Ortolani, "Le origini della critica d'arte a Venezia," *L'Arte*, XXVI (1923): 10, mentions this peculiarity in Aretino. Texts in which *giudizio* has "il senso convenzionale di innata capacità discriminante ed expressiva" are indicated in Barocchi, ed., *Trattati d'arte*, vol. I, p. 277, n. 1 (the references to Varchi and Sangallo, both Florentine, are the only ones which do not seem convincing).

20. P. Aretino, *Lettere sull'arte*, eds. Pertile, Cordié, Camesasca (Milan, 1957), vol. I, p. 88 (letter to Franc. Pocopanno, 24 November 1537).

21. *Ibid.*, pp. 101–104, letter to Fausto da Longiano, 17 February 1537 (2d ed.). The meaning of *giudizio* in that letter varies, and the original version,

which has been altered in the second edition, requires some comments; but such nuances are unimportant here.

22. Pino, p. 114.

23. See Danti, op. cit., pp. 230 and 268; Armenini, op. cit., p. 49.

24. Quintilian: 6, 3, 17. Alberti: *De re aedificatoria*, VII, 10. Politian, *Epistolae*, V, 1; in A. B. Scala, *Opera* (Lyons, 1539), vol. I, p. 130.

25. Preface to the *Mucellanea*, ibid., vol. I, p. 485.

26. *Inferno*, XIII, 70; *Paradise*, XXXII, 122. In thirteenth-century French the equivalent word was *talent*. This term first meant *gusto*, as desire; in contemporary French it now has the meaning of *gusto produttivo*.

27. Fed. Zuccaro, *Passaggio per l'Italia* (Bologna, 1608), passim (*i gusti*, "pleasures"). Soprani and Ratti, *Vite de' pittori genovesi* (Genoa, 1768–69), vol. I, p. 129, quote a letter from a customer in Madrid to G. B. Paggi: "send me the pictures, *ne sentirô molto gusto.*"

28. Dolce (1556), op. cit., vol. I, p. 176.

29. Doni (1549), *Il Disegno* (Venice, 1549), f⁰ 16 v⁰.

30. Filarete, *Trattato dell'architettura*, ed. W. v. Oettingen (Vienna, 1890).

31. Vasari, ed. Milanesi, vol. VII, p. 272.

32. Lomazzo, *Idea*, p. 87.

33. Danti, op. cit., dedication, vol. I, pp. 209 and 210.

34. Giulio Mancini, *Considerazioni sulla pittura* (written about 1619–21), eds. Adr. Marucchi and L. Salerno, 2 vols. (Rome, 1956–57), pp. 109 and 140.

35. Inversely there was also a contamination of *giudizio* by its recently promoted synonym. For instance Cristoforo Sorte, *Osservazioni nella pittura* (1580), ed. Barocchi, vol. I, p. 292, about the fugitive effects of light produced by a conflagration: "questi e cosi fatti sono soggetti tanto particolari e proprii del giudicio e della mano del pittore, che non si ponno né esprimere, e meno insegnare, se non che in fatto ciò l'operazioni dimostrano." This is more or less what Doni wrote about drapery (quoted in text, p. 167) but without using, as does Sorte, the word *giudizio* for those almost instinctive reactions which the phrase "productive taste" would properly describe.

36. Michelangelo to Tommaso Cavalieri, Frey CIX, 572; see also Ariosto, *Orlando Furioso*, XXXV, 26, where Emperor Augustus's *buon gusto* causes him to be forgiven for his crimes.

10. Notes on the End of the Image

1. Tinguely's electronic machines, for example, or more generally all forms of mobile sculpture (Calder), or the mechanical variations produced by the

projection of colored lights and shadows (Schoeffer). It would be absurd to wonder whether the work of art is within the mechanism, the support, the fortuitous result, or even the spectator's gaze.

2. Klee: "Space too is a temporal notion."

12. Modern Painting and Phenomenology

The works discussed in this essay are:
Robert Lapoujade, *Les Mécanismes de la fascination*, Foreword by Jean Hyppolite (Paris, 1955).
Paul Klee, *Über das bildnerische Denken*, ed. Jürg Spiller (Basel-Stuttgart, 1956).
Maurice Merleau-Ponty, "L'Œil et l'esprit," in *Art de France*, I (1960): 187–208.
Georges Duthuit, *L'Image en souffrance*. I. Coulures; II. Le Noeud (Paris, 1961).
Jean Paulhan, *L'Art informel* (Paris, 1962).

1. Hyppolite, Foreword to Lapoujade's *Les Mécanismes*, p. 17.

2. L. Van Haecht, "Les Racines communes de la phénoménologie, de la psychanalyse, et de l'art moderne" in *Revue Philosophique de Louvain*, LI (1953): 568–90.

3. Paulhan, *L'Art informel*, p. 10.

4. Jean-Paul Sartre, "Le Peintre sans privilèges," foreword of the catalogue of the Lapoujade Exhibition, Pierre Domec Gallery (Paris, 1961).

5. Merleau-Ponty, "Le Langage indirect et les voix du silence," in *Les Temps modernes* (June 1952): 2113–44; (July 1952): 70–94. See p. 2123.

6. Merleau-Ponty, "Le Doute de Cézanne" in the anthology *Sens et non-sens* (Paris, 1948, pp. 15–49, and "L'Œil et l'esprit," in *Art de France*, I (1960): 187–208.

7. J. Gasquet, *Cézanne* (Paris, 1921), p. 91.

8. Merleau-Ponty, "L'Œil et l'esprit," p. 199.

9. Merleau-Ponty, "Le Doute de Cézanne," p. 36; "L'Œil et l'esprit," p. 192.

10. Merleau-Ponty, "L'Œil et l'esprit," p. 206.

11. Merleau-Ponty explains this in "Le Doute de Cézanne," pp. 36ff., and in "Le Langage indirect," 2d part.

12. The sides that are foreshortened or hidden are in effect "unfulfilled" intentions.

13. V. Kandinsky, *Über das Geistige in der Kunst*, 4th ed (Bern, 1952), p. 68.

14. Ibid., p. 63.

15. Ibid., p. 69, n. 1.

16. Werner Ziegenruss, *Die phänomenologische Aesthetik* (Leipzig, 1927).

17. This excludes both definitions based on objective characteristics of form and subjectivist theories that allow that an aesthetic experience depends entirely on a freely adopted aesthetic attitude. Naturally, it is necessary to realize the framework of the personality that determines its own situations and is determined by them.

18. Merleau-Ponty, "Le Langage indirect," I, p. 2135.

19. Lapoujade, *Les Mécanismes*, pp. 41–42

20. Paulhan, *L'Art informel*, p. 45.

21. Thus a pretty work, a flourish by Mathieu, only pretends to be informal.

22. Duthuit, *L'Image en souffrance*, I, p. 99.

23. Ibid., II, p. 20.

24. Ibid., I, p. 66.

25. There is much to be said about sociological interpretations of the bracketing of the work in contemporary art. But sociologism always introduces an external factor as a motor of development—which does not invalidate it, but puts it beyond the scope of this discussion. Walter Benjamin, in an excellent essay, *Die Kunst im Zeitalter ihrer Reproduzierbarkeit*, begins from the fact that industrial reproduction and the diffusion of innumerable copies has destroyed the halo of the "work of art" and turned it into an ordinary, casual consumer good; hence, he claims, the irresistible devaluation of the entire "bourgeois" aesthetic based on the specificity and dignity of the aesthetic experience. (With this idea of casual consumerism and nonspecificity, Benjamin approaches Brecht, and, needless to say, anticipates and refutes Malraux's conclusions about the reign of museums and reproductions.) W. Bense (*Plakatwelt* [Stuttgart, 1952]) forecasts an assimilation of contemporary art with poster art: the "effect" replaces representation; everything becomes a stimulant and an invitation, as can be expected in a world of signals and merchandise.

26. Duthuit, *L'Image en souffrance*, II, p. 128.

27. This is a very rough sketch of Duthuit's thought. Whenever he discusses one particular artist, and attempts positively to place him, he describes very accurately and well aspects of a process which on the whole seems impossible and absurd to him.

28. Cf. Merleau-Ponty, "Sur la phénoménologie du langage," in *Actes du Colloque international de phénoménologie, 1951* (Paris, 1952), p. 104.

29. Bazaine, *Notes sur la peinture d'aujourd'hui* (Paris, 1953), p. 65: "unity of God, of an active nature which clings to man like his own skin, and of man."

30. Radio interview with Azo Wou-ki published by G. Charbonnier, *Le Monologue du peintre*, II (Paris, 1960): 179–86. The act of painting is a complete fusion of the painter with the object ("La montagne, c'est moi"), an

experience which cannot be communicated and can only be integrated on a metaphysical plane, since it owes nothing to language: each works his "surface of the crystal" and the surfaces combine to "build a veritable reality."

31. Paul Klee, *Über das bildnerische Denken* (Basel-Stuttgart, 1956).

32. Cf. also the perceptive and much less dogmatic article by Jean-Louis Ferrier, "Le Paysagisme non figuratif," in *Art de France*, III (1963): 342–48.

33. Sartre, "Le Peintre sans privilèges."

34. Lapoujade, *Les Mécanismes*, pp. 122–23.

35. Ibid., p. 53.

36. Merleau-Ponty, "Le Langage indirect," p. 2128: "For those moderns who deliver sketches as pictures, and whose canvases must each be seen, as the signature of one moment of living, in an 'exhibition' within a series of successive canvases, this acceptance of the unfinished can mean one of two things: either they have indeed given up the *work* and look only for the immediacy, the felt, the individual, for the 'brute expression,' as Malraux calls it; or the finish, the objective and convincing presentation *for the senses* is no longer the means or sign of a really *made* work, because expression now goes from man to man, through the world they *live* in, without going through the anonymous realm of *the senses* or of Nature." Neither Malraux's expressionistic explanation nor Merleau-Ponty's somewhat linguistic ones ,takes into account the fact that unfinished works must be seen in a series and are completed within that series.

13. Thought, Confession, Fiction: On *A Season in Hell*

1. This passage, which echoes ironically a line from an adolescent poem: "O mort mystérieuse, ô sœur de charité" (Oh mysterious death, oh sister of mercy), alludes, it is true, to another illusory "Magus or angel": art. But the art in question is precisely poetry, as a state of grace. There are many quotations even more probing than this one but too long to be given here; for instance, the entire beginning of the chapter "Night in Hell."

2. A long commentary upon the admirable page entitled "The Impossible" would be relevant here.

3. The context does not allow us to interpret this expression other than as the renunciation of the hope of recovering the "key to that ancient feast."

Bibliography of
Robert Klein's Writings

Essays that were reprinted in the posthumous collection La *forme et l'intelligible (Paris, 1969) are indicated by an asterisk; those that appear in the present volume, by a dagger.*

Books

Le Procès de Savonarole, Paris, 1956 (Ital. trans. 1960).

L'Age de l'humanisme (with André Chastel), Brussels, 1963 (English, German, Italian trans.).

Italian art, 1500–1600: Sources and documents (with Henri Zerner), Englewood Cliffs, N.J., 1966.

Pomponius Gauricus, De Sculptura (1504). Critical edition with French translation (with André Chastel), Paris, 1969.

Articles

1952
"Sur la signification de la synthèse des arts," Revue d'esthétique, V, 1952, pp. 298–311.

1956
*"L'imagination comme vêtement de l'âme chez Marsile Ficin et Giordano Bruno," Revue de métaphysique et de morale, 1956, pp. 18–39.

1957
*† "La théorie de l'expression figurée dans les traités italiens sur les imprese, 1555–1612," Bibliothèque d'Humanisme et Renaissance, XIX, 1957, pp. 320–41.

1958
*† "La forme et l'intelligible," in Umanesimo e Simbolismo, Atti del IV Congresso internazionale di studi umanistici (Venice, 19–21 September 1958), Padua, 1958, pp. 103–21.

*† " 'La Civilisation de la Renaissance' Aujourd'hui," afterword in reprinted edition of J. Burckhardt, Paris, 1958, pp. 295–313.

1959
Augustin Renaudet, "In memoriam," Revue des études italiennes, 1959, pp. 54–61.

* "Les 'sept gouverneurs de l'art' selon Lomazzo," *Arte lombarda*, IV, 1959, pp. 277-87.

*† "Pensée, confession, fiction: à propos de la 'Saison en enfer,' " *La diaristica filosofica*, *Archivio di Filosofia*, 1959, no. 2, pp. 105-11.

"C'était déjà dans Tacite," *Club Panorama*, No. 1, April 1959, pp. 35-38.

1960
* "L'enfer de Ficin," *Umanesimo e esoterismo*, Atti del V Convegno internazionale di studi umanistici (Oberhofen, September 1960), *Archivio di filosofia*, 1960, nos. 2-3, pp. 47-84.

"La crise de la Renaissance italienne," *Critique*, XVI, 1960, pp. 322-40.

"La pensée figurée de la Renaissance," *Diogène*, no. 32, 1960, pp. 123-38.

"Francisco de Hollanda et les 'secrets de l'art,' " *Coloquio* (Lisbon), no. 11, 1960, pp. 6-9.

1961
* "Les humanistes et la science," *Bibliothèque d'Humanisme et Renaissance*, XXIII, 1961, pp. 7-16.

* "Art et illusion, le problème psychologique," *Art de France*, I, 1961, pp. 433-36.

*† "Pomponius Gauricus on perspective," *The Art Bulletin*, XLIII, 1961, pp. 211-30.

* "Appropriation et aliénation," *Filosofia della alienazione e analisi esistenziale*, *Archivio di Filosofia*, 1961, no. 3, pp. 53-64.

"La dernière méditation de Savonarole," *Bibliothèque d'Humanisme et Renaissance*, XXIII, 1961, pp. 441-48 (followed by a response to Goukovskij, XXV, 1963, pp. 226-27).

*† "*Giudizio* et *gusto* dans la théorie de l'art au Cinquecento," *Rinascimento*, XII, 1961, pp. 105-16.

1962
*† "Notes sur la fin de l'image," Atti del Colloquio internazionale su Demitizzazione e immagine (Rome, January 1962), *Archivio di filosofia*, 1962, no. 1-2, pp. 123-28.

1963
*† "Peinture moderne et phénoménologie," *Critique*, XIX, 1963, pp. 336-53.

* "La thème du fou et l'ironie humaniste," in *Umanesimo e ermeneutica*, *Archivio di Filosofia*, 1963, no. 3, pp. 11-25.

*† "Études sur la perspective à la Renaissance, 1956-1963," *Bibliothèque d'Humanisme et Renaissance*, XXV, 1963, pp. 577-87.

"L'esthétique mathématique" (with Jacques Guillerme), *Sciences*, no. 26, 1963, pp. 45-56.

"Pierre Soulages" (review), *Art de France*, 1963, pp. 384–85.

*† "Considérations sur les fondements de l'iconographie," in *Ermeneutica e tradizione, Atti del III Colloquio internazionale sulla Tematica della demitizzazione* (10–16 January 1963), *Archivio di Filosofia*, 1963, no. 1–2, pp. 419–36.

"Humanisme, conscience historique et sentiment national" (with André Chastel), *Diogène*, 44, 1963, pp. 3–20.

*† "L'urbanisme utopique de Filarete à Valentin Andreae," *Actes du Colloque international sur les utopies à la Renaissance* (Brussels, April 1961), 1963, pp. 209–30.

1964
* "Vitruve et le théâtre de la Renaissance" (with Henri Zerner), in the collection *Le Lieu théâtral à la Renaissance*, Paris, 1964, pp. 49–60.

"L'art et l'attention au technique," in *Tecnica e casistica, Atti del IV Colloquio internazionale sulla tematica della demitizzazione* (Rome, 7–12 January 1964), *Archivio di Filosofia*, 1964, no. 1–2, pp. 363–72.

"Mort de l'art ou mort de l'œuvre?" *Preuves*, no. 196, 1964, pp. 29–30.

"Humanisme et Renaissance" (bibliography with André Chastel), *L'Information d'histoire de l'art*, 9, 1964, pp. 222–25.

"Bemerkungen zum Untergang des Bildes," *Kerygma und Mythos*, VI, 1964, pp. 61–66.

1965
*† "Spirito peregrino," *Revue des études italiennes*, special number: *Dante et les mythes*, XI, 1965, pp. 197–236.

* "Les limites de la morale transcendantale" (with Ngô tieng Hiên), in *Demitizzazione e morale, Atti del V Colloquio internazionale sul problema della demitizzazzione* (Rome, 7–12 January 1965), *Archivio di Filosofia*, 1965, no. 1–2, pp. 269–79.

* "La méthode iconographique et la sculpture des tombeaux," *Mercure de France*, 1965, pp. 362–67.

"L'humanisme et les sciences de la Nature," *Bulletin de l'Institut de philosophie*, XIV, 1965, pp. 19–27.

1967
"Les tarots enlumines du XVᵉ siècle," *L'Œil*, no. 145, January 1967, pp. 11–17 and 51–52.

* "Die Bibliothek von Mirandola und das Giorgione zugeschriebene Concert champêtre," *Zeitschrift für Kunstgeschichte*, XXX, 1967, pp. 199–206.

*† "L'éclipse de l' 'œuvre d'art,' " *Vie des arts*, 1967, no. 47, pp. 40–44 and 48.

"Le canon pseudo-varronien des proportions," in *Les problèmes du gothique et de la Renaissance*, Proceedings of the International Days of the history of art (Budapest, 4–8 May 1965), *Acta Historiae Artium* XIII, 1967, no. 1–3, pp. 177–85.

Reviews

In *Revue de Littérature comparée*:
XXXV, 1961, pp. 655–56: Domingo Ricart, "Juan de Valdés y el pensamiento religioso europeo en los siglos XVI y XVII," Lawrence, 1958.

XXXVI, 1962, pp. 602–605: Manierismo, Barocco, Rococo, Concetti e termini (International conference, Rome, 21–24 April 1960, Reports and discussions), Rome, 1962.

XXXVII, 1963, pp. 312–13: H. A. Enno van Gelder, "The two Reformations in the 16th century. A study of the religious aspects and consequences of the Renaissance and Humanism," The Hague, 1961.

XXXVII, 1963, pp. 488–90: Renato Poggioli, "Teoria dell'arte d'avanguardia," Bologna, 1962.

XXXVIII, 1964, pp. 148–50: Maurice Pollet, "John Skelton (c. 1460–1529). Contribution à l'histoire de la Prérenaissance anglaise," Paris, 1962.

XXXIX, 1965, pp. 641–42: Don Cameron Allen, "Doubt's boundless sea. Skepticism and faith in the Renaissance," Baltimore, 1964.

XXXIX, 1965, pp. 642–45: Corrado Vivanti, "Lotta politica e pace religiosa in Francia fra Cinque e Seicento," Turin, 1964.

XL, 1966, pp. 141–42: Edmondo Cione, "Fede e ragione nella storia," Bologna, 1963.

In *Renaissance News*:
XIII, 1960, pp. 237–40: Edgar Wind, "Pagan Mysteries in the Renaissance," Yale, 1958.

In *Mercure de France*:
*1964, pp. 588–94: Raymond Klibansky, Erwin Panofsky, Fritz Saxl, "Saturn and Melancholy. Studies in the History of Natural Philosophy, Religion and Art," 1964.

In *Zeitschrift für Kunstgeschichte*:
XXIII, 1960, pp. 284–86: Edgar Wind, "Pagan Mysteries in the Renaissance," Yale, 1958.

XXV, 1962, pp. 85–87: Erwin Panofsky, "The Iconography of Correggio's Camera di San Paolo," London, 1961.

XXVI, 1963, pp. 190–92: André Chastel, "Art et Humanisme à Florence au temps de Laurent le Magnifique," Paris, 1959.

In *Bibliothèque d'Humanisme et Renaissance*:
XX, 1958, pp. 240–42: Tommaso Campanella, Magia e grazia (Theologicorum liber XIV) a cura di Romano Amerio," Rome, 1957.

XX, 1958, pp. 603–606: Tommaso Campanella, "De Sancta Monotriade (Theologicorum liber II) a cura di Romano Amerio," Rome, 1957.

XXI, 1959, pp. 513–14: Klaus Heitmann, "Fortuna und Virtus. Eine Studie zu Petrarcas Lebensweisheit," Cologne-Graz, 1958.

XXI, 1959, pp. 514–16: Federico Chabod, "Machiavelli and the Renaissance," London, 1958.

XXI, 1959, pp. 516–19: "Il mondo antico nel Rinascimento," Atti del V Convegno internazionale di studi sul Rinascimento, Florence, 1958.

XXI, 1959, p. 543: Roland H. Bainton, "La Riforma Protestante," Turin, 1958.

XXI, 1959, pp. 237–39: "*Umanesimo e Simbolismo*, Atti del IV Congresso internazionale di studi umanistici," Padua, 1958.

XXI, 1959, pp. 643–44: P. Suitbert Gammersbach: "Gilbert von Poitiers . . ." Cologne-Graz, 1959.

XXI, 1959, pp. 653–55: Enrico Castelli, "Le démoniaque dans l'art," Paris, 1959.

XXI, 1959, pp. 645–46: G. Rabuse, "Der kosmische Aufbau der Jenseitsreiche Dantes," Cologne-Graz, 1958.

XXII, 1960, pp. 423–25: Eugenio Anagnine, "Il concetto di Rinascimento attraverso il Medio Evo (V–X sec.)," Milan-Naples, 1958.

XXII, 1960, pp. 425–27: "Egidio da Viterbo, Scechina e Libellus de litteris hebraicis, inediti, a cura di François Secret," Rome, 1959, 2 vols.

XXIII, 1961, pp. 178–80: "Giovanni Rucellai ed il suo Zibaldone, I: 'Il Zibaldone Quaresimale,' a cura di Alessandro Perosa," London, 1960.

XXIII, 1961, pp. 180–82: "Umanesimo e esoterismo. Atti del V Convegno internazionale di studi umanistici," Padua, 1960.

XXIII, 1961, pp. 202–205: Eugenio Battisti, "Rinascimento e Barocco," Turin, 1960.

XXIII, 1961, pp. 205–206: Tommaso Campanella, "Il peccato originale" (*Theologicorum*, liber XVI), Rome, 1960.

XXIII, 1961, pp. 425–27: P. Rossi, "Clavis universalis. Arti mnemoniche e logica combinatoria da Lullo a Leibniz," Milan-Naples, 1960.

XXIII, 1961, pp. 646–49: Franco Simone, "Il Rinascimento francese. Studi e ricerche," Turin, 1961.

XXIV, 1962, pp. 268–71: "Trattati d'arte del Cinquecento. Fra Manierismo e Controriforma. A cura di Paola Barocchi," vols. I–II, Bari, 1960–61.

XXIV, 1962, pp. 513–16: Eugenio Garin, "La cultura filosofica del Rinascimento italiano. Ricerche e documenti," Florence, 1961.

XXIV, 1962, pp. 502–504: Georg Weise, "L'ideale eroico del Rinascimento e le sue premesse umanistiche," Naples, 1961.

XXV, 1963, pp. 258–60: Neal Ward Gilbert, "Renaissance Concepts of Method," New York, 1960.

XXV, 1963, pp. 260–61: "Trattati d'arte del Cinquecento, Fra Manierismo e Controriforma. A cura di Paola Barocchi," vol. III, Bari, 1962.

XXV, 1963, pp. 630–31: T. Klaniczay, "Probleme der ungarischen Spätrenaissance. Stoizismus und Manierismus" in *Renaissance und Humanismus, in Mittel-und Osteuropa,* Berlin, 1962.

XXV, 1963, pp. 631–33: Rudolf and Margot Wittkower, "Born under Saturn," London, 1963.

XXV, 1963, pp. 629–30: Giovanni Santinello, "Leon Battista Alberti. Una visione estetica del mondo," Florence, 1962.

XXVI, 1964, pp. 487–88: François Secret, "Les kabbalistes chrétiens de la Renaissance," Paris, 1964.

XXIX, 1967, pp. 717–18: Franco Simone, "Per una storia della storiografia letteraria francese. I. La più lontana origine dei primi schemi della storiografia letteraria moderna," Turin, 1966.

In *Critique*:
XVII, 1961, pp. 570–71: Victor-L. Tapié, "Le Baroque," Paris, 1961.

XVIII, 1962, pp. 382–83: Maurice Serullaz, "L'impressionnisme," Paris, 1961.

XIX, 1963, pp. 283–84: "Pascal e Nietzsche," ed. E. Castelli, *Archivio di Filosofia,* 1962, no. 3.

XXI, 1965, pp. 787–89: "Demitizzazione e morale"; a colloquy on the demythologization of morals, *Archivio di Filosofia,* 1965, no. 2.